KU-470-102

# scandinavian design

This present edition is based on the original 2002 edition and focuses on
Scandinavian furniture and textile design.

To stay informed about upcoming TASCHEN titles, please request
our magazine at www.taschen.com or write to TASCHEN America,
6671 Sunset Boulevard, Suite 1508, USA-Los Angeles, CA 90028,
Fax: +1-323-463.4442. We will be happy to send you a free copy of
our magazine which is filled with information about all of our books.

© 2005 TASCHEN GmbH
Hohenzollernring 53, D–50672 Köln
**www.taschen.com**

Original edition: © 2002 TASCHEN GmbH

Pp. 4/5, 336/337: Per Lütken, glass design for Holmegaard, 1950

© 2005 for the works by Gunnar Cyrén, Ulf Hanses, Stig Lindberg:
VG Bild-Kunst, Bonn

Design: Sacha Davison, London
Cover design: Sense/Net, Andy Disl and Birgit Reber, Cologne
Editorial coordination: Sonja Altmeppen, Sabine Bleßmann, Cologne
Technical editing: Thomas Berg, Bonn
Production: Ute Wachendorf, Cologne

This book is being published in simultaneous co-produced editions in several
languages. The Publisher regrets that for this reason it has been necessary
to follow international standards in the alphabetical guide to designers and
companies. This means that the letters Ä, Ä, Æ, Ö, and Ø are treated as
A and O.

Printed in India
ISBN 3-8228-4118-8

# scandinavian design

**Charlotte and Peter Fiell**

TASCHEN

KÖLN LONDON LOS ANGELES MADRID PARIS TOKYO

contents

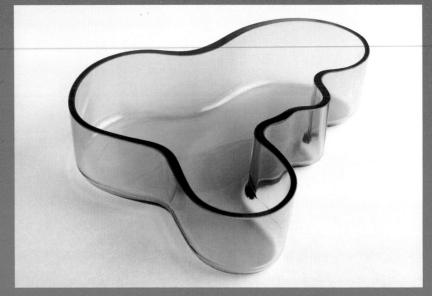

▷ Alvar Aalto, *Aalto* vase for Karhula, 1936 – later produced by Iittala – this version of Aalto's famous vase was also intended to be used as a simple serving tray

▷▷ Erik Magnussen, *Thermal Carafe (Colour 990 – Yellow)* for Stelton, 1976 – yellow version introduced in 1996

# scandinavian design

Scandinavia is a patchwork of northern European nation states that form a cultural and regional entity that is very distinct from the rest of Europe. Sharing a common economic and cultural history and linguistic roots (except Finland), the Scandinavian countries each possess a unique character that reflects their different geographies and environmental conditions. More than anywhere else in the world, designers in Scandinavia have instigated and nurtured a democratic approach to design that seeks a social ideal and the enhancement of the quality of life through appropriate and affordable products and technology. From its birth around 1920, modern Scandinavian design has been underpinned by a moral humanist ethos the roots of which can be traced to Lutheranism – the state religion throughout Scandinavia, which stresses truth and reason and teaches that salvation can be gained through honest work that benefits one's fellow man. It is this moral belief in social imperatives that has formed the philosophical bedrock from which Scandinavian design has evolved and prospered.

Scandinavia is a term generally used to describe Denmark, Finland, Iceland, Norway and Sweden.

But only the latter two nations are actually situated on the Scandinavian Peninsula. More properly, within the region the five countries are referred to as *Norden*, or quite literally "The North". Omitting Iceland, the lonely outpost in the North Atlantic, the other four countries form a territorial entity that extends 1,900 km (1,200 miles) from the Danish-German frontier to the northernmost part of Norway. Their combined land area is about 1,165,000 sq. km (450,000 sq. miles), greater than Britain, France and Spain put together. But the balance changes dramatically when people, not acres, are counted. Vast expanses of northern Finland, Norway and Sweden are given over to mountains and forest, while most of volcanic Iceland is totally uninhabitable. Those who can properly call themselves Nordic number just under 22 million and are to be found living mostly along the coasts or in the rich agricultural areas of the south, where nearly all the big towns are located.

Each Scandinavian country has enjoyed long-established nationhood and a strong identity, and cherished historical associations and myths from which their people have taken much inspiration.

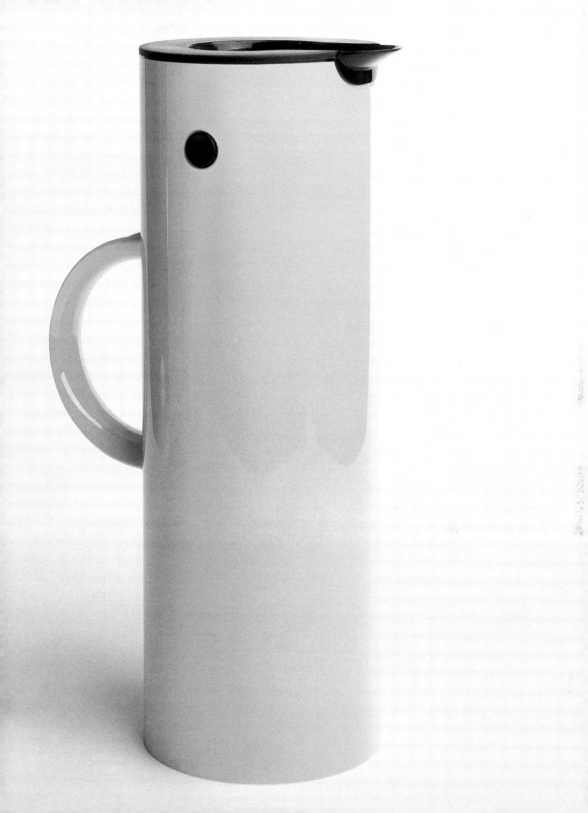

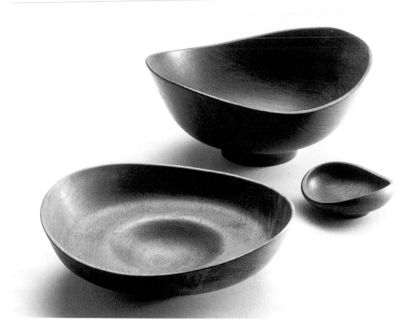

▷ Finn Juhl, teak bowls
executed by the Kay Bojesen
workshop, 1950

▷▷ Jens Quistgaard, cast-iron
candleholders for Dansk Inter-
national Designs, c. 1955

While in the distant past there was serious inter-Nordic conflict, the nations of Scandinavia have achieved a viable and continuous peace with one another for a period of almost two hundred years. Despite certain superficial differences, the Scandinavian people remain much alike. The populations of the five countries are remarkably homogeneous in ethnical and religious terms. The legal systems come from common origins and are dominated by a mutual philosophy – many modern social laws are formulated in common. Although there are many similarities and close bonds between the five *Norden* states, strong stylistic distinctions in terms of approach to design exist between each of the countries. These are due not only to different industrial, political, economic and social conditions, but also to the fundamentally different temperaments of each country's population. As the design writer Anne Stenros noted, "On the emotional level: the Danes are a little more 'southern', the Finns are a little more 'eastern', the Norwegians are a little more 'northern' and the Swedes stick to the golden mean. The Icelanders have sturdy roots of their own." These differences in national character have resulted in diverse approaches to the applied arts and the "flowering of design" at different times in their histories.

Perhaps the single most important unifying trend in the Nordic region over the last 500 years has been the movement away from tyranny towards a social world in which the voice, desires and efforts of the individual have played an increasingly significant role – one in which the maintenance of a prosperous, modern, democratic nation has been crucial. Indeed, while the basic common ideal of individualism is modified in practice by the varying degrees of socialism in each of the five states, today the Nordic countries are among the most affluent, just, humane, and democratic in the world. The most obvious inherent characteristic of the Scandinavian people, however, is their pervasive practicality, and nowhere has this had a greater effect than on the development of modern design. For centuries "the home" has been the central focus of the Scandinavian people's existence as it not only offers a vital haven from hostile climatic conditions, but also functions as a framing structure for family life. This age-old "household culture" was additionally prompted by the fact that self-sufficiency was often an economic necessity

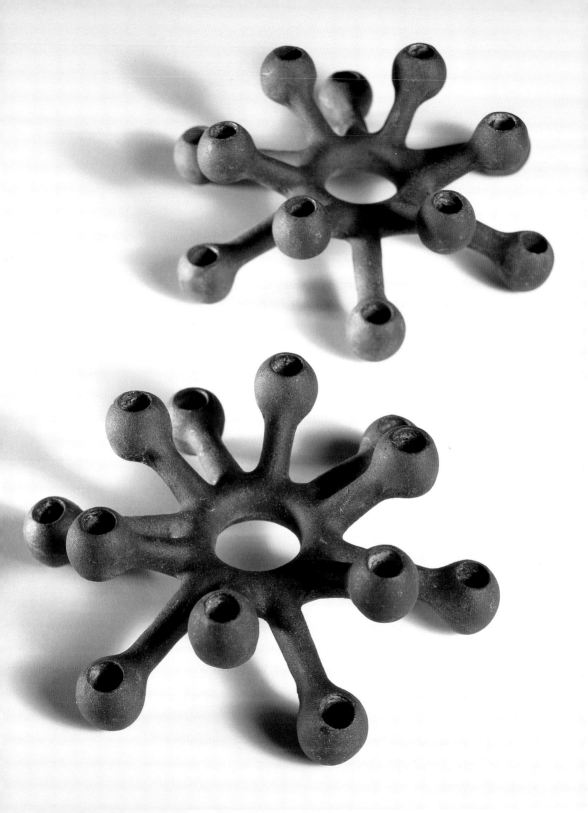

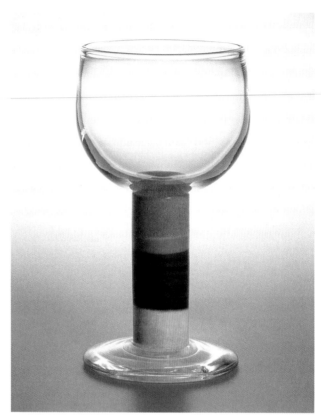

▷ Gunnar Cyrén, *Pop* goblet for Orrefors, 1965–1966

▷▷ Jens Quistgaard, rosewood, steel and leather lounge chairs for Nissen, 1965

in remote rural communities. It is not surprising, therefore, that over the long history of the applied and decorative arts, Scandinavian designers have tended to concentrate on the production of functional yet attractive wares for the home which reflect the craftsmanship and essentialist principles that throughout the ages have guided the making of tools, weapons and domestic implements. In Scandinavian countries well-designed products are commonplace because the whole notion of "good design" has permeated their socially inclusive cultures. Spurred on by Ellen Key's call for *Skönhet åt alla* (Beauty for All) and the Svenska Slöjdföreningen's (Swedish Society of Craft and Industrial Design) catchphrase *Vackrare Vardagsvara* (Good Everyday Goods – or as directly translated, More Beautiful Everyday Objects), Scandinavian designers in their pursuit of affordable, beautiful, yet useful household objects have historically adopted an approach to design whereby products are developed within a humanist interpretation of the formal, technical and aesthetic principles associated with Modernism.

For the majority of Scandinavian people, design is recognized not only as an integral part of daily life, but also as a means of effecting social change. There has also been a historical tendency among Scandinavian designers to seek an optimum balance between the man-made and natural worlds in their work. The climate in Scandinavia – nine months of dark wintry cold and three brilliant months of glorious and abundant summer – has also meant that designers have sought inspiration as much from the delights of the natural world as from the concept of the warm and cheerful home. The Scandinavian peoples have traditionally relied on design ingenuity for their very survival and have become adept at skilfully handling the limited material resources available so as to use them as efficiently as possible. This reliance on design as a means of survival has led them to regard it is an important element of their cultural, social and economic welfare. Although the majority of Scandinavian countries have enjoyed a long history of design excellence, it was not until the 1950s that the concept of "Scandinavian design" was first widely popularized through exhibitions such as the seminal "Design in Scandinavia" show, which toured the USA and Canada from 1954 to 1957.

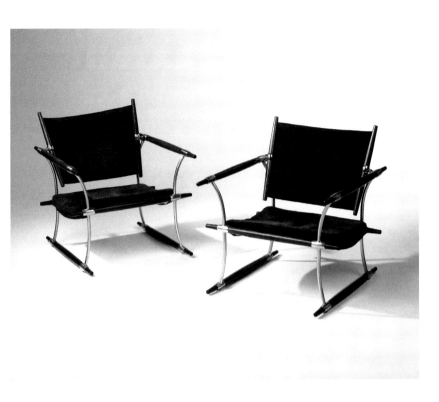

The Northern geography and harsh climate have not only bred a deep regard for the home comforts of the domestic environment but also a pervasive respect for the natural world. Scandinavians generally possess an intimate understanding of nature and because of this have a heightened appreciation of the intrinsic qualities of raw materials (especially local ones). The long and rich traditions of craftsmanship and folk art that have existed in all five countries demonstrate not only the Scandinavian peoples' empathy for materials, but also their desire to infuse everyday objects with a natural, unpretentious beauty. In comparison to the rest of Western Europe and the United States, industrialization came relatively late to Scandinavia and therefore the handcraft traditions of each of the countries remained in a far better state of preservation. By marrying these age-old craft skills to modern design practice, Scandinavian designers were able to produce high-quality objects that were eminently suited to industrial manufacture. The essentialist approach to design – the logical arrangement of only those elements which are absolutely necessary for the accomplishment of a particular purpose – practised by Scandinavian designer/

makers for centuries as a result of material shortages became an important principle of Scandinavian design, which in the modern era corresponded with the best approach to industrial manufacture. During the 20th century, Scandinavian craft skills and design sensibilities became a dominant influence on the development of modern design and came to epitomize the whole notion of "good design".

A key characteristic of Scandinavian crafts and design has been a striving for quality and a dislike of mediocrity. It is widely held that whether a product – chair, vase, coffee pot or storage jar – is handcrafted or machine-made, expensive or inexpensive, its design should provide an emotional comfort. The reason for this is that in Scandinavia, well designed and executed objects are seen as a vital enrichment of daily living rather than as status symbols. Scandinavian designers in general are well aware that by harmoniously combining artistic form and practical function, it is possible to create truly useful and relevant objects or *brukskunst* (useful art), as it became known. Scandinavian design is governed by the main principle of Modernism – to strike the optimum balance between

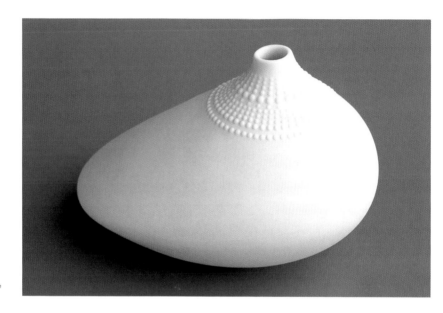

▷ Tapio Wirkkala, *Pollo* vase
for Rosenthal, 1970

form, function, material, colour, texture, durability
and cost so as to create democratic design solu-
tions. Designers from Scandinavian countries, how-
ever, have long understood that an overtly industrial
aesthetic can be alienating, and have therefore
sought to develop products that are fundamentally
humanizing – products that put man first, then the
machine. Although the majority of Scandinavian
designers have attempted to realize democratic
design solutions, there are also many examples
of designed objects that have been executed as
exclusive celebrations of artistry and craftsman-
ship. Whether a Scandinavian object is mass-
produced in a factory or lovingly handcrafted in
a specialist workshop, it will almost certainly
express the Scandinavian concept of *hygge* –
a Danish word that implies a very special charm,
a tender and comfortable feeling. *Hygge* can apply
to people, things, or surroundings that give a
sense of joy and well-being. It is probably most
closely related to "cosy", with a little "good cheer"
thrown in for extra warmth.

For centuries the five Scandinavian/Nordic coun-
tries have fostered a regional affiliation based on
co-operation (and at times domination), but each

has also had its own distinctive national history,
political aspirations and social concerns. These
distinguishing aspects have led design emanating
from each country to display a uniquely different
character. For instance, the influence of Oriental
pottery, English Regency furniture and American
Shaker chairs on Danish design reflects its cen-
turies-old sea-trading activities, whereas Swedish
design for (dis)ability reflects that country's strong
social agenda, while Iceland with its scarcity of
raw materials has had a long tradition of graphic
design that (thanks to computer technology) has
vigorously flourished in recent years. Despite
these regional emphases in design, the five
Scandinavian countries have a common aesthetic
culture that is the result of their shared desire for
a social ideal.

Historically, life has been a struggle in these geo-
graphically isolated countries with their limited
range of raw materials – conditions that have led
to a culture of minimizing waste wherever possible
through common sense practicality in design.
Similarly, an expertise has been passed down from
generation to generation in the handling of the
materials that are readily available, such as wood

▽ Arne Jacobsen, *Model
no. 3316 Egg* chair and *Model
no. 3127* footstool for Fritz
Hansen, 1958

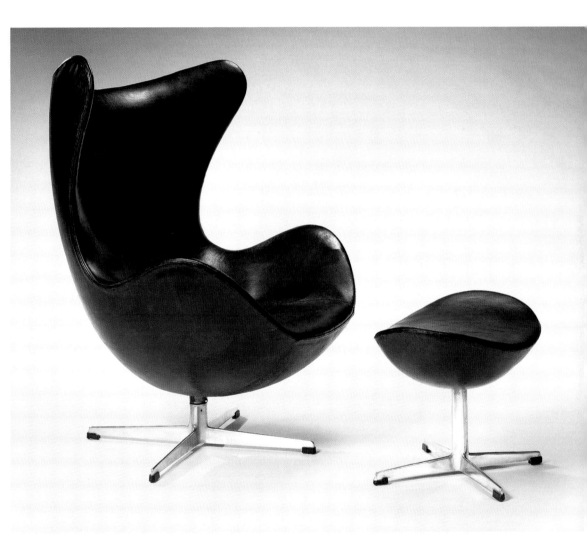

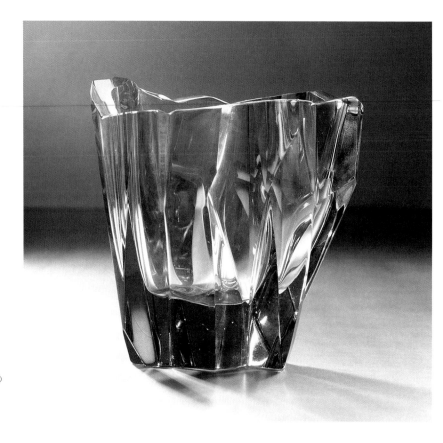

▷ Tapio Wirkkala, *Model no. 3525 Jäävuori* (Iceberg) vase for Iittala, 1951

▷▷ Søren Sass, silver and teak tea service for A. Michelsen, 1954–1955

from the dense forests of Sweden, Norway and Finland. As Eileene Harrison Beer noted, "The spectacular scenery all around them contributed design motifs and educated them to the realization that nature's ever-changing beauty is the best and most constant source of lasting pleasure in form and colour." Certainly, patterns inspired by native flora and fauna have embellished the objects of everyday life for centuries in Scandinavia, and it is therefore not surprising that in the 20th century the majority of Scandinavian designers, from **Alvar Aalto** and **Arne Jacobsen** to Jens Quistgaard and **Tapio Wirkkala**, adopted forms inspired by the natural world rather than the machine, and in so doing pioneered the concept of organic Modernism.

Traditionally, the acquisition of objects in Scandinavia has had more to do with pleasure than with displays of status. Because of this, Scandinavian interiors typically have a homely eclecticism that mixes the old with the new. There is a prevailing distaste for "high-style" showiness and a preference for subtle understated interiors that are imbued with *hygge*, from those in **Carl and Karin Larsson**'s home at Sundborn to the bright airy informal rooms illustrated in **IKEA** catalogues. Generally, Scandinavian interiors have an uncluttered simplicity that helps to create a greater sense of light – an important consideration when living through the dark months of a Northern winter. Scandinavian design has also been driven by the idea of inclusiveness rather than exclusiveness – affordable, practical, yet beautiful objects for everyone. That is not to say that creative individuality is sacrificed in the pursuit of democratic solutions, but rather that the designer often comes up with a very personal response to a particular design problem.

Although there is an overwhelming belief in the concept of *brukskunst* in Scandinavia, one can also find many examples of "art for art's sake" – objects that serve no functional purpose other than their life-enhancing beauty. The designers who also produce wares for industrial manufacture often design art objects such as these, which rely on craft skills for their production. The craft-roots of Scandinavian design have continued to survive thanks to a tradition of "art sponsorship" by manufacturers. Many large glassworks and ceramics factories, such as Arabia and Iittala,

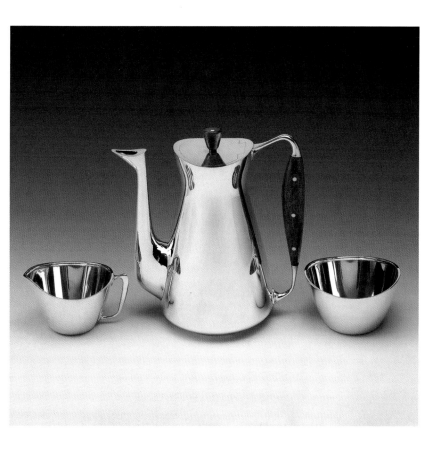

still maintain studios for the production of experimental one-off or limited edition pieces. Indeed, it is in these studios that industrially-manufactured products are often first conceived using craft processes. This studio tradition has ensured an enduring adherence to the concept of truth-to-materials and a way of working that strongly emphasizes the unique attributes of wood, glass, ceramic etc., while ornamentation is normally only used to accentuate these inherent qualities. This pursuit of honest, unadorned form is most powerfully expressed in Scandinavian industrial design – from Volvo cars to Husqvarna chain-saws to Nokia mobile phones – which is globally renowned for its functional integrity, understated aesthetics, outstanding durability and superlative quality.

Throughout their long and colourful histories, the remote and sparsely populated nations of Scandinavia have absorbed foreign cultural influences and reinterpreted them into something uniquely Scandinavian. As a result, Scandinavian craft skills and design sensibilities became a dominant international force in the evolution of modern design. This survey features those designers,

design groups and companies who have been instrumental in shaping the course of Scandinavian design, while the areas of activity covered include the design of furniture, glass, ceramics, jewellery, textiles, lighting as well as industrial products, such as cars, sewing machines and typewriters. The essays dedicated to the design of each country are followed by the main entry section, which has been laid out alphabetically with cross-references appearing in bold type so as to reveal the many illuminating interrelationships that have existed between designers and design-led companies. A timeline at the back of the book puts the design developments of the five countries in context with socio-political events, while the comprehensive list of addresses is intended to provide a useful reference source of relevant design associations, manufacturers, stores and places of interest to visit. Through highlighting the similarities and distinctions that exist in design from one country to another, a further aim of this book is to provide as broad an overview of the subject as possible so as to celebrate the international co-operation, idealistic endeavour, social conscience, practical function, beautiful crafts-

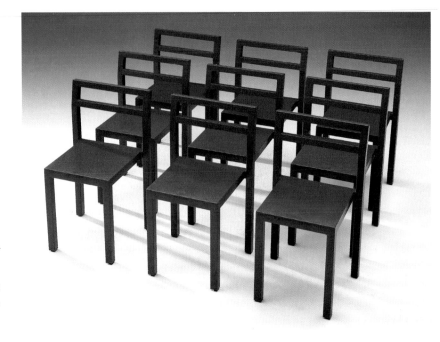

▷ Boris Berlin & Poul Christiansen (Komplot Design), *Non* rubber stacking chairs for Källemo, 2000

▷▷ Lovisa Wattman, *Model no. 4505.09 Collection* serving bowl for BodaNova-Höganäs Keramik, 1996 – black version introduced in 2000

manship and innate artistry that have become such strong defining features of Scandinavian design.

It is Scandinavian designers' promotion of Organic Design, however, that has had the greatest influence on the evolution of Modernism over the last 50 years. Through its preoccupation with the machine aesthetic, the Modern Movement could never gain a real and substantial foothold in Scandinavia, although their designers shared many of its fundamental goals, including the creation of well-designed democratic objects for everyday use. The pure stripped-down Functionalism of Bauhaus design lacked the humanism that was (and still is) such a vital characteristic of Scandinavian design. It is, therefore, understandable that it was Scandinavian designers who first offered the world a more accessible and less doctrinal form of Modernism, with softened forms and natural materials. By balancing the demands of the machine with human needs, Scandinavian designers did not reject the past but learnt from it, and in their pursuit of beautiful form and practical simplicity instilled in modern design what can only be expressed as a soul.

The underlying humanism and essentialism of Scandinavian design continue to embody the fundamental Nordic belief in social democratic liberalism and are based on the central tenet that good design is the birthright of all citizens, regardless of wealth, gender, age or physical ability. Above all else, it is the idea that "More Beautiful Everyday Objects" can enhance life that perpetuates the internationally recognized phenomenon of Scandinavian design. With the increasing complexities and acceleration of modern life, Scandinavian design continues to offer a haven of timeless simplicity that provides both physical comfort and emotional calm, while at the same time proffering an ethical approach to design that will become more and more pertinent as we face the increasingly worrying environmental and social challenges of the future. Spurred on by the pursuit of a social ideal, Scandinavian designers have consistently provided satisfying design solutions that fulfil both practical and aesthetic requirements, and which are tangible realizations of the five countries' shared utopian dream.

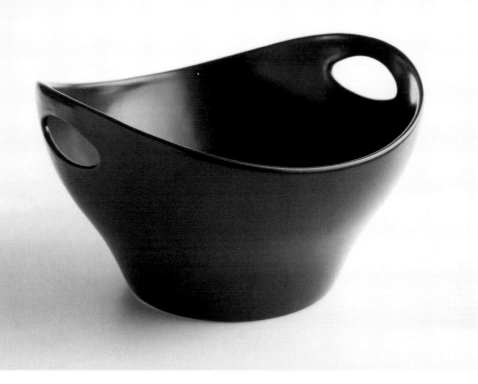

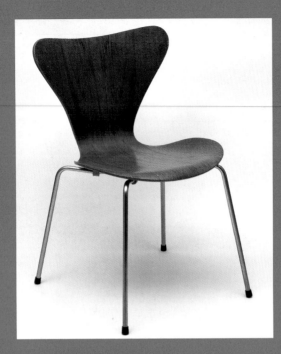

▷ Arne Jacobsen, *Model no. 3107 – Series 7* chair for Fritz Hansen, 1955

▷▷ The Ørsund bridge connecting Copenhagen to Malmö (Sweden), opened 2000

# design in denmark

Though small in territory and population, Denmark has nonetheless twice had a major cultural impact upon the rest of the world. A thousand years ago the Danes, together with other Scandinavians, dominated a large part of Europe when the Vikings undertook marauding, trading, and colonizing expeditions. During the mid-20th century Denmark achieved an aesthetic dominance throughout much of the West when Danish modern design exploded onto the world stage and became an international phenomenon. But while Denmark has been historically adept at exporting elements of its own culture, as a maritime nation with centuries-old trading alliances throughout northern and western Europe, the United States and the Far East, it has also been particularly receptive to new ideas and impulses from abroad. From the Viking Age to the present day, the talent for borrowing functional and aesthetic paradigms from foreign sources and moulding them with a high degree of craftsmanship into something "Danish" according to harsher Nordic conditions, has been a key factor in the evolution of the applied and decorative arts in Denmark. The tradition of craftsmanship for which Denmark is so famed grew as much out of poverty

and a lack of raw materials as out of a closeness to nature. By necessity the Danes developed an in-depth knowledge of locally available natural resources, from stone and clay to leather and wood, and over centuries learnt how to use them as efficiently as possible. In both building and the handcrafts, economic limitations made it essential to stress utility and durability over surface embellishment. This approach resulted in the simplicity, honesty and respect for function that became such defining features of Danish design.
Until the 1950s, Denmark's economy was mainly based on agriculture and the crafts rather than on industry. Traditional crafts-based production was consequently maintained much longer than elsewhere in Europe, but when the country did begin modernizing its manufacturing industries after the Second World War, age-old craft sensibilities and the Danish culture of high-quality workmanship were transferred to the design and manufacture of industrial products.
The handcraft tradition in Denmark, which placed great emphasis on tool making, was also based on a passion for exploring organic forms and the functional and aesthetic essence of objects. It is

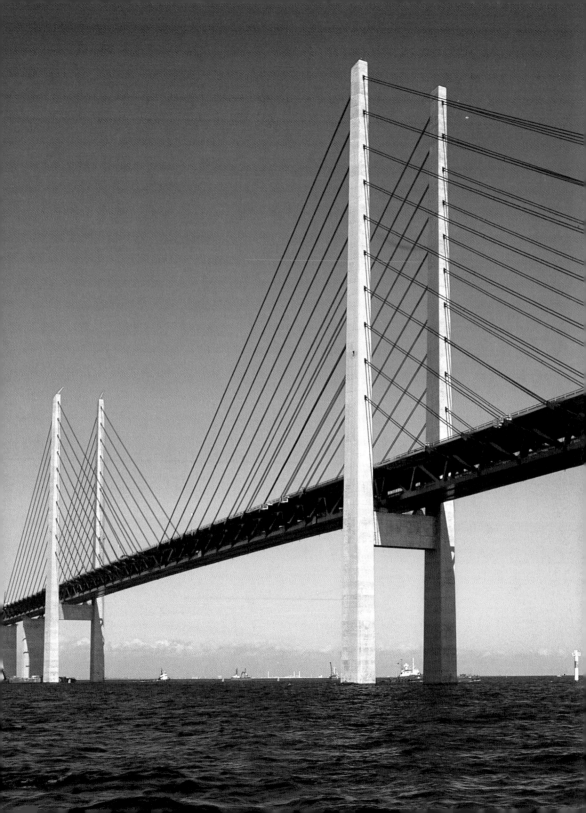

▷ Kay Fisker, silver jug for
A. Michelsen, c. 1952

▷▷ Arne Jacobsen, *City Hall*
clock for Louis Poulsen, 1955,
originally designed for Rødovre
City Hall – later reissued by
Georg Christensen for Mawa
Design

therefore not surprising that Japanese *objets d'art* and American Shaker furniture, with their elemental, almost spiritual qualities, were a major source of inspiration to many Danish designers, particularly in the 20th century. From Axel Salto's experiments with Oriental-style ceramic shapes and glazes to the extraordinarily refined furniture of **Hans Wegner** and **Børge Mogensen**, the search for the essential or "ideal form" has had a profound effect on Danish design.

The evolution of Danish design practice began in the late 18th century when, as a result of Denmark's (limited) industrialization, the process of making was transformed from a start-to-finish activity undertaken by an individual into a series of compartmentalized tasks executed by several people. This division of labour gave rise to the new profession of design, and with the establishment of the Royal Copenhagen Porcelain Manufactory in 1775, the very first Danish designers entered industry. Catering to the upper end of the domestic goods market, these industrial "artists" initially promoted the then fashionable Rococo style, which was later supplanted at the beginning of the 19th century by Neo-Classicism. While

strongly influenced by developments in France and Germany, Danish Neo-Classical objects had a unique character that was distinguished by an underlying formal simplicity and an almost bourgeois utility. As the architect-designer responsible for introducing the Empire style to the Royal Copenhagen factory during the 1820s, Gustav Friedrich Hetsch (1788–1864) stated, "The object of everything relating to interior design and architecture, large or small, must be that it answers its purpose and meets two main conditions: usability and suitability … beauty must always depend on usefulness because without this no satisfaction can be gained for the eye or the spirit." This desire for functional, appropriate yet attractive objects, which put the user first, became an important hallmark of Danish design.

In the 1860s Neo-Classicism was usurped in Denmark by a new Romantic style that drew its inspiration from an eclectic range of sources. Arnold Krog exemplified this change of direction when he adopted Japanese motifs for the decoration of his ceramics, as did Georg Jensen, who produced jewellery and silverware inspired by the British Arts & Crafts Movement. Common to the

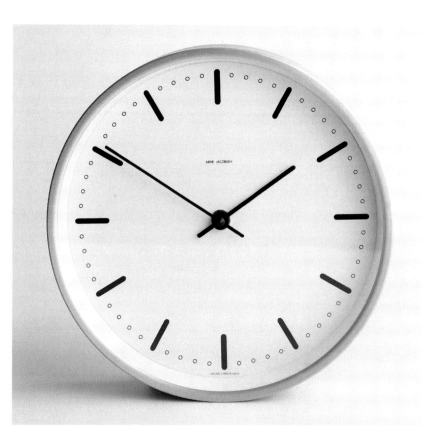

ARNE JACOBSEN

GEORG CHRISTENSEN

design of objects such as these was a rejection of historicizing classicism and an emphasis on exquisite detailing that delighted in the materials' intrinsic properties. The masterful handling of materials that is so characteristic of Danish design is an attribute that was born of the country's rich craft traditions, which were often passed from one generation to the next through family-run specialist workshops or artisan guilds. The quality of Danish products from the 19th century onwards, especially in terms of material handling, was also the result of a number of inspired designer/artists who critically cemented the traditions of cooperation between artistic creator and producer. To a large extent it was these pioneering individuals who set the artistic and qualitative ethical standards that remain the basis for the success of modern Danish design to this day.

The pioneering research into anthropometrics (the systematic collection and correlation of human body measurements) undertaken by **Kaare Klint** during the 1920s and 1930s also had a pivotal impact on the development of Danish design. Through his detailed studies of anatomical proportions, Klint not only revived the practical ideals of

Neo-Classicism but also established a humano-centric approach to design that formed the philosophical bedrock from which Danish Modernism grew. By devising a system of average measurements that was based on actual human proportions and then applying this data to the design of furniture, Klint hoped to develop timeless ideal solutions. In his pursuit of the essential, Klint and his students also carefully studied the dimensions of various historically successful furniture types. This information used in combination with his anthropometrical data led to his development of numerous modern interpretations of important historical precedents, such as his *Safari* and *Deck* chairs (1933). Apart from one chair designed for the Grundtvig Memorial Church in Copenhagen, Klint's furniture was never industrially manufactured and relied instead on time-honoured craft techniques for its production. More than any other Scandinavian country, Denmark's long and proud heritage of cabinet-making was put to good use during the inter-war period with the manufacture of simplified yet elegant solid-wood furniture. During the late 1920s and throughout the 1930s, however, Klint's approach to design, which relied on the craft skills

OVERLEAF
◁ Sigvard Bernadotte & Acton Bjørn, *Margrethe* melamine mixing bowls for Rosti, 1950

▷ Erik Bagger, *Café Lamp* candleholder for Rosendahl, 1997

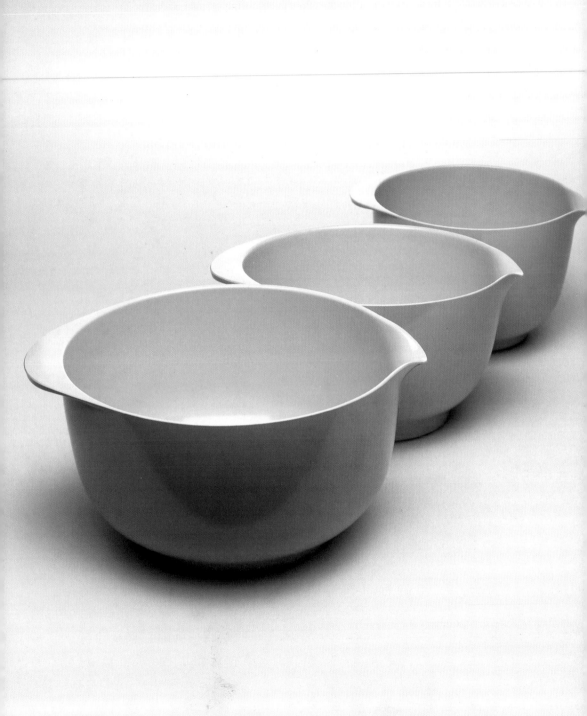

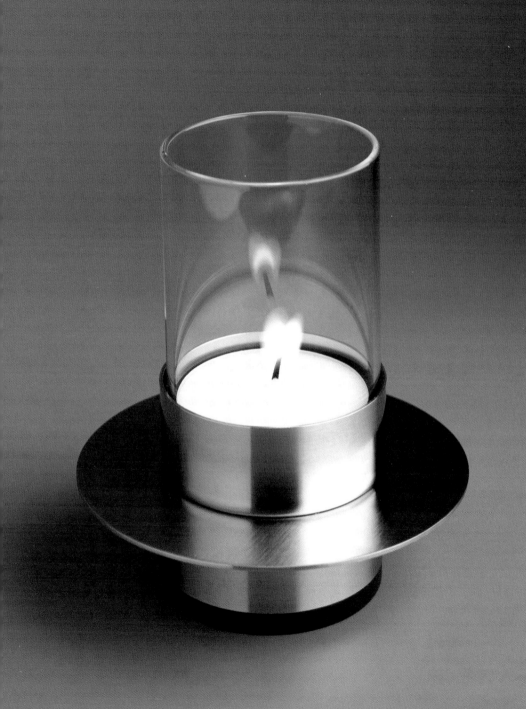

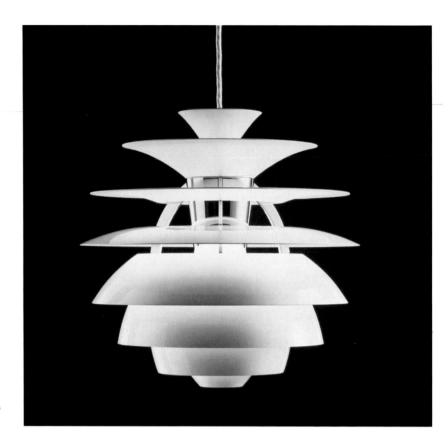

▷ Poul Henningsen, *PH Snowball* lamp for Louis Poulsen, 1958

▷▷ Jørgen Høvelskov, *Harp* chair for Christensen & Larsen, 1968

of the specialized workshop rather than on the industrial process, became increasingly at odds with the very real need for low-cost modern furnishings for the mainstream.

The inter-war years saw other Danish designers such as **Poul Henningsen** promoting a more industrial approach to design that sought to address the pressing social needs of the period. As editor of the influential *Kritisk Revy* (Critical Review) magazine, Henningsen outlined the requirement for a new objectivity in Danish design, stating that its goal must be "to promote architecture (and design) in accordance with the best of social, economic and technological endeavours in modern culture". The journal not only lambasted the inappropriate aesthetics of the Neo Classical style, which still found favour among many manufacturers, but also opposed the modern approach of the Bauhaus, which completely rejected the past and drew inspiration from avant-garde art movements (from De Stijl to Russian Constructivism) that had little relevance to ordinary peoples' lives. Instead, Henningsen and other designers such as Kay Bojesen pleaded for the design of objects for everyday use that were both simple and user-

friendly, such as the latter's no-nonsense *Bestik* cutlery for Raadvad (1938). This desire for low-cost yet practical domestic tools also permeated the landmark Copenhagen Cabinetmakers' Guild exhibition of 1930, where a fully fitted two-roomed model apartment was shown that attempted to address the need for more socially motivated design. This purposeful endeavour by architects and skilled cabinetmakers associated with the guild was undoubtedly spurred by the Danish furniture industry's general disinterest in providing low-cost yet high-quality modern furnishings for the masses. There were exceptions, however, most notably **Fritz Hansen**, a manufacturing company that produced a number of high-volume furniture items during the 1930s that were remarkable for their progressive aesthetic and simplicity of form. Apart from exhibiting at the annual Cabinetmakers' Guild Exhibitions, Danish designers were also able to promote their work through Den Permanente, a co-operative association established by Kay Bojesen in 1931. Although the designers could not sell their work directly to the public through the association's "permanent exhibition" store, it nevertheless became an important showcase for

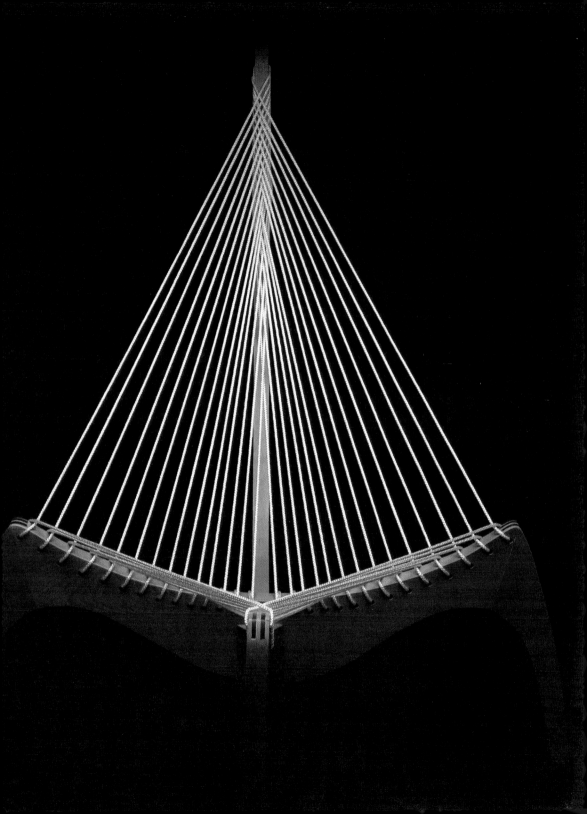

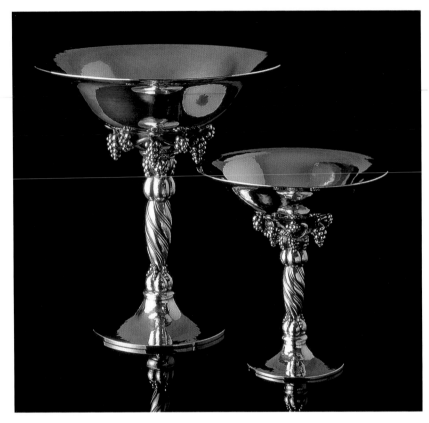

▷ Georg Jensen, *Model nos. 263A & 263B* silver bowls for Georg Jensen, 1918

▷▷ Jens Quistgaard, teak ice-bucket for Dansk International Designs, 1960

contemporary Danish design. Unlike their Swedish counterparts, who during the 1930s briefly fell under the spell of Modern Movement functionalism, Danish designers remained almost untouched by the influence of the Bauhaus. Their work instead reflected the general consensus in Denmark that functionalism had always existed in the applied arts and that because of this, design should be advanced by evolutionary rather than revolutionary means.

The next generation of designers, including **Børge Mogensen** and **Hans Wegner**, perpetuated **Kaare Klint**'s principal of ideal furniture forms and similarly produced modern re-workings of numerous vernacular furniture types. Mogensen's *Shaker* chair (1944) and Wegner's *Peacock* and *Chinese* chairs (1947 & 1943) epitomized this distinctively Danish approach to design. By studying the essence of successful antecedents and up-dating them within a modern idiom, Danish design presented a less doctrinal and more accessible form of Modernism. The soft-edged products of Danish design projected a homely informality and reassuring domesticity and because of this, they became the preferred choice of both taste-makers

and home-makers throughout much of Europe and the United States in the 1950s and 1960s. During the post-war period, greater emphasis was placed on the production of democratic furniture and other domestic products that were suitable for smaller post-war living spaces and could be afforded by the average family. By stressing high-quality machine-aided craftsmanship, Danish Modernism was seen to exemplify "Good Design", which in time came to infer "Good Taste". The profile of Danish design was significantly raised through a number of influential exhibitions held in America and Great Britain. As a result of these, by the mid-century "Design from Denmark" had become a truly international sensation.

One of the reasons for the remarkable ascendancy of Danish design was that from the early 1950s, teak was imported into Denmark from the Philippines to make furniture. Teak had been extensively logged during the Second World War as an out-come of military road clearing exercises, and as a result there was a reasonably priced surplus of it. This superior and highly popular hardwood was so widely used by Danish furniture designers, such as **Finn Juhl**, Hans Wegner and **Peter Hvidt**, that

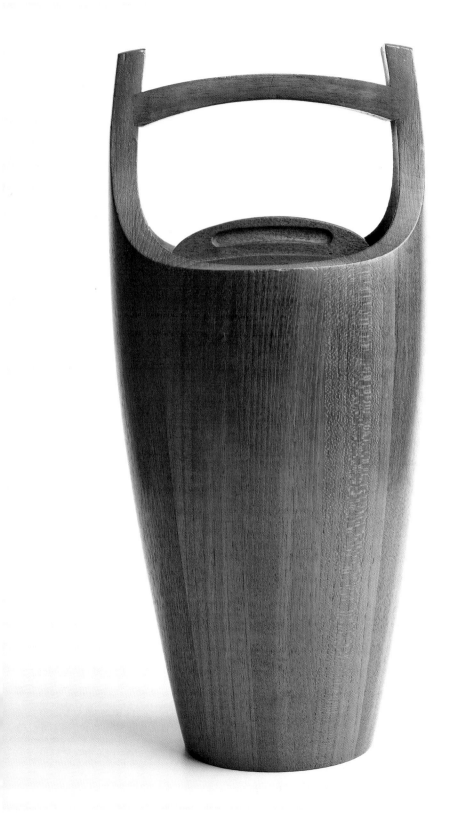

▷ Verner Panton, *Panton* chair,
1959–1960, manufactured by
Vitra

▷▷ Verner Panton, *Phantasy
Landscape* for *Visiona II*
exhibition by Bayer AG at the
Cologne Furniture Fair, 1970

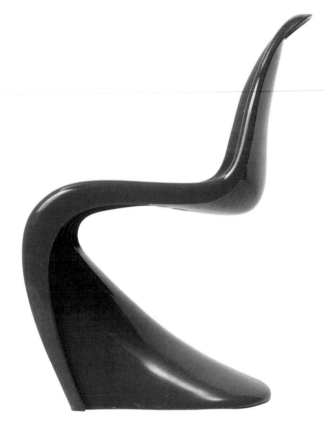

eventually their work led to the term "Teak Style" being coined. The fashion for teak also led to its application in a wide variety of Danish housewares, most notably Jens Quistgaard's ice bucket for Dansk International Designs and Kay Bojesen's double salad bowl and servers.

Other furniture designers who were concerned with reaching the mass market explored the potential of moulded plywood, most notably **Arne Jacobsen** whose remarkable *Model No. 3107* chair from the *Series 7* range (1955) not only became one of the best-selling chairs of all-time, but also one of the most iconic products of Danish design. Jacobsen's *Series 7* range of chairs and earlier *Ant* chair (1951–1952) signalled a complete break with the traditional evolutionary approach to design, and as such were among the first examples of truly modern furniture to come out of Denmark. Jacobsen's later *Cylinda Line* hollowware range (1967) for Stelton was similarly modern and it also very successfully perpetuated the Danish reputation for producing timeless, elegant and functional objects for everyday use.

It was not until the late 1950s that Danish designers began incorporating newly developed synthetic materials such as fibreglass and latex foam into their furniture products. Arne Jacobsen's revolutionary *Svanen* (Swan) and *Ægget* (Egg) chairs (1957) designed for the SAS Royal Hotel in Copenhagen marked a new sculptural confidence in Danish design, which was later radically evolved by **Verner Panton** in the 1960s into playful psychedelic Phantasy Landscapes of bold forms and brilliant saturated colours. Although Panton's work reflected the typically Scandinavian approach to Pop design by not embracing the "use-it-today-sling-it-tomorrow" ethos of the style, it did seek in a very un-Danish manner the popularization of revolutionary forms that were a complete departure from anything that had gone before.

The global recession of the early 1970s coincided with a declining interest in "Design from Denmark". In response to this and the difficult economic climate, leading Danish firms such as Bang & Olufsen, Georg Jensen and Stelton reaffirmed their commitment to high standards of design and manufacture through the production of beautiful yet highly rational products. Crucially, the superlative quality of these objects enabled their manufacturers to strengthen their brand identities

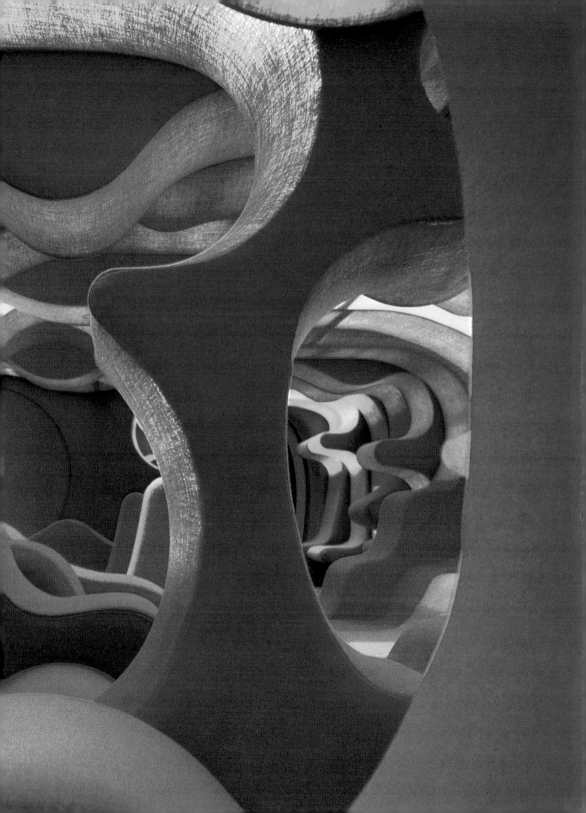

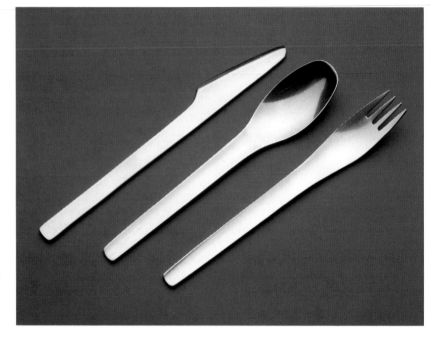

▷ Erik Magnussen, *Model no. 544* dessert fork, *Model no. 545* dessert knife and *Model no. 546* dessert spoon for Stelton, 1995

▷▷ Nanna Ditzel, *Bench for Two Model no. 2600* and *Model no. 2601* table for Fredericia Furniture, 1989

within an increasingly competitive marketplace. In 1977, the Danish Design Center was founded in order to promote the cause of Danish design more effectively. The same year, Niels Jørgen Haugesen (b. 1936) designed his *X-line* chair, which signified the growing influence of the High Tech style in Scandinavia. The following decade saw a return to relative prosperity in Denmark, which led many Danish designers to embrace the Post-Modern style and begin exploring a greater freedom of expression. This resulted in the appearance of a number of extraordinary products, such as the Japanese-inspired butterfly-like *Bench for Two* (1989) designed by **Nanna Ditzel**. Post-Modernism, however, never really gained a sound foothold in Denmark and by the 1990s designers such as **Niels Gammelgaard** and Alfred Homann were developing furniture, lighting and other products that underscored the aesthetic, functional and commercial desirability of the essentialist approach to design.

The long tradition of Good Design in Denmark remains one of the country's greatest assets. Certainly, no other country (except perhaps Italy) has produced such a plethora of iconic "design

classics" – from **Arne Jacobsen**'s ubiquitous *Ant* chair to David Lewis' (b. 1939) revolutionary *Beosystem 2500* (1990) for Bang & Olufsen. The formal and functional clarity and manufacturing integrity that so strongly differentiate these products from others have historically not only been the result of good cooperation between designers and industry, but also of the timeless ideals of Danish design: simplification without upsetting the balance of form and function; truth to materials; and a deep respect for the task at hand, while facilitating meaningful connections between the user, their tools for living, and the environment. Against the current background of dwindling natural resources, ecological problems, social changes and a growing demand for more ethical and relevant products, the enduring humanist goals of Danish design are more important than ever.

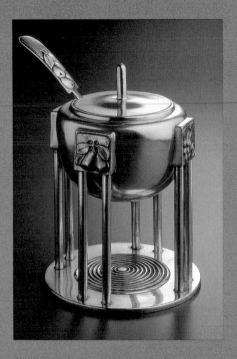

▷ Valle Rosenberg, silver jelly
bowl for A. Alm, 1911

▷▷ Finnish lakeside summer
cottages

# design in finland

Bordered by Norway, Sweden and Russia, Finland is one of the world's most northern and geographically remote countries, with one third of its landmass located within the Arctic Circle. Much of Finland is heavily forested with pine and spruce, but in the south there is a zone of deciduous trees comprising mainly birch, aspen, maple, elm and alder. The country contains some 55,000 lakes, extensive areas of marshland and numerous rivers, and while it is mostly flat, except in the northwest, the landscape possesses a striking – if sometimes bleak – beauty. In Finland's northernmost reaches, where the seasons are sharply divided between the prolonged and extremely severe winter and the warm though brief summer, the indigenous and nomadic Sami (Lapp) people continue to herd reindeer as they have done for centuries. "The North" holds a particular attraction for the Finnish people, who revere its awesome temperament and dramatic unspoiled beauty. Surviving nature at its most extreme has demanded of the Finns an innovative approach to problem solving, while a long history of economic hardship and difficulties in affording materials for the construction of buildings and implements has bred an intuitive feeling for formal,

functional and material efficiency. Over centuries of living close to the land, the Finns have developed a special relationship with nature, and in their approach to design this connection manifests itself in an inherent respect for materials and a prevalence of organic forms. Because of the Finns' almost mystical affinity with the natural world, the products of Finnish design have often been seen to best express the "Soul of the North".
The Finnish people belong to both the Baltic and Scandinavian races and are renowned for their gentle stoicism, toughness, tenacity, calmness and an inner resolve. These character traits are reflected in the Finnish concept of *Sisu*, which stands for the philosophy of that which must be done, will be done whatever it takes – the almost magical ability to muster the strength, stamina, courage and willpower to succeed in the face of adversity. In other words, *Sisu* can be roughly equated with the American notion of having the "right stuff", but it is a defining aspect of the Finnish people as a whole and not restricted to an elite of highly trained individuals. For centuries the Finns struggled against exceptionally difficult environmental conditions and foreign invaders and this gave rise

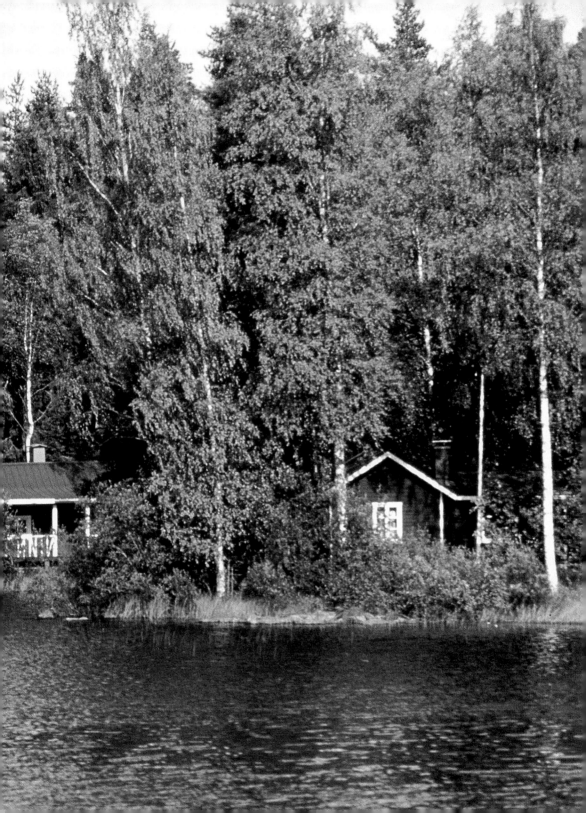

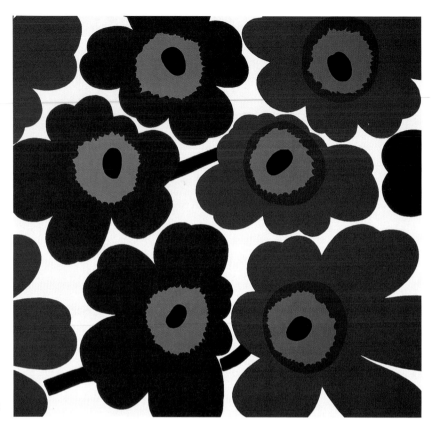

▷ Maija Isola, *Unikko* (Poppy) textile for Marimekko, 1965

▷▷ Tapio Wirkkala, *Model no. 9015* table top (laminated padouk, maple, hazel, teak and birch) for Asko, c. 1958

to a strong determination to overcome seemingly insurmountable obstacles. The concept of *Sisu* has been a basic source of inspiration for Finnish architects and designers, who have created buildings and products that reveal a dogged perseverance to strike the best balance between form, function and materials. It is interesting that the taciturnity and emotional reserve of the Finns are often offset by the use of design as a means of creative expression.

The expressive artistry of Finnish design, which over its history has occasionally been criticized for its un-Scandinavian elitism, was to a large extent born of the long-held tradition of producing exquisite one-off studio pieces alongside more democratic mainstream products. Very often, however, unique experimental or limited edition designs have directly informed the development of utilitarian mass-produced goods. Even today the tradition of producing exclusive "art" pieces is perpetuated by companies such as Arabia and littala, who use them as a means of preserving and re-invigorating craft traditions as well as giving their designers the opportunity to explore their own creative impulses through new forms and techniques.

Having for centuries been under the successive jurisdiction of Sweden and Russia, the Finnish people have enjoyed only a relatively short period of political autonomy since the declaration of independence 1917. Until the late 1980s, when the Soviet Union eventually collapsed, all major foreign and even domestic policy decisions were carried out with an *a priori* assessment of possible Soviet reaction – the so-called Finlandization. The long struggle to become a nation state bred a strong desire in the Finnish people to assert their cultural, political and economic autonomy. One of the great turning points in Finnish history took place in 1835, when Elias Lönnrot (1802–1884) published an epic poem known as the *Kalevala*. Based on an oral tradition of ancient poetry, ballads and songs, the *Kalevala* (Land of Heroes) proved that the Finnish language could be used as a vehicle for lyrical compositions comparable to the great epics of classical civilization. During the second half of the 19th century, this mythological poem not only became a symbol of national consciousness and patriotism, but was also the single most important cultural influence on Finnish art and design. Its publication also led to the increasing acceptance

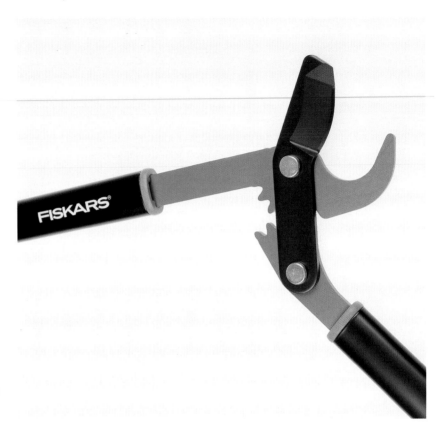

▷ Olavi Lindén, *Clippers*
garden scissors for Fiskars,
1996

▷▷ Yrjö Kukkapuro, *Karuselli*
(Carousel) chair for Haimi,
1964–1965 – reissued by
Avarte

of Finnish, which forms part of the Finno-Ugric group of the Uralic language family, as the official national language. Inspired by the *Kalevala* and the growing aspiration to assert an autonomous cultural identity, the National Romantic movement emerged in art, architecture and design at the end of the 19th century. Pioneered by, among others, **Eliel Saarinen**, the style was a powerful expression of Finnish nationalism, especially with its mythical allusions to Karelian culture. Yet at the same time National Romanticism was also part of the wider "New Art" movement in architecture and design that flourished throughout Europe and America in the late 19th and early 20th centuries. This synthesis of the national and the international later became an important defining feature of modern Finnish design.

During the early 1900s, the development of Finnish design was greatly assisted by government support and craft organizations, which actively encouraged young artists to collaborate with industry so as to raise the standards of everyday goods. From 1905 onwards, enlightened Finnish manufacturers were sponsoring design competitions in order to attract talented young designers who would be able to develop products that could be exhibited internationally. During the period running up to the outbreak of the First World War, Finnish design continued to be influenced by the New Art movement, but during the inter-war years a new objectivity in the applied arts emerged. **Aino Aalto** and **Alvar Aalto**'s design of inexpensive utility glassware and furniture intended for the home market can be seen as a direct response to the austerity of the time. During this period, the ceramics manufacturer Arabia also began producing affordable standardized domestic products, such as Kurt Ekholm's *Sinivalko* (White-Blue) tableware range (1936–1940), which were based on the idea that even everyday household objects should enhance the quality of life through beauty, simplicity and practical function.

During the 1930s, Alvar Aalto provided a much-needed re-interpretation of Modern Movement functionalism with his holistic and humano-centric approach to design, which rejected the hard-edged machine aesthetic of the Bauhaus. By incorporating organic forms and natural materials into his revolutionary yet highly practical furniture designs, Aalto hoped to effect better physical and psycho-

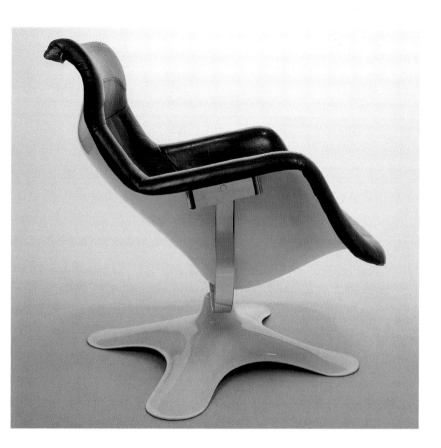

logical connections between products and users. Revealing the almost spiritual affinity that Finnish designers have with the natural world, Aalto's work often adopted forms that echoed those found in the Finnish landscape; for example, the undulating shape of Finnish lakes directly influenced the form of his famous *Savoy* vase (1936). By expressing the abstract essence of nature through humanizing essentialist designs, Aalto provided one of the key philosophical foundations from which Scandinavian design evolved and flourished.

Another figure to have a seminal influence on the development of post-war Finnish design was Arttu Brummer (1891–1951), who having been editor of the influential Italian design journal *Domus* during the 1930s, was able to forge crucial links between the two countries' design communities. Against a background of economic depression, he wrote in 1931, "In our times and especially under the circumstances in which we now live, the artist has become an individual who in a way exists outside society. Nobody really needs him and in vain he raises his voice to demand support and protection from the state." Beyond his career in journalism, Brummer was also an inspirational teacher and

eventually became artistic director of the Taidete-ollinen Korkeakoulu (University of Art and Design) from 1944 to 1951. In this role he urged his students to develop design solutions that appealed to both their senses and sensibilities, while exploring the rich vocabulary of forms found in nature. By promoting a greater degree of individual creative expression in design and stressing the importance of "vital living art", Brummer had an enormous impact on the work of the succeeding generation of Finnish designers, such as **Tapio Wirkkala** and Timo Sarpaneva.

After the hardships of the Second World War and the enormous burden of war reparations that had to be paid to Russia, there was an overwhelming need to boost national self-confidence. This was achieved almost immediately through the promotion of a Finnish identity in the applied arts. During these years of optimism and renewal, designers such as Tapio Wirkkala, Timo Sarpaneva, **Antti Nurmesniemi, Ilmari Tapiovaara** and **Maija Isola** forged a distinct and sensuous language of design that took their work to a completely new level of aesthetic expression. In 1951 the so-called "Milan Miracle" happened, with Finnish designers,

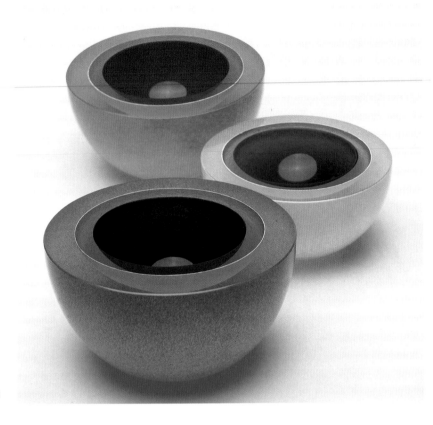

▷ Pertti Metsälampi, *Fons II
& Fons III* bowls (self-pro-
duction), 2000

▷▷ Alvar Aalto, *Model no. 60*
stool for Artek, 1932–1933

most notably Wirkkala, winning numerous design categories at the IX Milan Triennale exhibition. For the following X Milan Triennale in 1954, the Finnish section was designed by Wirkkala for the display of a variety of objects, including award-winning glassware that emphasized the new found sculptural confidence of Finnish design, which according to one commentator revealed a "mixture of primitive daring and incredible elegance". Exhibitions such as these gained Finnish designers much international recognition for their individualistic product designs, which celebrated the expressive properties of materials through beautiful organic forms. Clearly distanced from the aesthetic blandness of functionalism, Finnish furniture, textiles, ceramics and glass projected a seductive forward-looking vitality that perfectly embodied the spirit of the age.

The sensitive handling of materials and the promotion of evocative organic forms remained defining features of Finnish design throughout the 1960s and early 1970s – a period that is often regarded as the "Golden Age" of Finnish design. As Nanny Still McKinney noted of this glorious epoch, "All designs came from the heart, because there were

no outside influences. At that time not many countries were as interesting as Finland." During this period, designers experimented with new manufacturing techniques and playfully explored bold colours and iconoclastic shapes. From Oiva Toikka's glassware to **Vuokko Eskolin-Nurmesniemi**'s textiles to **Eero Aarnio**'s furniture, Finnish design reflected on the one hand an informal and youthful simplicity and on the other a high degree of aesthetic sophistication. Bright, textural and experimental, Finnish products received widespread critical acclaim as much for their technical inventiveness as for their innate artistry.

The global oil-crisis of the early 1970s, however, put a dampener on the Finnish glass-making industry, which had a high-energy requirement. Other areas of design were also affected by the economic downturn and as a result a more rational approach to design emerged, which placed a greater faith in technology. Ergonomics, workplace safety and social inclusiveness also gained increasing currency within the Finnish design community during this period. For example, **Yrjö Kukkapuro**'s *Fysio* chair (1978) for Avarte was one of the first office chairs to have a form that was almost entirely

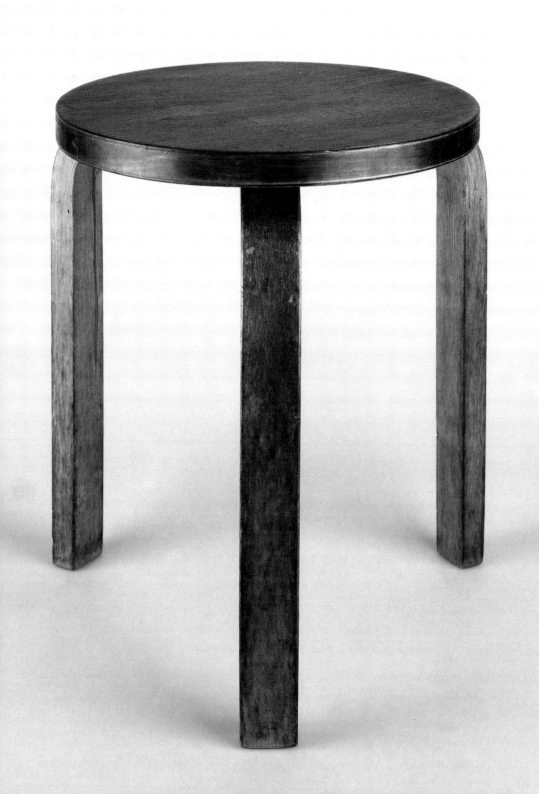

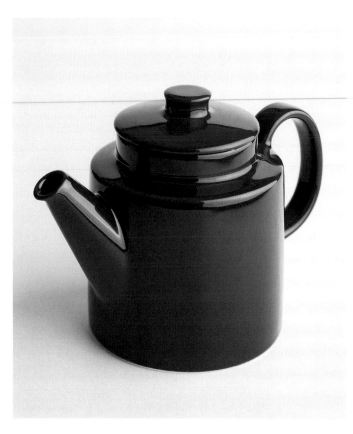

▷ Kaj Franck, *Teema* teapot for Arabia, 1977–1980

dictated by anthropometric data. The following decade not only saw increasing prosperity but also a greater internationalism in Finnish design. The influence of Post-Modernism led to the development of a number of radical products such as Stefan Lindfors' insect-like *Scaragoo* lamp (1987) for Ingo Maurer. During the late 1980s and early 1990s, Finnish companies began reintroducing "classic" designs from their illustrious pasts and retailing them alongside contemporary products designed by a new generation of talented young designers.

Globally recognized for its long-held commitment to the development of innovative product solutions and for the excellence of its manufacturing capabilities, Finland has in recent years enjoyed a design-driven economic boom that has become the envy of its Scandinavian neighbours. Today, Finnish companies, such as Arabia and Iittala, pride themselves not only on their connections with the great Finnish designers of the past, but also on their associations with the very best up-and-coming designers from both Finland and abroad. At the core of companies such as **Artek**, Hackman, Fiskars and Nokia there is a belief

in the fundamental moral imperative of design and the responsibility to create well-conceived, durable and ecologically sustainable products. By combining an in-depth knowledge of ancient craft traditions with an empathy for materials and a concern for function, Finnish designers have created, and continue to create, products of high-object integrity. Apart from their long-held respect for craftsmanship and love of experimentation, it is the Finns' romanticizing of the primitive and their deep-rooted connection with nature that provide their designs with a sublime transcendence over pure function that delights both the hand and the eye. Distinguished by a simple functional honesty, an underlying naturalism, a sensual purity and a strong stylistic authenticity, Finnish design has long been driven by a concern for both man and nature, and because of this can be seen to exemplify the true foundations of Scandinavian design.

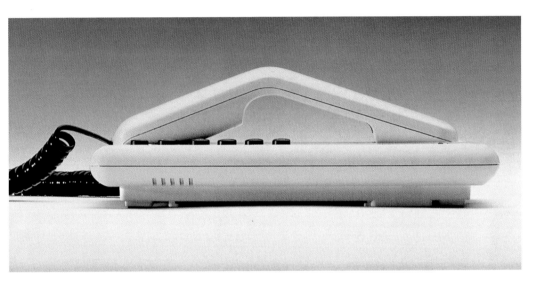

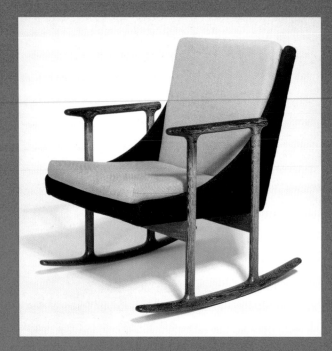

▷ Helgi Hallgrimsson,
Rocking chair for FHI,
1968

▷▷ The Strokkur geyser
erupting at Geysir

# design in iceland

Located in the North Atlantic Ocean between Norway and Greenland, Iceland is a country of spectacular contrasts. Huge glacial expanses lie across rugged mountain ranges, while extensive subterranean thermal activity makes it one of the most active volcanic regions in the world (the island lies astride the geological plate boundary known as the Mid-Atlantic Ridge). Although its northernmost tips nearly touch the Arctic Circle, Iceland's climate is much warmer than might be expected, but it is notoriously changeable and can at times be ferocious. Since the settlement of the country in the 9th century by Nordic Vikings and Celts, this unique environment and the difficulties it has posed for survival have played a central role in shaping the character and lifestyles of the Icelandic people.

Renowned for their tenacity, entrepreneurial spirit and reverence for the purity of the Icelandic language – the linguistic root from which other Scandinavian languages evolved – the Icelanders form a remarkably homogeneous Nordic population. Of the original settlers who began arriving on the island over 1100 years ago, the majority came from Norway and the remainder from other Scan-

dinavian countries, Ireland and Scotland. Since these bloodlines merged, centuries ago, there has been little subsequent immigration. The early blending of Nordic and Celtic stock may partly account for the Icelanders (unique in Scandinavia) production of great medieval literature – the Icelandic sagas, most of which recount heroic episodes that took place at the time the island was settled, are considered among the finest literary achievements of the Middle Ages.

Iceland is also home to the world's oldest proto-democratic parliament, the Althing, which was established as an annual mid-summer gathering at Thingvellir around 930 AD by the island's chieftains as a way to peacefully resolve their differences. Iceland's culture has long been characterized by a spirit of co-operation in the face of environmental and colonial hardship – from the 13th century the country was under foreign rule, first by Norway and then Denmark, until its independence in 1944. Apart from a brief period in the 1920s and 30s, Iceland has rarely experienced any significant discord between the social classes, while the political consensus of the country has for the most part endorsed democratic

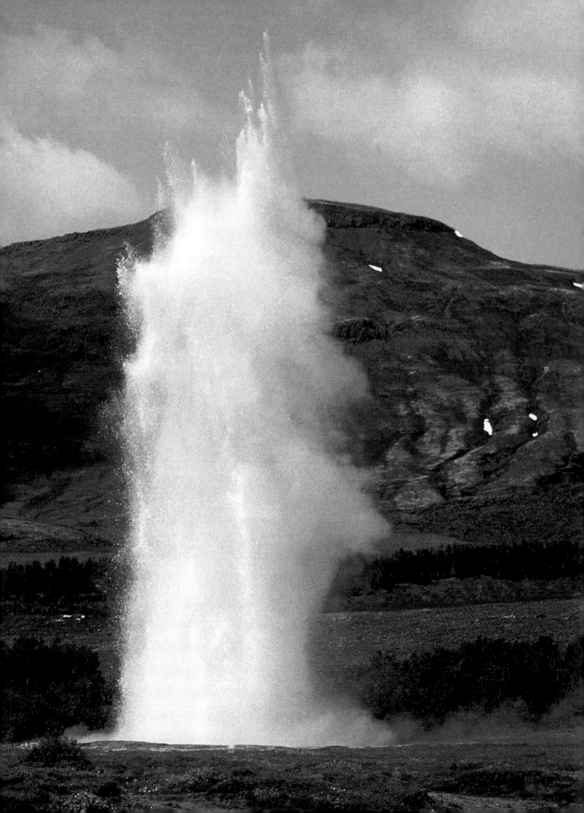

▷ Gunnar Magnússon, *Apollo* chairs and table for Kristján Siggeirsson, 1967

▷▷ Einar Þorsteinn Ásgeirs-son, *Bucky* chair (self-production), 1980

conservatism and social inclusiveness. As a result of this, Icelandic designers have never really been motivated to produce "high-style" objects for an elite, but rather have concentrated their efforts on designing objects that emphasize function – even the now-famous Icelandic sweaters were originally left plain and undecorated and were only embellished with complicated patterns for the export market from 1953 onwards. Throughout its history fishing has been Iceland's economic mainstay and today accounts for some 80% of its gross national product. With few natural resources (lava rock, driftwood and wool being the only non-imported materials) Iceland has always had to rely on foreign goods and imported materials and this has strongly impacted on the development of Icelandic design.

For many centuries, Iceland's geography meant that it remained a decentralized society with no significantly large urban settlements. By the late 19th century, however, the country began transforming itself from a nation of self-sufficient farmers into a population of city-dwellers. During this period, nationalistic sentiments began to galvanize the Icelandic people and the idea of asserting their own cultural identity through architecture and the applied arts caught many imaginations. In 1883, for example, a number of craftsmen participated in an exhibition that attempted to encourage "taste, beauty and functionality in the industrial crafts of the Icelandic nation". As in other Scandinavian countries at the time, National Romanticism inspired Iceland's architects and designers, although they did not share the same degree of nostalgia for the past, having themselves only just begun to emerge from their own "dark ages". Many were receptive to the challenges of industrial progress, but because of the country's changing social and economic conditions the major influences that were shaping architecture and design throughout the rest of Scandinavia took hold in Iceland at a much later date.

From 1900 to around 1930, Icelandic designers, such as **Gudjón Samúelsson**, employed traditional crafts skills to produce furniture made of imported wood which, stylistically, was either a quasi-Arts & Crafts interpretation of the Viking style or a simple and austere rendition of National Classicism. During the 1930s, Iceland continued to suffer from being stereotyped by foreigners,

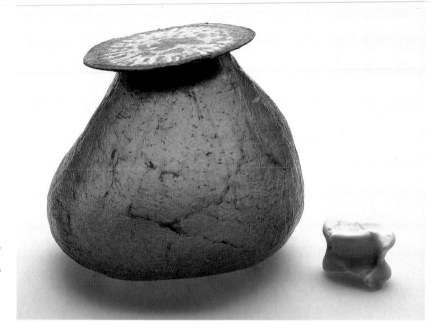

▷ Valdis Harrysdóttir, fortune-telling pig's bladder pot with vegetable lid and "wish" bone, 1996 – based on a traditional Icelandic pastime, with your fortune depending on how the bone falls

▷▷ Anna Þóra Karlsdóttir & Guðrún Gunnarsdóttir, *Tó-Tó* felt bowl (self-production), 2000

especially in Germany and Austria where there was a "fetishizing" of "the North" that perpetuated the notion that Iceland remained a primitive and untouched culture. It was, however, during these inter-war years that a true Icelandic identity began to appear in architecture and design, when the first generation of architects and designers, such as Jónas Sólmundsson (1905–1983), returned from their studies abroad and introduced the concepts of the Modern Movement. Crucially, because the ascendancy of Modernism coincided with Iceland's final struggle for independence, it was adopted not as an intellectual polemic, but as a powerful symbol of nationalism.

As there were virtually no local construction materials available in Iceland, easy-to-transport cement was used from the early 1900s as an alternative building material to imported brick, wood and corrugated iron. By the 1920s and 1930s concrete was being employed in an expressive proto-Brutalist manner – unpainted, cubic and elemental – as the Einar Jónsson Museum (1916–1923) demonstrates, which was designed by the sculptor Einar Jónsson (1874–1954) in collaboration with the architect Einar Erlendsson

(1883–1968). During the 1930s and 1940s Iceland was badly affected by economic depression, meaning that there was little money for imported finished goods. To compensate small factories were established for the manufacture of many different types of products, which still depended on the use of expensive imported materials such as pine, plywood and tubular metal. The objects that were produced were generally characterized by a robustness and purposeful simplicity, but all too often they ended up looking like watered-down Danish designs.

In response to the worsening world situation, which was making it increasingly difficult for Icelanders to travel abroad for their studies, the Icelandic School of Applied Art was established in Reykjavik in 1939. The founding of this institution, which favoured the teaching of fine art and crafts over industrial design, was a landmark event in Icelandic design history. Under the visionary leadership of Ludvig Gudmundsson (1897–1966) the school was instrumental in formulating a more unified approach to the theory and practice of design. After the country finally gained its independence from Denmark in 1944, an Icelandic

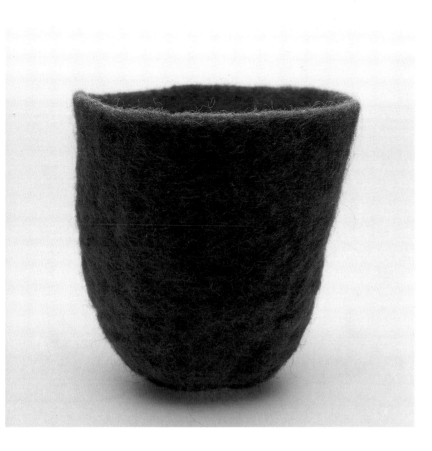

identity in the applied arts became increasingly apparent, especially in the field of graphic design. While for centuries Iceland had been famed as a nation of book producers – from the celebrated Sagas onwards – the onus was traditionally placed on the quality of the words rather than on the beauty of the typography, which was more often than not characterized by a rugged primitivism. Icelandic graphic designers later perpetuated this rough-and-ready approach in the 20th century through their use of simple forms and bold colours. Because of their interest in rudimentary design solutions that come "straight from the heart" and the limited availability of materials Icelandic designers have tended not to aspire to the polish and finesse of products from other Scandinavian countries.

During the 1950s and 1960s the importation of furniture was forbidden in Iceland, so several small-scale factories were established to manufacture furniture for the home-market. This resulted in a number of notable designs, including Helgi Hallgrímsson's upholstered rocking chair of 1968 and **Gunnar Magnússon**'s *Apollo* chair of 1967, the form of which was inspired by the staging

sections of NASA's *Saturn V* moon rocket. Later in 1980 Einar Porsteinn Ásgeirsson (b. 1942) designed his unusual *Bucky* chair, which as its name suggests, was influenced by Richard Buckminster Fuller's geodesic domes. Like Magnússon's earlier design, this chair reveals the tendency in Icelandic design to take existing forms and adapt them into something new and often surprising. This feature of Icelandic design is echoed in the way imported products are often customized according to the needs of the country – hence the remarkable tractors and 4x4 vehicles that can handle extreme off-road and glacial terrain. During the 1990s, when Iceland's artistic community, especially graphic designers, began exploiting the creative potential of increasingly powerful computer technology, Icelandic graphic design, music, films and computer games exploded onto the scene.

Today, Icelandic designers continue to perpetuate a tradition of individualism that sets their work apart from that of other Scandinavian countries. Increasingly, they are finding overseas manufacturers receptive to their idiosyncratic product solutions, that are often refreshingly original in either

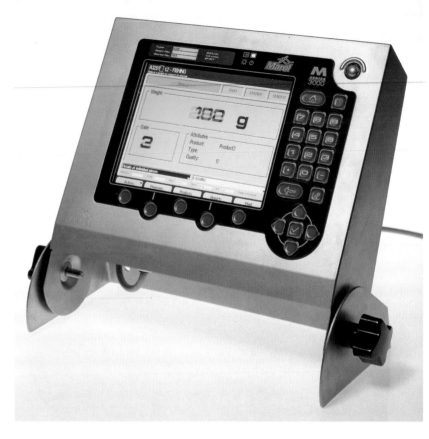

▷ *Series 3000* fish weighing scales produced by Marel hf., 2000

▷▷ Gunnar Karlsson, milk carton packaging decoration, 2000 – designed to encourage children to drink more milk

their use of form, function or materials. From laser-cut textiles and state-of-the-art prosthetic legs to felt bowls and pig's bladder fortune-telling pots, Icelandic contemporary design is distinguished by a contrariness that reflects a faith in modern technological progress on the one hand, and on the other an almost primeval connection with nature. This contradictory aspect of Icelandic design mirrors the unique geographical contrasts of this small yet dynamic land of fire and ice.

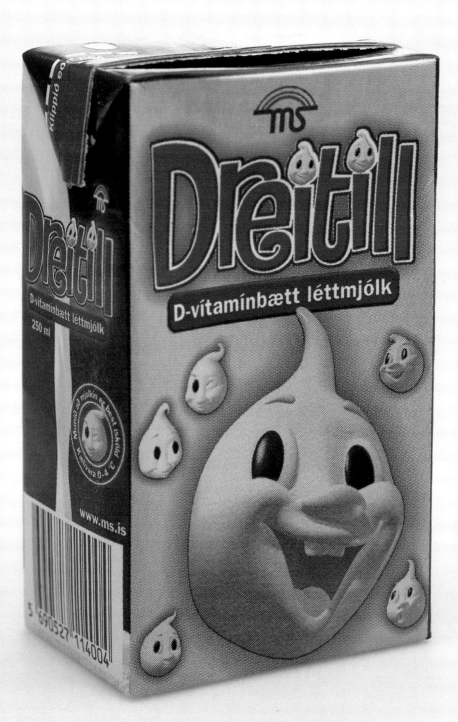

▷ Johan Verde, *Verde* mug for
Figgjo, 1995 – from a range of
tableware that won the Norwe-
gian Government's design
competition for china for the
Government Administration
complex

▷▷ Lofoten Islands coastline

# design in norway

Situated on the northernmost edge of Europe,
Norway is a sparsely populated land of majestic
mountains, dense forests and breathtaking fjords.
Until the 20th century much of the country's in-
land population lived in almost complete isolation
on farms scattered around the inner fjords and
up the valleys. Often separated by formidable
natural boundaries, individual families were gener-
ally forced to live their own lives, existing on their
own resources, with little contact with the outside
world. Agriculture provided the people with the
necessities of life, but it was very much a seasonal
occupation due to the country's severe climatic
conditions. During the long winter months a
great deal of time was available for other kinds
of work and this gave rise to much home industry,
which was largely aimed at the beautification
of domestic surroundings, the manufacture of
weapons, tools and implements for farm use, and
the weaving and sewing of textiles and national
costumes. Inspired not only by the artistic ideas of
the Vikings and the northern Sami people, but
also by the rich palette of colours and shapes of
the natural world, the patterns and forms evolved
by the Norwegian people have been passed

down from generation to generation. Thus through
the ages an incredibly rich and distinctive folk art
culture has evolved and been preserved in Nor-
way, which perpetuates a reverence for craftsman-
ship and a love of materials. More than anything
else, it is this "living" tradition in the handcrafts
that has influenced the development of Norwegian
design.
The Norwegians are an intensely proud nation of
people, whose character has been shaped as
much by their Viking past and centuries-old sea-
faring heritage as by their history of material hard-
ship and foreign domination. While the people
have always considered their homeland the *Anner-
ledeslandet* (the different country), throughout
much of its history Norway was subjugated by
its wealthier and more powerful neighbours – the
434-year union with Denmark, which has been
described by Norwegians as the "four-hundred-
year-night", was eventually dissolved in 1814 only
to be followed by nearly a century of Swedish rule.
It was not until 1905 that Norway finally gained its
independence. During this long period of foreign
domination, it was the country's rural rather than
urban communities that preserved the Norwegian

▷ Frida Hansen, design for
*Røde Roser* (Red Roses)
tapestry portière, 1899

▷▷ Torolf Prytz, *Snowdrop*
enamelled stemmed bowl for
Jacob Tostrup, c. 1900

identity in the arts and crafts. Indeed, the desire for cultural autonomy spurred on by the persistent threat of wholesale "Danification" helped strengthen the country's folk art traditions, from rose painting to intricately patterned hand-weaving. Unsurprisingly, around the turn of the 19th century when Norway's long-struggle for independence was nearing its ultimate goal, there was a flowering of National Romanticism in both Norwegian architecture and the applied arts. The Neo-Viking "Dragon Style" reflected a deeply patriotic aspiration to tap into the very roots of the Norwegian identity. For example, **Gerhard Munthe**'s furniture for the Fairy Tale Room at Holmenkollen Tourist Hotel, Frederik Holm's silverware for David-Andersen, and Henrik Bull's (1864–1953) ceramics for Porsgrund can be seen not just as historicizing decorative exercises, but as political statements that sought to underscore the cause of independence. While objects such as these can also be seen as an expression of the Pan-Scandinavian decorative revival that occurred during the *fin-de-siècle* years, they did in fact go some way towards establishing the foundations of a national identity within the Norwegian applied arts.

Around the time of Norway's independence, there was a marked shift away from National Romanticism towards a greater internationalism in design, which was demonstrated by the wholehearted acceptance of the Art Nouveau style. Because Art Nouveau was inspired by nature rather than past historical styles it can be considered the first truly modern international style, and no other country in Scandinavia embraced it quite so much as Norway. Gustav Gaudernack and Thorolf Holmboe (1866–1935) perhaps best exemplified Norwegian Art Nouveau with their exquisite *plique à jour* enamelled objects designed for David-Andersen, which incorporated stylized yet sensitive representations of native flora and fauna. Designs such as these had an extreme delicacy of line that revealed the virtuoso craftsmanship of Norwegian goldsmiths, whose enamelling skills even today remain unrivalled in Scandinavia. While Norway's outstanding natural beauty became the inspirational focus for many Norwegian designers during the pre-war period, others were more directly influenced by traditional folk weaving, most notably **Frida Hansen**, whose woven panels with their highly stylised floral motifs were

▷ Thor Bjørklund, cheese slicer for Thor Bjørklund & Sønner A/S – originally designed in 1925

▷▷ Theodor Engebøe, silver fish servers for Theodor Olsen and for Kristian Hestens, c. 1920–1924

quintessentially Norwegian yet also of the Art Nouveau style.

After the upheaval of the First World War, an important arts and crafts organization was officially founded in Norway known as the Foreningen Brukskunst, which later became known as the Landsforbundet Norsk Brukskunst (LNB; Norwegian Society of Arts and Crafts and Industrial Design). This institution played a vital role in shaping a national identity in Norwegian design through its promotion of greater cooperation between artisans and designers and the cross-pollination of artistic disciplines. Thus, it was not uncommon for members of the LNB to work independently in the creation of unique studio pieces, while also producing designs for industrial manufacture – the roles of artisan/craftsman and industrial designer were seen as aspects of the same process of design. Working together under the umbrella of the LNB, interior designers, artisans and industrial designers sought to produce better everyday goods and to improve the quality of living conditions while advocating the concept of *brukskunst* to the general public. With no precise parallel in English, *brukskunst* was defined by Ferdinand

Aars, a former executive of the LNB, as "embracing the arts and crafts, applied arts and industrial design; it comprehends the process of social thinking, understanding of consumer needs, design, and first-class technical and artistic production. Above all it implies the creation, for use, of objects which are technically appropriate and at the same time contain a quality of beauty which renders them easy and enjoyable to live with." Through numerous exhibitions (up to the early 1970s) of its members' work, which featured everyday industrial designs alongside one-off studio-based objects, the LNB cultivated an increased understanding of and respect for quality in design and production among the Norwegian people.

During the period between the World Wars, many Norwegian designers were influenced by the Art Deco style and began producing work that was distinguished by simplified forms and decoration. For example, Nora Gulbrandsen (1866–1935) designed ceramics for Porsgrund that incorporated strong geometric lines, while Thorbjørn Lie-Jørgensen's silver jug (1934) for David-Andersen had a characteristically Moderne volumetric form. The 1930s in Norway also witnessed a flirtation

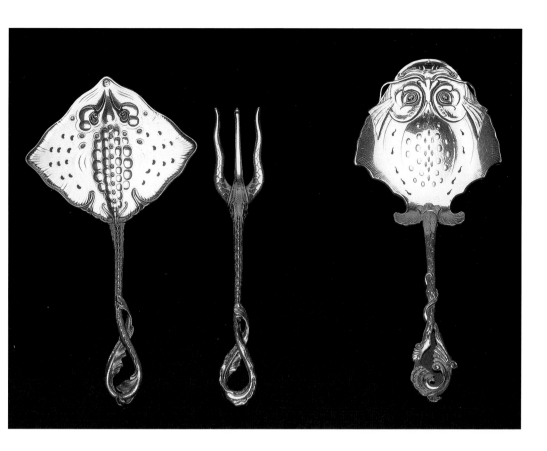

with functionalism, as demonstrated by the manu-
facture of some tubular metal furniture, notably
the *Folkestolen* (People's chair, 1928–1929)
designed by Herman Munthe-Kaas (1890–1977)
and the *Stålrørstolen* (Tubular Steel chair, 1932)
designed by Bernt Heiberg for the University of
Oslo.
As in the other Scandinavian countries during the
early 1940s, a softened form of Modernism began
to gain ground in Norway. Alf Sture's (b. 1915)
wood and cane chair (1943), which was manufac-
tured by Hiorth & Østlyngen, not only reflected
this more humanistic approach to design, but with
its anatomically moulded back section also predict-
ed the ergonomically refined seating of later Nor-
wegian designers. After the German occupation
of Norway during the Second World War, it took
the country a while to regain confidence and to
renew itself socially, politically and economically.
In recognition of the need to bolster national self-
belief, the periodical *Bonytt* (Interior News) pub-
lished an article in 1945 by Håkon Stenstadvold
entitled "Our National Character", which argued
that although Norwegian designers should be
open to new international tendencies in design,

their central aim should be to seek and express
through their work a cultural distinctiveness. While
this concern for asserting a national identity in the
applied arts was widely embraced by Norwegian
designers, it led to an inward-looking approach to
design. This, coupled with the smallness of Nor-
way's population, the limited industrial capacity of
the country and its comparatively high production
costs, partially explains why Norwegian design did
not achieve the level of success as that enjoyed
by Denmark, Sweden and Finland during the post-
war years.
In the 1950s, however, Norwegian designers
achieved more international success than at any
other time previously, as exemplified by Grete
Prytz, Tias Eckhoff, Hermann Bongard (b. 1921)
and Arne Jon Jutrem (b. 1929), who were award-
ed Lunning Prizes for their work, and Willy
Johansson who won silver and gold medals for
his glassware for Hadeland at the Milan Triennale
exhibitions. But even given these individual achieve-
ments, Norwegian design in general lacked the
sheer stylistic brio of consumer products from
Denmark, Finland and Sweden. During the "Golden
Age" of Scandinavian design, from the 1950s to

▷ Willy Johansson, glass vase
for Hadeland, 1958

▷▷ Tias Eckhoff, *Una* cutlery
for Norsk Stålpress, 1973

the early 1970s, each of these three neighbouring countries successfully promoted themselves through the distinctiveness of their design output, while in Norway designers continued to grapple with establishing a national identity of their own. Having no core areas of design excellence comparable to the Danish furniture industry, the Finnish glassmaking industry or the Swedish consumer products industry, Norwegian design tended to lack directional focus and consequently found it much more difficult to promote its products in an increasingly competitive marketplace. By the 1970s, *brukskunst* was all but abandoned by the Norwegian design community, and the ensuing separation of the arts and industry saw design teaching divided into independent specializations. The absence of interdisciplinary synergy between the teaching of handcrafts and industrial design led to a dearth of experimentation, which in turn meant that there was a general lack of innovation. The resulting loss of creativity in Norwegian design was later compounded in the early 1970s by the development of the country's petrochemical industry. With the exploitation of Norway's phenomenal oil and gas reserves, the country quite simply did not need to rely on the design and manufacture of consumer products for its economic well-being.

During the 1980s Norway grew ever wealthier from its North Sea revenues – in just a few decades one of the poorest countries in Europe had become one of the richest (the country is currently the world's third largest exporter of oil). Apart from shipbuilding, the idea of design spearheading an export-led manufacturing strategy was completely ignored. There were, however, a few notable exceptions, including **Peter Opsvik**'s ergonomic seating designs for **Stokke**, such as his hugely successful *Tripp Trapp* extendable highchair (1972) and the innovative and influential *Balans Variable* sitting tool (1979). Distinguished by the use of highly innovative yet functional forms, Opsvik's furniture reflected the general tendency in Scandinavian design during this period towards the development of socially motivated, real need-based product solutions.

With its long tradition of combining craft sensibilities with social ideals, Norwegian design has historically been characterized by constructional integrity, functional clarity, user-friendliness and

the skilled handling of materials. Despite these attributes, Norwegian design has, for the reasons already discussed, never really managed to emerge from the shadows of its more successful neighbours. Recently, however, there has been an increasing realization that Norwegian oil reserves will become seriously depleted within the next twenty years and that the country must develop other industries for its long-term economic success. In response to these concerns there has been a concerted effort to promote Norwegian design abroad by Norsk Designråd (the Norwegian Design Council), which is funded by the Norwegian Ministry of Trade and Industry. Whether Norway will be able to make up for lost time, only the future will tell, but certainly the efforts of young Norwegian designers such as those associated with **Norway Says** are pointing in a promising direction. It would seem that Norwegian designers are now less concerned with projecting a national identity in design than with espousing once again the concept of *brukskunst* through products that marry craftsmanship to a concern for simplification, technological and functional appropriateness and aesthetic durability. Against a background of grow-

ing environmental awareness, there is an understanding within the Norwegian design community that by reconciling art with technology and by focussing on the development of sustainable solutions, it is possible to create innovative and relevant products that have a wider international appeal.

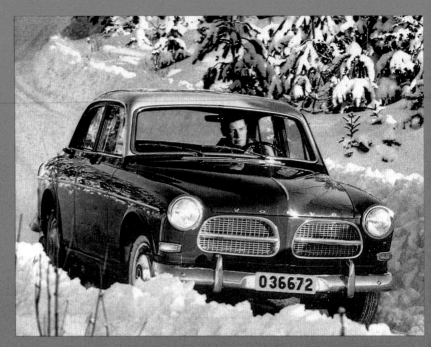

▷ Volvo P120 (Amazon),
introduced in 1956

▷▷ Aerial view of Gamla Stan
(the old town), Stockholm –
a city of islands

# design in sweden

Occupying the majority of the Scandinavian Penin-
sula, Sweden lies at the very heart of Scandinavia.
It is the largest of the five countries and has a
varied geography that includes mountains, lakes,
forests, waterfalls, fertile agricultural plains and
thousands of small islands that form archipelagos
along its scenic rocky coastlines. Although its terri-
torial expanse changed often until 1809, Sweden
can boast a 1000-year-long continuous history as
a sovereign state. As a peace-loving nation, Swe-
den long ago disavowed the military aggressive-
ness that once embroiled its armies in European
warfare and chose instead to play a balancing role
among the world's conflicting ideological and polit-
ical systems – hence the disproportionate number
of Swedish statesmen who have held key positions
in the United Nations. Since the Second World
War, Sweden has followed the political doctrine
of "non-alignment in peace aiming at neutrality in
war" and has come to be viewed as a leading light
of liberal democracy. Historically, like its Scandi-
navian neighbours, Sweden rose from a predomin-
antly peasant culture and widespread poverty to
a highly developed industrialized society with an
advanced welfare system.

The country's taciturn yet proud people value
tolerance, honesty and community, while almost
every feature of Swedish daily life is guided by
liberal attitudes that are tempered by a strong
sense of civic duty. This balancing of individual
freedoms with collective responsibility has ensur-
ed the development of a very stable and inclusive
society. Sweden is a country of remarkable reli-
gious homogeneity and the influence of the state
religion, Evangelical Lutheranism, which places
great emphasis on personal morality and the idea
of "living faith", manifests itself in the purity, func-
tionality and social emphasis of Swedish design.
Indeed, the humanist ethos of Liberal Protestant-
ism can be seen to have permeated all aspects of
Swedish life, from the early acceptance of women's
rights to the promotion of need-based design.
From Volvo's pioneering development of car safety
features to **IKEA**'s production of low-cost demo-
cratic home furnishings, Swedish design has been
motivated by the belief in a moral duty to produce
ethical solutions that meet real social needs.
The origins of a Swedish identity in design can be
traced to the 18th century, when King Gustav III
(reigned 1771–1792) initiated a style of decoration

▷ Louise Adelborg, *Swedish Grace* bowl for Rörstrand, 1930

▷▷ Ingeborg Lundin, *Äpple* (Apple) vase for Orrefors, 1955

that took its inspiration from the high Neo-Classical style found elsewhere in Europe, especially France. Emphasizing lightness, comfort, simplicity and a sense of space, Swedish Gustavian interiors were distinguished by pastel colour schemes, pale painted pine furniture and bare wooden floors, and offered a gentler and more liveable interpretation of Continental Neo-Classicism. Later in the 1830s and 1840s Swedish designers came under the influence of the German Biedermeier style and produced sparsely decorated furniture often using blond woods, in particular birch and maple. The restrained design of these essentially Neo-Classical objects not only reflected the general lack of funds to import fine materials, but also the Swedish belief in the moral supremacy of modesty and simplicity.

In the mid-19th century, Swedish Neo-Classicism was usurped by Revivalism with its heavily ornamented mix of historical influences from Gothic to Baroque to Rococo. In response to this stylistic eclecticism, the world's oldest design association, the Svenska Slöjdföreningen (Swedish Society of Craft and Industrial Design) was founded in 1845 to "bring about improvements in the products of

Swedish handicraft and industry through co-operation with artistic forces, better the household culture, and work to raise the general level of taste". The Svenska Slöjdföreningen's early efforts at design reform were guided by the conviction that design could and should be used as a catalyst for social change. At the end of the 19th century, the applied arts in Sweden were strongly influenced by the reforming pared-down vernacularism promoted by the British Arts & Crafts Movement, which offered an approach to design that helped forge a national cultural distinctiveness. To this end, **Carl and Karin Larsson** furnished and decorated their small house in Sundborn in an unpretentious and homely style that was on the one hand inspired by simple peasant culture, and on the other by a classical country-house idyll. The idealized rural home life that Carl Larsson subsequently depicted in his widely published watercolours can be seen as a reaction against the inevitable encroachment of industrialization and a desire to preserve the handcraft tradition. The Larssons' home, which was sited in the Dalarna region – the mystic heart of Sweden – was not only a celebration of "Swedishness", but also per-

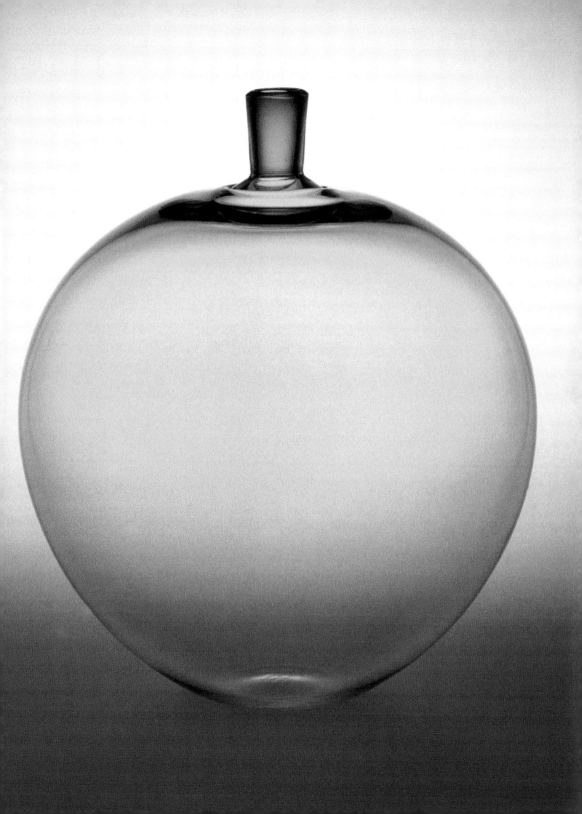

▷ Erik Gunnar Asplund, *Paradiset* restaurant at the 1930 Stockholm Exhibition – This landmark event is sometimes referred to as the "Funkis exhibition" as it marked the flowering of Functionalism within Swedish design

petuated a strong national identity both at home and abroad. The Swedish Art Nouveau style was similarly prompted by the desire to assert a distinctive national aesthetic. Designers associated with this *fin-de-siècle* style, such as Gunnar Wennerberg, incorporated in their work naturalistic representations of the country's flora and fauna, which were already perceived to be under threat from the intrusion of urban life.

At the turn of the century, the Swedish writer and feminist Ellen Key (1849–1926) advocated the liberal and radical doctrine of ethics through aesthetics, which she outlined in her pamphlet entitled *Skönhet åt alla* (Beauty for All, 1899). Inspired by Carl Larsson's illustrations of a simple yet aesthetic life at Sundborn, Key suggested that by refining people's taste and enhancing their appreciation of aesthetic issues, design standards could be raised to such a level that they would help bring about a programme of wide-ranging social reform. As she once noted, "beautiful home surroundings would be sure to make people happier". Key's promotion of design reform had so much influence in Sweden during the early years of the 20th century that when the 1914 Baltic Exhibition was held in

Malmö, objects in the Swedish Art Nouveau style were roundly criticized for their moral turpitude and lack of social purpose. The following year, the Svenska Slöjdföreningen established an agency to promote contact between artists and manufacturers as a means of enhancing the quality of industrially produced goods. The results of these matchmaking efforts were shown at the 1917 "Home Exhibition", which was held at Liljevalchs Art Gallery, Stockholm. Key's idea of tackling social issues through the creation and distribution of beautiful everyday objects was manifested in many of the plain and affordable mass-produced objects that were exhibited in cheerful light-filled interiors. Wilhelm Kåge's *Arbetarservisen* (Workers' Service, 1917) for Gustavsberg was first shown at the exhibition and exemplified the new ethos of ethics-through-aesthetics in Swedish design. The printed *Liljeblå* (Blue Lily) decoration of this flintware service alluded to Swedish folk-art, while the shapes of its various pieces were derived from the soft Rococo forms of the mid-18th century. Despite these vernacular and historicizing references, the low-cost industrially-produced *Workers' Service* was essentially modern and must be

◁ Sven Markelius, *Pythagoras* textile produced by Ljungbergs Textiltryck for Nordiska Kompaniet, 1958

regarded as a three-dimensional realization of the Svenska Slöjdföreningen's belief that "what is useful is beautiful". At the time, however, the commercial success of products like the *Workers' Service* was rare – most of the other products that resulted from the society's promotion of industrial art were not particularly well received, especially by the working classes, for whom they were primarily intended. Often these honest utilitarian goods were still too expensive for most workers, but even if they had been able to afford them, it is unlikely they would have purchased them because by and large "simple" domestic products were still widely associated with low socio-economic status. The "Home Exhibition" was nevertheless a crucial event in that it sparked a vigorous debate on the appalling housing conditions that existed in Sweden's rapidly expanding cities, and focused attention on the pressing need for inexpensive, well-designed household goods.

The idea of simplicity as a principle of beauty began to gain ground in Sweden after the end of the First World War, when a new world order conjured up fresh ideas for a socially progressive society that could be achieved by harnessing technological advances. In 1919, the Society's director, Gregor Paulsson (1889–1977), published a propaganda pamphlet entitled *Vackrare Vardagsvara* (More Beautiful Everyday Objects) that was essentially a manifesto aimed at manufacturers rather than consumers. In this seminal publication, Paulsson identified a new and large group of consumers who continued to be overlooked by many manufacturers – low-wage earners. He argued that this sector of society needed low-cost, useful yet attractive industrially-produced wares and surmised that manufacturers could benefit economically by using design as a competitive marketing tool. His message, however, fell mainly on deaf ears, with most manufacturers continuing to concentrate their efforts on luxury artistic goods as a means of preserving the small yet wealthy clientele they already had. During the 1920s, many Swedish designers studied in Paris or Berlin and were strongly influenced by avant-garde artistic trends emerging from these cities. Other designers who had remained in Sweden were inspired by the rapid industrialization of what had until recently been a mainly rural society. At the landmark 1925 "Exposition Internationale des Arts Décoratifs et Industriels Mod-

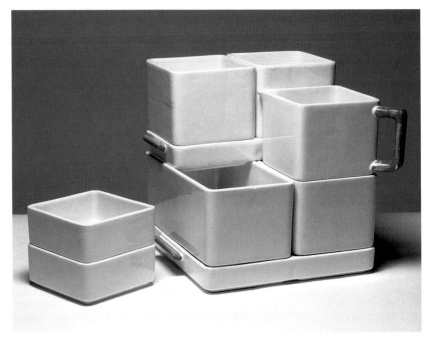

▷ Gunnar Nylund, *Frigi*
refrigerator storage jars for
Rörstrand, 1941

▷▷ Bruno Mathsson, *Eva*
chairs for Karl Mathsson, 1935

ernes" held in Paris, the exhibits displayed in the Swedish Pavilion revealed many contradictory tendencies: primitive versus modern, urban versus rural, national versus international. The objects on show, however, did share a definable character that was distinguished by simplicity and elegance. The British design critic, Morton Shand, coined the term "Swedish Grace" to describe these essentially Art Deco designs, which incorporated simplified Neo-Classical forms and bold abstracted decoration. It could be said that the Swedish products exhibited at the 1925 exhibition were modernistic rather than modern, but within five short years Swedish design would be altered almost beyond recognition as artistic sensibilities in the applied arts were swept away by the industrial aesthetic of Swedish Functionalism – luxury supplanted by utility, historicism superceded by Modernism.

After the Social Democrats formed a minority government in 1920, there was a radical reinterpretation of socialism. It was now no longer viewed as a means to end exploitation but as a way of achieving a larger shared prosperity. The Social Democrats regarded modern design as a tool for social

change rather than just an exercise in avant-garde aesthetics. During the 1920s, pre-fabricated wall sections for standardized one-family houses rolled off manufacturers' conveyor belts and were delivered directly from the factories to the assembly sites. Industrialists and workers alike – the empowered and the powerless – embraced modernity and technological progress so as to create greater equality of opportunity and enhance national prosperity. The Social Democrats saw industrialism as a way of bridging the ideological gap between capitalism and collectivism and as a means of fulfilling their vision of *Folkhemmet* (the people's home). Social planning became the central goal of official design doctrine in Sweden, and as a result, Swedish Functionalism *(Funkis)* projected a rather sterile institutional aesthetic that emphasized hygiene over homely comfort.

The preoccupation with cleanliness can be explained by the cholera epidemics that swept through many Swedish cities during the late 19th century as a result of poor sanitation and overcrowded living spaces. To make matters worse, the First World War halted essential building work, which led to an even more desperate shortage

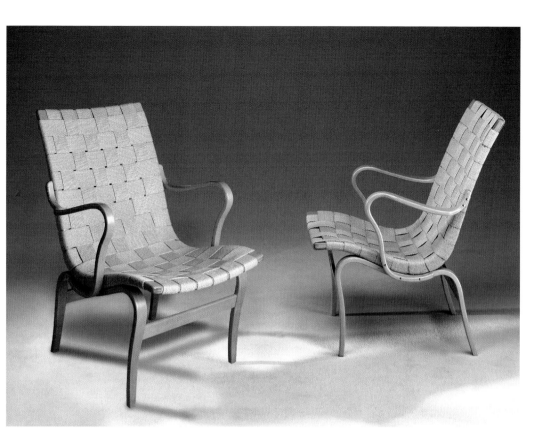

of housing and worse overcrowding. During the 1920s and 1930s, the high incidence of tuberculosis in Sweden made the provision of good quality social housing an absolute priority. Quite simply, hygiene was recognized as the key to good health and a healthy populace was seen as the foundation of a strong nation. While the clean machine aesthetic of Functionalism offered a promise of national improvement (especially in health matters), the centralization of Swedish government made it easier to implement Modernism for social housing needs.

In 1930 the "Stockholmsutställningen" (Stockholm Exhibition) organized by the Svenska Slöjdföreningen, which was then headed by the arch-reformer Gregor Paulsson, marked a watershed in Swedish design. As co-director of the event, **Erik Gunnar Asplund** was responsible for the exhibition's modern form, which was the realization of the Functionalists' credo that "purposed design is beautiful". The Stockholm Exhibition was primarily a celebration of urban progress over rural traditionalism and projected a vision of social utopia, from model apartments for low-income families to modern light-filled interior installations for public buildings such

as schools, hospitals and hotels. The architecture and design exhibited were politicized expressions of the new social democracy in Sweden and reflected the Functionalists' unquestioning faith in advanced technology. Designers associated with the *Funkis* movement believed that industrialization was both a social and aesthetic ideal, and maintained that buildings (even homes) should be standardized just like machines and that furniture should function as "equipment for living". Praising industrially manufactured products, from aircraft to sewing machines, as exciting indicators of future possibilities, the Functionalists also argued that the new Machine Age demanded an innovative type of architecture that was of its own time.

Not all Swedish architects and designers, however, were captivated by the utopian promises of Functionalism. **Josef Frank**, for example, noted that "The home must not be a mere effective machine. It must offer comfort, rest and cosiness (soothing to the eye, stimulating to the soul). There are no puritan principles in good interior decoration." Certainly, the Functionalists' promotion of a machine aesthetic had many detractors from across the political spectrum, who criticized it for its lack of

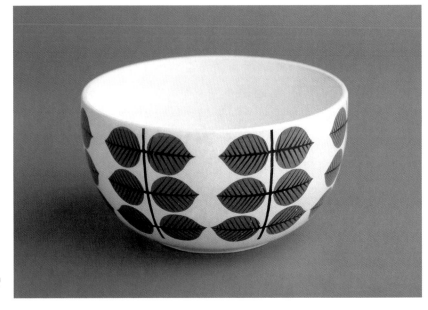

▷ Stig Lindberg, *Berså* bowl
for Gustavsberg, 1960

▷▷ Estrid Ericson, *Elefanter*
textile for Svenskt Tenn,
1930s – this design was
based on an African textile and
was introduced by the founder
of Svenskt Tenn

"Swedishness". While the Functionalist camp count-
ered this disapproval by arguing that simplicity
was an inherently Swedish attribute, critics also
voiced concern over the humanist and environmen-
tal vacuity of an unrestrained industrial system that
produced an endless stream of superfluous novel-
ties. The opponents of the *Funkis* movement did,
however, recognize that social needs could be
addressed through the implementation of modern
design and therefore sought a compromise that
would balance the organic (natural materials) with
the rational (industrial production). This "third way"
approach to design was epitomized by **Bruno
Mathsson**'s elegant and essentialist *Eva* chair
(1934), which featured a seat section constructed
of moulded solid wood and woven hemp webbing
that closely followed the contours of the body
so as to provide comfort without the need for
upholstery.
After the Second World War, the idea of the
"people's home" was translated into a comprehen-
sive welfare state with a state-controlled housing
policy that had an immense influence on the struc-
ture of Swedish society. Modernism had now
become a potent symbol of the post-war home-

making dream, while the idea of "design as life-
style" gained increasing currency within Swedish
design circles. There was a strong belief that daily
life could be enhanced through the comprehen-
sive implementation of design, as the "Swedish
Creation Today" exhibition of Swedish design held
in Zurich in 1949 sought to demonstrate. During
this period, Swedish designers began evolving a
less austere form of Modernism, which was reflect-
ed in the homely informality of post-war interior
schemes with their light-coloured wooden furniture,
patterned curtains and woven rugs. The country's
greater economic prosperity was also a major
reason for a less rigorous adoption of Functional-
ism, and even the great prophet of design stand-
ardization, Gregor Paulsson, had to admit that "the
choice of goods is a choice of lifestyle". The land-
mark "H55" exhibition held in Helsingborg in 1955
revealed not only a downright rejection of dogmatic
Functionalism, but also an evolution of Modernism,
which was now characterized by expressive sen-
sual forms, warm earth colours and the use of nat-
ural materials. Although these craft-based industri-
ally-produced designs could perhaps be construed
as a return to traditionalism, Post-war Swedish

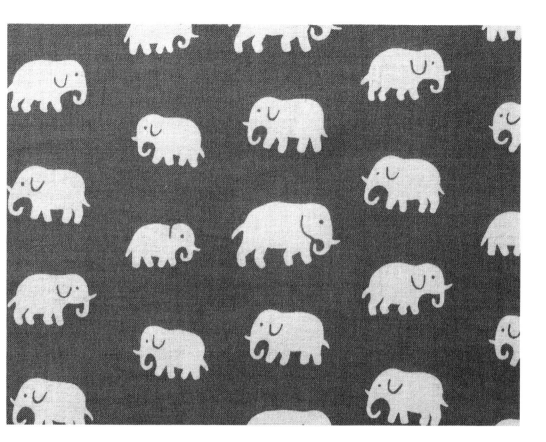

Modernism did have an underlying rationalism, while the adoption of natural materials was prompted as much by the reliance on readily available non-imported materials as by ideology.

During the 1940s and 1950s, a pioneering generation of Swedish engineers/designers began developing a variety of innovative products that fulfilled the long-held Svenska Slöjdföreningen goal of producing visible expressions of the Machine Age through deliberate industrial design solutions. Working with state-of-the-art materials and processes, this new legion of industrial design consultants, which included Sixten Sason, Sigurd Persson, Alvar Lenning (1897–1980), Ralph Lysell (1907–1987), Carl-Arne Breger (b. 1932) and Sigvard Bernadotte, designed vehicles, tools, business machines and household appliances for Swedish companies such as Ericsson, Electrolux, Gustavsberg, Hasselblad, Husqvarna, Saab and Volvo. Although strongly influenced by American streamlining, Swedish industrial designers often used aerodynamic forms not for stylistic purposes but as a way of creating better performing products, most notably Sixten Sason's *Saab 92* (1942), which featured a sweeping drag-resistant monocoque body that set new standards in automotive design. Hugo Blomberg and Ralph Lysell's *Ericofon* telephone (1956) for Ericsson was a similarly groundbreaking design, which integrated the earpiece, mouthpiece and dial into a single, unified and ergonomically refined sculptural form. 1957 saw the founding of the Society of Swedish Industrial Designers (SID), which subsequently raised the profile of Swedish industrial design both at home and abroad. Placing a strong emphasis on the aesthetic aspects and status value of industrially manufactured goods, Swedish industrial designers also created a number of radical yet attractive everyday consumer products that incorporated newly developed plastics, most notably Carl-Arne Breger's mass-produced household wares for Gustavsberg. Crucially, it was during this period that Swedish designers first managed to forge a distinct national identity within the field of industrial design and at the same time establish an international reputation for the quality of industrially manufactured Swedish products.

The late 1950s post-war baby boom led to the growing prominence of child-centred design, while the 1960s and 1970s saw a greater focus placed

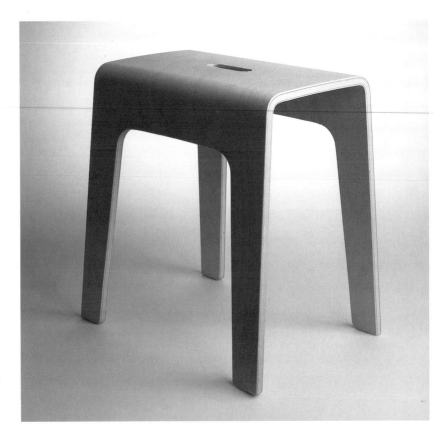

▷ Peter Brandt, *Bimbo* stool
for Blå Station, 1993

▷▷ Ulf Hanses, *Streamliner*
*(model no. 12 655 Black)*
toy for Playsam, 1984

on ergonomics and product safety. In 1970, Victor Papanek's seminal book, *Design for a Real World* was first published in Swedish (published in English the following year) and quickly became a bible for the design profession, especially in Sweden. Calling for a high level of moral and social responsibility within the design profession, Papanek highlighted numerous "real" non-consumerist issues, from automobile safety and environmental pollution to design for (dis)ability and the Third World. Undoubtedly inspired by Papanek's plea for socially responsible design, two Stockholm-based groups, A&E Design (founded 1968) and Ergonomi Design Gruppen (founded 1979), specialized in the development of innovative life-enhancing products for handicapped users, which went on to receive many awards and widespread recognition as real design for real needs.

The work of **Johan Huldt** and **Jan Dranger** also reflected the general desire in Swedish design circles for a less consumerist approach to design. Having founded their own manufacturing company, Innovator Design, in 1969, Huldt and Dranger retailed their furniture designs anonymously so as to counter the cult of "designer" products. Using

tubular metal, sheets of perforated metal and canvas, they developed a range of colourful and inexpensive yet highly practical furnishings that not only exemplified the democratic roots of Swedish design, but also signalled a new internationalism within Scandinavian design as a whole. Innovator products enjoyed huge sales success throughout the late 1970s and early 1980s and were even retailed by **IKEA**. While Huldt and Dranger's furniture designs can be seen to have evolved from the industrial approach of 1930s Swedish Functionalism, they can also be viewed as quintessential examples of the international High-Tech style.

During the early 1980s, Swedish design fell under the spell of Post-Modernism, with **Jonas Bohlin**'s *Concrete* chair (1981) being one of the first Scandinavian manifestations of this new international style. The manufacturer, **Källemo**, subsequently produced a number of other Post-Modern furniture designs, such as Mats Theselius' *National Geographic Magazine* bookcase (1990), which brought much international attention to contemporary Swedish design. It was, however, IKEA, with its affordable flat-pack modern furnishings, that played

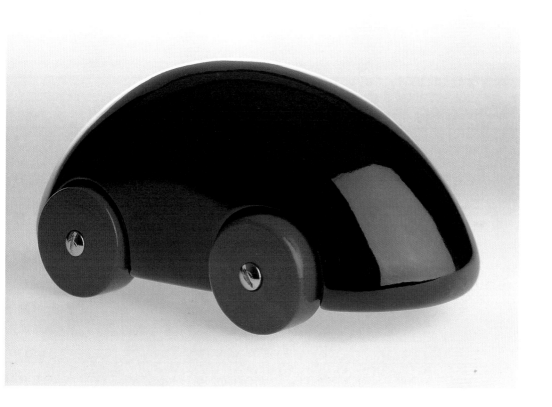

the greatest role in exporting contemporary Swedish design and promoting the Swedish concept of "design as lifestyle". From Björn Dahlström's colourful toys for Playsam to Ingegerd Råman's beautiful glassware for Orrefors, Swedish design today continues to perpetuate the attributes of durability, economy, honesty, affordability, and functional clarity through democratic and socially responsible product solutions. Guided by the conviction that well-designed products can enhance the quality of life through their practical beauty, the Swedish design community's long-held credo of *Vackrare Vardagsvara* (More Beautiful Everyday Objects) will become increasingly valid in the future as the need for relevant design solutions becomes ever more imperative. As a senior design consultant at Volvo and an important design educator in Sweden, Victor Papanek noted in a publication to mark the 50th anniversary of IKEA that, "The sustainability of life on this planet can be helped or hindered through the design and use of the objects we make. Ethical design must be environmentally and ecologically earth-friendly. It must be human-scale; it must be humane; it must be embedded in social responsibility."

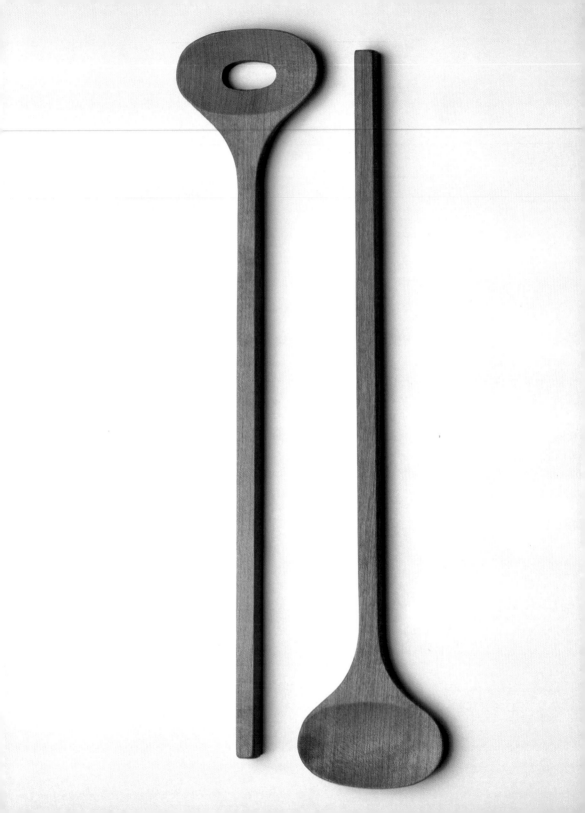

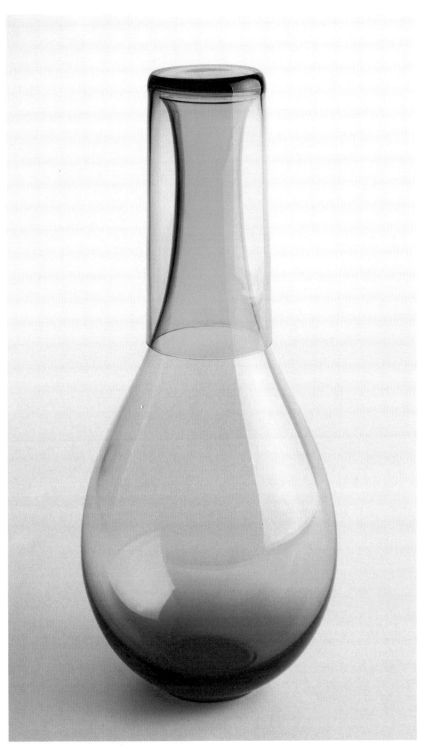

◁◁ Carina Seth-Andersson, *Tools* heat-treated birch salad servers for Hackman, 1998

◁ Ingegerd Råman, *Drop of Water* decanter for Orrefors, 2000 – shaped like a drop of water this decanter was originally designed for the Museum of Watercolours in Sweden

▷ Gunila Axén, *Hundar* (Dogs) textile produced by Borås Wäfveri for 10-Gruppen, 1972

# 10-gruppen *(founded 1970 Stockholm, Sweden)*

**10**
**SWEDISH DESIGNERS**

During the late 1960s a new spirit emerged in Swedish textile design that was epitomized by the bold and brightly coloured screen-printed Pop textiles designed by among others, Gunila Axén (b. 1941) and Ingela Håkansson. Although these textiles possessed a remarkable freshness, it was difficult to get them into production because of the general conservatism of the textile industry in Scandinavia. Even if a manufacturer was prepared to take on a particular design there was no guarantee that the colourways or pattern would not be changed. Against this background, Inez Svensson (b. 1923), who was artistic adviser to the manufacturer Borås Wäfveri, managed to persuade the company to launch a new collection of youthful, Pop inspired designs, including Gunila Axén's well-known *Moln* textile (1968) with its sky-blue background and cut-out cotton-wool-like clouds. These designs were withdrawn after only a short period, but following the protests of several journalists in several interior design magazines the textiles were re-introduced. After this incident, Inez Svensson, Ingela Håkansson and Susanne Grundell decided to form a design collective so they could themselves decide how long a particular textile remained

in production. Eventually in 1970, these three designers together with Gunila Axén, Britt-Marie Christoffersson, Birgitta Hahn (b. 1938), Lotta Hagerman, Tom Hedqvist, Carl-Johan De Geer and Tage Möller formed their own production company – 10-Gruppen – to manufacture silk-screened textiles and retail them directly to the public. A poster showing their first ten designs, including Gunila Axén's *Hundar* textile was exhibited the following year at a major textile exhibition held in the Centre Culturel Suédois, Paris, that bore the statement, "We are ten Swedish designers working in textiles, paper and plastics. The Swedish textile industry is in a crisis. This affects us too. We feel isolated. And we want to reach further out. If you are interested in good Swedish design, contact us whether you are passing through Sweden or not." Borås Wäfveri eventually undertook the production of the collective's first ten designs on its behalf in 1972. The following year, 10-Gruppen opened its own store in Stockholm and by the mid-1970s its bold and colourful 100% cotton textiles were being sold internationally. They were especially popular in France, where there was a particularly strong fashion for primary-

coloured high-tech interiors. Later in 1977 the group launched its *Black & White* collection in response to the emergence of the short-lived Matt Black style. In 1987 the "Ten Swedish Designers" were reduced to five members and today only three of the original founders – Birgitta Hahn, Ingela Håkansson and Tom Hedqvist – are actively involved in the group, which is still renowned for its striking co-ordinated collections that are still printed by Borås Wäfveri. The group has also designed collections for **IKEA**, Rörstrand and Duro and its patterns have not only been used for furnishing textiles but also for clothing and various domestic objects including wash-bags, plastic tablemats and melamine trays. Today, 10-Gruppen's associated designers continue to produce distinct textile ranges with bold and colourful silk-screened patterns that promote a playful and accessible form of Modernism that is characteristically Scandinavian in spirit.

△◁ 10-Gruppen's first poster, 1971

△▷ 10-Gruppen, poster for *Play* collection, 1980

▽ Birgitta Hahn, *Thread* screen-printed tray for 10-Gruppen, 1999

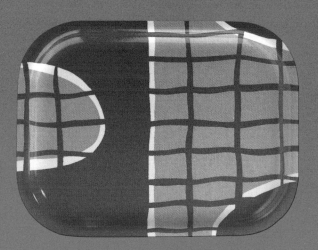

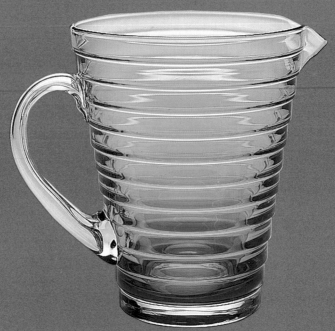

▷ Aino Aalto, *Bölgeblick*
pitcher for Karhula, 1932 –
later renamed *Aalto* and pro-
duced from 1988 by Iittala

# aino aalto *(Finnish 1894–1949)*

Aino Aalto (née Marsio) studied architecture at the Teknillinen Korkeakoulu (Institute of Industrial Arts) in Helsinki, graduating in 1920. In 1924, she was employed by fellow architect **Alvar Aalto,** whom she married the same year. They subsequently collaborated closely on various projects, including the development of techniques for bending wood. These researches eventually enabled the Aaltos to co-develop a number of landmark furniture designs that utilized bent laminated wood and plywood. In 1932, Aino participated in a glassware design competition sponsored by the Karhula-Iittala glassworks. This competition arose partly as a result of the annulment of Finland's prohibition laws (which were enforced from 1919 to 1932) and the glassworks' subsequent expectation of a sudden demand for new drinking glasses. Aino's submission, known as the *Bölgeblick* (Wave View) pressed glass set, included a pitcher, a drinking tumbler, a bowl, a shallow dish, a sugar bowl and a creamer. The simple yet elegant design of the set, which was born out of Aino Aalto's concern for practicality and standardization, was awarded second prize in the competition. The relatively chunky stepped and ribbed forms of the individual pieces helped

to disguise the inherent imperfections of pressed glass, while their solidity conveyed a sense of quality not generally associated with utility glassware. With only a few minor modifications, Karhula put the *Bölgeblick* pieces into production in 1934, with other items such as plates, vases, mugs, schnapps glasses and a decanter being added to the range later. Originally these were only available in either azure blue, brown, green and smoky grey. Later the *Bölgeblick* set was re-named *Aalto* and from 1988 it was produced by Iittala. For the same competition, Aino also submitted a proposal for "art glass" – the *ABCD* series – which included a vase with a wave-like base for flowers of different lengths. Although this vase did not win any prizes, its unusual form anticipated Alvar Aalto's famous *Savoy* vase by some four years. From 1932, Aino worked as a freelance designer for Karhula-Iittala, and the following year she co-founded the **Artek** furniture company with Alvar Aalto, Nils-Gustav Hahl and Maire Gullichsen. In 1933, the Aaltos participated in the Riihimäki glass design competition by jointly designing the *244* series of stacking glasses and vases (which was entered only under Alvar Aalto's name). Having been

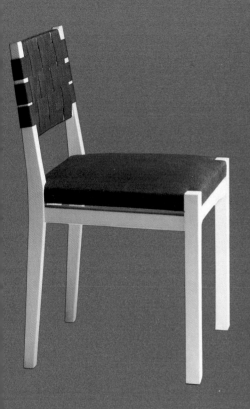

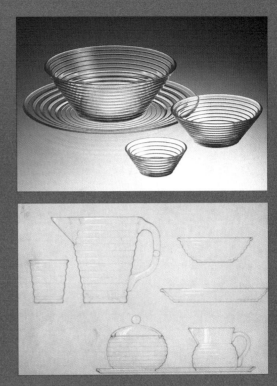

awarded second prize, this blow-moulded series
became known as the *Riihimäki Flower* series
because of the curious floral shapes the pieces
made when stacked. The simplicity and practicality
of the series reflected the growing tendency
towards functionalism in Scandinavian design, but
at the time of its appearance the general public
was still not fully accustomed to such starkly pure
and undecorated forms. One contemporary com-
mentator described the Aaltos' *Riihimäki Flower*
series as "modern, matter-of-fact utility which
almost resembles laboratory equipment." Aino Aalto
was awarded a gold medal at the 1936 (VI) Milan
Triennale and continued to collaborate closely with
her husband until her death in 1949.

◁△ Aino Aalto, *Model no. 615*
chair for Artek, 1935–1937

△△ Aino Aalto, *Aalto* bowls
and plate for Karhula, 1932

△ Aino Aalto, design drawings
for the *Bölgeblick* pressed
glass range, c. 1932

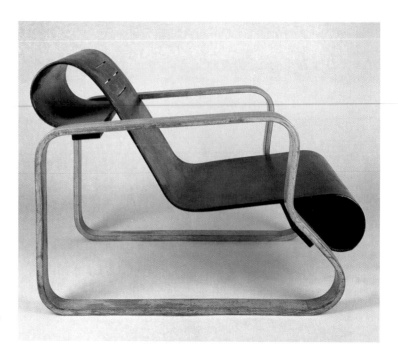

▷ Alvar Aalto, *Model no. 41*
*Paimio* chair for Huonekaluja,
Rakennustyötehdas,
1931–1932 – later
manufactured by Artek

# alvar aalto *(b. 1898 Kuortane – d. 1976 Helsinki, Finland)*

The son of an engineer who specialized in geodetic surveying, Hugo Alvar Henrik Aalto is Finland's most celebrated architect/designer and one of the greatest pioneers of organic Modernism. At an early age Aalto showed an interest in and aptitude for the fine arts, and went on to study architecture from 1916 to 1921 at the Teknillinen Korkeakoulu (Institute of Industrial Arts), Helsinki. After completing his studies, he worked as an exhibition designer and travelled extensively throughout central Europe, Italy and Scandinavia. In 1923 he established his own architectural practice in Jyväskylä, which was later moved to Turku (1927–1933) and Helsinki (1933–1976), and the following year he married the architect Aino Marsio who subsequently became his closest collaborator. Between 1924 and 1929 they conducted numerous experiments in the bending of wood – a material that occurs in natural abundance in Finland. This crucial research later enabled Aalto in the 1930s to develop several revolutionary chair designs, which came to symbolize a completely new direction in Scandinavian design. It was his work as an architect, however, that first brought Aalto international recognition. In 1927 he designed the Turun

Sanomat Building in Turku, which was his first functionalist building, and two years later he co-designed an exhibition to celebrate Turku's 700th anniversary – his first complete modern structure for Scandinavian public display. These early yet important schemes were followed by a number of highly acclaimed architectural projects, including the Viipuri Library (1927–1935), the Paimio Tuberculosis Sanatorium (1929–1933) and the Finnish Pavilion for the 1939 New York World's Fair. Unlike his Modernist contemporaries in Germany and Italy, who promoted the use of synthetic materials such as steel and glass in furniture design, Aalto turned to laminated wood and plywood as his materials of choice, and in 1929 began investigating veneer bonding and the limits of moulding plywood with Otto Korhonen, the technical director of a furniture factory near Turku. These experiments resulted in Aalto's most technically innovative chairs, the *No. 41* (1931–1932) and the cantilevered *No. 31* (1931–1932), both of which were designed contemporaneously with or as part of his *Gesamtkunstwerk* scheme for the Paimio Tuberculosis Sanatorium (which to this day still treats lung patients). These comfortable yet functional designs

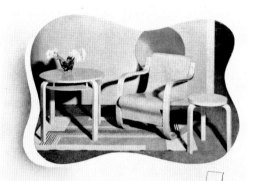

**SPECIFICATIONS OF MODELS ILLUSTRATED ABOVE**

ROUND TABLE. Plain birch · · · · £1 15 0
(25 inches diameter) Curled birch · · · · 2 10 0

SPRING CHAIR. Plain birch or black, red or blue seat £2 17 6
Curled birch · · · · · 4 0 0

STOOL. Plain birch or black, red or blue top 9 0
Curled birch · · · · · 13 6

Dining Chair (Model 21) · £2 0 0
Verandah Chair (Model 51) · £1 12 6
Cafe Table (Models 81-5) from £1 2 6

Write or 'phone VIC. 2844-5 for free illustrated literature
describing other Finmar models and address of your nearest dealer.

Awarded the Certificate of the Royal Institute of Public Health and Hygiene.

FINMAR LTD., 44 RANELAGH RD., GROSVENOR RD., S.W.I

"*Look for this
label on
every model.*"

**F i n m a r**
FURNITURE OF THE FUTURE FOR THE HOME OF TO-DAY

◁ Finmar advertisement for Aalto furniture, c. 1935 – Finmar was the British subsidiary of Artek

▽ Alvar Aalto, hybrid armchair for Huonekaluja Rakennustyötehdas, 1931–1932

signalled immediately to the international avant-garde a new direction in materials towards plywood, and the emergence of a softer, more humane vocabulary of form. The success of his furniture established Aalto as one of the pre-eminent designers of the 20th century, and led him and his wife to found the manufacturing company **Artek** in 1935. Aalto believed that his most important contribution to furniture design was his solving of the age-old problem of connecting vertical and horizontal elements. His bentwood solution developed in conjunction with Korhonen, and which Aalto dubbed "the little sister of the architectonic column", allowed for the first time legs to be attached directly to the underside of a seat without the need for any framework or additional support. This novel technique gave rise to his series of *L-leg* (1932–1933), *Y-leg* (1946–1947) and *Fan-leg* (1954) furniture. Apart from producing landmark furniture designs and buildings, Aalto also worked as a freelance designer for the Riihimäki (1933) and Iittala glassworks (1936). Like his furniture and architecture, Aalto's glassware designs are notably characterized by the use of organic forms – the *Savoy* vase of 1937 being his most famous. Originally entitled,

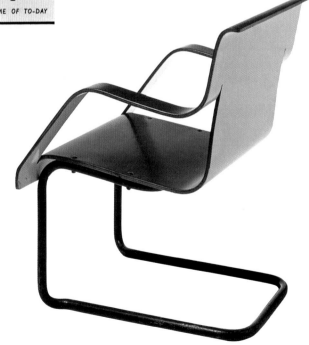

◁ Alvar Aalto, interior of the
Finnish Pavilion at the 1939
New York World's Fair

▽ Alvar Aalto, *Model no. 98*
tea trolley for Artek, 1935–1936

▽◁ Alvar Aalto, *Model no. 31*
armchair for Huonekaluja
Rakennustyötehdas, 1931–1932
– later manufactured by Artek

▽▷ Dining room on display
at Bowman Bros., London,
with furniture designed by
Alvar Aalto for Artek, c. 1938

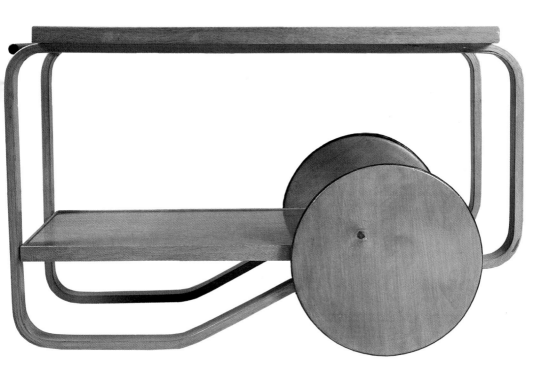

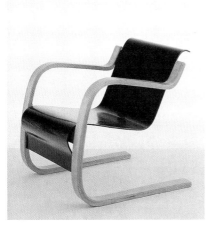

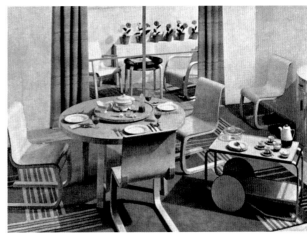

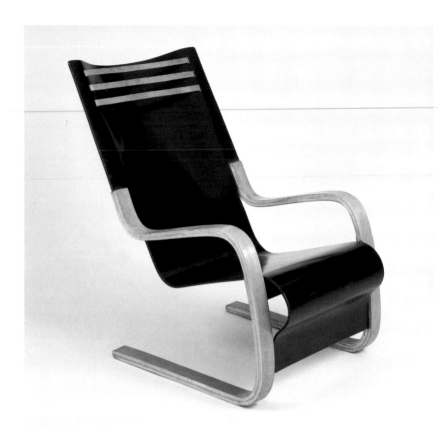

△ Alvar Aalto, armchair for Huonekaluja Raken-nustyötehdas, Turku, c. 1931–1932

▷ Alvar Aalto, entrance foyer of the Paimio Sanatorium, 1929–1933

OVERLEAF
◁ Alvar Aalto, main entrance of the Paimio Sanatorium, 1929–1933

▷ Alvar Aalto, *Model no. 3031 Savoy* vase for Karhula, 1936 – later produced by Iittala

"Eskimoerindens skinnbuxa" (Eskimo woman's leather trousers), the *Savoy* vase was reputedly inspired by the lake shorelines of his native Finland. Its wave-like form may also have been a play on his surname, which translated literally means "wave" in Finnish. Certainly the rhythmic asymmetrical form of the *Savoy* vase did capture some of the abstract essence of nature and in so doing, predicted the amorphous shapes that became so identified with Scandinavian design during the post-war years. Aalto believed strongly that design should be humanising, so he not only rejected severe geometric forms but also, in the case of furniture, man-made materials such as tubular metal, because for him they were inappropriate to the human condition. Aalto's work was especially well received in Britain and America during the 1930s and 1940s, and as one of the founding fathers of organic Modernism, his design philosophy was highly influential on post-war designers such as Charles and Ray Eames. As an early opponent of the Modern Movement's adherence to an alienating machine aesthetic and a stringently rationalist design approach, Aalto stated, "The best standardization committee in the world is nature herself, but in nature stan-

dardization occurs mainly in connection with the smallest possible units, cells. The result is millions of flexible combinations in which one never encounters the stereotyped." Aalto's pioneering organic designs not only provided a new vocabulary of form, they also eloquently represented to the general public what was widely regarded as the acceptable face of Modernism. In 1952, he married the architect Elissa Mäkiniemi, with whom he collaborated until his death. Aalto's life and work were celebrated by the Museum of Modern Art, New York, through three exhibitions held in 1938, 1984 and 1997. Inspired by the relationship that exists between mankind and nature, Aalto's holistic and human-centric approach to design provided one of the key philosophical foundations from which Scandinavian design evolved and flourished.

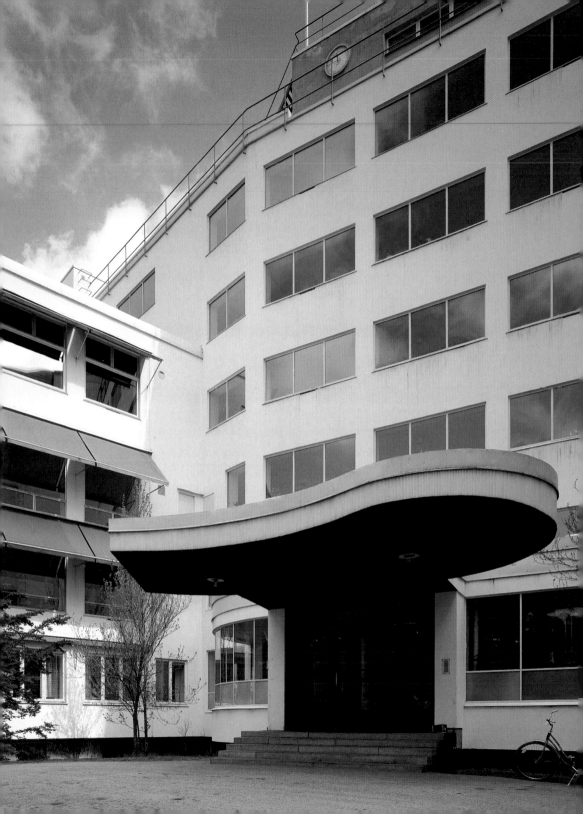

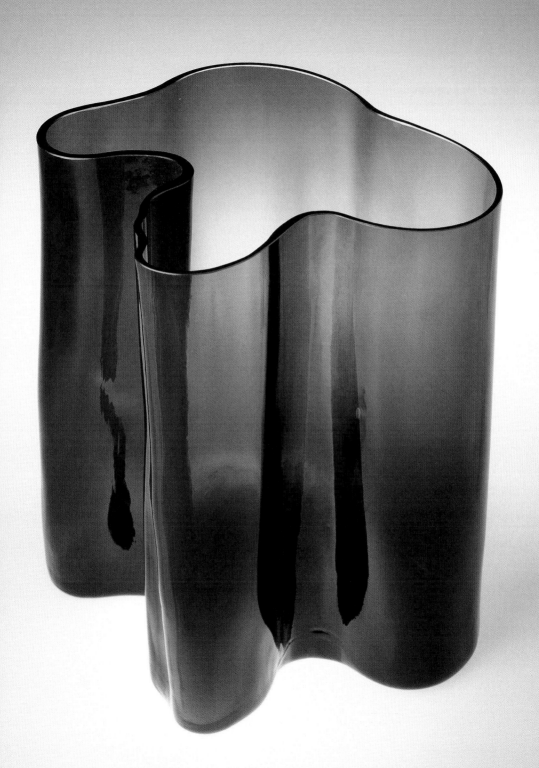

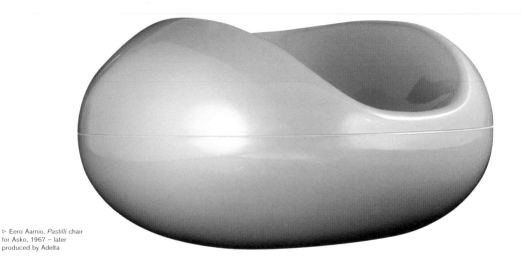

▷ Eero Aarnio, *Pastilli* chair
for Asko, 1967 – later
produced by Adelta

# eero aarnio *(b. 1932 Helsinki, Finland)*

One of several designers to bring international recognition to Finnish design in the 1960s, Eero Aarnio studied at the Taideteollisuuskeskuskoulu (University of Art and Design) in Helsinki from 1954 to 1957. He subsequently established his own design practice in 1962 and since then has worked mainly as an interior and industrial designer. Following the precedent set by earlier Finnish designers during the first half of the 20th century, Aarnio initially designed furniture in natural materials using traditional handcraft techniques, such as his *Jattujakkare* wicker stool (c. 1958). Believing, however, that, "Design means constant renewal, realignment, growth," Aarnio began experimenting during the 1960s with fibreglass and in particular the bold and exciting forms that this material permitted. His best-known series of designs from this period included the *Ball* or *Globe* chair (1962), the rocking *Pastilli* chair (1967) for which he won an AID (American Industrial Design) award in 1968, and the Perspex hanging *Bubble* chair (1968). While these iconoclastic seating solutions captured the spirit of the 1960s with their visually exciting space-age forms, Aarnio did not embrace the Pop culture ethos of ephemerality and disposability. In 1973 Aarnio designed his playful toy-like yet adult-sized *Pony* seat, which was marketed as the *Mustang* by Stendig in the United States. This unusual design made of upholstered moulded foam reflected Aarnio's belief that, "A chair is a chair, is a chair, is a chair … but a seat does not necessarily have to be a chair. It can be anything as long as it is ergonomically correct." This unusual Pop design could either be sat on sideways or "rode" presumably into a "fantasy" landscape limited only by one's own imagination. During the 1980s Aarnio developed a prototype plywood chair and later in the 1990s designed two fibreglass tables – the *Copacabana* (1991) and the *Screw* (1992) – for Adelta, as well as sculptural metal door furniture (1996) for Valli & Valli. Aarnio looks forward optimistically to a time when, "The personal approach of the past and the robot manufacture of the future clasp hands … (so that) … industrial production will be so completely mastered that we can forget it." Although best known for his furniture and interior schemes, Aarnio has also worked in the areas of graphic design and photography.

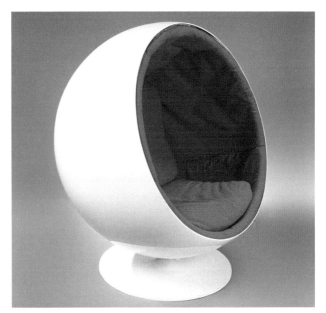

▷ Eero Aarnio, *Ball* or *Globe*
chair for Asko, 1962 –
later produced by Adelta

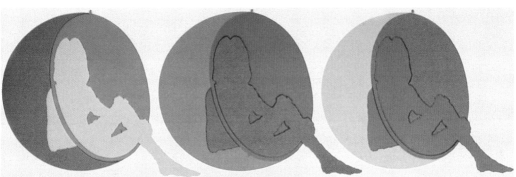

△ Graphic portrayal of *Bubble*
chair, published in *Design
from Scandinavia*, no. 3, late
1960s

◁ Eero Aarnio, *Bubble* chair
for Asko, 1968

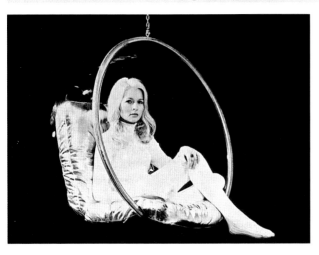

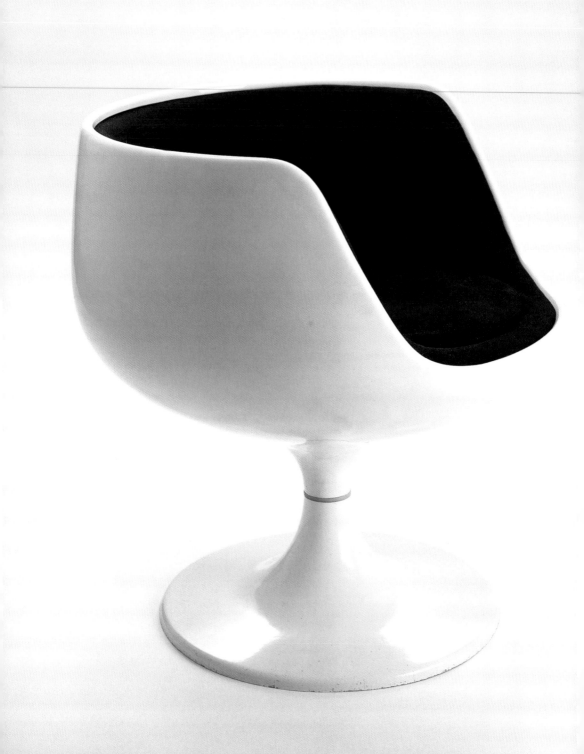

◁ Eero Aarnio, armchair for
Asko, c. 1967

▷ Eero Aarnio, *Pony* chair for
Asko, c. 1970

▽ Stendig showroom in New
York with *Pony* chair for Asko,
c. 1970

▽▷ Eero Aarnio, Asko poster
advertising *Pony* chair, c. 1970

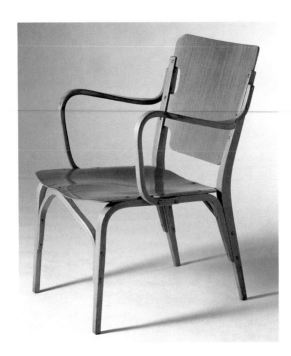

▷ Carl-Axel Acking, bent-
wood chair for Svenska
Möbelfabrikerna, Bodafors,
1944

# carl-axel acking *(Swedish 1910–2001)*

The Swedish architect and designer Carl-Axel Acking trained in Stockholm at the Konstfack-skolan (University College of Arts, Crafts and Design, 1930–1934) and at the Kungliga Tekniska Högskolan (Royal Institute of Technology, 1934–1939). During the early 1930s, he also worked for the great Swedish functionalist **Erik Gunnar Asplund**, assisting with the design of the court-house in Gothenburg. Acking participated in the 1937 "Exposition Internationale des Arts et Techniques dans la Vie Moderne" in Paris and two years later exhibited his work at the 1939 New York World's Fair. That same year he established his own studio in Stockholm. Unlike the majority of Swedish architects, Acking not only designed buildings but also interiors, furniture and lighting. In 1944 he designed his award-winning bentwood chair with moulded plywood seat and back sections as an easy-to-assemble construction that was eminently suited to high-volume production. Apart from factory-made furniture produced by Nordiska Kompaniet and Svenska Möbelfabrikerna in Boda-fors, Acking also designed more exclusive pieces that were executed by various craftsmen in Stockholm and sold through the Hantverket (the sales

organization of Stockholm's handicrafts association). His numerous architectural designs included the Hässelby Hotel in Stockholm (1954–1956), while his interiors work included several important schemes for, among others, North Star Line ships, the Swedish Embassy in Tokyo, and the Hotel Malmen in Stockholm (1949). For this latter project he designed some innovative armchairs with fully upholstered seat shells that could be removed from their cradle-like frames for cleaning and repair. For the same scheme he also designed a sturdy yet simple laminated beech dining chair that comprised just five easy-to-assemble elements. As a prominent member of the Swedish design community, Acking was commissioned to design a building for the landmark "H55" exhibition in Helsingborg in 1955. Over the course of his career he produced a number of designs for wallpapers, textiles, light fittings, a telephone booth (1944), and a postage-stamp vending machine. Acking also taught design for many years at the Konstfackskolan in Stockholm (1943–1964), and from 1965 to 1976 he was professor of theoretical and applied aesthetics at the University of Lund. In recognition of his achievements, Acking became

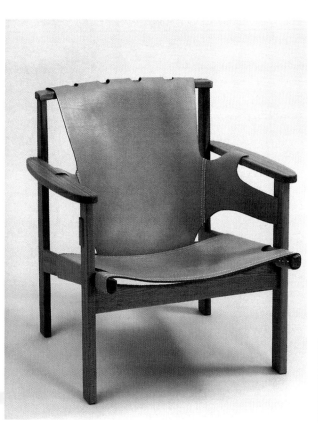

◁ Carl-Axel Acking, *Trienna* armchair for Nordiska Kompaniet, 1957 – later reissued by Källemo

▽ Carl-Axel Acking, interior with *Trienna* armchair, c. 1957

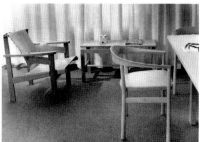

the first Swedish designer to be awarded the prestigious Lunning Prize in 1952. Although much of Acking's furniture did not possess the elegance normally associated with Scandinavian design, it did possess an honest constructional simplicity and robustness that made it highly suitable for contract use and mass production.

◁ Carl-Axel Acking, telephone booths for the Royal Board of Telegraph & Telereklam, 1944

▷ Lis Ahlmann, woven
upholstering textile, 1958

▷▷ Lis Ahlmann, *Pinjekogler*
"rya" panel, 1947

# lis ahlmann *(b. 1894 Århus – d. 1979 Copenhagen, Denmark)*

Lis (Elisabeth) Ahlmann initially trained as a painter under Harald Giersing in 1919. Between 1917 and 1921, she also worked as a ceramics painter in Herman Kahlers' workshop in Næstved and later from 1922 to 1929 she apprenticed as a weaver at Gerda Henning's (1891–1951) workshop in Copenhagen. She subsequently worked as a freelance designer producing woven textiles for furniture by **Kaare Klint**, **Børge Mogensen** and **Mogens Koch.** During the mid-1930s, Ahlmann established her own weaving workshop in Copenhagen, and later in 1948 her work was included in the exhibition "Danish Art Treasures through the Ages" held in London. She also participated at the Milan Triennale (from 1957), and her work was included in the American touring exhibition "Design in Scandinavia" (1954–1957). During the 1950s, Ahlmann moved away from hand-woven textiles in favour of industrially-produced fabrics that were distinguished by their simple checked and striped patterning and muted earth tones. Like many Scandinavian designers, Ahlmann used traditional craft processes, such as weaving on a handloom, as an aid in the conception and planning of designs intended for industrial manufacture. From 1953,

she worked with Børge Mogensen as a design consultant for the Copenhagen-based textile manufacturer C. Olesen, and also designed fabrics with him for the Cotil company. During this period, Mogensen persuaded Ahlmann to adopt a bolder use of colour and to design textiles that could be woven on more sophisticated power looms. For her design work she received the prestigious Eckersberg Medal in 1964 and later the C.F. Hansen Medal in 1978. As a leading modern designer who made the transition from craft-based production to industrial manufacture, Ahlmann was one of the key individuals responsible for the post-war renewal of Scandinavian textile design. Her work became synonymous with the uncluttered yet homely Nordic look that became so popular in America and Britain during the late-1940s and 1950s.

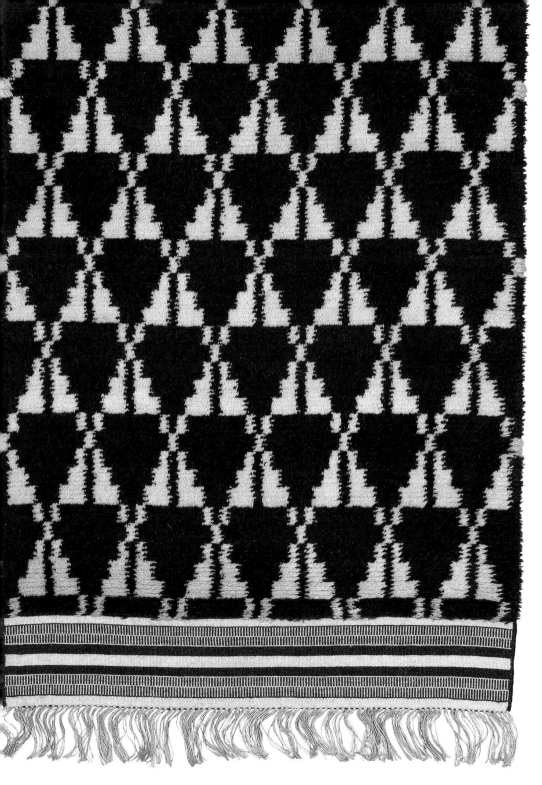

▷ Interior of Artek showroom,
Helsinki, 1930s

# artek *(founded 1935 Helsinki, Finland)*

During the 1920s, the Modern Movement began popularizing the idea of industrially produced furnishings for the home, while at the same time contemporary streamlined forms became increasingly accepted by mainstream consumers. Against this background of change within the domestic environment, **Alvar Aalto** and his wife **Aino Aalto** began developing highly innovative modern furniture using state-of-the-art production methods. Their resulting bent plywood and laminated wood designs possessed soft yet elegant humanizing forms that contrasted strongly with the alienating steel and glass machine aesthetic associated with Bauhaus design. Aalto's alternative soft-edged Modernism was especially appreciated in Britain, where his furniture was displayed at an exhibition of Finnish design in 1933 that was sponsored by the *Architectural Review* magazine. Bolstered by the export orders that resulted from this exhibition, which was held at the Fortnum & Mason department store in London, as well as the widespread interest generated at the 1933 (V) Milan Triennale, Alvar Aalto, Aino Aalto, Nils-Gustav Hahl, and the fine arts patrons and collectors Harry and Maire Gullichsen, founded a sales and marketing company known as Artek Oy AB in October 1935. This new enterprise was intended as a showcase for modern furniture and household fittings, and as a forum for design exhibitions and the Modernist cause in general. By 1939, Alvar and Aino Aalto had designed the majority of the pieces in Artek's extensive collection, which ranged from traditionally joined straight-legged stacking chairs to formed plywood and laminated wood designs such as the seminal *No. 41* (1931–1932) and the cantilevered *No. 31* (1931–1932). Alvar Aalto also designed his ubiquitous *L-leg* stacking stools (1932–1933), which featured a revolutionary leg construction – one of his most functionally versatile innovations. During the 1940s, the *Y-leg* range was incorporated into the Artek collection, as was the fan-shaped *X-leg* range in the 1950s. With Artek, Aalto's aim was to produce the widest selection of furniture with the fewest and simplest elements. He believed that the soul of a design was derived from its most fundamental component and stated, "To make furniture you need a basic element, a structural standard part, which modified in some way, appears in all pieces. *Sine qua non*: apart from its structural characteristics, the basic element must have a

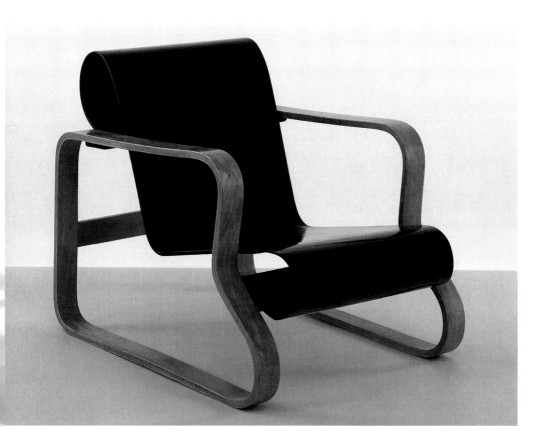

purposeful and style-creating form." Today, Artek continues to market Aalto-designed textiles, lamps and furniture (which is still made by Korhonen Oy, as it has been for over 60 years), while also producing newer designs that possess a complementary aesthetic by, among others, Ben af Schultén (b. 1939), and Hanspeter Weidmann (b. 1958). Artek furnishings are completely synonomous with the Modern Scandinavian interior and are distinguished by simple organic lines and warm natural materials that give a sense of homely practicality.

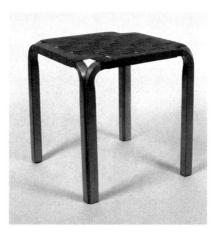

△ Alvar Aalto, *Model no. 41 Paimio* chair for Artek, 1931–1932

◁ Alvar Aalto, *Model no. Y61* stool for Artek, 1946–47

OVERLEAF
◁ Alvar Aalto, *Model no. 100* screen for Artek, 1935–1936

▷ Ben af Schultén, *Espa* chair for Artek, 1999

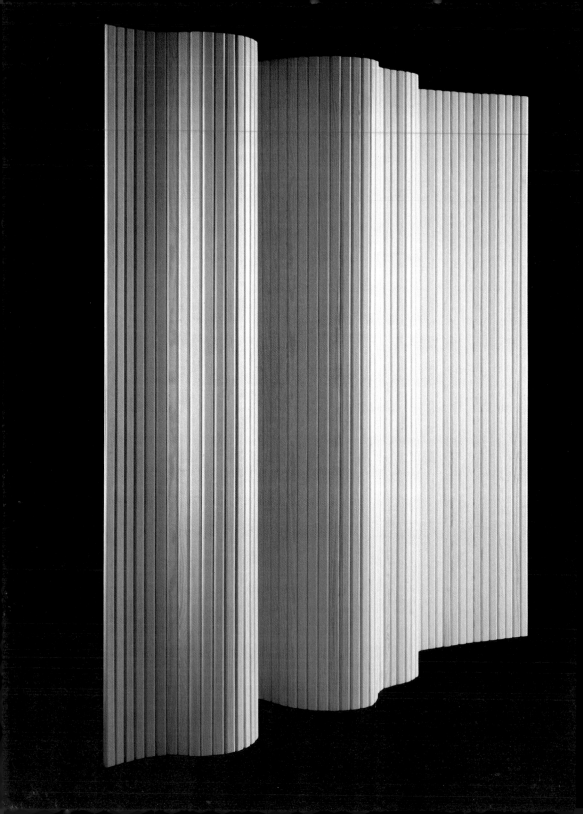

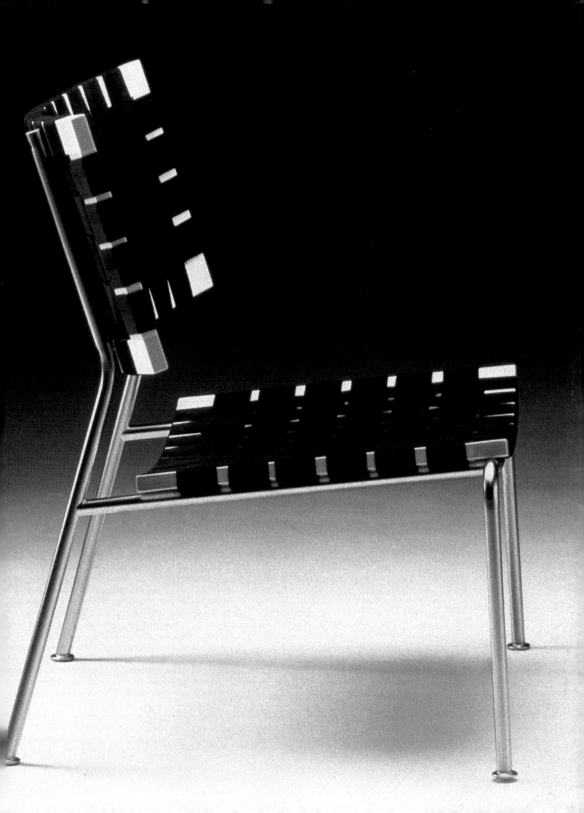

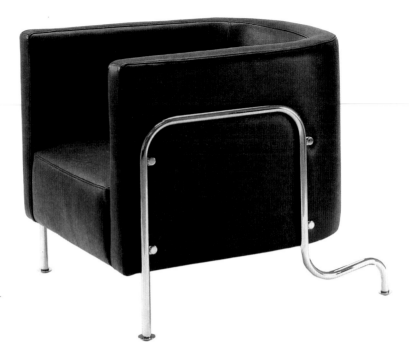

▷ Erik Gunnar Asplund,
*Model no. GA-2* armchair for
Nordiska Kompaniet, c. 1931 –
later reissued by Källemo

▷▷ Erik Gunnar Asplund,
*Karmstol* chair for Nordiska
Kompaniet, 1931

# erik gunnar asplund

*(b. 1885 Stockholm – d. 1940 Stockholm, Sweden)*

One of the most prominent advocates of func-
tionalism in Scandinavia and generally considered
to be Sweden's most important architect, Erik
Gunnar Asplund fused common sense with artistic
intuition in his life-long search for balanced unity
and clarity of form. Having studied at the Kungliga
Konsthögskolan (Royal University College of Fine
Arts), Stockholm, from 1905 to 1909 he initially
pursued a career in painting. From 1909, however,
he concentrated on architecture and shortly there-
after opened his own architectural practice in
Stockholm. He became editor of the journal *Tek-
nisk Tidskrift Arkitektur* in 1917, and the same year
received much praise for his interiors exhibited at
the Liljevalchs Art Gallery in Stockholm. From 1911
to 1930, he designed a number of Neo-Classical
inspired buildings, most notably the Scandia Cine-
ma, Stockholm (1923), and the Stockholm City
Library (1928). During this period he also designed
furnishings that were similarly classicist in style,
such as his *Senna* chair of 1925. Asplund's work
underwent a dramatic transformation when he was
appointed chief architect for the 1930 Stockholm
Exhibition organized by the Svenska Sljödförenin-
gen (Swedish Society of Craft and Design). At

this event, which drew significant international
recognition, his Modernist glass and metal exhibi-
tion building introduced the International Style
to Sweden for the first time. By combining Mod-
ern functionalism with the grace of Scandinavian
Neo-Classicism, Asplund developed a language
of design that was less severe than that of con-
temporary German Modernist architects. Among
Asplund's many other achievements was the
design of the Skogskykogården, Stockholm, and
an extension to the Town Hall in Gothenburg. From
1931 to 1940, he was also professor of architec-
ture at Kungliga Konsthögskolan (Royal University
College of Fine Arts), Stockholm.

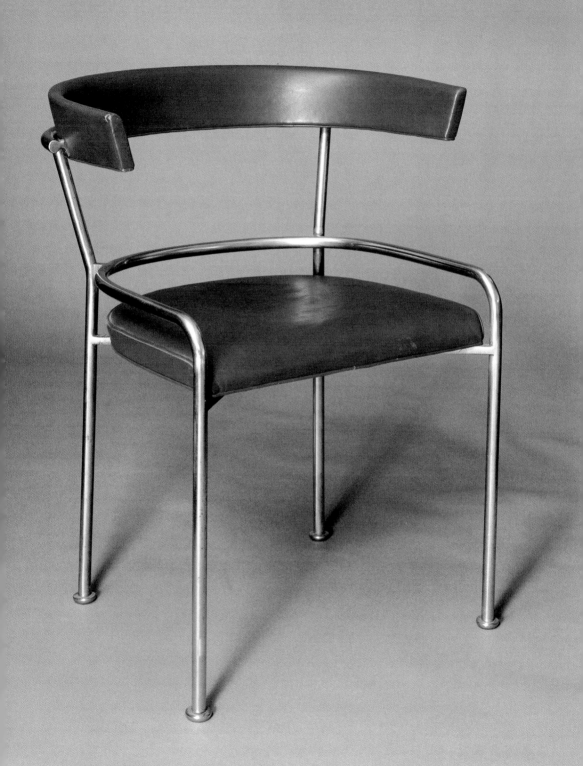

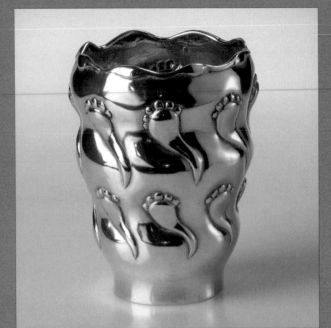

▷ Thorvald Bindesbøll, silver
beaker for A. Michelsen, 1899

▷▷ Thorvald Bindesbøll, chair
made by J. P. Mørck for the
1900 Paris "Exposition Uni-
verselle et Internationale"

OVERLEAF
◁ ▷ Thorvald Bindesbøll,
earthenware plates made
at G. Eifrig's workshop,
c. 1900 – with characteristic
Art Nouveau cloud-like motifs

# thorvald bindesbøll

*(b. 1846 Copenhagen – d. 1908 Copenhagen, Denmark)*

The son of the Danish architect M. G. Bindesbøll, Thorvald Bindesbøll trained as an architect at the Konstfackskolan (University College of Arts, Crafts and Design), Copenhagen, where he graduated in 1861. From 1872 he received numerous decorative art commissions that included designs for furniture, embroideries and book illustrations. In 1882 Bindesbøll exhibited his work both in Denmark and abroad, and the following year began designing ceramics for the J. Walmann Pottery, which were inspired by the art of Japan and natural forms. Also influenced by both William Morris (1834–1896) and the British Arts & Crafts Movement, Bindesbøll developed a highly individual and expressionistic style that was characterized by bold shapes and bizarre patterns that often included abstracted cloud, wave and seaweed-like motifs. From the 1890s onwards, Bindesbøll was the leading Danish designer of his generation and his decorative Art Nouveau style had much influence on many younger designers, such as F. Hegel, Molger Kyster and even Georg Jensen. During the 1890s, Bindesbøll also worked for the Københavns Lervarefabrik and the Kaehler Keramik ceramics factories – the former producing his well-known earth-

enware dishes decorated with incised cloud-like motifs. His first silverware designs date from 1899; with their more delicate paisley-like motifs, which are reminiscent of those found on Indian textiles, these pieces display great finesse and stylistic innovation. His silver designs for A. Michelsen were subsequently shown at the 1900 Paris "Exposition Universelle et Internationale". Throughout his career, Bindesbøll successfully translated his individualistic and forward-looking style into a number of diverse disciplines, including metalwork, leatherwork, jewellery, furniture, textiles, glass, graphics, lighting and stained glass. As one of the leading exponents of the Scandinavian Art Nouveau movement, Bindesbøll's designs were the antithesis of contemporary industrially-produced products. His adoption of abstracted decoration and simple forms, however, can be seen as anticipating the later emergence of modern design in Scandinavia.

▷ Jonas Bohlin, *LIV-Collection* pendant lamp (self-production), 1997

▷▷ Jonas Bohlin, *Concrete* chair (self-production), 1981 – re-issued by Källemo

# jonas bohlin *(b. 1953 Stockholm, Sweden)*

Jonas Bohlin worked as a civil engineer prior to studying interior design at the Konstfackskolan (University College of Arts, Crafts and Design), Stockholm (1976–1981). At his degree show in 1981 he shocked the Swedish design establishment with his *Concrete* chair – a tubular steel and concrete construction conceived more as an art piece than as usable furniture. The *Concrete* chair, which made reference to Bohlin's earlier life as an engineer working on bridge building projects, completely countered the tenets of Scandinavian good design and came to epitomize Swedish Post-Modernism. Bohlin subsequently worked as a freelance designer for **Källemo**, which produced the *Concrete* chair in 1982 in a limited edition. Källemo also made available his *Concave* chaise longue (1983), another Post-Modern design with a segmented form and highly graphic profile. Idiosyncratic designs such as these were widely publicized throughout the 1980s and helped to establish Bohlin as one of Sweden's most avant-garde designers. Bohlin founded his own design practice 1983, and two years later established a Stockholm-based art and design gallery, Stockholm Mobile, exhibiting his own work, which played with form, function and emotion. In 1988 Bohlin became a professor at Beckman's School of Design, Stockholm, and was later appointed head of its Form Course (1992–1996). The same year he was awarded the prestigious Georg Jensen Prize. During the 1980s and 1990s, Bohlin exhibited his numerous limited-edition designs in Scandinavia, Japan, America and Europe. One of his most notable projects known as "LIV" (the Swedish word for "life" and the Roman numeral for "54"), involved him and 53 friends of his rowing from Stockholm to Paris over a period of 116 days. This extraordinary exercise, marked by the publication of a book documenting the journey, inspired a design collection that included lighting, furniture, a vase and a rug. From 1991 to 1993, Bohlin was chairman of SIR (National Association of Swedish Interior Architects) and since then has remained one of the leading figures in the contemporary Swedish design community. On his approach to design Bohlin has stated: "I want my furniture to touch and please, to communicate with time and space, to be made by hand and heart, and to be considerate of mankind and nature."

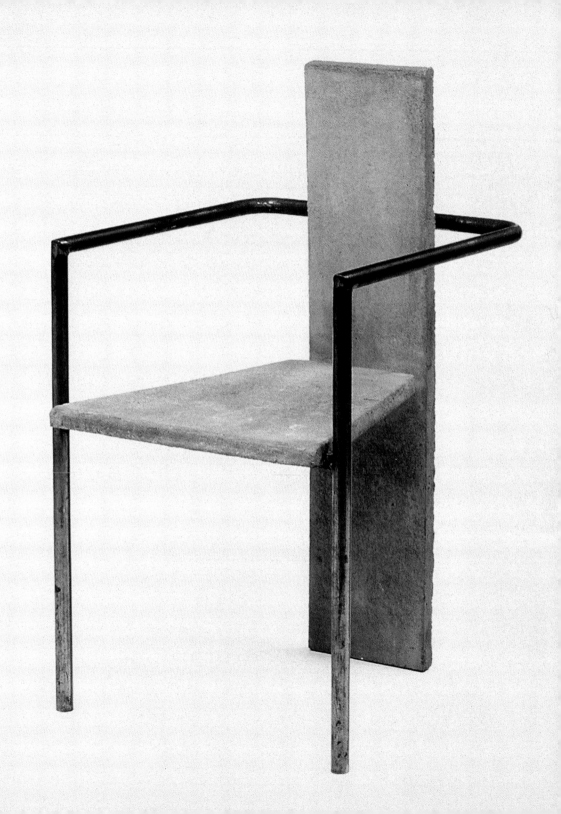

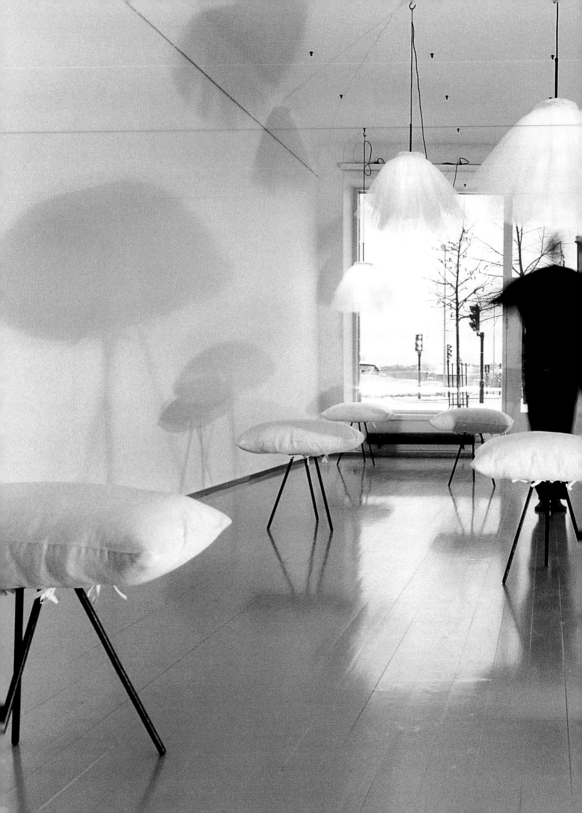

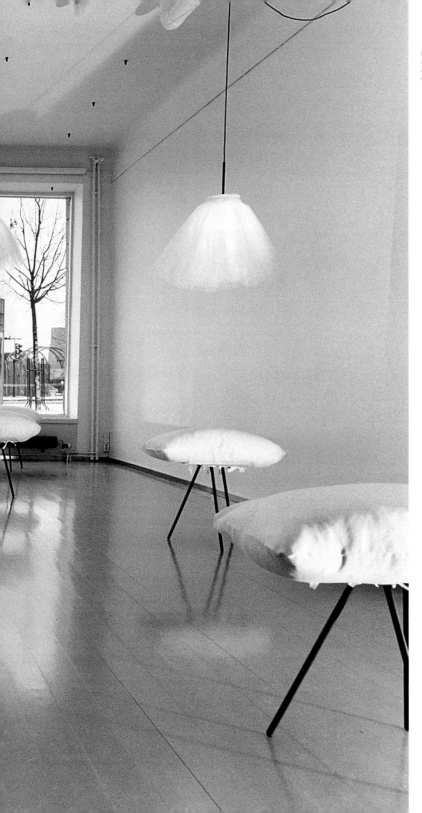

◁ Installation at Jonas Bohlin
Design, Stockholm, 2000 –
showing *LIV-Collection* stools
and pendant lamps (self-pro-
duction), 1997

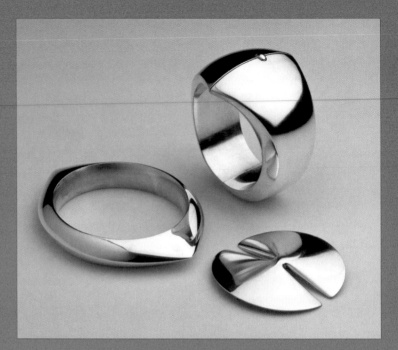

▷ Nanna Ditzel, *Model no. 111* silver armring, *Model no. 107* silver bracelet and *Model no. 333* silver brooch for Georg Jensen, 1956

# nanna ditzel *(b. 1923 Copenhagen, Denmark)*

Nanna Ditzel (née Hauberg) studied cabinet making at the Richards School in Copenhagen alongside **Grete Jalk** and **Kristian Vedel**. She later trained as a furniture designer under **Kaare Klint** at the Kongelige Danske Kunstakademi (Royal Academy of Fine Arts) and also at the Kunsthåndværkerskolen (School for Applied Arts), Copenhagen, where she was taught by among others **Orla Mølgaard-Nielsen**, **Peter Hvidt**, Aksel Bender Madsen (1916–2000), Peter Koch, Ejner Larsen (1917–1987), and the painter Victor Isbrand. While at the latter institution, she met her future husband, Jørgen Ditzel (1921–1961), who had earlier trained as an upholsterer. In 1944, they exhibited living room furniture together at the Cabinetmakers' Annual Exhibition in Copenhagen. These designs, which included a tea table with a removable tray designed for Louis G. Thiersen, received considerable attention. Two years later, the couple married and established their own design studio in Hellerup. Initially, they concentrated their efforts on solutions for small living spaces and Nanna explored the concept of using kitchen units as room dividers. In the early 1950s, she worked as a furniture designer in the architectural

practice of Fritz Schlegel (1896–1965) while continuing to design and exhibit furniture with her husband. In 1952, they designed a range of children's plywood furniture for Knud Willadsen Møbelsnedkeri, and collaborated with Gunnar Aagaard Andersen (1919–1982) on the design of a stand for the Cabinetmakers' Exhibition. During this period, Nanna also designed silver jewellery for Georg Jensen with remarkably forward-looking organic forms. In 1954, she and her husband published a book entitled *Danish Chairs* and in 1956 they were jointly awarded the Lunning Prize, which allowed them to travel extensively – Italy, Greece, Mexico and the United States. From 1957, they designed a range of wicker furniture for R. Wengler that included the well-known hanging egg-shaped chair. They also designed a range of solid-wood children's furniture for Kolds Savværk, which comprised their ubiquitous highchair (still used extensively throughout Scandinavia) and the simple yet elegant *Toadstools* children's stool. This creative partnership was abruptly ended, however, by the untimely death of Jørgen in 1961. Nanna subsequently designed several playground environments and was asked by Søren Georg Jensen to design

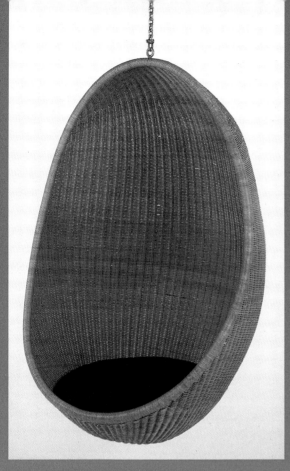

◁ Nanna Ditzel, hanging egg-shaped woven cane chair for R. Wengler, 1957

▽ Period photograph showing egg-shaped woven cane chair hanging from a tree, c. 1957

▽▽ Nanna Ditzel, living room installation with Oregon Pine furniture executed by Poul Christiansen, 1962

jewellery that incorporated semi-precious stones, such as agates and tourmalines, for his family's silversmithy. Eventually Nanna married Kurt Heide in 1968 and spent fifteen years living in London. After his death, she returned to Copenhagen (1986) where she established a workshop, studio and home in one of the oldest parts of the city. Driven by her natural curiosity and "appetite for change", Nanna Ditzel continues to execute innovative craft-based designs for furniture, metalware, tableware, jewellery and textiles. Her work, such as her butterfly-like *Bench for Two Model no. 2600* (1989) for Fredericia Furniture, possesses a remarkable sense of lightness and texture as well as "motion and beauty".

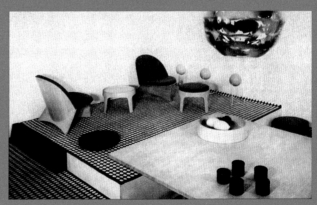

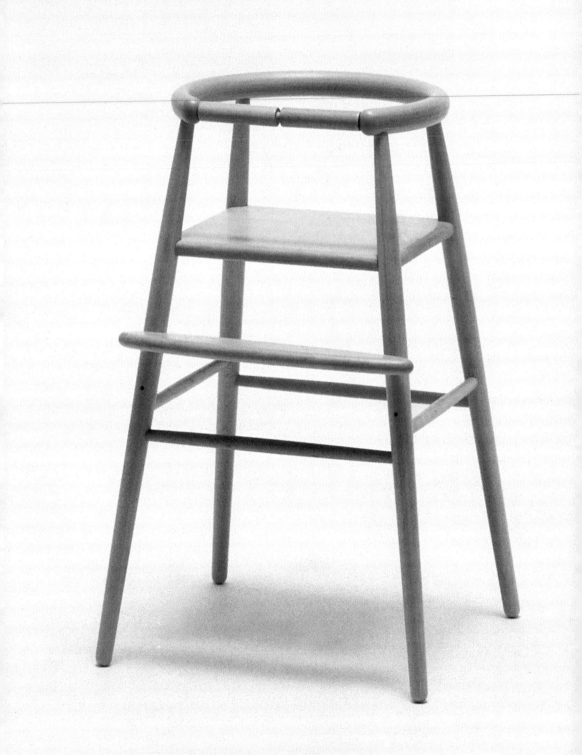

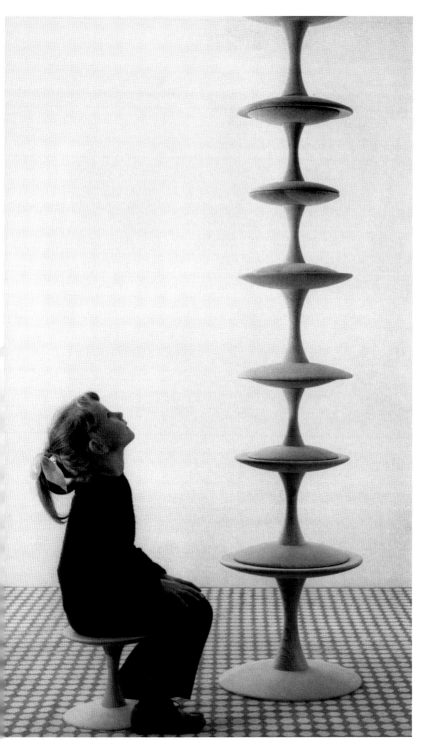

◁◁ Nanna Ditzel, child's high-
chair for Kold, 1955

◁ Nanna Ditzel, *Toadstools*
for Kold, 1962 – later produced
by Krüger and today by Trip
Trap

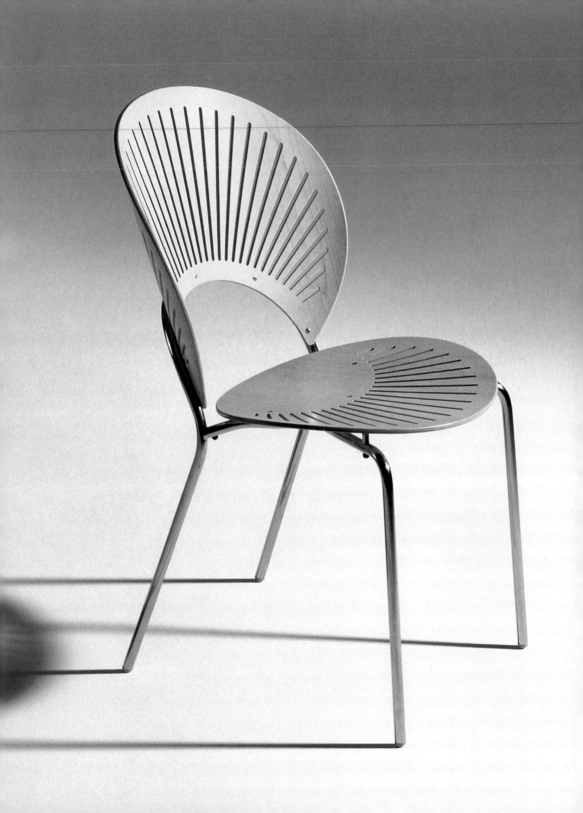

◁ Nanna Ditzel, *Trinidad* chair for Fredericia Furniture, 1993

▷ Nanna Ditzel, *Sommerfugle* (Butterfly) chair for Fredericia Furniture, 1990

▽ Nanna Ditzel, *Bench for Two Model no. 2600* and table *Model no. 2601* for Fredericia Furniture, 1989

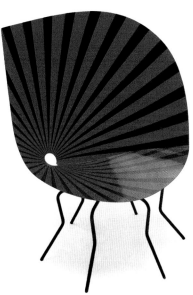

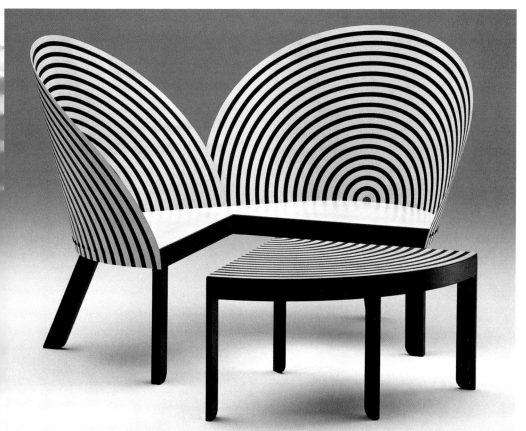

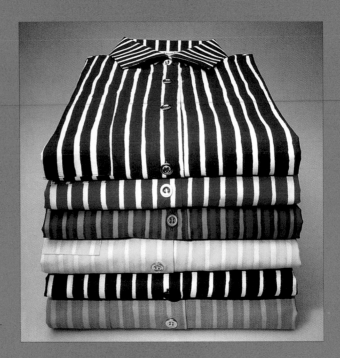

▷ Vuokko Eskolin-Nurmesnie-
mi, *Jokapoika* (Every Boy)
shirts for Marimekko, 1957

# vuokko eskolin-nurmesniemi

*(b. 1930 Helsinki, Finland)*

Vuokko Eskolin-Nurmesniemi revolutionized Finnish design during the post-war years with her boldly patterned and coloured textiles. She began her training at just 16 years of age in the ceramics department of the Taideteollinen Oppilaitos (Institute of Industrial Arts) in Helsinki. After completing her studies in 1952, she worked briefly as a designer for the Wärtsilä-Arabia ceramics factory, and in 1953 married the Finnish furniture and interior designer **Antti Nurmesniemi**. The same year, the founders of **Marimekko**, Viljo and Armi Ratia (1912–1979), "hand-picked" her to become the company's new artistic director. During the immediate post-war years there were shortages of all kinds in Finland and the lack of new clothes meant that women's dresses, which tended to be made of dark and drab coloured textiles, were endlessly adapted in the cause of "make do and mend". Around this time, however, the Ratias' other firm Printex had begun producing colourful and vibrant furnishing textiles designed by **Maija Isola** that were printed on inexpensive cotton sheeting. The concept for Marimekko was to use similar screen-printed textiles for clothing, and Vuokko Eskolin-Nurmesniemi was entrusted with

creating the first line of youthful, fun and off-the-peg garments, which were the very antithesis of the expensive and rather staid collections emanating from the well-known Paris fashion houses. Eskolin-Nurmesniemi's textiles, such as *Tibet* and *Ram*, were patterned with large geometric motifs, and often used two overlapping colours so as to create a third colour – a technique that became a key feature of Marimekko fabrics. The design of Eskolin-Nurmesniemi's clothes was as radical as the patterning of her textiles. In her search for greater universality of appeal she eliminated traditional features such as tucks, darts and button-holes and replaced them with zippers and touch-and-close fasteners such as Velcro and press-studs (up until then only ever used on men's clothing) so as to make her garments more user-friendly and less physically restrictive. The first Marimekko show was held in Stockholm in 1957 and Eskolin-Nurmesniemi's ground-breaking designs were widely acclaimed by critics. The bright colours she used were especially appreciated in the United States and her clothes soon became highly fashionable there after Jacqueline Kennedy purchased a number of them. One of

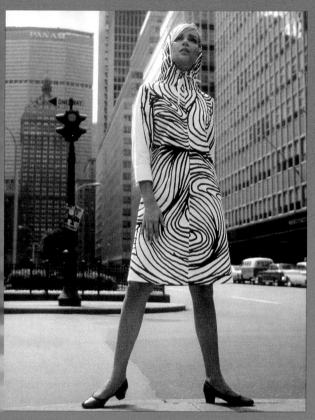

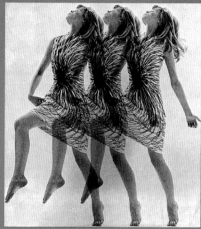

Eskolin-Nurmesniemi's best known designs, the *Jokapoika* shirt (1957) with its small yet colourful piccolo stripes is still in production after 45 years – a remarkable feat given the fickle nature of the world of fashion. Her clothes and textiles were favoured in particular by designers, architects and other creatives who preferred her unconventional look, which relied on structural essentialism rather than on gimmickry or showiness. In 1964, Eskolin-Nurmesniemi founded her own Helsinki-based company, Vuokko, and continued to create loose-fitting clothing that predicted the future work of designers such as Issey Miyake (b. 1938), who regards her as his "design mother". She has received numerous awards including the Lunning Prize (1964), the Finnish State Design Prize (1969), the Prince Eugen Medal (1986), and the Kaj Franck Prize (1997). In 1977 her printed cottons and jacquards were exhibited at New York's Metropolitan Museum of Art, and in 1988 she was made an Honorary Royal Designer in London. Throughout her career Vuokko Eskolin-Nurmesniemi has created trends rather than followed them. As one of the most successful Finnish designers of all time, her clothes and textiles helped define the unmistakable character of Finnish design.

◁△ Vuokko Eskolin-Nurmesniemi, *Hood* dress for Vuokko, 1966

△ Vuokko Eskolin-Nurmesniemi, *Pyörre* (Whirl) dress for Vuokko, 1965

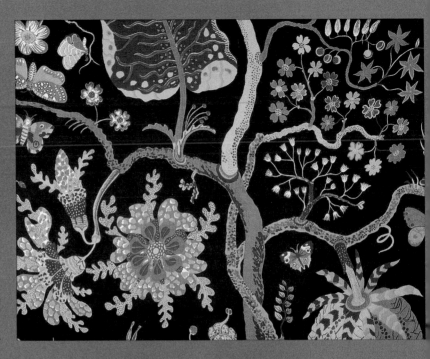

▷ Josef Frank, *Hawaii* textile
for Svenskt Tenn, 1943–1944

# josef frank *(b. 1885 Baden, Austria – d. 1967 Stockholm, Sweden)*

Austrian-born designer Josef Frank trained as an architect at the Technische Hochschule (Polytechnic) in Vienna (1903–1910). From 1919 to 1927 he was a professor at the Kunstgewerbeschule (School of Arts and Crafts) there. Between 1925 and 1934, he also ran a home furnishings business Haus & Garten with Oskar Wlach (1881–1963). As one of the most prominent architects in Austria, Frank designed for the Wiener Werkstätte and participated in the Deutscher Werkbund's landmark 1927 "Die Wohnung" exhibition in Stuttgart. His specially designed flat-roofed reinforced-concrete double house was extremely modern, but his furniture from the same period was Neo-Classical in tone and completely at odds with the Modernist functionalist aesthetic. In 1933 Frank began designing for the Swedish interior design company Svenskt Tenn. Two years later, he moved to Stockholm, became the firm's chief designer and adopted Swedish nationality in 1938. He designed numerous textiles and furniture for the company inspired by the 19th century British Arts & Crafts Movement and by turn-of-the-century Viennese design. Although he rejected functionalist ideology and viewed personal taste and comfort as the basis of domestic design, Frank's work was essentially modern, being distinguished by a purity of form. His furniture was remarkable for its harmonious proportions and high quality craftsmanship, as well as its practicality and comfort. From 1942 to 1944, he taught at the New School for Social Research in New York, and as a theorist wrote several books, including *Architektur als Symbol* (1930) and *Accidentism* (1958). He returned to Stockholm in 1946 and remained there until his death in 1967. His work enjoyed a revival in the 1980s and a number of his designs have remained in production with Svenskt Tenn. Like **Carl Malmsten** and **Bruno Mathsson**, Josef Frank is regarded as one of the three classicists of Swedish design. As an early pioneer of "the Scandinavian style", his contribution was immense, while his belief that, "the home does not have to be planned out in detail, just put together with pieces its inhabitants love" epitomized the Scandinavian distrust of dogmatic universalism such as that promoted at the Bauhaus.

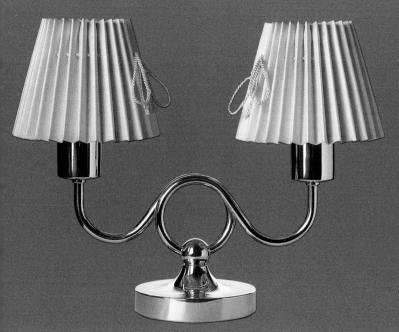

◁ Josef Frank, *Model no. B2483* table lamp for Svenskt Tenn, 1936

◁▽ Josef Frank, *Model no. 881* cabinet-on-stand for Svenskt Tenn, c. 1938

▽ Josef Frank, interior with mahogany chest-of-drawers and *Poisons* textile – both for Svenskt Tenn, c. 1943

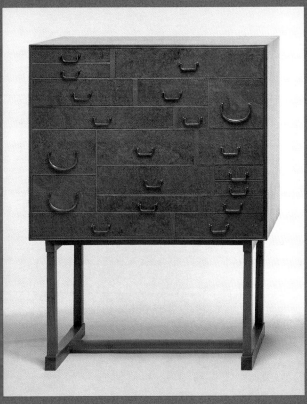

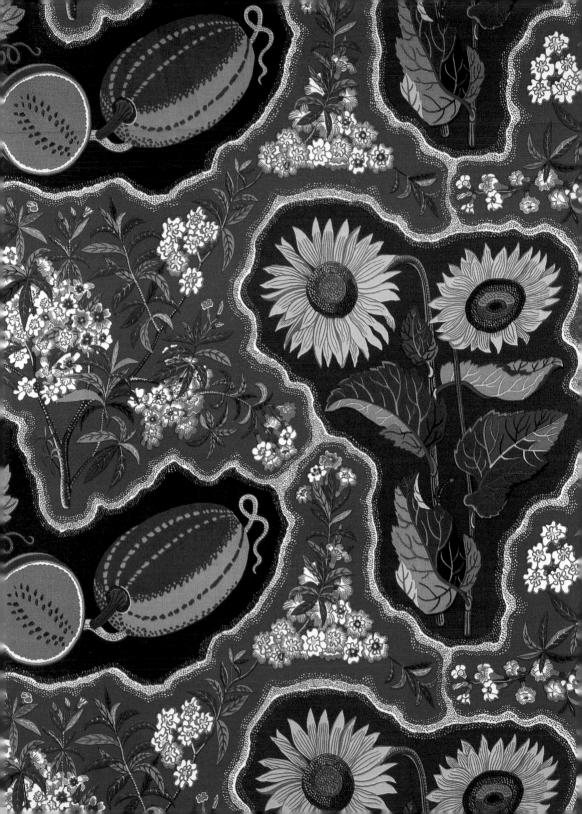

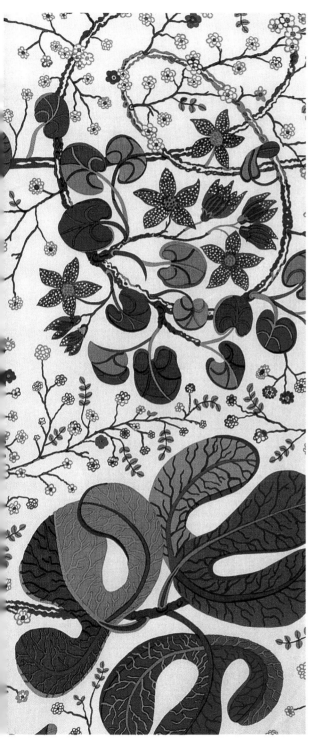

◁◁ Josef Frank, *Dixieland*
textile for Svenskt Tenn,
1943–1944

◁ Josef Frank, *Tehran*
textile for Svenskt Tenn,
c. 1943–1945

▽ Josef Frank, *Celotocaulis*
textile for Svenskt Tenn,
c. 1930

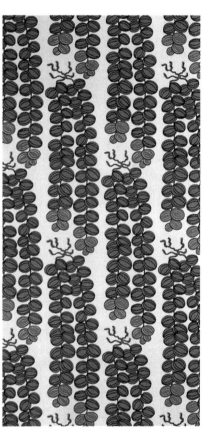

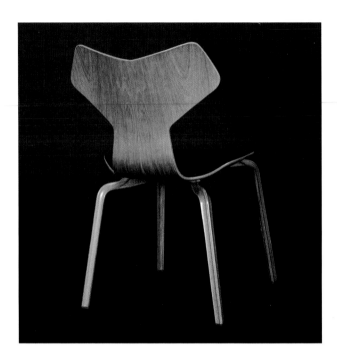

▷ Arne Jacobsen, *Model
no. 4130 Grand Prix* chair
for Fritz Hansen, 1955

# fritz hansen *(founded 1872 Copenhagen, Denmark)*

In 1872, Fritz Hansen established a cabinet-making workshop in Copenhagen that specialized in wood-turning and the manufacture of wooden and iron frames for upholstered furniture. In 1915, Fritz Hansen's son, Christian, introduced various industrial processes to enable the mass production of furniture. These new manufacturing techniques, which included wood bending processes that were similar to those developed earlier by Michael Thonet in Austria, allowed significant expansion of the company during the 1920s. In 1932, Christian's sons, Fritz and Søren, joined the firm and began modernizing its product line with designs such as Søren Hansen's *DAN* chair (1930) – a subtly updated Thonet-style cafe chair. One year later the company became involved in a legal dispute with Lorenz-Thonet over a chromed tubular-metal cantilever chair designed by the architect Mogens Lassen (1907–1987). This was one of many legal wrangles within the furniture industry over the ownership of the intellectual rights to the cantilever format. During the 1930s, Fritz Hansen also produced a large number of other Modernist-style designs in bentwood and tubular metal by architects such as Heilmann Sevaldsen, Fritz

Schlegel (1896–1965) and **Kaare Klint**. In the late 1940s, the firm began producing furniture designed by **Hans Wegner**, for example his *Chinese Chair No. 1* (1944), which was inspired by an antique Chinese chair illustrated in **Ole Wanscher**'s book, *Types of Furniture* (1932). Like other designs by Wegner, this chair was not a reproduction but an evolution of an existing type – a high-quality modern reworking that enhanced the chair's rationale for volume production. Other notable furniture that Fritz Hansen manufactured in the late 1940s included a beech armchair by Ove Boldt (a reinterpretation of the traditional *Windsor* chair), an upholstered beech chair designed by **Søren Hansen** (which anticipated the sculptural forms of **Arne Jacobsen**), and a beech sofa with collapsible side elements by **Børge Mogensen** (a modern reworking of an antique type). Fritz Hansen also developed and manufactured the landmark moulded-plywood *AX* chair (1950) designed by **Peter Hvidt** and **Orla Mølgaard-Nielsen**, an accomplishment that signified an important shift towards a more Modern idiom for the company. In 1951/52 Arne Jacobsen designed the stackable *Ant* chair for Fritz Hansen, which with its continu-

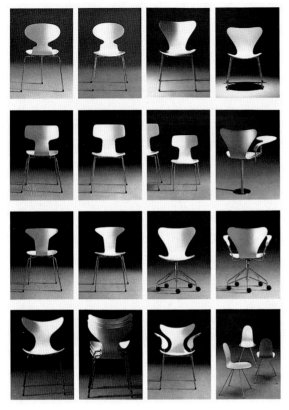

◁△ Arne Jacobsen, variants of the *Ant* and *Series* 7 seating ranges for Fritz Hansen, 1952–1968

△ Mogens Lassen, wicker and tubular steel chair for Fritz Hansen, 1933

ous moulded-plywood seat section and tubular metal leg construction was a masterpiece of simplification. With its pinched waist and curvaceous form, the *Ant* chair went on to become iconic of "The New Look" in the 1950s. This revolutionary design was followed in 1955 by the even more successful *Series* 7 range of chairs, which had a similar moulded-plywood, tubular metal construction that was eminently suited to high-volume industrial production. Later in the 1950s, Fritz Hansen began production of Arne Jacobsen's seminal *Swan* and *Egg* chairs (1958). These hugely popular designs not only predicted the space-age forms of the later 1960s, they were also among the first seat furniture to fully exploit the potential of latex foam as an upholstering material. Furniture designers who employed this new material benefited enormously from the freedom it granted them – latex foam-upholstered chairs did not require any springing so their forms could become much more sculptural while at the same time more visually unified. A decade after Fritz Hansen launched these chairs it commissioned **Piet Hein** and **Bruno Mathsson** to develop a group of tables that complemented Jacobsen's earlier *Ant* and *Series* 7

chairs. The form used for this range of tables (1968) was based on Hein's mathematical concept of the "superellipse" – a shape in-between a rectangle and an oval. In 1974, Fritz Hansen also began production of **Verner Panton**'s extraordinary *1. 2. 3.* series of chairs, which comprised twenty different models. Having remained a family concern for four generations, the firm was eventually acquired by the Skandinavisk Holding Company and its offices were moved from Copenhagen to Allerød. Today, Fritz Hansen continues to produce its classic designs by Arne Jacobsen and **Poul Kjærholm** alongside its more contemporary collections by, among others, Alfred Homann and Pelikan Design. Throughout its long and industrious history, Fritz Hansen has been one of the most prominent furniture manufacturing companies in Scandinavia, and as such it has contributed greatly to the promotion and acceptance of the simple yet elegant Scandinavian style throughout the world.

▷ Elmar Moltke Nielsen &
Knud Friis, *FM* chair for Fritz
Hansen, 1985

▽ Arne Jacobsen, *Model
no. 3107* chairs for Fritz
Hansen, 1955 – later made
available in a wide range of
colour finishes

▷▷ Poul Kjærholm, *PK9* chair
for Fritz Hansen, 1960

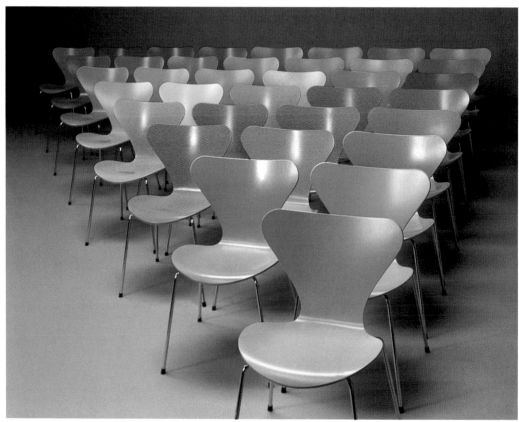

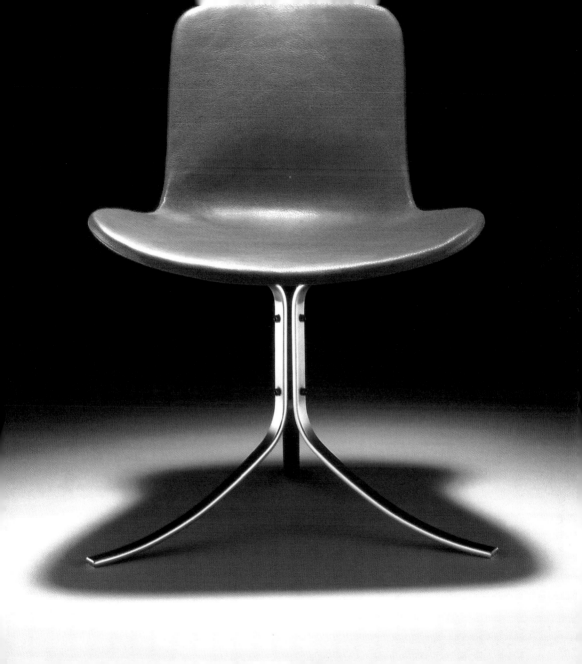

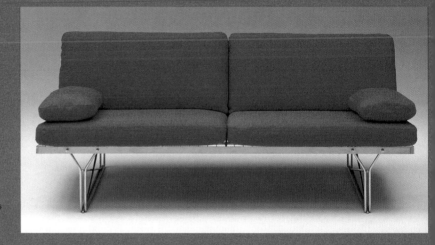

▷ Niels Gammelgaard,
*Moment* sofa for IKEA, 1985

▷▷ Niels Gammelgaard,
*Nevil* chair for IKEA, 1994

# niels gammelgaard

*(b. 1944 Copenhagen, Denmark)*

Niels Gammelgaard studied industrial design under Erik Herløw at the Kongelige Danske Kunstakademi (Royal Danish Academy of Fine Arts) in Copenhagen, graduating in 1970. In 1969, he co-founded Box 25 Architects, which undertook the design of Sofiegården College, Christianshavn in 1973, and the *Kvarterlygten* (Streetlight) for **Louis Poulsen** in 1976. After meeting Ingvar Kamprad, the founder of **IKEA**, Gammelgaard began designing products for the company in 1975. Since then, his furniture designs for IKEA, such as the *Ted* folding chair (1977) and *Moment* sofa (1985), have not only won numerous prizes, including eight Ütmarkt Awards and two Red Dot Awards, they have also been among the company's best-selling products. In 1978, Gammelgaard co-founded with Lars Mathiesen (b. 1950) Pelikan Design, a Copenhagen-based industrial design practice, which over the past 24 years has designed and seen into production literally hundreds of products ranging from small pencils to children's tricycles to hospital beds. Pelikan Design is best known, however, for the design of contract furniture – offices, waiting halls, rest areas – and can name many of the most prestigious Danish furniture

manufacturers among its clients, including **Fritz Hansen**, Bent Krogh, Fredericia, and Erik Jørgensen. Gammelgaard and Mathiesen view furniture as a fundamentally industrial product and so high-tech plastics tend to feature strongly in their repertoire of materials. Among the largest commissions Pelikan Design has received was the interior design of the Copenhagen city and suburban railway (1995), which won a Brunel Award in 1996. This project involved a radical space concept whereby asymmetrical bench seats were used to encourage passengers to move toward the windows in order to decrease congestion in the aisles. More recently, Pelikan Design was awarded the Danish Design Council's Annual Award in 1998 for the *Wing* screen wall (1993) and a Neocon Silver Award in 2000 for the *IQ* furniture series (1996). With its abiding mission to establish long-lasting relationships between its products and users, Pelikan Design remains at the very forefront of Scandinavian design practice.

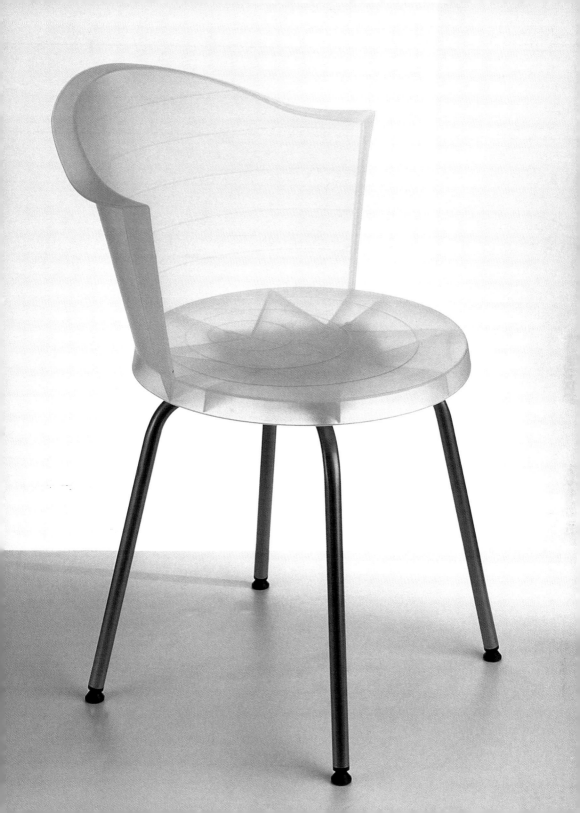

▷ Elsa Gullberg, *Fish* textile
hanging for Elsa Gullberg
Textilier, c. 1950

▷▷ Arthur Percy, *Spaljé*
(Trellis-work) screen-printed
rayon textile for Elsa Gullberg
Textilier, 1936 – Gullberg's
company also produced other
designers' textiles

# elsa gullberg *(Swedish 1886–1984)*

The Swedish textile designer Elsa Gullberg learnt the art of weaving at her family home in Scania. As a young woman she also practised carpentry, metalwork and printing prior to and during her studies at the Konstfackskolan (University College of Arts, Crafts and Design) in Stockholm. From around 1910 she began designing textiles that were intended for either traditional craft production or industrial manufacture. Aware of the design reforms advocated by the German Werkbund and well grounded in the tenets of functionalism, Gullberg was director of the testing and furniture design departments at the Svenska Slöjdföreningen (Swedish Society of Craft and Industrial Design) from 1907 to 1917. She later went on to head the Society's intermediary bureau from 1917 to 1924, where she gained first-hand experience of large-scale industrial production methods. She eventually established her own textile company known as AB Elsa Gullberg Textilier in 1927, which produced knotted hangings and carpets with rhythmic folk-style patterns. Around this time she also began experimenting with the weaving of synthetic silk-like materials, such as rayon, which led to her designing a checked upholstering textile (1930)

for Nordiska Kompaniet. In 1955, Gullberg handed over the running of her company to her daughter, Elsa-Maria Gullberg, but continued to design textiles and carpets, some of which were suitable for domestic weaving techniques. During her career she also produced a number of specially commissioned textiles, including those for the Stockholm Concert Hall, Gothenburg Town Hall, Malmö City Theatre, and King's College Chapel in Cambridge. Like fellow textile designer Märta Måås-Fjetterström (1873–1941), Elsa Gullberg played a major role in the revitalization of hand-weaving that took place in Sweden during the inter-war years; but more significantly she was also an important pioneer of textile design for industrial production. Whether produced by hand or in a factory, Gullberg's brightly coloured textiles reflected her unquestionable skill and knowledge of design and manufacture. Her company also produced a wide range of modern mix-and-match upholstering textiles, as well as tapestry hangings by other designers, such as Birgitta Graf, Arthur Carlsson Percy (1886–1976) and Einar Forseth (1892–1988).

▷ Frida Hansen, design for
*Poppy* tapestry, c. 1898

▷▷ Frida Hansen, *Summer
Night's Dream* tapestry hang-
ing, c. 1899

# frida hansen

*(b. 1855 Hillevåg-by-Stavanger – d. 1931 Oslo, Norway)*

The Norwegian textile designer Frida Hansen studied painting and then later established an embroidery workshop in Stavanger in 1882. During this period she became increasingly famil-iar with the Norwegian folk tradition of tapestry weaving – since the 18th century "peasant" weavers had produced tapestries depicting rela-tively primitive biblical scenes. These textiles, whose powerful artistic expression made up for all that they lacked in technical finesse, were gen-erally viewed in Norway as national art treasures. Inspired by these antecedents, Hansen began learning weaving techniques on a standing loom at Kjerstina Hauglum in Sogn, and in 1889 com-pleted her first woven tapestry. A year later she established her own textile studio, and then in 1892 moved to Oslo (then known as Christiania) where in 1899 she founded a weaving company under the name of Det Norske Billedvæveri (DNB). Initially she drew motifs from the ancient Norwegian sagas, but after a trip to Paris around 1885 she embraced the Art Nouveau style. From this period onwards, her tapestries were often adorned with "Mackintosh-style" roses and other highly stylized flowers with strong saturated

colours and bold swirling outlines. At the DNB workshop, Hansen not only revived the use of natural dyes and old weaving techniques, but also pioneered special new techniques including her famous "transparent weaving", which brought her widespread acclaim. This innovative process involved leaving some areas of the warp exposed so as to create a transparent background that contrasted dramatically with the richly coloured woven motifs. During the 1890s, Hansen collab-orated with fellow Norwegian designer **Gerhard Munthe** (who designed several tapestries for DNB), and in 1899 she wrote a book entitled *Husflid og Kunstindustri i Norge*. She exhibited her work at the 1893 "World's Columbian Expo-sition" in Chicago and also at the 1900 Paris "Exposition Universelle et Internationale", where she was awarded a gold medal. By the turn of the century, Frida Hansen was not only the most important Norwegian weaver, she had also be-come one of the greatest advocates of the natur-alistic Art Nouveau style in Scandinavia.

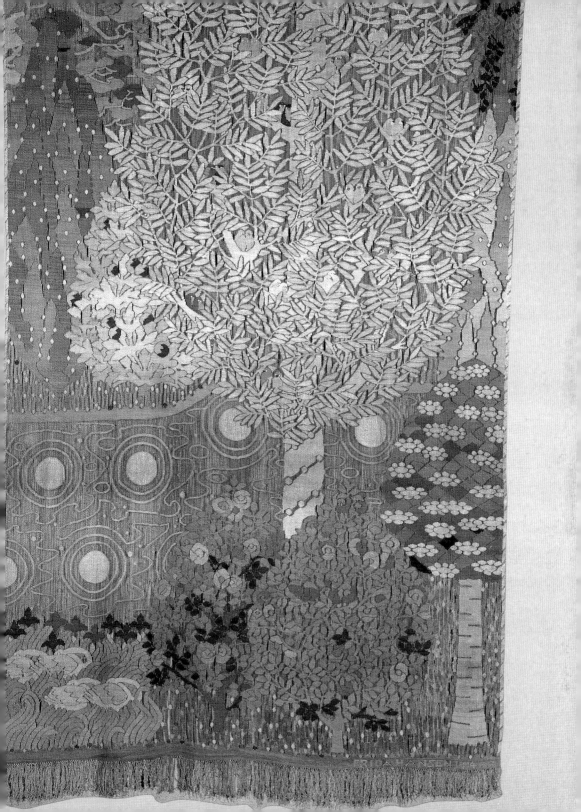

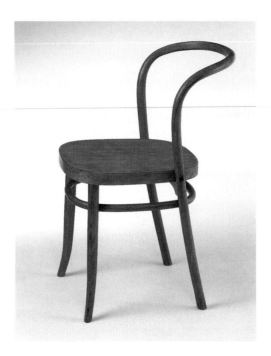

▷ Søren Hansen, *DAN* chair
for Fritz Hansen, c. 1930

# søren hansen *(Danish 1905–1977)*

After the First World War, the Danish manufacturer **Fritz Hansen** began experimenting with the production of bentwood furniture using techniques that had been pioneered at the turn-of-the-century by the Austrian designer and industrialist, Michael Thonet (1796–1871). Eventually, Søren Hansen (a descendent of the company's founder) and Fritz Schlegel (1896–1965) came up with some designs for the company, which after several attempts were successfully put into production. As Karl Mang noted in his publication, *History of Modern Furniture* (1979), Søren Hansen's bentwood *DAN* chair of 1930 was, "One of the few truly new ideas for the bentwood process, which was stagnating in terms of formal process." The chair's continuous bent-wood element, which incorporated both the back rest and rear legs was not only a technical masterpiece, but also provided the design with an elegant line that emphasized its structural essentialism. Both Hansen and Schlegel went on to design tubular metal Modernist-style furniture for Fritz Hansen, which was similar to that emanating from Germany at the time and which was shown at the 1932 "Den Permanente" exhibition. The same year, Søren Hansen officially joined the family firm

and designed a number of chairs for the company, including a painted beech upholstered armchair (c. 1949) that was notable for its curvaceous sculptural form. Like other leading Danish designers, Hansen's considerable skill and understanding of construction enabled him to re-invent and modernize existing furniture types, while balancing function and aesthetics so as to achieve optimum solutions for industrial manufacture.

◁ Production of a bentwood
element for the *DAN* chair,
c. 1930

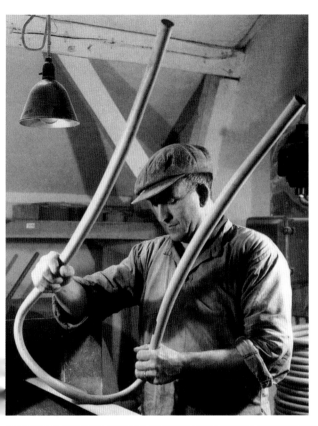

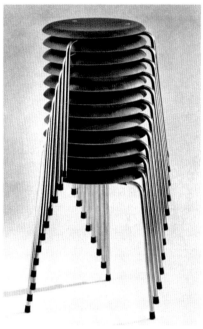

◁△ Søren Hansen, stacking
stools for Fritz Hansen, 1953

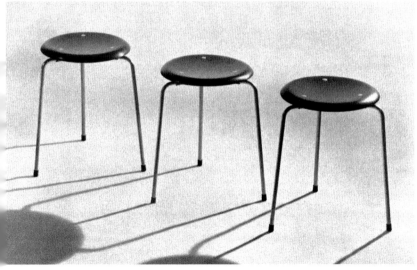

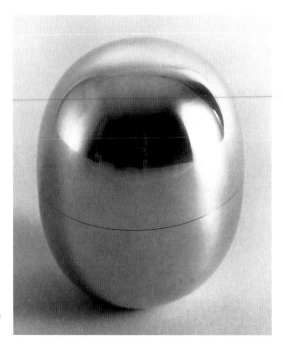

▷ Piet Hein, *Model no. 1147A Superegg* silver box for Georg Jensen, 1966

▷▷ Piet Hein, leather and steel bar stool for Fritz Hansen, 1961

# piet hein *(b. 1905 Copenhagen – d. 1996 Funen, Denmark)*

The Danish mathematician, author, inventor and designer Piet Hein studied at the Copenhagen University, Copenhagen, and the Kungliga Kunsthögskolan (Royal University College of Fine Arts), Stockholm. Throughout Scandinavia, he is best known for his thousands of epigrammatic poems, which he referred to as "grooks" and published under the pseudonym, "Kumbel". He also wrote extensively on the relationship between the arts and sciences. While working as a consultant on a town-planning project in 1959 that encompassed the design of Sergels Square in Stockholm, he devised the concept of the "superellipse" as a way of solving traffic problems. Halfway between an oval and a rectangle, the "superellipse" form was repeated in his product, lighting and furniture designs, such as the *Superegg* box (1966) for Georg Jensen and the *Superellipse* table (1964), which he co-designed with **Bruno Mathsson** for **Fritz Hansen**. For his achievements as an inventor and his work in the sciences Hein was awarded the Alexander Graham Bell Prize in 1968, and an honorary doctorate from Yale University in 1972. His pioneering work as a designer was also recognized when he was awarded the prestigious ID Prize and the German "Die gute Industrieform" Award in 1971. Hein's product designs can be seen as an outcome of the continuous search for the "ideal" form – a defining characteristic of much Scandinavian design. Unlike most other practitioners, however, Hein used mathematics as the basis of his solutions rather than historic precedent. He was a wry commentator on design, who summarized his definition of good design in a poem entitled *Form and Content*: "Most design is sheer disaster/hiding what one doesn't master. True design asks one thing of us/to uncover what it covers."

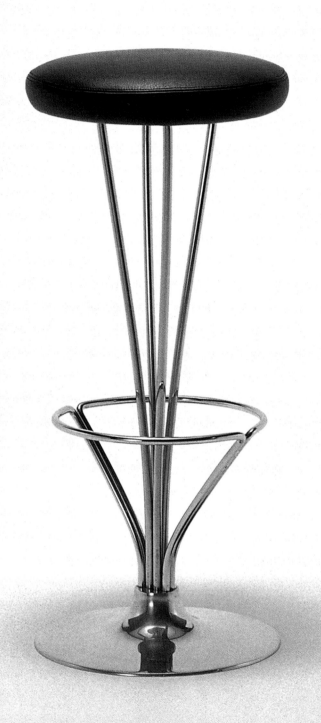

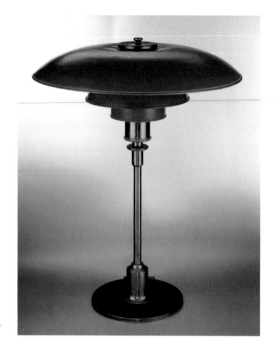

▷ Poul Henningsen, *PH* table
lamp for Louis Poulsen, 1927

# poul henningsen

*(b. 1894 Ordrup – d. 1967 Ordrup, Denmark)*

One of the greatest lighting designers of all time, Poul Henningsen studied building techniques at the Tekniske Højskole (School of Technology), Copenhagen, from 1911 to 1914, and then architecture at the Polyteknisk Læreanstalt (Polytechnic) from 1914 to 1917. While studying architecture he designed his first chandelier as part of an interior design project. After leaving the Polyteknisk, having not sat his final exam, Henningsen worked as a reviewer for the art journal *Vor Tid* and as co-editor of the art periodical *Klingen* from 1917 to 1921. He was also a journalist for the newspapers *Politiken* and *Extra Bladet* from 1921 to 1925. During this early part of his career he experimented with different materials such as copper and glass, and designed a number of light fixtures including a chandelier for the Carlsberg brewery in 1919. Three years later he exhibited a spherical light fitting with reflective planar rings at the "Artists' Autumn Exhibition", and designed the reflective *Slotsholm* street light for Copenhagen's municipal lighting department. As a left-wing radical who throughout his life agitated for social improvement, Henningsen used his column in *Politiken* as a platform for presenting his views on design – on

the need for better lighting he wrote: "The aim is, by working scientifically, to make lighting cleaner, more economical, and more beautiful." In 1924, he developed a series of multi-shaded table and hanging lights that were designed to reduce the dazzling glare of the modern electric bulb. The same year, he began designing lights for **Louis Poulsen** and the first lamp from his subsequent *PH* series was exhibited to great acclaim at the 1925 Paris "Exposition Internationale des Arts Décoratifs et Industriels Modernes", where he was awarded a gold medal. Henningsen's revolutionary *PH* series of hanging, wall, and table lamps were the result of many years of scientific study and fine-tuning. By using light diffusion graphs and reflection sketches he was able to develop a system of lights with alternately shaped and positioned shades that could direct light downward, provide good ambient light, and minimize the intensity of the reflected light and bulb – all at the same time. The logarithmic spiral configuration of the elegantly curved *PH* shades was reputedly inspired by a cup, bowl and plate stacked on top of one another. The *PH* lamps, which were designed for mass production and are still manufactured

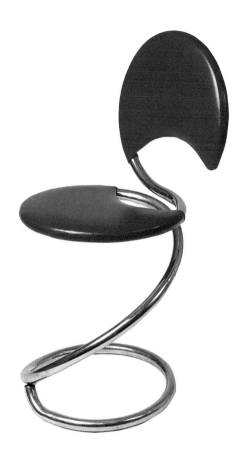

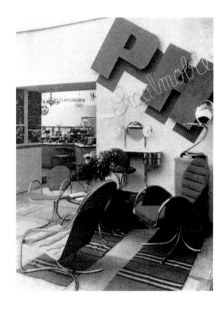

by Louis Poulsen, were widely exported through-
out Europe, North and South America, Africa and
Asia. Prior to the Second World War, they were
especially popular in Germany, where they were
featured in *Das Neue Frankfurt* magazine and
*Licht und Beleuchtung*, the Deutsche Werkbund's
architects' reference book on lighting. In the early
1930s Henningsen also designed furniture such
as his *Slangestolen* (Snake chair, 1932), which
was constructed of a single length of bent tubular
metal, for the Copenhagen-based manufacturers
V. A. Høffding. Throughout much of his life, Hen-
ningsen denounced what he saw as the artistic
pretensions of Scandinavian design and urged
for a more utilitarian approach that would bring
good design to the masses. Unlike the majority
of Modern Movement designers, however, Hen-
ningsen regarded traditional forms and materials
as eminently suitable for the manufacture of more
democratic products. On his death in 1967, he
left over one hundred lighting designs, some of
which have been issued posthumously.

△ ◁ Poul Henningsen, tubular
steel and red leather *Slange-
stolen* (Snake chair) for V. A.
Høffding, 1932

△ Tubular steel furniture
designed by Poul Henningsen
for V. A. Høffding on display
in Fredericia, 1932

▽ Poul Henningsen, *PH* piano lamp for Louis Poulsen, 1931

▽▽ Poul Henningsen standing next to his *PH* grand piano, for Andreas Christensen, c. 1931

▷▷ Poul Henningsen, *PH* grand piano, for Andreas Christensen, 1931

OVERLEAF
◁ Poul Henningsen, *PH* Artichoke lamp for Louis Poulsen, 1957

▷ Louis Poulson, modern version of the *4-shade* lamp by Poul Henningsen, 1980 – originally designed 1926–1927

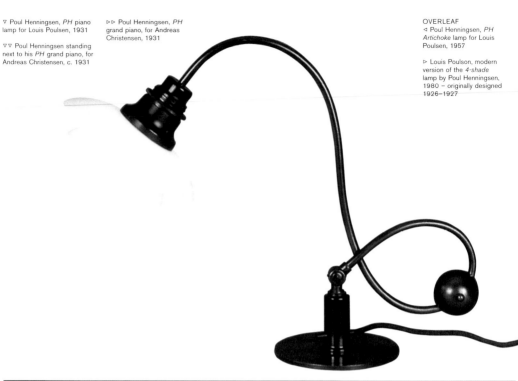

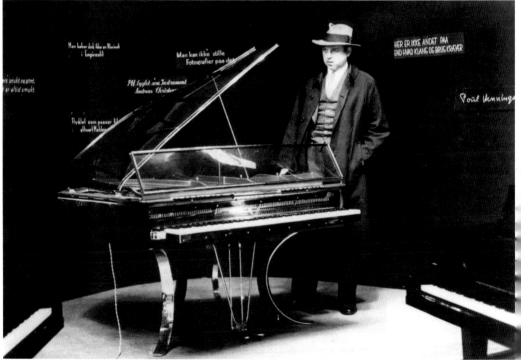

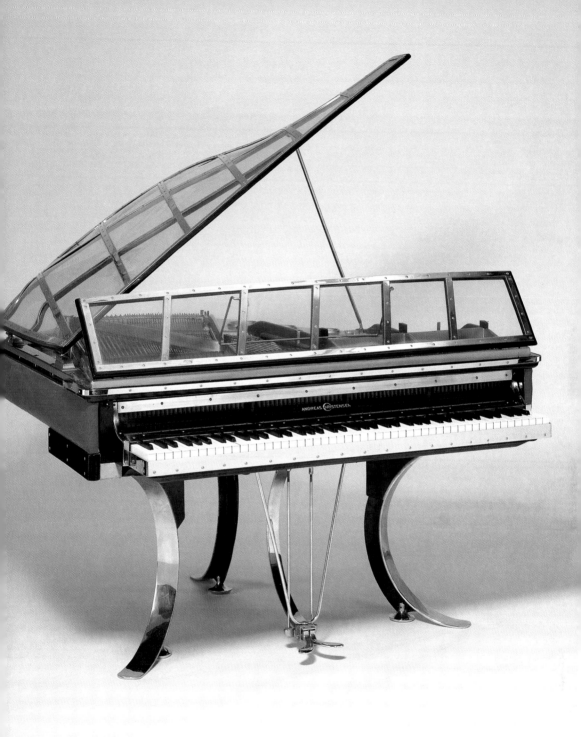

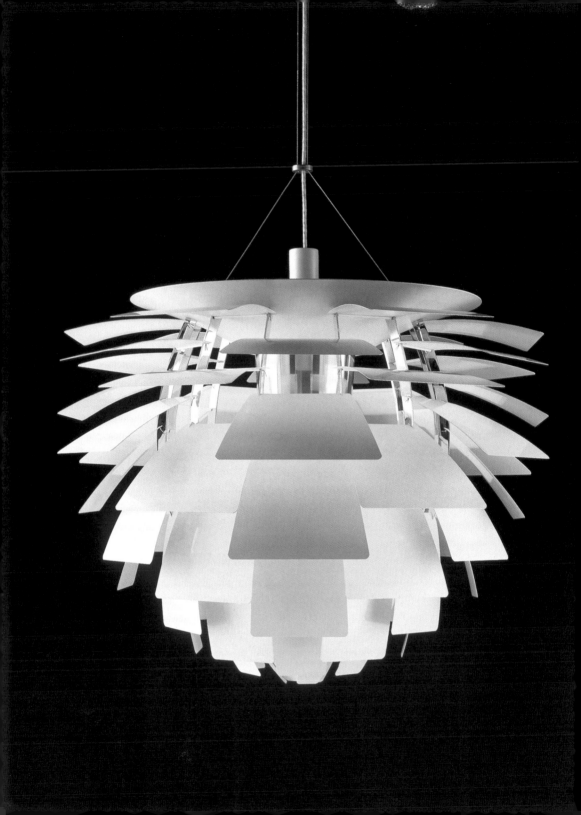

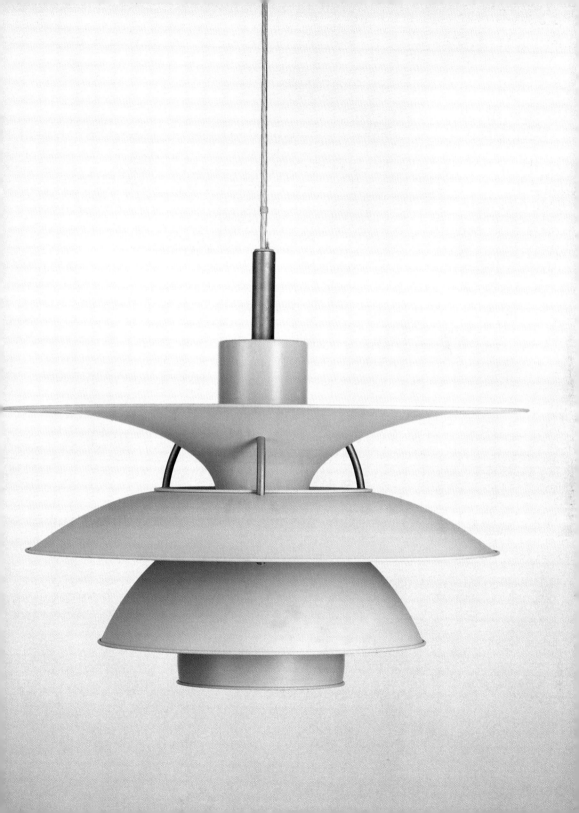

▷ Johan Huldt & Jan Dranger,
*Stuns* chair for Innovator
Design, 1973

# johan huldt & jan dranger

*(b. 1942 Stockholm, Sweden)*      *(b. 1941 Stockholm, Sweden)*

During the 1960s there was a commonly-held belief that group action was a more effective means of producing a result than going it alone – the espousal of this conviction resulted most dramatically in the anti-Vietnam war protests and student riots of 1968. The idea of organizing direct group action was also embraced by many young designers, especially in Sweden, a country that already had a long history of design collectives and manufacturing co-operatives. In the late 1960s, four students from the Konstfackskolan (University College of Arts, Crafts and Design) and Tekniska Skolan (Institute of Technology) in Stockholm, Johan Huldt, Jan Dranger, Martin Eiserman and Jan Ahlin, formed an alliance known as Dux4yra. Initially, they began developing experimental furniture made of plastics and paper. Following this, the group was invited to the factory of the Swedish furniture manufacturer Dux to conduct further experiments with tube bending machines. It seemed that bent tubular metal was the material best suited to their objectives: the realization of functional, affordable democratic furniture that comprised a "do-it-yourself" element. As Kerstin Wickman noted, "The American 'do-it-yourself' idea

had now taken hold and the intention was that it should be as easy to buy furniture as to buy food in the self-service store. This was the tone of the discussions during these years." After graduating in 1968, two of the group members – Johan Huldt and Jan Dranger – founded their own manufacturing company the following year. Known as Innovator Design, the venture came to international prominence when it exhibited the *Stuns* chair at the Cologne Furniture Fair in 1973. This highly functional tubular metal easy chair with a canvas sling and polyurethane upholstered cushions was startling for its simplicity and prefigured the new international style of High Tech. As a piece of knockdown furniture, the chair was sold in unassembled component form in a cardboard box so that it could be bought literally off the shelf. Interestingly, Johan Huldt grew up in his childhood home with an early example of Swedish knockdown design, the *Trivia* furniture range (1943) designed by Elias Svedberg and Erik Wørts, the latter of whom became one of the pioneers of flatpack furniture at **IKEA** during the 1950s. Huldt and Dranger's furniture, which was made available in five different colours – yellow, orange, green,

◁ Johan Huldt & Jan Dranger,
*Tech* trolley for Innovator
Design, late 1970s

▽ Johan Huldt & Jan Dranger,
*Slim* chair for Innovator
Design, 1982

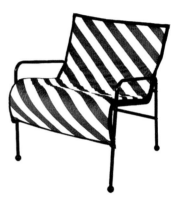

brown and black – and with chrome finishes, was especially well received in France, where it was retailed by Habitat and Roche Bobois. Colourful, cheap and easy-to-assemble, their *Innovator* range of chairs, tables and trolleys projected a youthful image that was unashamedly industrial. While countering the natural wood aesthetic so closely associated with Scandinavian design, Innovator Design furniture could be seen as a re-interpretation of 1930s Swedish Modernism, which was itself associated with experimental applications of industrial materials such as steel and glass. Huldt and Dranger's landmark furniture designs signalled a new internationalism in Scandinavian design and were retailed anonymously so as to counter the cult of designer-names that had gained enormous currency in the 1950s and 1960s. The furniture became so popular during the late 1970s and early 1980s that eventually Innovator Design production plants were established in four different countries and IKEA began retailing pieces from the range. In tribute to his far-reaching contribution to Scandinavian furniture design, Huldt was made director of the Swedish Furniture Research Unit (1974–1976) and in 1983 was appointed chairman of the

National Association of Swedish Interior Architects. He has also consulted to the United Nations and in 1994 was made director of Svenska Form – the Swedish design council. Having subsequently suffered much copyright infringement with *Innovator* furniture, Huldt became a leading campaigner against design plagiarism. Since the mid-1980s, Jan Dranger has collaborated with IKEA and has concentrated on sustainable design. In 1999 he received an Ecology Design Award (IF Hanover) for his inflatable *softAir* seating. Manufactured by News Design DFE, the *softAir* range includes a couch that uses 83% less resources than an upholstered version and takes 10% less space to transport and warehouse. Inexpensive, durable, and environmentally sound, this highly innovative furniture is available through IKEA.

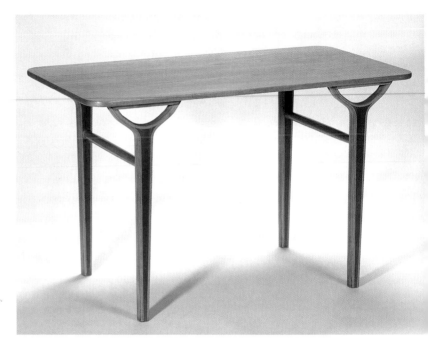

▷ Peter Hvidt & Orla Møl-
gaard-Nielsen, *AX* table for
Fritz Hansen, c. 1950

▷▷ Peter Hvidt & Orla Møl-
gaard-Nielsen, teak and paper-
cord armchair for Søborg
Møbelfabrik, c. 1956

▽ Peter Hvidt

# peter hvidt *(b. 1916 Copenhagen – d. 1986 Copenhagen, Denmark)*
# orla mølgaard-nielsen
*(b. 1907 Ålborg – d. 1993 Hellerup, Denmark)*

Orla Mølgaard-Nielsen apprenticed at the Nielsen Brother's workshop in Iborg and subsequently studied cabinetmaking at the Kunsthåndværker-skolen (School of Arts & Crafts), Copenhagen. He later trained under **Kaare Klint** in the furnishing and interior design department of the Kongelige Danske Kunstakademi (Royal Danish Academy of Fine Arts), Copenhagen. As one of Klint's students, Mølgaard-Nielsen was grounded in the relatively new science of anthropometrics – the systematic collection and correlation of measurements of the human body – and taught how to apply this data to his furniture designs so as to achieve better performance and more comfortable solutions. After completing his academic studies, he worked for a number of Danish architectural firms, including those headed by Kaare Klint, Helweg Moller, **Arne Jacobsen**, and Palle Suenson (1904–1987). Between 1944 and 1975, he worked in partnership with Peter Hvidt, who had similarly studied cabinetmaking at the Kunsthånd-værkerskolen, Copenhagen (graduated in 1940 and established his own design practice in 1942). One of the earliest fruits of this collaboration was the *Portex* chair (1944) – a teak design with an

innovative construction that was one of the first modern stacking chairs produced in Denmark, and one of the first Danish furniture products conceived for industrial manufacture. Manufactured by Foreningen for Møbelexport, the space-saving *Portex* chair was available with or without arms and with an optional upholstered seat cushion. Hvidt and Mølgaard-Nielsen also collaborated with the well-known Danish furniture manufacturing company **Fritz Hansen**, and this association led to the pioneering of a completely novel form of furniture construction known as "lamella-gluing" in which layers of beech wood were laminated onto a mahogany core – a technique similar to that used for wooden tennis rackets. The *AX* chair (1947) was the first Danish furniture product to employ this method of construction. Initially, the chair had a quilted leather-upholstered sling seat/back that was attached to its beech-veneered mahogany core frame, but the design was later modified so that it was better suited to industrial mass production – from 1950 it was manufactured with a teak and laminated beech frame with separate moulded teak-faced plywood seat and back elements. Although most often seen as an

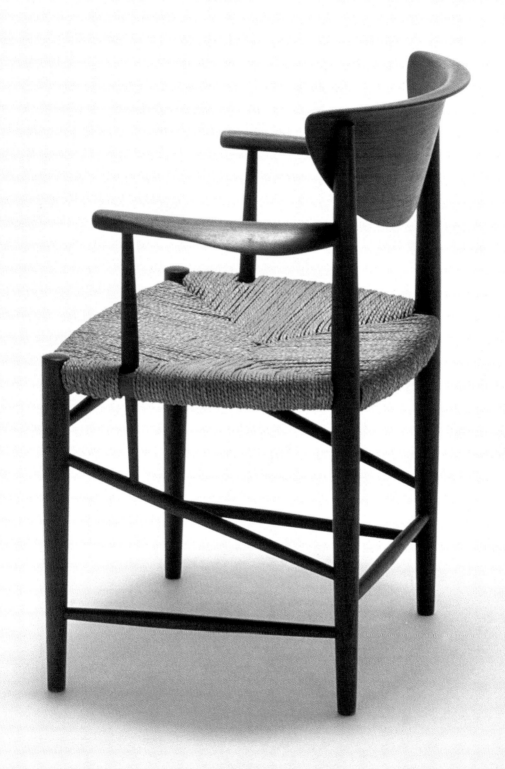

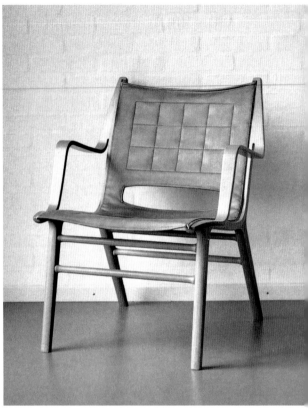

△ Peter Hvidt & Orla Møl-
gaard-Nielsen, unassembled
AX chair elements for Fritz
Hansen, c. 1950

△▷ Peter Hvidt & Orla Møl-
gaard-Nielsen, AX chair for
Fritz Hansen, 1947 – this early
version had a padded leather
sling seat/back section

▷▷ Peter Hvidt & Orla Møl-
gaard-Nielsen, AX chair for
Fritz Hansen, 1950 – the
mass-produced version

armchair, the AX chair was also available without
arms and with a single armrest. Tables were also
produced to match the range of chairs. Importantly,
the AX series could be sold in knockdown form,
which made the different pieces easy to transport
and relatively inexpensive to produce. As a result,
the AX armchair became one of the best-selling
chairs in Scandinavia during the 1950s. It was also
awarded a number of prizes, including diplomas
of honour at the 1951 (IX) and 1954 (X) Milan
Triennale exhibitions, and a Good Design Award
from the 1951 "Good Design" exhibition in Amer-
ica. During the 1950s, Hvidt and Mølgaard-Nielsen
also designed a number of "Teak Style" chairs for
France & Son and for Søborg Møbelfabrik, which
revealed the influence of **Finn Juhl**'s sculptural
furniture. Later in 1961 they developed the X
lounge chair for Fritz Hansen, which featured a
woven cane seat construction and utilized the
lamella-gluing process. The design of this chair
was adapted in 1977 to facilitate a quilted seat
section and to enable it to be linked into bench-
like configurations for waiting areas. From 1970,
Hvidt and Mølgaard-Nielsen also collaborated
with the designer Hans Kristensen. Through

their high-quality, democratic, and technically
innovative furniture designs, such as their hugely
successful AX chair, Peter Hvidt and Orla Møl-
gaard-Nielsen helped disseminate around the
world the casual yet modern Scandinavian look
that became so popular and influential during
the 1950s and 1960s.

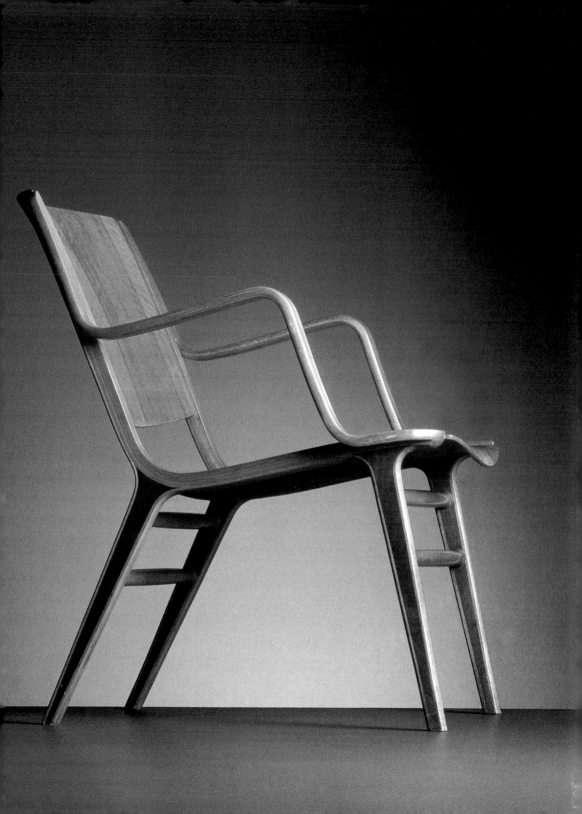

▷ First IKEA store, 1958

▽ Ingvar Kamprad, founder of IKEA

# ikea *(founded 1943 Älmhult, Sweden)*

No other company has promoted the concept of Scandinavian design more widely than IKEA, which for over 50 years has manufactured and retailed highly democratic products based on the trinity of "form, function and affordability". From its outset, IKEA espoused a particularly Swedish philosophy born out of the socialist belief that "people who are not well off should be given the same opportunities as people who are" – which in IKEA's case has meant the possession of well-designed yet inexpensive home furnishings. The origins of this extraordinary and now major international company can be traced to 1943, when the 17-year-old Ingvar Kamprad (b. 1926) established IKEA with a £150 loan from his father. Founded in the town of Älmhult, a few miles from Kamprad's home village, IKEA was situated in the Småland region, which had historically been one of the poorest areas in Sweden. The company originally sold a variety of products through mail order, from cattle soap to stockings. Later, during the early 1950s, IKEA began retailing furniture at factory prices through mail-order catalogues. This move was met with such resistance from the established furniture trade that IKEA was not allowed to exhibit at the

large furniture trade fair held in Stockholm, and suppliers threatened to boycott the company. Kamprad observed that "most nicely designed products were very, very expensive", yet he desired to manufacture well-designed practical products that the majority of people could afford. With this social mission to democratize design, Kamprad realized that there were three essential priorities – aesthetics, function and suitability for mass production. During the late 1950s, he recruited his first designers, Gillis Lundgren, Bengt Ruda and Erik Werts who, while working within the modern idiom, were designing furniture for self-assembly – a revolutionary development in domestic furniture design. The *Regal* bookshelf (1959) designed by Lundgren was one of the first IKEA products sold in flat-pack form. Another concept for the home IKEA's designers were developing at the time was "modular thinking", which involved the design of modular components and interlinking systems rather than individual one-off products. This led to the company's co-ordination of its product range and promotion of an integrated home furnishing look – an early and important example of lifestyle retailing. The advent of particleboard in the 1960s heralded

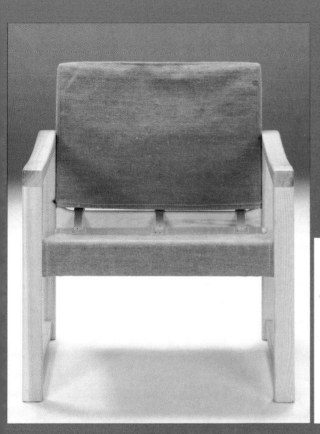

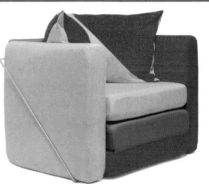

◁ Karin Mobring, *Diana* chair
for IKEA, 1972

▽ Jan Dranger, *Tärnaby* chair
for IKEA, 1900

▽▽ Cover of the first IKEA
catalogue, 1951

the arrival of really low-cost furniture and this influ-
enced IKEA's product line immensely. An inexpen-
sive yet relatively hard-wearing material, particle-
board was used extensively by IKEA for all kinds
of self-assembly furniture, as it still is today. While
the 1970s were a period of general insecurity,
IKEA prospered and expanded thanks to its policy
of producing inexpensive functional furniture with
a youthful appeal. During this time the company
developed several products made of plastic, in-
cluding the *Telegono* lamp (1970) designed by
the avant-garde Italian designer Vico Magistretti
(b. 1920). Throughout its history, however, IKEA
has mainly concentrated on producing interpreta-
tions of well-known classic designs – from the
ubiquitous Thonet café chair to the plastic *Poly-
prop* stacking chair by Robin Day (b. 1915). The
1970s were also the decade of stripped pine and
brightly coloured textiles, and IKEA developed this
informal look within its product range specifically
for younger consumers. The following decade,
IKEA began producing stylish yet practical furni-
ture designed by, among others, **Niels Gammel-
gaard** – whose *Moment* table (1987) won the
Excellent Swedish Design Award. Other award-

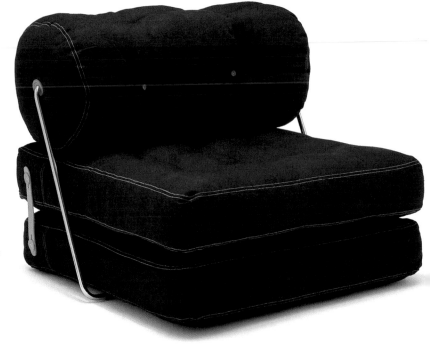

▷ Gillis Lundgren, *Tajt* chair for IKEA, 1973 – could be converted into a single bed

▽ ◁ Tord Björklund, Bogen table/trolley for IKEA, 1986

▽ ▷ Knut Hagberg & Marianne Hagberg, *Puzzel* children's furniture range for IKEA, 1988 – recipient of an Excellent Swedish Design Award in 1988

▷ ▷ Olle Gjerlöv-Knudsen & Torben Lind, *Skopa* chair for IKEA, 1974

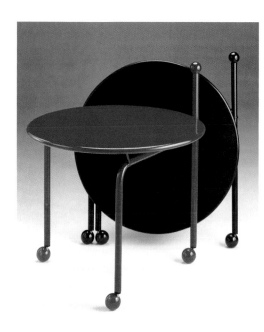

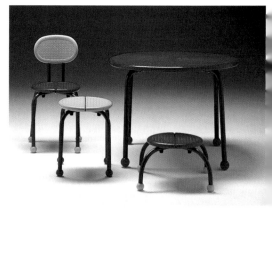

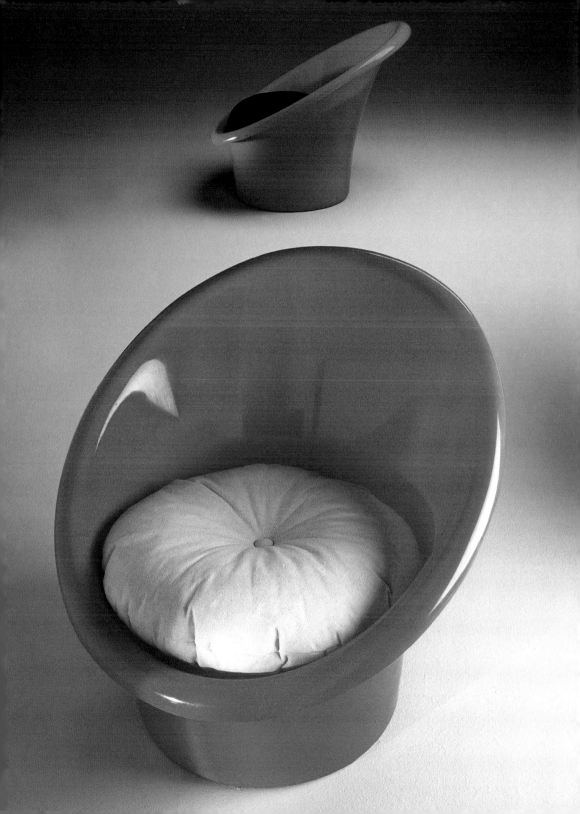

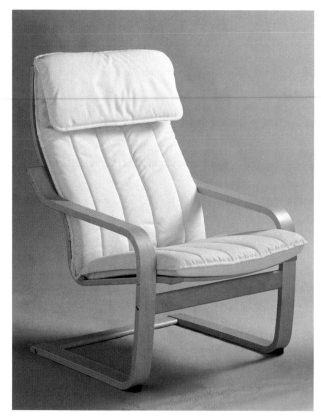

△ Noboru Nakamura, *Poem* chair for IKEA, 1977 – although designed by a Japanese designer this chair is "so strong, so blond, so typically Scandinavian that it remained in the IKEA range for years"

△▷ Cover of British IKEA catalogue, 1989

winning designs included the *Puzzel* range of children's furniture (1988) designed by Knut and Marianne Hagberg, which combined primary colours and simple forms and became a best-seller. Throughout the 1990s, IKEA continued to expand its international operations and popularize its version of Scandinavian Modernism. Today, the IKEA Group has 143 stores in 22 countries with a further 20 stores owned and operated by fran-chisees in 13 countries/territories. More than 2,000 suppliers in over 50 countries manufacture its 12,000 products. In 2001, the company's turnover was 11.3 billion Euro, while more than 255 million people visited its stores worldwide. Despite these impressive figures, Kamprad is not content with just producing home furnishing and plans to diversify his product line into small pre-fabricated flats. As the design theorist Victor Papanek wrote, "One thing is certain: IKEA will continue in the forefront – ecologically, socially and culturally – of making things that work, possess beauty and are affordable."

◁ Thomas Sandell, *PS-Serie*
wheeled storage unit for IKEA,
1995

▽◁ Morten Kjelstrup & Allan
Østgaard, *Mammut* child's
chair for IKEA, 1993

▽▷ Page from British 2002
IKEA catalogue showing best-
selling *Billy* shelving system
which was designed in-house
and first launched in 1978

## A best seller, in anyone's books

Clean design lines, high level versatility and low level prices have
kept BILLY at the top of the sales list for over twenty years.
Just look what you get for your money. Two different heights, two
widths, beech, birch or new medium brown ash veneer and a
range of finishes. Low doors or glass high doors, shelf inserts and
height extension units. For something novel, this year we've intro-
duced decor edging which you can just add to an existing Billy
bookcase. Functional, low cost design? We wrote the book at IKEA.

100

▷ Maija Isola, *Unikko* (Poppy)
textile for Marimekko, 1960

# maija isola *(b. 1927 Riihimäki – d. 2001 Finland)*

The Finnish textile designer Maija Isola studied painting at the Taideteollinen Korkeakoulu (University of Art and Design) in Helsinki from 1946 to 1949. Between 1949 and 1960, she was the principal designer for the Finnish textile firm Printex, which had been established by Viljo Ratia and was under the artistic directorship of Armi Ratia (1912–1979). During her time there, Isola designed numerous printed textiles for interior use that the company manufactured. From 1951, she also produced designs for Printex's sister company, **Marimekko**, which had been founded with the intention of promoting the use of Printex textiles in fashion and interior design. The inexpensive cotton sheeting used for Isola's designs was completely transformed by her bold abstracted patterns into elegant yet avant-garde textiles. Her designs for dress and furnishing fabrics for Marimekko, as well as her textiles for Printex, were included in the "Design in Scandinavia" exhibition that toured America and Canada from 1954 to 1957. In 1958, her work was included in the "Formes Scandinaves" exhibition in Paris and displayed at the Brussels' World's Fair. The following year, her textiles began to be retailed in the

United States, where they were admired for their startling originality. Isola's earliest designs were inspired by the African art she first saw on a trip to Norway in 1949. Initially, these were executed in brightly coloured crayons and later included hand-painted stripes in their patterns. By the mid-1950s, Isola was producing textiles decorated with floral motifs. She also designed fabrics influenced by Slovakian folk art in the late 1950s, and by traditional Karelian peasant motifs in the late 1960s and early 1970s. Many of her silk-screened textiles were translations of her own artwork. In the mid-1960s, she produced her most famous range of printed cotton textiles, which incorporated large-scale geometric patterns that were printed in strong flat colours. These bold designs such as *Kaivo* (1964), *Melooni* (1963), and *Cock and Hen* (1965), reflected contemporary artistic trends, most notably the influence of Colour Field painters in America. Isola's fabrics from this range had a strong graphic quality and came to epitomize not only Marimekko textiles but also a new direction in Finnish design. She received ID Prizes in 1965 and 1968, and during the later part of her life was partnered with Fujiwo Ishimoto (b. 1941), one of

...he few in-house designers working at Marimekko. ...sola's colour-saturated and elemental patterned ...abrics, which have been widely exhibited through- ...out Europe, America and Australia, have had an ...enormous influence on contemporary textile design.

△ Maija Isola, *Lokki* (Seagull) textile for Marimekko, 1961

◁ Maija Isola, *Melooni* (Melon) textile for Marimekko, 1963

◁ Maija Isola, *Kaivo* textile for Marimekko, 1964

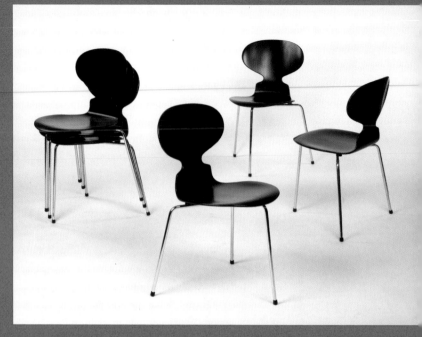

▷ Arne Jacobsen, set of *Model no. 3100 Myren* (Ant) chairs for Fritz Hansen, 1952

▷▷ Arne Jacobsen, *Model no. 3107 – Series 7* chair for Fritz Hansen, 1955

# arne jacobsen

*(b. 1902 Copenhagen – d. 1971 Copenhagen, Denmark)*

The most celebrated postwar Danish architect and designer, Arne Jacobsen initially trained as a mason at the Skolen for Brugskunst (School of Applied Arts), Copenhagen, from where he graduated in 1924. He went on to study architecture at the Kongelige Danske Kunstakademi (Royal Danish Academy of Fine Arts) Copenhagen and graduated in 1927. This combination of practical and artistic training enabled Jacobsen to later produce buildings, interiors, and many different types of product designs that elegantly balanced function with aesthetics. Following the completion of his studies, he worked as an assistant in the City Architect's Office (Paul Holsøe) in Copenhagen until 1929. While there, he designed a music pavilion, shelters, and entrance gates for Enghave Park in Copenhagen. His early work was influenced by Modernists such as Le Corbusier (1887–1965), **Erik Gunnar Asplund** and Ludwig Mies van der Rohe (1886–1969). Jacobsen became one of the first designers to introduce Modernism to Denmark through his projects such as the circular *House of the Future*, which featured all mod cons including a helicopter landing pad on the roof, and which he co-designed with Flemming Lassen (1902–1984) for the build-

ing and housing exhibition held by Copenhagen's Academic Architects' Association in 1929. For this project, Jacobsen also designed several pieces of tubular metal furniture that were aesthetically suited to their Modernist surroundings. Around 1930, he established his own design office in Hellerup and began practising independently as an architect and interior designer. One of his first important architectural commissions was the functionalist Rothenborg House, Ordrup (1930), which was conceived as a *Gesamtkunstwerk* (total work of art). Another important early project was the beach-fronted Bellavista apartment block with the adjoining Bellevue theatre and restaurant complex (1930–1934) in Copenhagen. The interior of the Bellevue Theatre was remarkable for its sweeping balcony and its wave-like rows of steam-bent plywood auditorium seats. In 1936, Jacobsen and Erik Møller (b. 1909) won a competition for the design of the Århus Town Hall (1937–1942), a scheme that was distinguished by soft flowing lines that not only revealed a decidedly humanistic approach to Modernism, but also predicted the bold organic forms of Jacobsen's later projects. Aside from his architectural work, from 1945 onwards Jacobsen

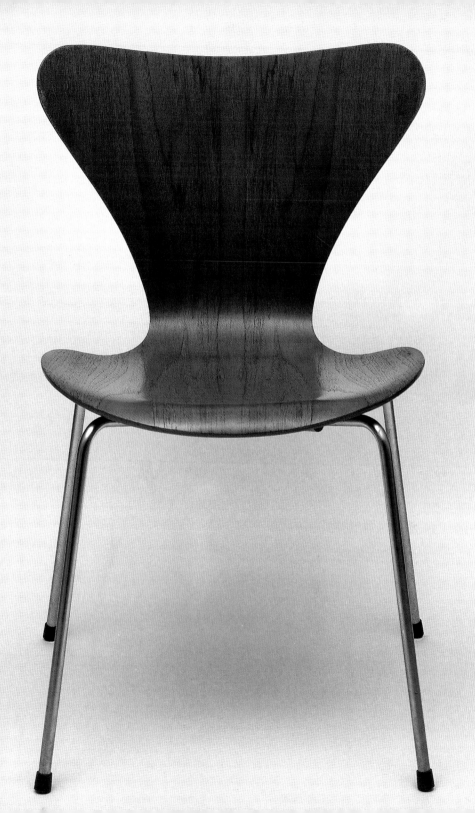

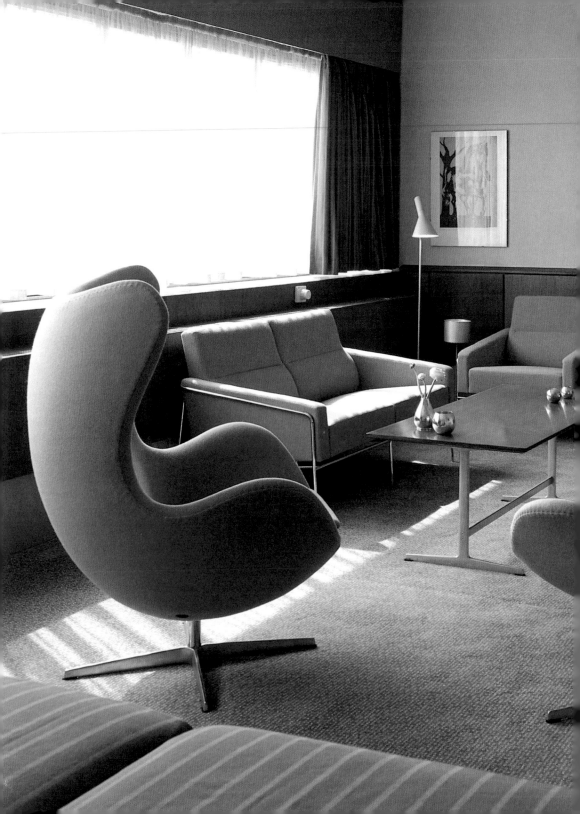

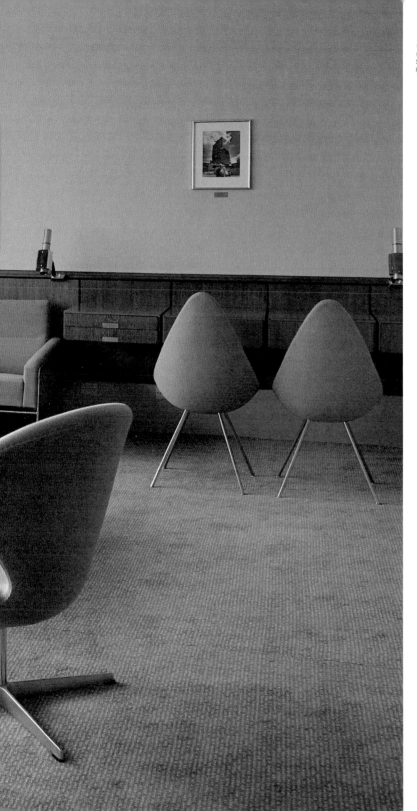

◁ Arne Jacobsen, Room 606 *(The Jacobsen Suite)* of the SAS Royal Hotel, Copenhagen, 1955–1960

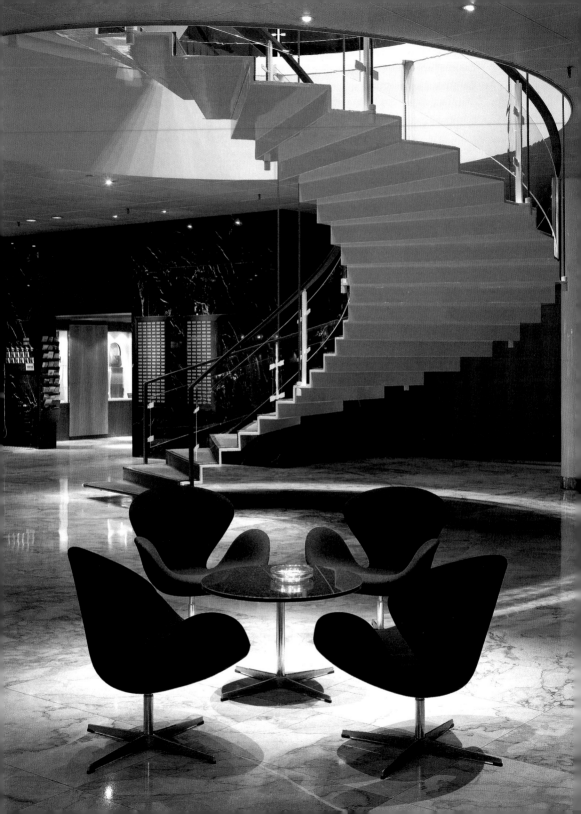

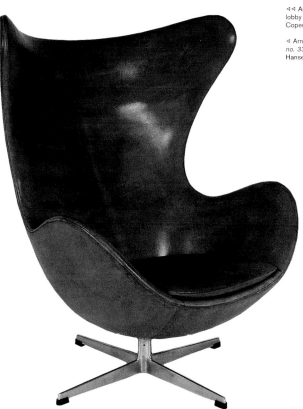

◁◁ Arne Jacobsen, entrance lobby of the SAS Royal Hotel, Copenhagen, 1955–1960

◁ Arne Jacobsen, *Model no. 3316 Egg* chair for Fritz Hansen, 1958

▽◁ Arne Jacobsen, *Giraffen* dining chair site-specific designed for the dining hall at the SAS Royal Hotel, 1958

▽▷ Arne Jacobsen, dining hall of the SAS Royal Hotel in Copenhagen with site-specific designed furniture and lighting, 1955–1960

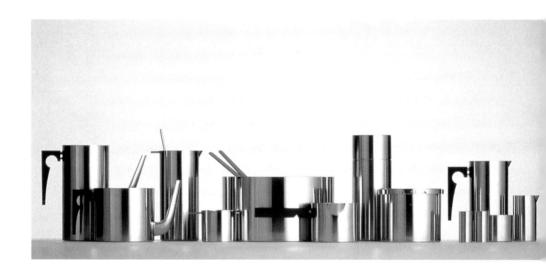

△ Arne Jacobsen, *Cylinda Line* stainless steel hollowware range for Stelton, 1967

▷ Arne Jacobsen, *Model no. 600 AJ* stainless steel flatware for A. Michelsen, 1957 – later produced by Georg Jensen

also designed furniture for industrial mass production. His greatest successes in this field were his *Ant* chairs (1951–1952) and *Series* 7 chairs (1955), both designed for **Fritz Hansen**. The latter range, which remains among the most commercially successful seating programmes ever produced, comprised a standard single-form compound-moulded plywood seat (with veneered or lacquered finish) onto which a wide range of options (different bases, arms and tablets) could be attached. Often Jacobsen's furniture and lighting designs were initially produced within the context of specific projects and then later put into serial production. For his most holistically integrated project, the SAS Air Terminal and Royal Hotel, Copenhagen (1956–1960), Jacobsen designed every detail from textiles and light fittings to cutlery and furniture. The interiors of the SAS Royal Hotel, for which the famous *Egg* and *Swan* chairs (1957–1958) were specifically designed, were extraordinary for their futuristic aesthetic. Apart from his furniture designs manufactured by Fritz Hansen, Jacobsen also designed the *AJ* range of lighting for **Louis Poulsen** (1955–1960), the *Cylinda Line* metalware collection for Stelton (1967), cutlery for

A. Michelsen, bathroom fittings for I. P. Lunds, and textiles for August Millech, Graucob Textilen and C. Olesen. From 1956 until 1965, he was a professor emeritus at the Skolen for Brugskunst in Copenhagen. During the 1960s, Jacobsen's most important architectural scheme was St. Catherine's College, Oxford – another wholly unified project for which he designed site-specific furniture (also manufactured by Fritz Hansen). Above all else, Jacobsen believed that it was essential for buildings and product designs to be well proportioned and that materials and colours should be compatible so that the optimum "overall impression" could be achieved. Jacobsen combined sculptural and organic forms with traditional Scandinavian design attributes – material and structural integrity – to produce elegant, essentialist and functional designs that have a remarkable, timeless appeal. He summed up his concern for the appearance of products by saying: "Pastry usually tastes best when it looks nice … there's nothing I mind if it looks nice."

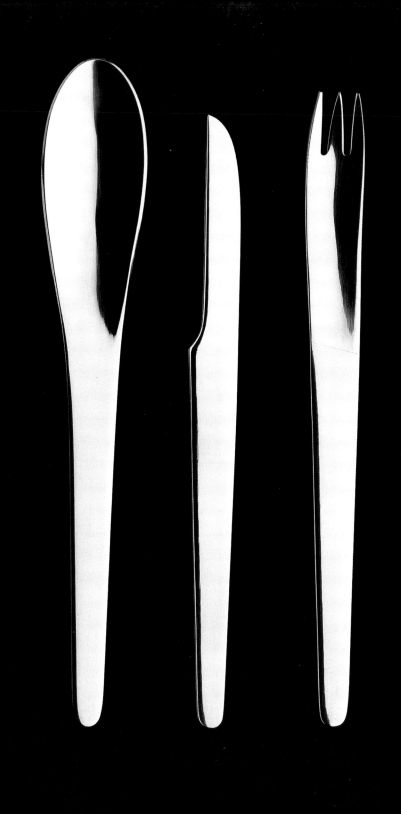

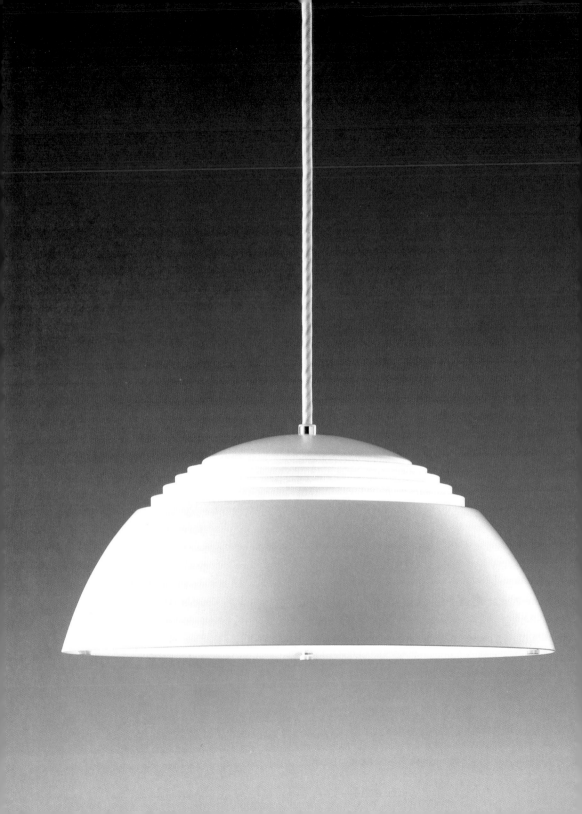

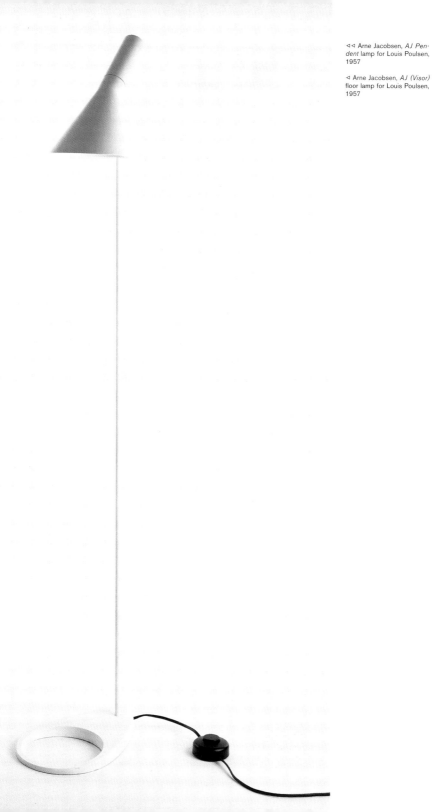

◁◁ Arne Jacobsen, *AJ Pendent* lamp for Louis Poulsen, 1957

◁ Arne Jacobsen, *AJ (Visor)* floor lamp for Louis Poulsen, 1957

▷ Jacob Jacobsen, *Luxo L-1*
task lamp for Luxo, 1937 –
an early example

▷▷ Jacob Jacobsen, chromed
Luxo *L-1* lamp for Luxo, 1937

# jacob jacobsen *(b. 1901 Oslo – d. 1996 Oslo, Norway)*

The Norwegian lighting designer Jacob Jacobsen was an engineer who initially trained in the textile manufacturing industry in England and Switzerland. In 1937, he acquired the Scandinavian production rights to the *Anglepoise* lamp (1934), which was designed by George Carwardine (1887–1948) and manufactured by Herbert Terry & Sons in Britain. During the same year, Jacobsen designed a variation of this lamp, the Luxo *L-1*, which incorporated a similar auto-balancing system of springs. As a talented entrepreneur, Jacobsen successfully commercialized his re-designed lamp, which had a more refined connection between the shade and stand and a softer aesthetic than Carwardine's. The lamp not only exemplified the influence of functionalism in Norwegian design during the 1930s, but also predicted the soft-edged aesthetic of postwar Scandinavian Modernism. Within a few years, Jacobsen also acquired the United States production rights to the *Anglepoise's* constant tension principle and during the 1940s he had a virtual monopoly on the sale of task lamps in both Europe and America. His manufacturing company, Luxo, continues to produce the classic *L-1* lamp, which is notable for the ease with which its arm

and shade can be articulated. There are several variations of the design, including one with an enlarged shade known as the *Panoramic*. The Luxo *L-1* has won numerous awards and is in the permanent collection of the Museum of Modern Art. Although Jacobsen's lamp has been widely imitated over the years, its technical performance has rarely been equalled. Norway's most notable contributions to our material culture have included the universally available paperclip and the humble yet useful cheese slicer – both forms of which were derived entirely through their function. Jacobsen's Luxo *L-1* shares a similar utilitarian vocabulary of form and functionality and as such has enjoyed enormous commercial success – over 25 million have been sold to date.

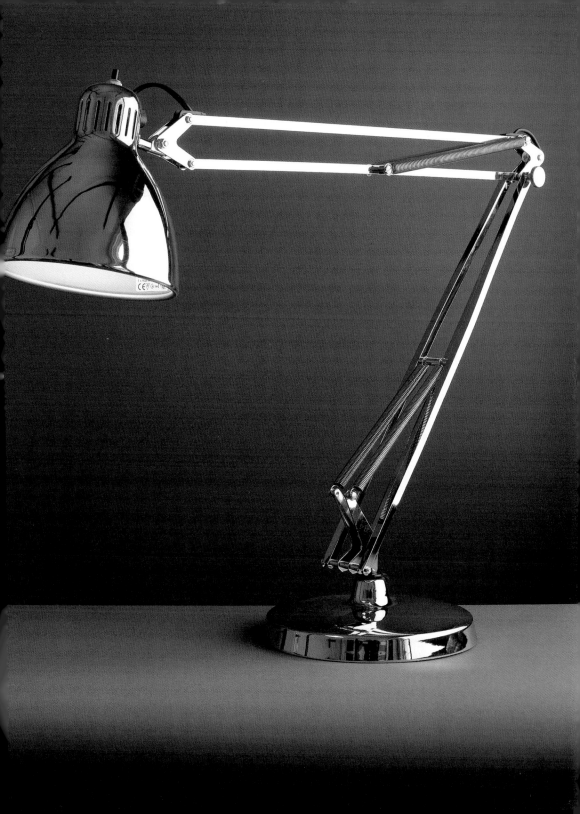

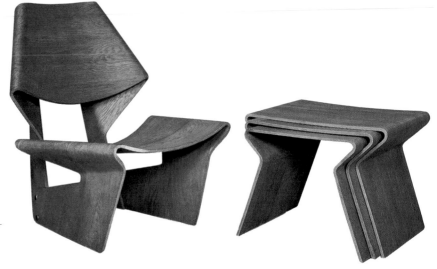

▷ Grete Jalk, teak-faced lam-
inated lounge chair and set
of tables for Poul Jeppesen,
1963

# grete jalk *(b. 1920 Copenhagen, Denmark)*

The Danish furniture designer Grete Jalk appren-
ticed as a joiner at the Kunsthåndværkerskolen
(School of Arts & Crafts), Copenhagen, from 1940
to 1943, and then trained as a furniture designer
under the guidance of **Kaare Klint** at the Konge-
lige Danske Kunstakademi (Royal Danish Academy
of Fine Arts), Copenhagen, from where she gradu-
ated in 1946. As one of Klint's students, Jalk would
have studied the "ideal" forms of historic furniture
types, such as the *Windsor* chair, undertaken
research into anthropometrics, and been taught to
combine traditional craft skills with rational design
principles. In 1946 she was awarded first prize in
the annual Cabinetmaker's Competition in Copen-
hagen and five years later her furniture designs
were exhibited at the 1951 (IX) Milan Triennale.
In 1953 she won the Georg Jensen competition,
and the following year established her own design
practice. As a prominent member of the Danish
design community, she was co-editor of the Danish
design journal *Mobilia* (1956–1962 & 1968–1974)
and received widespread recognition for her beau-
tifully designed furniture, which was produced
by Henning Jensen, **Fritz Hansen**, France & Son,
Søren Horn, and Poul Jeppesen. The majority of

Jalk's designs, such as her rosewood and leather
armchair of 1956 and her mahogany and leather
stool of 1961, were modern re-workings of tradi-
tional furniture types but were nonetheless notable
for their interesting "hidden" joins and subtle
curves. Her most celebrated design, however, the
two-piece moulded-plywood chair of 1963, had a
completely innovative form and speculated on the
possibility of industrial mass production. Though
beautiful and comfortable and awarded first prize
in a competition sponsored by the *Daily Mirror*
newspaper in the UK, the chair was never pro-
duced in large numbers. This perhaps had less to
do with the way the small radii of its curved sur-
faces led to the material and bending process
being pushed to the limit than with the fact that by
the mid-1960s plywood was beginning to fall out
of fashion with manufacturers. During the 1970s
and 1980s, Jalk was a member of the jury for the
prestigious ID Prize and organized several travel-
ling exhibitions for the Danish Ministry of Foreign
Affairs. As a leading commentator on Danish furni-
ture design, she also edited the book *Dansk
möbelkunst gennem 40 aar* (Fourty Years of
Danish Furniture Design), which was published in

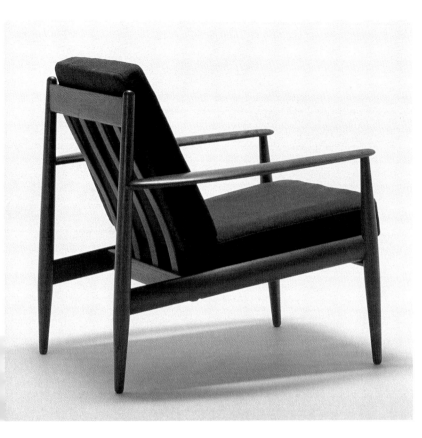

◁ Grete Jalk, rosewood and leather easy chair for France & Son, c. 1960

▽ Grete Jalk, *Watch and Listen* furniture group executed in Oregon pine by the cabinet-maker J. H. Johansen, 1963

1987. The pervasive ethos of social inclusiveness in Scandinavia has ensured that more women designers, such as Grete Jalk, have risen to prominence than elsewhere. This long tradition of gender equality perhaps also accounts for the particular focus within Scandinavian industrial design on products intended for the domestic environment, and the general disinterest in creating bravado design statements that have a high visual impact yet little practical function.

▷ Gocken Jobs, *Ros och Lilja* (Rose and Lily) textile for Jobs Workshop, 1946

▷▷ Gocken Jobs, *Gobelin* nursery hanging, c. 1950

OVERLEAF
◁ Lisbet Jobs, faïence bowl with flowers for Jobs Workshop, 1939

▷ Gocken Jobs, *Trollslända* (Dragonfly) textile manufactured by Jobs Workshop for Ljungbergs Textiltryck, 1945

# gocken jobs & lisbet jobs

*(Swedish 1914–1995)*   *(Swedish b. 1919–1961)*

From the late 1930s, the Jobs' family studio produced hand-printed textiles and hand-painted ceramics that epitomised the idea of Swedishness. Based in Leksand, the studio was located in the beautiful province of Dalarna – the mystic heart of Sweden, with its Falun-red houses and picturesque lakes. Here Lisbet Jobs-Söderlund decorated glazed earthenware plates and bowls with freely painted representations of wild flowers found in the surrounding countryside. These painterly designs had a spontaneity and liveliness that reflected the spiritual reverence for the natural world of Sweden, where the annual midsummer maypole festivals reveal the nation's almost paganistic love of nature. Lisbet's older sister, Gocken, also incorporated motifs of wild flowers – wild arum lilies, ferns, buttercups, dandelions, lilies-of-the-valley – and insects into her silk-screen printed textiles that embodied an unprepossessing informality and fresh originality. Certainly, Gocken Jobs' textiles were endowed with an enchanting lyricism and a delight in patterns – key distinguishing features of later Swedish textile design. Although many of Gocken's textiles were hand-printed in the family's studio, other designs,

such as *Trollslända* (Dragonfly) of 1945, were produced by Ljungbergs Textiltryck in Dala-Floda. Significantly, Gocken's richly detailed yet unpretentious floral textiles brought a touch of much-needed colour into Swedish interiors, which had been dominated by the subdued Gustavian palette of pale blues and grey-whites. One of Gocken's most interesting designs is a textile entitled *Gobelin* – a pun on her name and a reference to the famous Parisian tapestry factory. This design is essentially a celebration of Swedishness with its Gustavian-style furnishings and dancing girls – it even includes a depiction of the famous Dala wooden horse. Hand screen-printed in the Jobs' studio, the textile was presumably intended for nursery use. The almost child-like innocence of its design reflects the strong influence of Swedish folk art, and also refers to the cultural importance of children in Scandinavian society. Today the Jobs family still produce beautiful screen-printed textiles in their Leksand-based workshop.

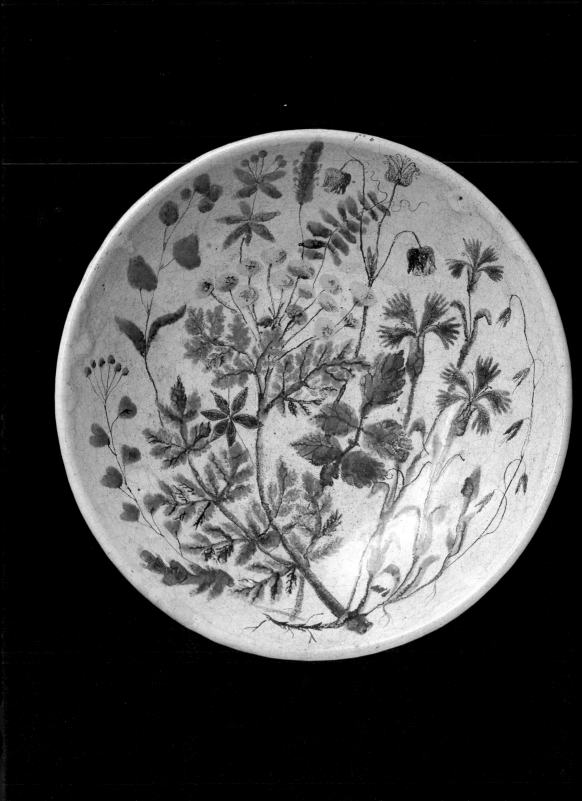

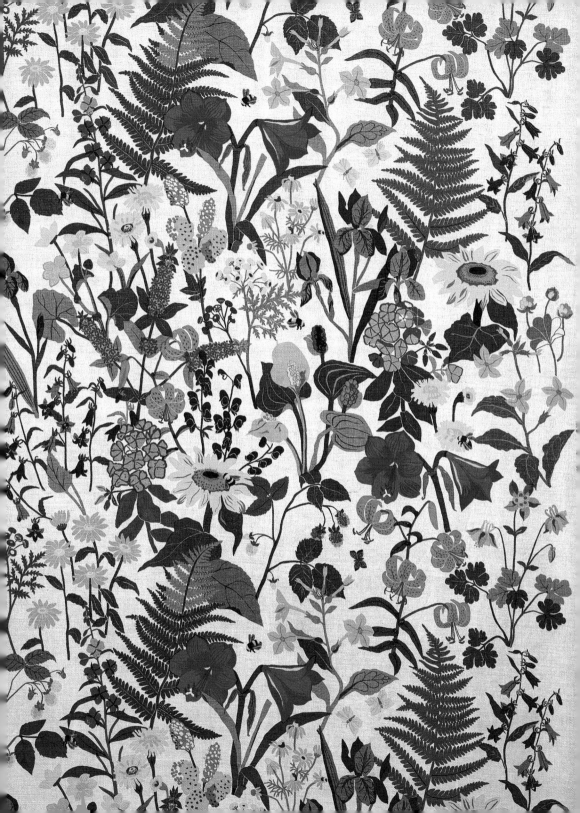

▷ Lisa Johansson-Pape, chair
for Stockmann, 1930–1933

▷▷ Lisa Johansson-Pape,
hanging lamp for Stockmann-
Orno, 1954

# lisa johansson-pape *(Finnish 1907–1989)*

The Finnish designer, Lisa Johansson-Pape, trained at the Taideteollinen Korkeakoulu (University of Art and Design), Helsinki, graduating in 1927. From 1928 to 1930 she designed furniture for Kymäkoski and from 1928 to 1937 she designed textiles for the FFH (Friends of Finnish Handicraft), becoming its artistic director in 1952. Johansson-Pape also worked as a furniture, textile and interior designer from 1937 to 1949 for the well-known Stockmann department store in Helsinki. Her furniture designs, such as the wood and lacquered armchair (c. 1935) upholstered in a textile designed with Greta Skogster-Lehtinen, were distinguished by graceful and simple forms that belied both the stability and strength of their constructions. From around 1947 onwards, she designed numerous electric light fittings for Stockmann's sister company, Stockmann-Orno, that were similarly rational in form and construction. These included her turquoise-enamelled sheet-metal hanging lamp of 1947, which was delicately pierced with holes that allowed the light to shine through, and her later more sculptural sandblasted and etched glass hanging lamp of 1954, which was produced by littala for Stockmann-Orno. In the mid-1950s,

Johansson-Pape designed a number of light fittings with enamelled aluminium shades that were sectioned in such a way as to diffuse the light as effectively as possible. Among these was the brass-coloured *Orno* pendant lamp (c. 1957), which stylistically predicted the more utilitarian approach to lighting design in Scandinavia during the 1970s. Her revolutionary metal and acrylic lighting designs were awarded medals at the 1951 (IX), 1954 (X) and 1960 (XII) Milan Triennale exhibitions, and their influence on later lighting designers can not be understated. As Johansson-Pape noted, "When we started out, there was just wood, yarn and clay, but soon there was a flood of materials … Industry gave us unlimited scope for experimentation with different colours and materials." In common with many Finnish designers, Johansson-Pape enjoyed exploring the formal potential offered by new materials and industrial techniques, while developing simple yet striking forms that were very graphic in outline.

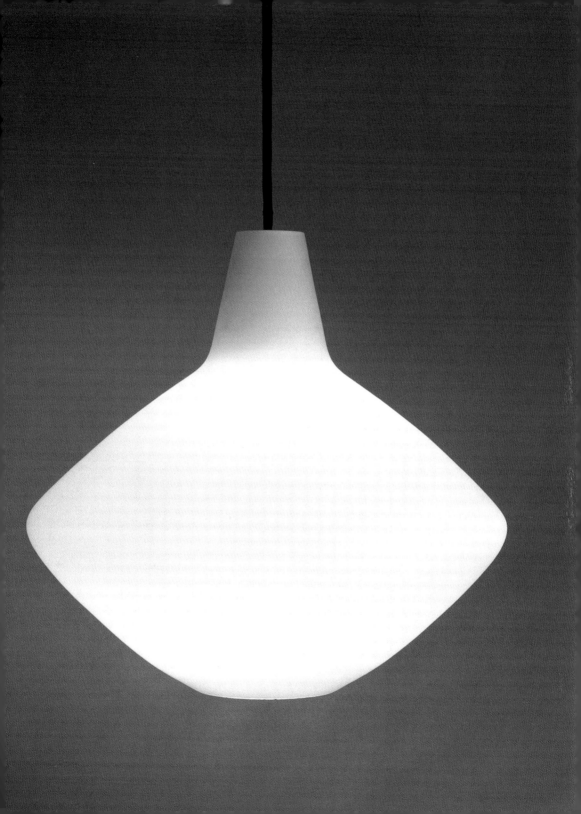

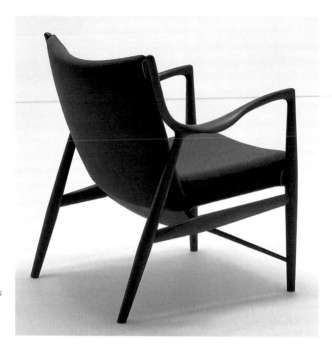

▷ Finn Juhl, *Model no. NV-45* easy chair for Niels Vodder, 1945 – this elegant design was offered in a variety of woods: rosewood, mahogany, teak and walnut

# finn juhl *(b. 1912 Copenhagen – d. 1989 Copenhagen, Denmark)*

When he was eighteen years old, Finn Juhl visited the landmark 1930 Stockholm exhibition and was greatly impressed by the steel and glass buildings designed by the grand master of Swedish Modernism, **Erik Gunnar Asplund**. That same year, he enrolled at the Kongelige Danske Kunstakademi (Royal Danish Academy of Fine Arts), Copenhagen, where he studied architecture under Kay Fisker, who was renowned for his riveting lectures. In 1934, Juhl began working as an architect in the office of Vilhelm Lauritzen (1894–1984), who was also a prominent teacher at the academy. Although originally intended as only a summer job, Juhl remained in Lauritzen's office for eleven years and never actually graduated from the academy. He was, however, accepted as a member of the Federation of Danish Architects in 1942. During this period, he also designed several pieces of furniture that were first shown at the 1937 Copenhagen Cabinetmakers Guild exhibition. Many of his pieces, which were designed in collaboration with the master cabinetmaker Niels Vodder, were remarkable for the sheer virtuosity of their construction. Juhl's furniture, such as the *Pelican* chair (1940), differed significantly from

the modern re-workings of traditional furniture types, such as those promoted by Kaare Klint and his followers, and signalled a new and important direction in Danish design towards more sculptural and abstracted organic forms. In 1945, Juhl set up his own practice and began designing solid wood chairs, tables and sofas within this visually seductive vocabulary of form, the results of which brought him much acclaim – he was awarded six gold medals at Milan Triennale exhibitions and fourteen prizes by the Copenhagen Cabinetmakers Guild. His work, such as the *No. 45* chair (1945), the *No. 48* chair (1948) and the famous *Chieftain* chair (1949), was distinguished by superlative craftsmanship and highly expressive, almost floating forms. Some of the elements of his furniture, such as the back of the *Model no. 48* chair, reflected the influence of contemporary abstract sculptors such as Alexander Calder (1898–1976) and Hans Arp (1887–1966). Juhl also developed numerous constructional techniques specifically for the use of teak, which led to the material's widespread use in Danish furniture design and ushered in what became known as the "Teak Style". From 1945,

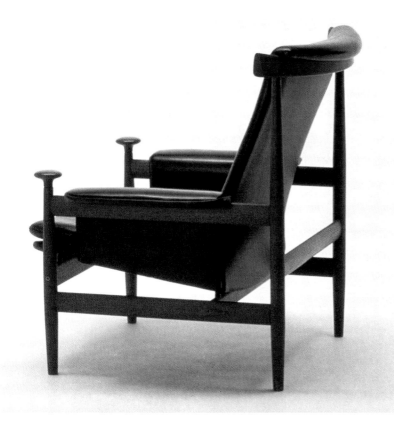

△ Finn Juhl, *Model no. 152 Bwana* easy chair for France & Son, c. 1962

▽ Finn Juhl, upholstered sofa for Niels Vodder, 1939 – a very early example of the use of sculptural organic forms in Danish furniture design

OVERLEAF
◁ Finn Juhl, *Model no. NV-44* armchair for Niels Vodder, 1944

▷ Finn Juhl, *Model no. NV-48* armchair for Niels Vodder, 1948

Juhl was the senior instructor at the School of Interior Design in Copenhagen and in this position he played a key role in influencing the course of Danish design. Juhl's exclusive, mainly handcraft-ed furniture was adapted for large-scale man-facture in America by Baker Furniture in the early 1950s. Beyond furniture, however, Juhl also de-signed exhibitions, interiors, wooden bowls for the firm of Kay Bojesen, appliances for General Electric, carpets for Unika-Væv, ceramics for Bing & Grøndahl, and glassware for Georg Jensen. Described by the architectural critic Henrik Sten Moller as "the out-and-out dandy", Finn Juhl exerted much influence on the following generation of Scandinavian designers with his use of bold sculptural forms and ultra-refined detailing.

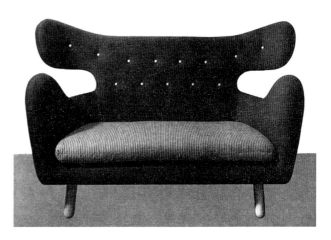

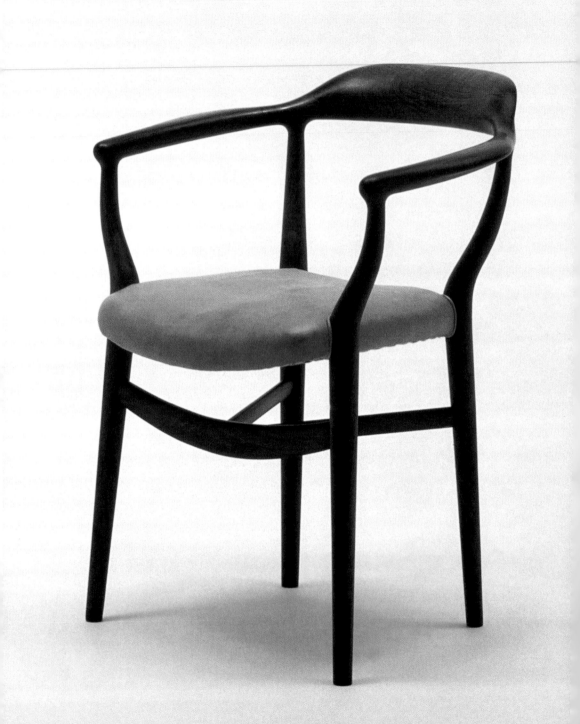

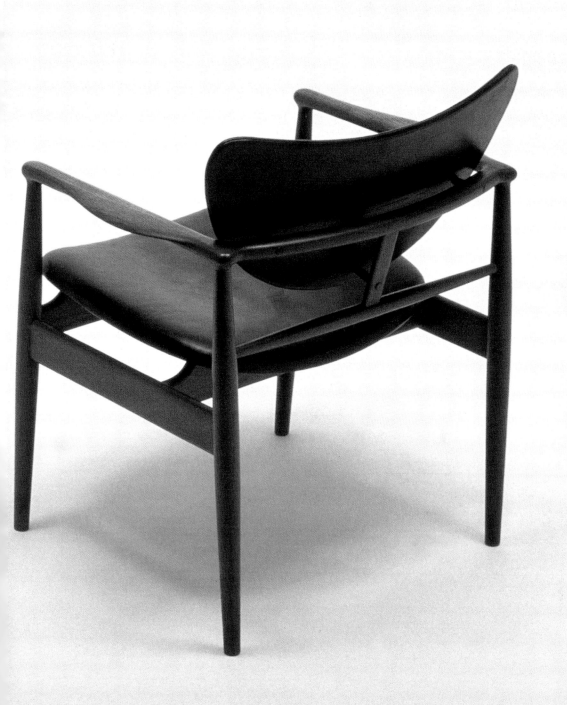

▷ Finn Juhl, rosewood table
for Niels Vodder, c. 1950

▽ Finn Juhl, teak bowl for Kay
Bojesen Workshop, 1950

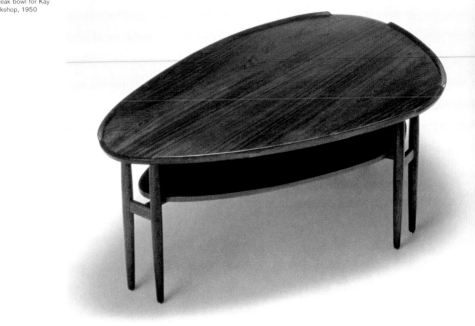

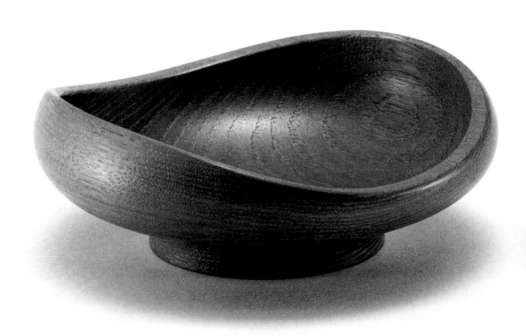

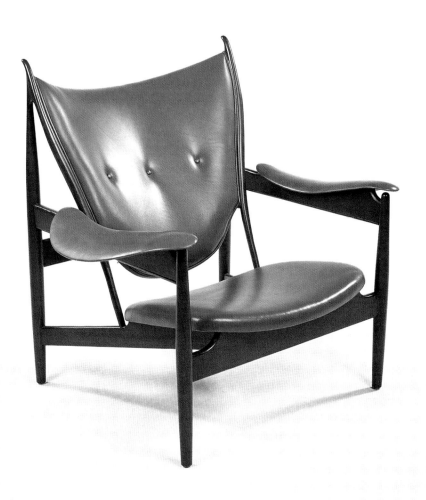

▽ Finn Juhl, *Pelican* chair for
Niels Vodder, 1940

▽▽ Finn Juhl, chair design for
Niels Vodder, 1955

▷ Finn Juhl, design for a dining
chair (produced by Niels
Vodder) and teak and Oregon
pine sideboard, c. 1953

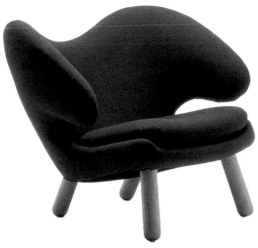

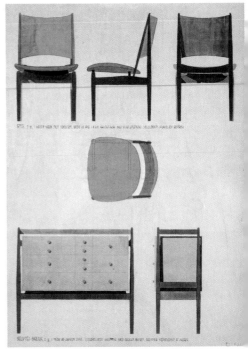

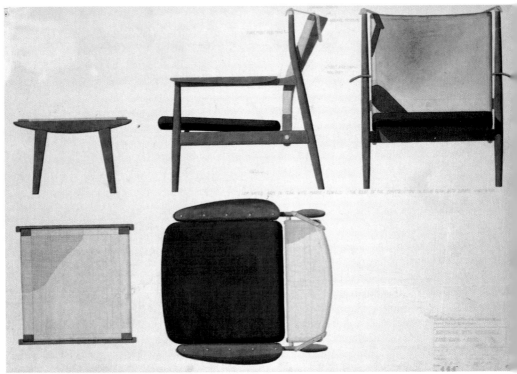

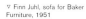

∇ Finn Juhl, sofa for Baker
Furniture, 1951

∇∇ Finn Juhl, sofa design for
Baker Furniture, c. 1951

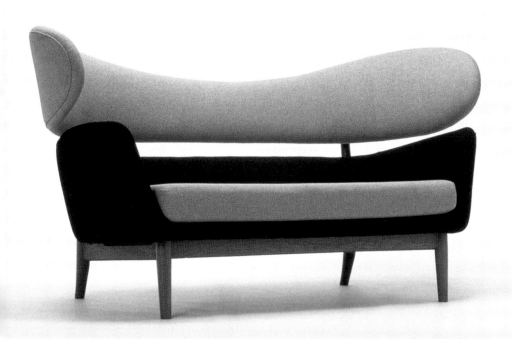

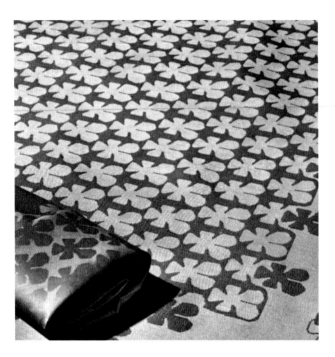

▷ Dora Jung, *Viol* damask
tablecloth for Tampella,
c. 1968

# dora jung *(b. 1906 Helsinki – d. 1980 Helsinki, Finland)*

The Finnish textile designer Dora Jung trained
at the Taideteollinen Korkeakoulu (University of Art
and Design), Helsinki, and later in 1932, estab-
lished her own studio in Helsinki. In 1951 she
exhibited her textile designs at the IX Milan Trien-
nale, where she was awarded a Grand Prix. She
became especially well known for her work in
woven damask – a material that had long been
associated with naturalistic flower patterns, espe-
cially chrysanthemums. Jung, however, preferred
the use of abstracted and stylized floral motifs
and subtle geometric patterns while employing a
restricted range of earth tones – olive, copper,
grey, dusky yellow and natural white. Her well-
known *Hundred Roses* textile, for instance, incor-
porated an informal yet dense scattering of Charles
Rennie Mackintosh-style roses over its entire sur-
face, which produced a completely new and con-
temporary aesthetic for woven damask. In 1957,
she was awarded a Grand Prix at the XI Milan
Triennale for her damask design known as *Linen
Play*, which with its strong geometric patterning
of intersecting "hand-drawn" lines signalled a new
and more casual approach to the design of table
linen. While Jung's table linens were mass prod-

uced by Tampella of Finland, she also became
renowned for her one-off wall hangings and
church textiles, which highlighted her mastery of
complicated weaving techniques. She also occa-
sionally used to dramatic effect a technique known
in Norway as *smettevev*, which combined coarse
damask weaving with areas of hand-stitched
colour. For her tapestries Jung would also use the
weft to produce an almost three-dimensional effec
She often developed her own weaving techniques
which gave her, as Eileene Harrison Beer noted,
"the deepest possible insight into her craft" and
ensured that her textiles achieved the highest leve
of artistic and manufacturing excellence. She also
experimented with unusual materials – some of
her upholstering fabrics, for example, were woven
from threads of paper. Jung's innovative textiles
exemplified the high technical standards common
to both the handicrafts and serial production in
Scandinavia, while her simple abstracted patterns
typified the bold graphic quality that is so charac-
teristic of Finnish textile design.

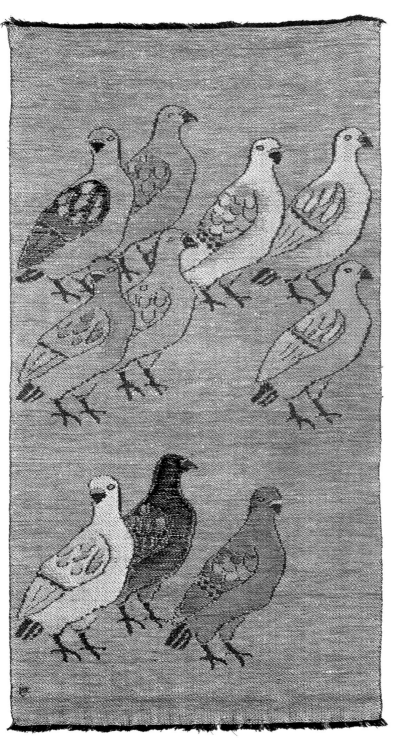

◁ Dora Jung, *Kyyhkysiä* (Doves) woven hanging executed by the Dora Jung Studio, 1951

▷ Mats Theselius, *Chaise Longue* for Källemo, 1992 – limited edition of 50

# källemo    *(founded 1965 Värnamo, Sweden)*

The origins of Källemo AB can be traced to a small furniture manufacturing company that was acquired in 1965 by Sven Lundh (b. 1925), who sought to produce interesting and exciting furniture made to exacting standards. Unlike **IKEA**, which offered "a wide range of home furnishing items of good design and function, at prices so low the majority of people could afford them", Källemo took an alternative approach that centred on creative artists and designers producing expressive objects in small runs. Rejecting what he saw as the banality and blandness of mass-produced furniture, Lundh wanted to manufacture products that radiated a human warmth so that their users could establish a more meaningful emotional connection with them, in much the same way as works of art are supposed to function. Influenced by the work of American artists, such as Robert Rauschenberg (b. 1925) and Jasper Johns (b. 1930), and the "ready-mades" of Marcel Duchamp (1887–1968), Lundh attempted to bring some of the qualities of contemporary fine art to the design of functional objects. Eventually in 1982 he found an object that met his aesthetic and practical ideals – **Jonas Bohlin**'s controversial and iconoclastic *Concrete* chair (1981).

Källemo immediately produced a batch edition of this landmark Post-Modern design and so ushered in a completely new era of furniture design and manufacture in Sweden. Bolstered by the success of the *Concrete* chair, Källemo subsequently began working with other young up-and-coming designers and artists, such as Mats Theselius (b. 1956), Ernst Billgren (b. 1957), Rolf Hansson (b. 1953) and Fredrik Wretman (b. 1958), who created highly individualistic products in a diverse range of styles. One of the most widely published of these furniture pieces was Theselius' *National Geographic Magazine* bookcase (1990), which not only invoked the global cultural symbolism of the magazine but also provided enough storage space for 25 years' worth of editions. As one of the greatest protagonists of Scandinavian Post-Modernism and the driving force behind Källemo, Lundh has stated, "It cannot be dangerous for man to have a creative nature. The only danger is that one becomes non-commercial. The danger of society becoming less commercial is that it becomes more human."

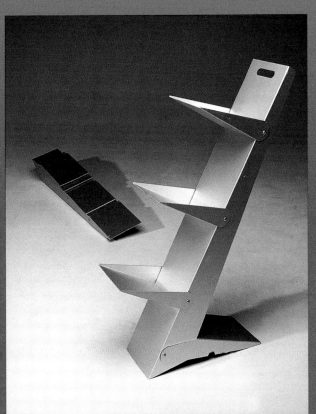

◁ Harri Koskinen, *Pick Up* aluminium shelves for Källemo, 1999

▽ Sigurdur Gustafsson, *Take Off* stainless steel and hemp rope chair for Källemo, 2001

▽▽ Mats Theselius, *National Geographic Magazine* bookcases for Källemo, 1990

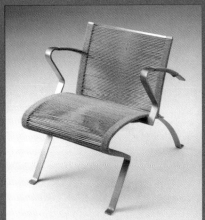

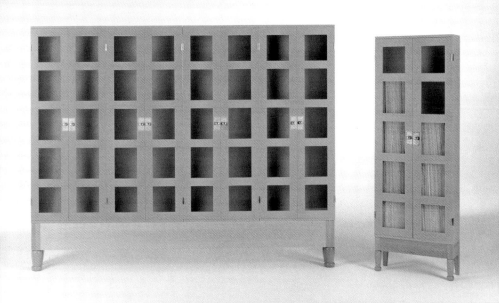

▷ Mats Theselius, *Fåtölj* chairs for Källemo, 1990

▽ Mats Theselius, *Bruno* chairs for Källemo, 1997

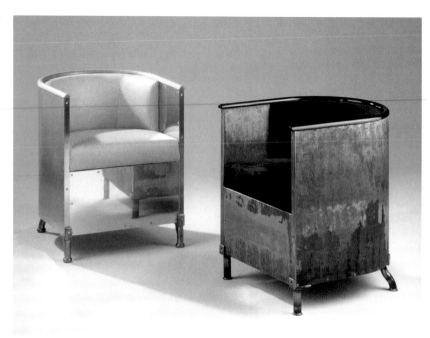

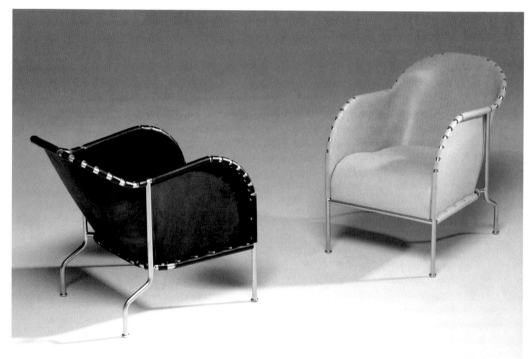

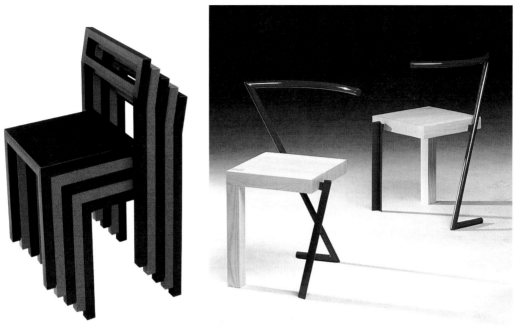

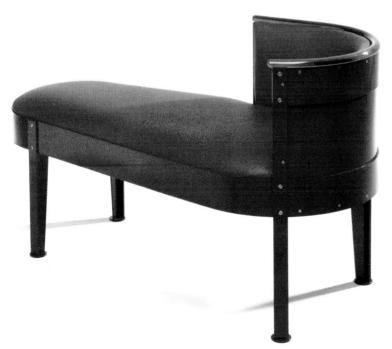

△ ◁ Boris Berlin & Poul Chris-
tiansen (Komplot Design), *Non*
rubber stacking chairs
for Källemo, 2000

△ Sigurdur Gustavsson, *Red
Baron* chairs for Källemo,
1997

◁ Mats Theselius, *Canapé*
chaise longue for Källemo,
1991 – limited edition of 35

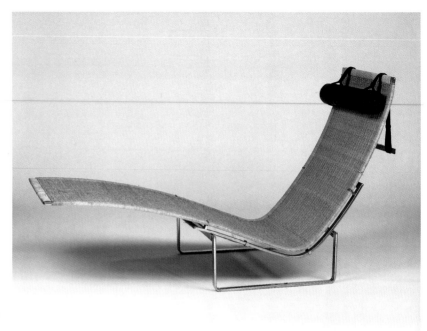

▷ Poul Kjærholm, *Model no. PK24 Hammock* chaise longue for E. Kold Christensen, 1965 – reissued by Fritz Hansen

# poul kjærholm

*(b. 1929 Øster Vrå – d. 1980 Hillerød, Denmark)*

The celebrated Danish architect and furniture designer Poul Kjærholm trained as a carpenter before studying furniture design and cabinet-making at the Kunsthåndværkerskolen (School of Arts and Crafts), Copenhagen, from 1949 to 1951. During this period the school ran an industrial design programme for a few months, and while on the course Kjærholm was taught by **Jørn Utzon** (b. 1918) – the designer of the Sydney opera house – who found that "Poul had a great talent. Nothing was difficult for him. It was child's play for him to design, to choose materials and use them correctly. He needed no instruction." Certainly his graduate project, the *PK25* steel chair (1951) with its halyard seat and back, demonstrated a remarkable sureness of handling and was immediately put into production by the furniture manufacturer E. Kold Christensen (later produced by **Fritz Hansen**). Around 1952, Kjærholm designed another constructionally innovative chair, the *PK0*, which was made of only two moulded plywood sections. Obviously inspired by Charles and Ray Eames's earlier moulded plywood chairs of 1945–1946, this remarkably progressive design could be considered even more rational because

of its reduced number of elements. However, for reasons presumably to do with either cost or sales appeal the chair was not put into production until 1997. Throughout his career, Kjærholm concentrated on the design of furniture for mass production and from 1955 he mainly worked in conjunction with E. Kold Christensen based in Hellerup. Unlike many of his Danish contemporaries, Kjærholm adopted steel rather than wood as his material of choice – his designs being inspired more literally by those of Modern Movement designers, especially Le Corbusier (1887–1965), than by the **Kaare Klint** school, which continued to advocate the reworking of existing "ideal" types. Although Kjærholm's elegant and rational furniture designs, such as the *PK22* chair (1956) and the *Hammock PK24* chaise longue (1965), were conceived within the Modernist idiom, they managed to avoid the alienating hard-edged aesthetic so common to the work of the Modern Movement. Kjærholm achieved this through the high-quality construction and realization of his designs, which retained a sense of traditional craftsmanship even though they utilized modern industrial materials and were mainly produced by machine. Kjærholm was awarded a

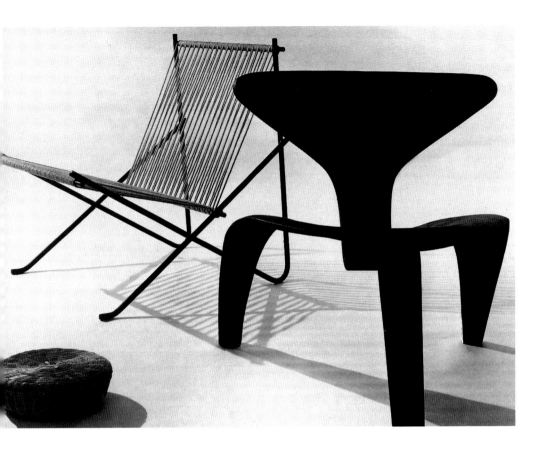

Grand Prix at both the 1957 (XI) and 1960 (XII)
Milan Triennale and also received a Lunning Prize
in 1958 for his furniture, the manufacture of which
was taken over from E. Kold Christensen by Fritz
Hansen around 1970. Although Kjærholm was
one of the Scandinavian designers most influenc-
ed by the functionalist approach to design, his
aesthetically pure furniture was to a great extent
humanized by a traditional Scandinavian sensibility
based on the mastery of materials and technical
construction. Of his choice of materials he stated,
"Steel's constructive potentials are not the only
thing that interest me; the refraction of light on its
surface is an important part of my artistic work.
I consider steel a material with the same artistic
merit as wood and leather."

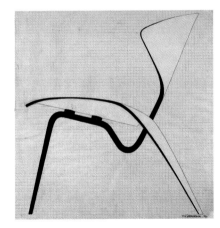

△ Poul Kjærholm, *Model
no. PK25* steel and halyard
chair with *Model no. PK0*
moulded plywood chair for
Fritz Hansen (produced
by Fritz Hansen from 1997),
1951 & 1952

◁ Poul Kjærholm, design for
the *Model no. PK0* chair
(produced by Fritz Hansen
from 1997), 1952

▷ Poul Kjærholm, *Model no. PK20* chair for E. Kold Christensen, 1967 – reissued by Fritz Hansen

▽ From left to right: Poul Kjærholm, *Model no. PK41* folding stool, *Model no. PK33* stool and *Model no. PK80* day bed for E. Kold Christensen, 1961, 1958 & 1957 – reissued by Fritz Hansen

▷▷ Poul Kjærholm, *Model no. PK22* chair for E. Kold Christensen, 1955 – reissued by Fritz Hansen

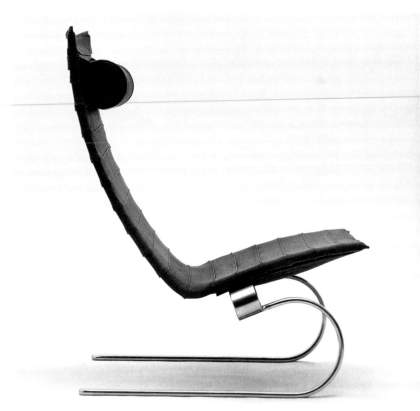

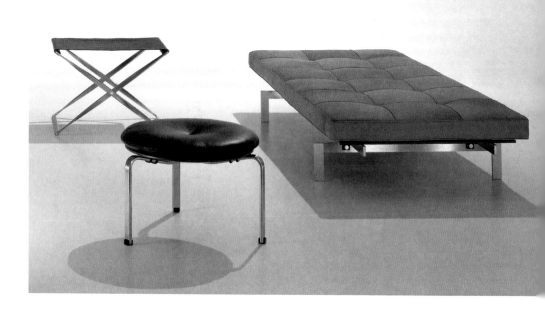

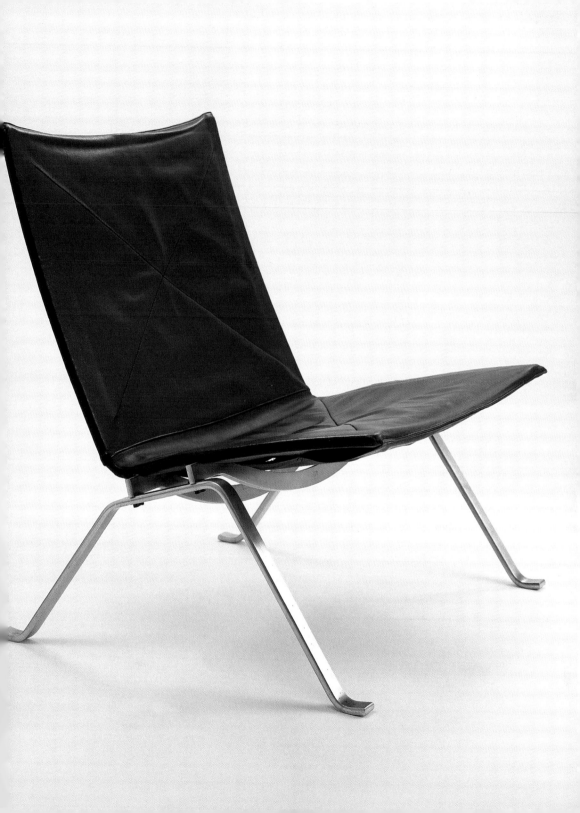

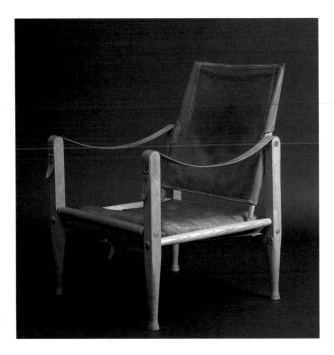

▷ Kaare Klint, *Safari Chair*
for Rud. Rasmussen, 1933 –
This design was based on
the earlier knock-down *Indian*
chair used by the British Army
overseas and retailed by
Maples & Co. from c. 1904

# kaare klint

*(b. 1888 Frederiksberg – d. 1954 Copenhagen, Denmark)*

Kaare Klint was the son of Peder Vilhelm Jensen-Klint (1853–1913), who is generally considered to have been the leading Danish architect of the early 20th century. Klint initially studied painting at the Polytechnic of Frederiksberg from 1903, before serving an apprenticeship as an architect under his father, who believed in the importance of studying earlier styles and traditional materials and whose own work carefully balanced 19th century historicism with 20th century expressionism. Kaare Klint later worked with the Copenhagen architects Kai Nielsen from 1911 to 1912 and Carl Petersen (1874–1923) from 1914 to 1917. From 1917, he began practising as an independent furniture designer, establishing his own design office in 1920 and working for among other manufacturers **Fritz Hansen** and Rud. Rasmussen. Klint's furniture designs, such as his *Deck Chair* (1933), were largely reworkings of earlier types drawn from a variety of influences including Scandinavian vernacularism, Shaker design, Regency furniture and oriental cabinet making. Many of his designs were notable for the high quality of their wood finishes and for their well-considered proportions. In 1924, he established the furniture department at the Kongelige

Danske Kunstakademi (Royal Danish Academy of Fine Arts), Copenhagen, and together with his students undertook important pioneering research into anthropometrics – the systematic collection and correlation of measurements of the human body – in an attempt to generate data that would enable the development of furniture that corresponded better with users' physical characteristics. As an influential design theorist and commentator, Klint also urged the combining of the attributes associated with traditional craftsmanship, such as attention to detail and in-depth knowledge of materials, with rational design principles. Like his father, he additionally stressed the importance of studying earlier styles and encouraged his students to take precise measurements of "classic" furniture forms – such as the traditional English *Windsor* chair – so as to gain an understanding of the principles of proportion, construction and function. In 1944, he became professor of architecture at the Kongelige Danske Kunstakademi in Copenhagen, and the same year designed his *Fruit* lamp, which was constructed of folded paper. These inexpensive paper lamps were manufactured by Le Klint, a company that had evolved from a cottage indus-

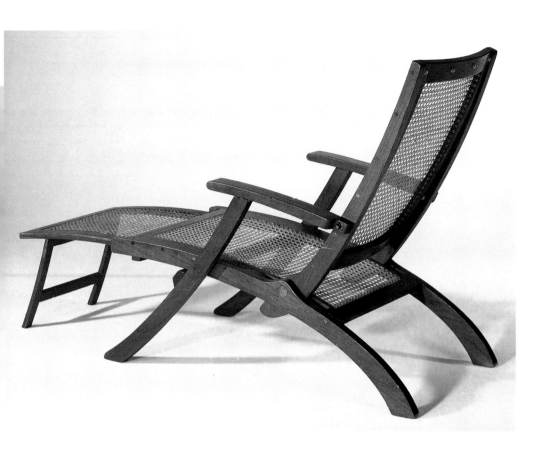

...ry established by his father, who had also made ...nd designed paper lamps. Klint believed that ...esign should serve the public and that the best ...vay of achieving this was through the adoption of ...ational design principles and the study of anthro- ...ometrics. Klint's teaching laid the foundations for ...he renewal of Danish design after the Second ...World War, and inspired a number of furniture ...esigners, especially **Hans Wegner** and **Børge** **Mogensen**, to create "classic" modern designs ...at were essentially reworkings of historical furni- ...ure types.

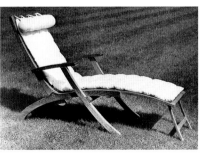

△ Kaare Klint, *Model no. 4699 Deck Chair* for Rud. Rasmussen, 1933

◁ Kaare Klint, drawing for *Model no. 4699 Deck Chair*, c. 1933

▽ Kaare Klint, *Model no. 4699 Deck Chair* with seat cushion and head rest for Rud. Rasmussen, 1933

OVERLEAF
◁ Kaare Klint, mahogany & leather armchair for Rud. Rasmussen, 1930

▷ Kaare Klint, *Model no. 3758A Red Chair* for Rud. Rasmussen, 1927 – This design is also known as the *Barcelona Chair* as it was awarded a prize at the 1929 "Exposición Internacional de Barcelona"

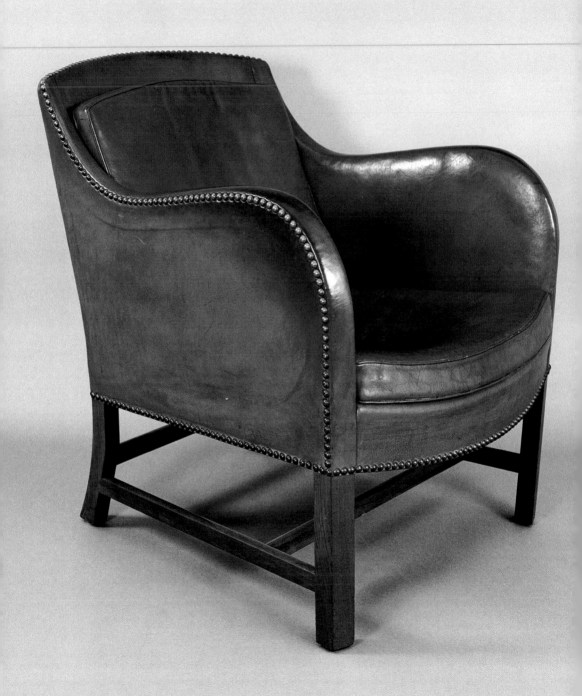

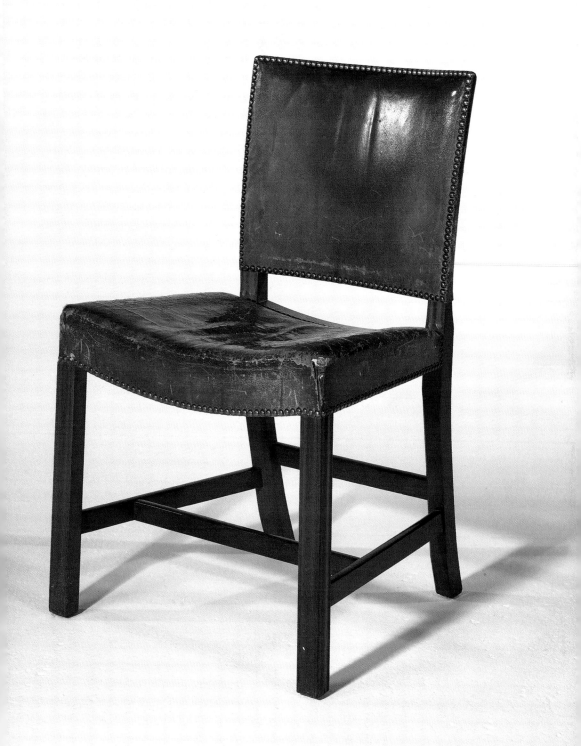

▷ Vibeke Klint, red carpet with zig-zag pattern, 1953

▷▷ Vibeke Klint, striped woven textile, 1980

# vibeke klint *(b. 1927 Frederiksberg, Denmark)*

The Danish textile designer Vibeke Klint studied weaving under Gerda Henning at the Kunst-håndværkerskolen (School of Arts and Crafts) in Copenhagen, graduating in 1949. From 1949 to 1950 she worked in Henning's workshop and in 1951 went to France to continue her training as a weaver under the guidance of Jean Lurçat (1892–1966) at the renowned Aubusson tapestry school in St. Céré, and also with Jean Wemaire in Brittany. On her return, Klint took over the direction of Henning's workshop and by the early 1950s was regarded by **Lis Ahlmann** as "indisputably the most competent of the young Danish weavers". Using simple zigzag and striped patterns, Klint remained true to traditional materials and weaving techniques, yet her designs radiated a contemporary freshness through her use of bright saturated colours, such as deep reds, dark blues, unbleached whites and warm golds. Inspired by Indian and American First Nation textiles, Klint's designs projected an almost "primitive" aesthetic that contrasted strongly with the refined craft skills used to produce them. This combination of bold geometric patterning with masterful weaving techniques gave Klint's work a distinctive character

that revealed, according to Jörgen Schou-Christensen, the "noble simplicity of genuine handcraft". Apart from her hand-loom textiles in cotton and silk, from 1956 onwards Klint also translated her designs into patterns suitable for industrial manufacture, such as her carpet collection for C. Olesen. In 1957, she executed tapestries for the Egmont H. Petersen College in Copenhagen after cartoons devised by the painter William Scharff (1886–1959), and three years later was awarded the celebrated Lunning Prize. Vibeke Klint not only promulgated the Scandinavian tradition of hand weaving but also revitalized it with her bright yet simple textiles, which she often adapted so as to meet the requirements of mass production.

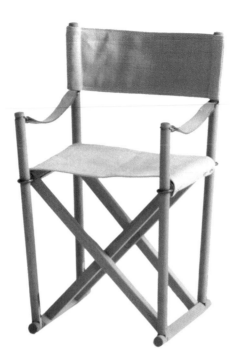

▷ Mogens Koch, *MK Safari* chair for Rud. Rasmussen, 1932

# mogens koch

*(b. 1898 Copenhagen – d. 1992 Copenhagen, Denmark)*

From 1921 to 1925 the Danish furniture designer Mogens Koch worked as an assistant to the architect Carl Petersen (1874–1923) while studying architecture at the Kongelige Danske Kunstakademi (Royal Danish Academy of Fine Arts), Copenhagen, from whence he graduated in 1925. Following this, he went on study tours throughout the United States, Mexico and Europe, and from 1925 to 1930 he worked as an assistant to **Kaare Klint**. Later in 1932 Koch designed his *MK Safari* chair, which like Klint's slightly later *Safari* chair (1933) was based on the design of a traditional campaign chair. Although Koch's chair is now considered a classic Danish furniture design, when it first appeared it was deemed too radical to be put into production. Eventually, the chair was manufactured by Interna and Rud. Rasmussen in 1960. In 1934, Koch established his own design practice and four years later was awarded the prestigious Eckersberg Medal. Influenced by Kaare Klint's evolutionary approach to design, Koch's furniture – like Klint's – can be seen as essentially modern reworkings of traditional types. His *Wingback* chair of 1936, for example, was an homage to Georgian chairs made in Great Britain during the 18th cen-

tury. Apart from Interna and Rud. Rasmussen, Koch also designed furniture for Danish CWS and N.C. Jensen Kjær which exemplified the Danish look. Beyond furniture, Koch designed silverware, textiles and carpets in connection with various Danish church restoration projects. His work was regularly exhibited at the Milan Triennale exhibitions and was included in the "Arts of Denmark" travelling exhibition that toured America in 1960. From 1950 to 1968, Koch was a professor at the Kongelige Danske Kunstakademi and was also a visiting lecturer at the Massachusetts Institute of Technology from 1956 and at the Industrial Art Institute, Tokyo, from 1962. As one of the leading pioneers of modern Danish furniture design, he was awarded the C.F. Hansen Medal and the Cabinetmakers' Guild Annual Prize in 1963 and 1964 respectively. Koch's subtle yet fundamentally modern approach to problem solving, which relied on the refinement of "ideal" forms, exemplified Danish design during the inter-war years.

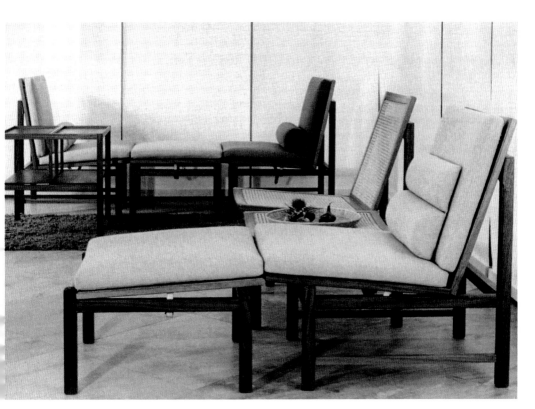

△ Mogens Koch, mahogany
sectional chairs, foot stools
and tables for Rud. Rasmus-
sen, 1961

◁ Mogens Koch, two-piece
mahogany and rosewood table
executed by N. C. Jensen Kjær,
1952

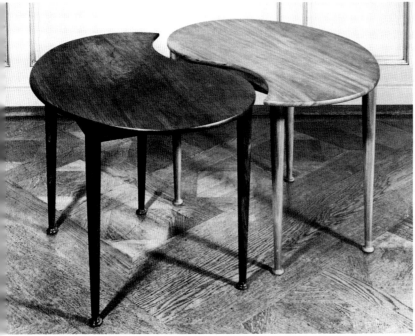

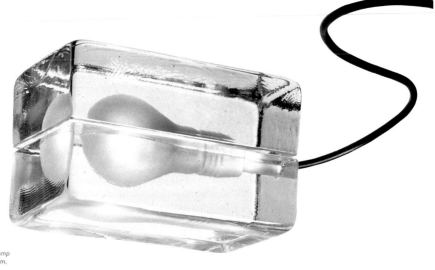

▷ Harri Koskinen, *Block Lamp*
for Design House Stockholm,
1997

# harri koskinen *(b. 1970 Karstula, Finland)*

One of the leading contemporary product design-ers in Finland, Harri Koskinen studied at the Lahti Design Institute and graduated in 1993. The fol-lowing year he took an MA in Product and Strate-gic Design at the Taideteollinen Korkeakoulu (Uni-versity of Art and Design), Helsinki. While there, he collaborated with the Iittala glassworks on a project for a wedding present for the year 2021 – a pair of red schnapps glasses that rested in a box of cast glass. Although not particularly satisfied with the resulting design, he was fascinated by how the molten glass glowed when it was being poured into the mould, and as a result set to work developing a cast glass lamp. For this, Koskinen carved a graphite mould using the shape of a regular-sized light bulb as a template and then once the form had been cast in glass, sandblasted the void so that the smaller-sized bulb inserted inside as the light-source would not be seen. The *Block Lamp* as it became known was exhibited in Helsinki in 1997 and was put into production by Design House Stockholm, which has to date sold over 15,000 units. The *Block Lamp* also led to Koskinen winning a placement at Designor Oy in 1996, where he initially worked at the Nuutajärvi

glassworks. Two years later, he was transferred to Iittala (also part of the Designor group), which has historically employed many of the greatest Finnish glassware designers, from **Alvar Aalto** to **Tapio Wirkkala**. Koskinen has also produced designs for the other companies in the Designor group. For Hackman, he designed stainless steel utensils for outdoor cooking (2000), which com-bine simplicity and functionalism and reflect the influence of having grown up on a farm in the Finnish countryside – an experience that Koskinen says gave him "a belief and courage to rely on the fundamental things in life". For Arabia, his *Air* storage containers (2001) are similarly practical yet beautiful in a subtle, almost elemental way. He has also designed several furniture prototypes and his work has been included in numerous exhibi-tions throughout Scandinavia, Europe and the Far East. As an heir to the remarkable legacy of design achievements in Finland, Koskinen's work embodies the key values so famously associated with Finnish design – innovation, functionalism, simplicity, and a touch of refined artistry.

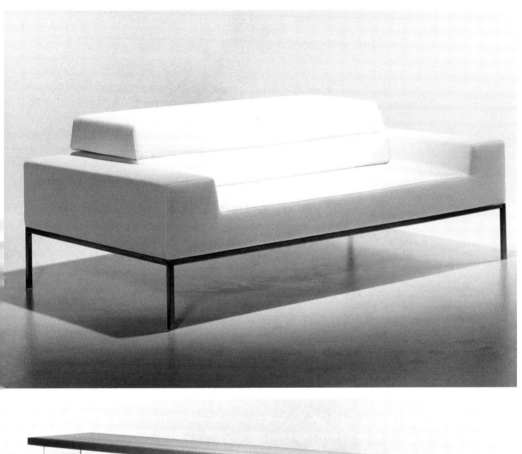

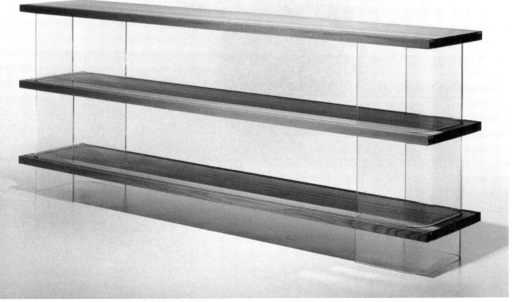

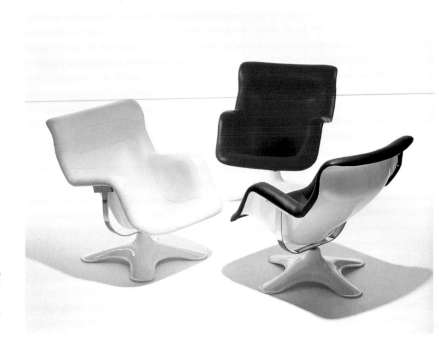

▷ Yrjö Kukkapuro, *Karuselli*
(Carousel) chairs for Haimi,
1964–1965 – reissued by
Avarte

▷▷ Yrjö Kukkapuro, *Experi-
ment 401* chair for Avarte,
1983

# yrjö kukkapuro *(b. 1933 Yiipuri, Finland)*

One of Finland's leading furniture designers, Yrjö Kukkapuro studied interior design at the Taideteollinen Korkeakoulu (University of Art and Design), Helsinki, from where he graduated in 1958. A year later, he established his own design studio in Kauniainen and began designing furniture within a functionalist vocabulary. His early work was greatly influenced by **Ilmari Tapiovaara**, who taught at the Taideteollinen Korkeakoulu in Helsinki and who was a pioneer of knockdown furniture. During the late 1950s Kukkapuro began designing chairs with moulded plywood seat elements and tubular metal frames – not because these were his materials of choice, but because they were readily available. As Kukkapuro later noted, "I was already dreaming of making fibreglass chairs, but the dream was little short of utopia in the Finland of those days." He did, however, eventually get the chance to experiment with plastics thanks to the advent of sintering in 1961. With this relatively simple technique, a heated steel form is dipped into powdered plastic so as to form a layer of melted material that can then be removed from the mould once it has cooled down sufficiently. Kukkapuro developed a couple of prototype chairs using this technique,

but he was unable to find a manufacturer or the necessary financial backing to put the designs into production. In early 1964, Kukkapuro made a second attempt at designing a chair in plastic and constructed a prototype from wire mesh that had been moulded to fit the shape of his own seated body. He then attached this shaped element to a tubular metal frame, covered it with sacking that had been dipped in plaster, and smoothed and scraped it into the required form. It took nearly a year of modelling before a working prototype of the chair was finally completed. The resulting fibreglass and leather *Karuselli* (Carousel) chair (1965) featured an innovative cradle-like construction and a comfortable single-form seat shell that embodied Kukkapuro's belief that "a chair could also be a reflection of the human form. As softly shaped as people are. And if at all possible, just as beautiful." In 1966, the *Karuselli* chair was featured on the cover of *Domus* magazine, testifying not only to the importance of this particular design but also to the increasing influence of Finnish design in general. During the late 1960s and early 1970s, Kukkapuro designed other chairs and tables that were constructed of moulded plastic, such as his *Saturnus*

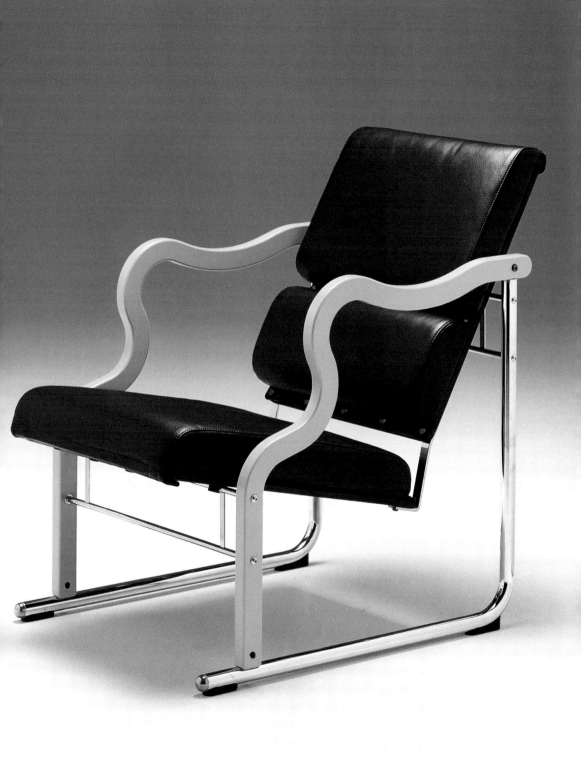

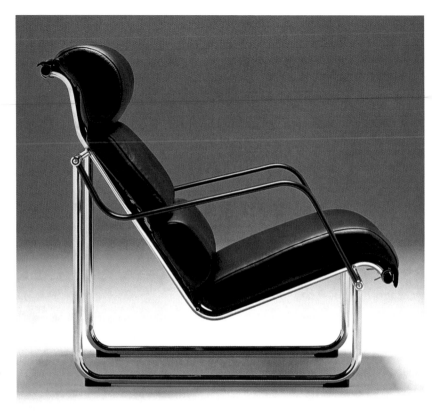

▷ Yrjö Kukkapuro, *Model
no. 817H-1K Remmi* chair for
Avarte, 1970

▷▷ Yrjö Kukkapuro, *Model
no. 455F Fysio* chair for
Avarte, 1978

tables (1987). By the post-oil-crisis years of the
mid-1970s, however, the plastics era with its exper-
imental and expressive forms had been replaced
by "the golden age of ergonomics and ecology".
As a result, Kukkapuro undertook various "physio-
metrical examinations" of different human sizes so
as to generate the anthropometric data necessary
for the development of a form-pressed plywood
office chair. The subsequent *Fysio* chair (1978)
was completely revolutionary, being one of the very
first office chairs to have a form based almost
entirely on ergonomic considerations. Kukkapuro
was a professor at the Taideteollinen Korkeakoulu
(University of Art and Design) in Helsinki from 1974
to 1980 and the institution's rector from 1978 to
1980. By the 1980s, with the ascendancy of Post-
Modernism, Kukkapuro began producing more
expressive designs, such as his *Experiment* chairs
(1982–1983). Of this high style he declared,
"Post-Modernism has once again put us in touch
with the vital element that the French call 'joie de
vivre'". Kukkapuro's furniture was originally manu-
factured by Haimi, but in 1980 a new company,
Avarte, was established to take over its produc-
tion. Kukkapuro's work can be seen as classically

Finnish, being distinguished by strong graphic out-
lines, technical innovation, experimentation and the
use of high-quality materials and construction.

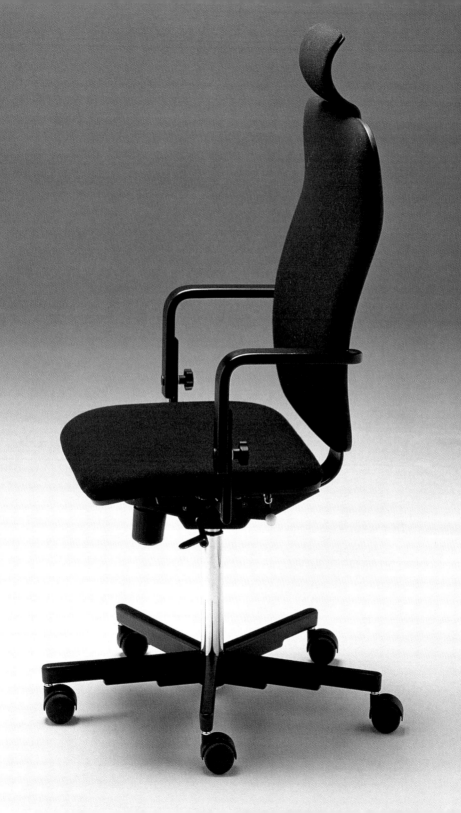

▷ Börge Lindau & Bo Lindekrantz, *Model no. S70-3* bar
stool for Lammhults, 1968

# lammhults *(founded 1945 Lammhult, Sweden)*

**LAMMHULTS**

The internationally renowned Swedish furniture
company, Lammhults, was founded in 1945 with
meagre financial resources and an empty barn.
Initially, the firm supplied various fittings to local
furniture manufacturers and it was not until 1955
that it began making its own furniture. The earliest
Lammhults products were designed by one of the
company's founders, Edvin Ståhl (1896–1971),
and included the tubular metal and plastic *282*
stool (1955), the stackable and linkable *Pyramid*
chair (1955), and the *Kongress 57* armchair
(1957). Ståhl also designed furniture for trans-
Atlantic ships and the *Spindeln* chair that was
used for the outdoor restaurant at the landmark
1955 "H55" exhibition at Helsingborg. In the mid-
1960s, the company commissioned two of the
most avant-garde designers working in Sweden,
Börge Lindau (1932–1999) and Bo Lindekrantz
(b. 1932), to design a stacking chair for use in
assembly halls. What they came up with were two
designs, the *Ritz* (1965) and the *Royal* (1965),
which were named after the two best-known cafés
in the Lammhult's region. These chairs enjoyed
much success and were followed in 1968 by the
Bauhaus-inspired *S70* range of furniture also

designed by Lindau and Lindekrantz, which in-
cluded wall-mounted and floor-standing ashtrays,
a hat stand, two tables, a bed, a sofa-bed, a sofa,
two armchairs and the well-known reversed can-
tilevered seat that was available in three different
heights – tabouret, armchair and barstool. During
the 1970s, Lindau and Lindekrantz designed a
wide range of furniture that was influenced by
1930s Swedish Modernism. In the 1980s, they
designed furniture in the Post-Modern style, such
as the *Plakan* chair (1985), which was intended
as an homage to Gerrit Rietveld's *Red/Blue* chair
of 1918–1923. In 1989, Lammhults introduced
designs by Gunilla Allard (b. 1957), who was the
first female designer to contribute to Lammhults'
furniture range. Her minimalist designs, such as the
*Casino* and *Chicago* chairs (1997 & 1998), were
especially favoured by German architects, who
appreciated her re-interpretation of functionalist
Bauhaus principles. During the 1990s, Lammhults
also produced designs by Love Arbén (b. 1952)
and **Jonas Bohlin** that articulated a more expres-
sive vocabulary of form. Over the last fifty years,
Lammhults has produced furniture that has been
strongly influenced by both Modernism and Post-

◁ Gunilla Allard, *Cinema Sport* armchair for Lammhults, 1999

▽ Gunilla Allard, *Cosmos* chairs for Lammhults, 2000

▽▽ Gunilla Allard, *Cinema* easy chair with footstool for Lammhults, 1994

Modernism, yet its products have avoided stylistic extremes, epitomizing the measured Scandinavian approach to design that generally precludes aesthetics from overriding considerations of practical function.

▷ Axel Larsson, living room
furniture, 1939

▷▷ Axel Larsson, chair and
magazine cabinet for Svenska
Möbelfabrikerna, 1933

# axel larsson *(Swedish 1898–1975)*

One of the greatest proponents of Swedish Modernism during the inter-war period, Axel Larsson studied at the Tekniska skolan (School of Technology) in Stockholm. In 1925, he began designing furniture for Svenska Möbelfabrikerna (Swedish Furniture Manufacturers) that was suitable for mass production. Around this time he also established his own workshop in Stockholm and designed a dining room interior for the 1930 Stockholm Exhibition. This installation revealed the strong influence of German Functionalism, but the overall effect was somewhat lightened by the inclusion of potted plants and a boldly patterned geometric rug. Like his fellow countryman and contemporary **Sven Markelius**, Larsson initially designed furniture with simple, pared-down forms that was primarily informed by functional concerns. By the mid-1930s, however, his work became softer and more organic, much in the manner of **Bruno Mathsson**'s landmark *Eva* chair (1934). In 1939, Larsson designed a living room interior for the Swedish Pavilion at the New York World's Fair, the furniture for which adhered to Modern Movement principles while also demonstrating the distinctly Scandinavian concern for superlative craftsmanship and ergonomic form. From the 1930s until 1956, Larsson was the principal designer for Svenska Möbelfabrikerna in Bodafors, one of the first firms in Scandinavia to pioneer the manufacture of aesthetically pleasing mass-produced furniture. Larsson's designs for the company such as his light stained-ash side chair and shelved cupboard (c. 1934), exemplified the subtle detailing of modern Swedish design, and possessed an elegant functionalism that rejected the hard-edged Bauhaus style for a warmer and more inviting aesthetic. Like many other Scandinavian designers Larsson also designed exclusive handcrafted furniture. During his career he was commissioned to design a number of public and private interior schemes, including those for the Gothenburg Concert Hall (co-designed with Nils Einar Eriksson and the Foreign Office in Stockholm. Although Larsson's furniture – both handcrafted and mass-produced – was essentially modern, it was not born out of a dogmatic adherence to Functionalism and as such presaged the softer and more humanistic approach to design that flourished in Scandinavia during the post-war years.

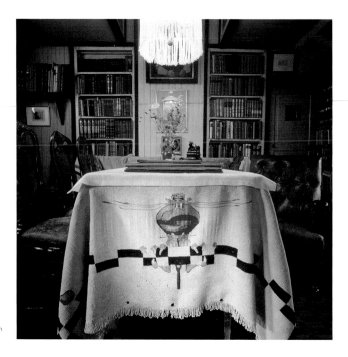

▷ The library at Lilla Hyttnäs, with tablecloth woven by Karin Larsson

# carl & karin larsson *(b. 1853 Stockholm –*

*d. 1919 Sundborn, Sweden & b. 1859 Örebro – d. 1928 Esbjörn, Sweden)*

Carl and Karin Larsson were important pioneers of the concept of "design as lifestyle". Together, they formulated an informal eclectic style that focused on the idea of warm familial domesticity, which became hugely influential especially in Scandinavia and Germany. Carl's artistic talents as a youth led to him winning a place at the Academy of Art in Stockholm, where he subsequently studied classical art and life drawing. During this period, he contributed caricatures to the journal *Kasper* and graphics to the newspaper *Ny Illustrerad Tidning*. In 1877 he moved to Paris and in 1882 settled in Grez with a number of other Swedish painters. While there, he produced watercolours that had a poetic realism and strong narrative quality. In 1879, he met the Swedish artist, Karin Bergöö, whom he married in 1883. During the 1880s, Larsson joined the Swedish art group, Opponents, and worked as an illustrator. In 1888, Karin's father gave the growing Larsson family a small house, Lilla Hyttnäs in Sundborn, which they used as a summer residence until 1901, when it became their permanent home and the central focus of their lives. Karin decorated its interiors in a simple folk style, which included white painted

and built-in furniture, wooden floors, embroidered textiles and pots of red geraniums, while Carl portrayed their daily life and their six children in his watercolours. His brightly coloured stylized studies, which captured this idyllic, rural, self-sufficient and carefree lifestyle, were widely reproduced in an album, *Ett Hem* (Our Home, published in 1899), so as to "reform taste and family life". The house was sited in the picturesque village of Sundborn in the Dalarna region – the mystic heart of Sweden – and was remodelled and embellished with a refreshing simplicity and characterful warmth by the Larssons in an attempt to evolve a new concept of Swedish domesticity. Believing in the importance of "art in the home", the Larssons decorated practically every surface of the house including the backs of doors, which they adorned with portraits of their children, and walls which they inscribed with heart-warming mottos such as "Love Each Other Children, for Love is All". The Larsson house was a complete realization of the Arts & Crafts goal of "a rural ideal" and was also an important and hugely influential manifestation of the Scandinavian concept of *hygge* – a joyful domestic cosiness. The integrated and simple lifestyle pro-

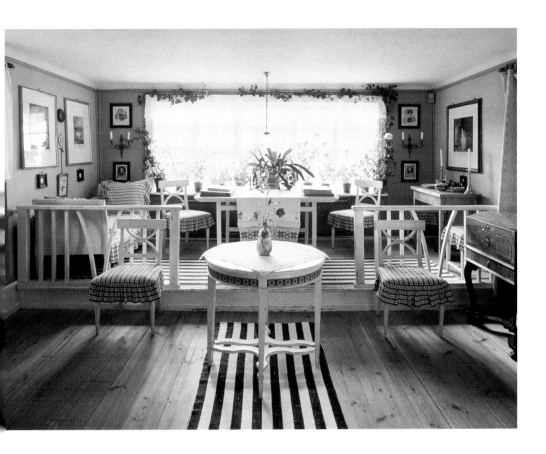

moted by Carl and Karin Larsson formed a key part of the foundation from which modern Swedish design evolved, and can be seen as the spiritual progenitor of the **IKEA** aesthetic.

△ The best parlour at Lilla Hyttnäs – This light, bright and airy room shows a marked contrast to the general stuffiness of bourgeoisie turn-of-the-century interiors

▽ Carl Larsson, drawing of the best parlour at Lilla Hyttnäs, c. 1900

◁◁ Carl Larsson, *Papa's Room* watercolour study, c. 1895

◁▽ Carl Larsson, *The Resting Place in the Parlour* water-colour study, c. 1895

◁ Carl Larsson, *Old Anna* watercolour study, c. 1896

▽ Carl Larsson, *The Bedroom of Mama and the Little Girls* watercolour study, c. 1896

OVERLEAF
◁ The dining room at Lilla Hyttnäs – with the most remarkable paper lampshades designed by Karin Larsson

▷ The working room at Lilla Hyttnäs

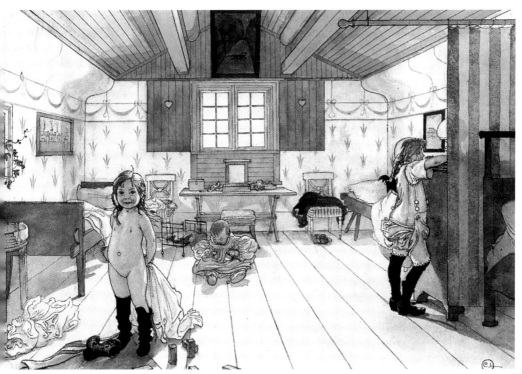

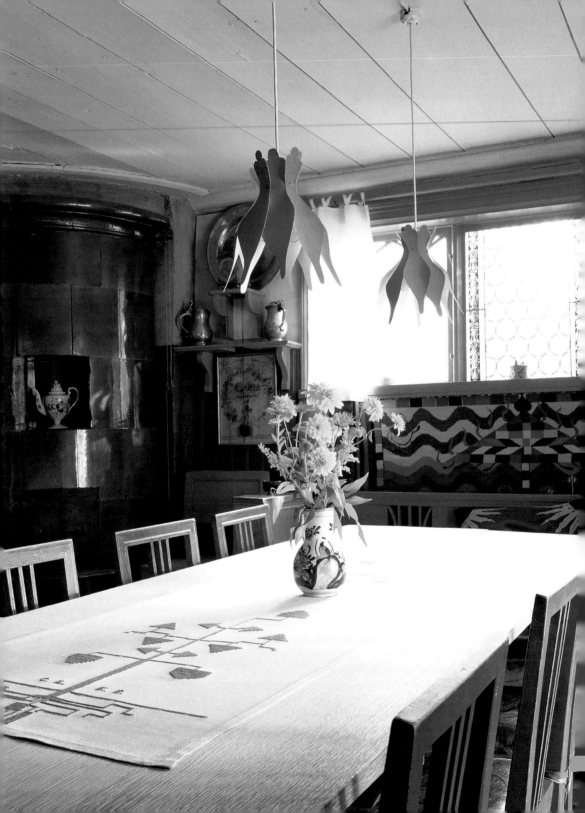

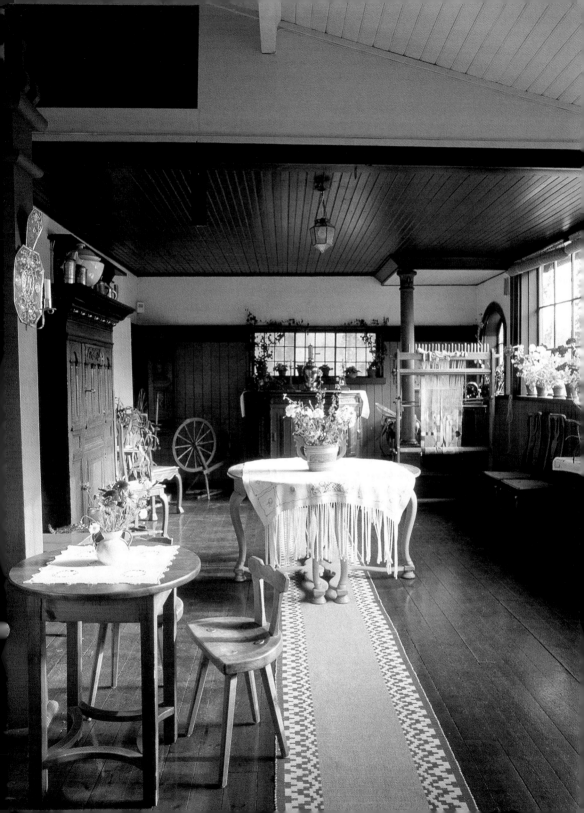

▷ Poul Christiansen, *Model no. 172 Sinus* hanging lamp for Le Klint, c. 1972

▽ Peder Vilhelm Jensen-Klint, originator of Le Klint

# le klint *(founded 1943 Odense, Denmark)*

In 1901, the renowned Danish architect, engineer and craftsman Peder Vilhelm Jensen-Klint (1853–1913) designed a rustic-style stoneware oil-lamp for himself, which he wanted to fit with a simple pleated paper shade. Unable to buy a suitable readymade lampshade, he set about making his own from a piece of parchment. Folding the paper into small pleats along its length, Jensen-Klint devised a "collar" that not only helped to retain the shape of the shade but also kept it at a safe distance from the heat of the lamp's glass chimney. Soon, making lampshades out of folded pleated paper became a pastime enjoyed by other members of his family and in time evolved into a small cottage industry. During this period the architect's eldest son, Tage Klint (1884–1953), devised a method by which the paper-pleated shades could be fitted onto an ordinary lampshade fitment without the need of an additional supporting frame, and in 1943 he founded the Le Klint company to commercially exploit the family hobby. The following year, his architect-brother **Kaare Klint** designed the pendant *Fruit* lamp, a drawing of which is still used as part of the company's logo. Kaare

Klint's "cross-pleated" designs for the company were highly suitable for use in modern interiors, being not only simple and sculptural but also relatively inexpensive to produce. Later, his son, Esben Klint (1915–1969), designed several well-known lamps for the company. Other designers were also recruited to design new lamps, including **Peter Hvidt** and **Orla Mølgaard-Nielsen**. While still a student at the Kongelige Danske Kunstakademi (Royal Danish Academy of Fine Arts), Poul Christiansen (b. 1947) began developing a hand-folded lampshade that incorporated sine curves, which he first presented to Le Klint in 1967. Immediately, the company's director Jan Klint saw the potential of Christiansen's innovation and put his first lamp design, the *Model no. 167*, into production. Following this, Christiansen added a new sine curve pendant lamp to the Le Klint range on an annual basis. With their sculptural mathematical curves Christiansen's designs captured the spirit of the late 1960s and early 1970s and made the earlier classic cross-pleated shades look positively dated. Today, Le Klint lamps are still made by hand at the company's Odense factory and

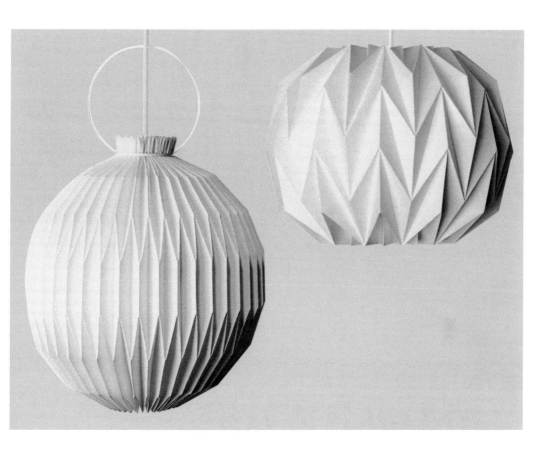

are internationally recognized as a "shining example of world-class Danish applied art."

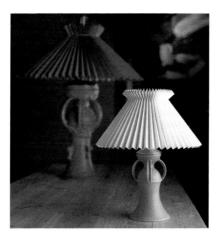

△ Esben Klint, *Model no. 107* hanging lamp, and Andreas Hansen, *Model no. 157* hanging lamp for Le Klint, 1950s

◁ Peder Vilhelm Jensen-Klint, stoneware lamps with folded paper shades, 1901 – the first Le Klint lamp

▷ Marie Gudme Leth, *Bregner*
textile for Dansk Kattuntrykkeri,
1937

▷▷ Marie Gudme Leth,
*Kirsebær* textile printed at
designer's own workshop,
1946

# marie gudme leth

*(b. 1910 Århus – d. 1997 Copenhagen, Denmark)*

The renowned Danish textile designer Marie Gudme Leth studied at the Industrial Art School for Women and the Kongelige Danske Kunstakademi (Royal Danish Academy of Fine Arts) in Copenhagen. Following this, she trained at the Kunstgewerbeschule (School of Arts and Crafts) in Frankfurt prior to heading the textile department at the Kunsthåndværkerskolen (School of Arts & Crafts), Copenhagen, from 1931 to 1948. In 1935 she co-founded the textile company Dansk Kattuntrykkeri, remaining its director for the next five years, and in 1940 established her own textile workshop, where she specialized in the production of colourful silk-screen printed fabrics. One of her earliest designs, *Jagten* (1932), shows the strong influence of oriental art, while her slightly later *Landsby I* (1935) and *Landsby II* (1936) textiles, which depict scenes of houses, windmills and trees, were inspired by traditional folk art. In these landscapes Gudme Leth also included factories and in so doing acknowledged the increasing industrialization of the Danish countryside. Her *Bregner* textile (1937) with its unfurling ferns signalled a move away from "busy" pictorial scenes. She went on to design numerous textiles with

floral motifs that became increasingly stylized and complex. Her beautiful *Kirsebær* textile of 1946, for example, would have been difficult to print with its six-colour design. During the 1950s, Gudme Leth's work became increasingly abstract and block-like, with textiles such as *Bølger* (1955) and *Izmir* (1955–1960) stylistically predicting the bold and colourful fabrics produced by **Marimekko** in the 1960s. She was awarded a gold medal at the 1951 (IX) Milan Triennale and her textiles were included in the landmark "Design in Scandinavia" exhibition that toured the United States and Canada from 1954 to 1957. In 1995, a major retrospective of Marie Gudme Leth's work was held at the Danske Kunstindustrimuseum (Danish Museum of Applied Arts) in Copenhagen.

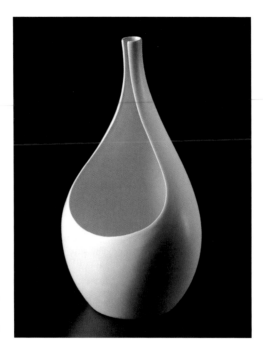

▷ Stig Lindberg, *Pungo*
(Pouch) vase for Gustavsberg,
c. 1953

▷▷ Stig Lindberg, *Pottery*
textile for Nordiska Kompaniet,
c. 1947

# stig lindberg

*(b. 1916 Umeå, Sweden – d. 1982 San Felice Circeo, Italy)*

The Swedish designer, Frederick Stigurd (Stig) Lindberg studied in Jönköping and later at the Konstfackskolan (University College of Arts, Crafts and Design) and the Kungliga Tekniska Högskolan (Royal Institute of Technology) in Stockholm from 1935 to 1937. Between 1937 and 1940, he trained under Wilhelm Kåge at the Gustavsberg ceramics factory and executed a number of geometric designs in the Art Deco style, and at least one asymmetrical piece that presaged his later organic approach to design. During this period, he also briefly studied in Denmark and at the Académie Colarossi in Paris, the latter of which he claimed was utterly crucial to his artistic training. Lindberg's ceramics were first shown publicly in Stockholm in 1941, and during the post-war years they became widely recognized as exemplars of Scandinavian Modernism. He launched his first range of painted earthenware in 1942 at an exhibition entitled "Fajanser målade i vår" (Faïence painted this Spring). His subsequent faïence designs introduced whimsical elliptical forms and decorative patterns with bands of colourful stripes. From 1947 to 1949, he designed glassware for Målerås glassworks and textiles for Nordiska Kompaniet, while also working as a book illustrator. In 1949, Lindberg succeeded Wilhelm Kåge as Gustavsberg's artistic director and over the following years introduced several new ceramic ranges, which included his beautiful *Pungo* (Pouch) vase (1953). Epitomizing the organic forms that came to typify post-war Scandinavian design, the elegant and sophisticated *Pungo* vase contrasted strongly with his homely and at times humorous earthenware designs. Lindberg also designed faïence wares painted with scenes inspired by the paintings of Marc Chagall (1887–1985), which were produced in the Gustavsberg studio. His work in other areas of design also possessed a similar pictorial quality, especially his textile designs, such as *Pottery* (c. 1947). In 1957, Lindberg left Gustavsberg and began teaching at the Konstfackskolan (University College of Arts, Crafts and Design) in Stockholm (1957–1970). He also began designing glassware for both Holmegaard (1959–1960) and Kosta glassworks (1965). From 1971 to 1980 he resumed his directorship at Gustavsberg and following this established his own studio in Italy. Like many other Scandinavian designers, Lindberg skilfully

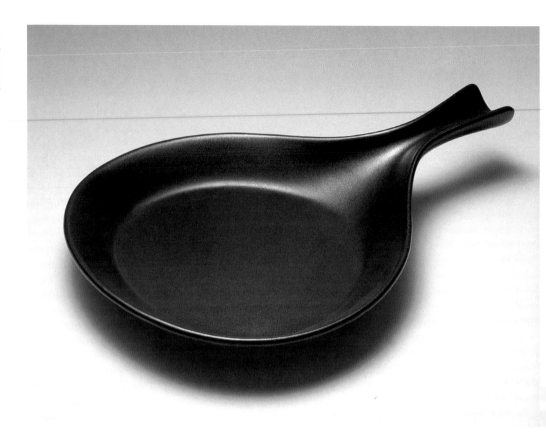

△ Stig Lindberg, *Terma* stoneware frying pan for Gustavsberg, 1955

▷ Stig Lindberg, *Model nos. 243, 245 & 236* vases for Gustavsberg, c. 1949

adapted his style to suit the nature of the material he was working with. His work possessed a classical Scandinavian character and warmth of appeal, which was mainly derived from his use of elegant asymmetrical forms and folk-inspired decorative patterns.

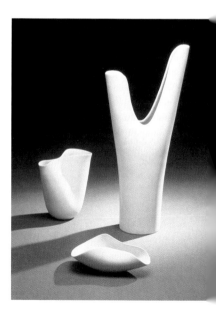

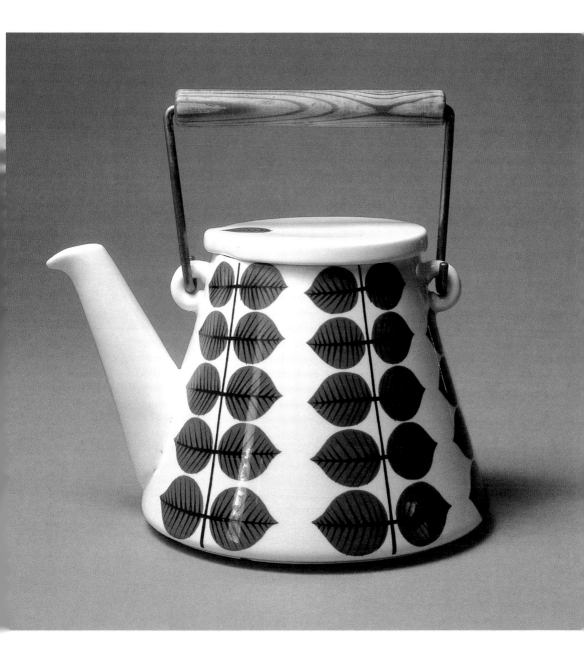

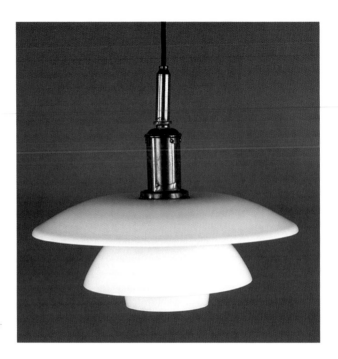

▷ Poul Henningsen, *PH* hanging lamp for Louis Poulsen, c. 1927

# louis poulsen *(founded 1874 Copenhagen, Denmark)*

The well-known Danish lighting company, Louis Poulsen evolved from a cork-trading and general ironmongery business, which from 1892 had an "electrical department" that supplied carbon arc lamps. Louis Poulsen (1871–1934), the nephew of Ludwig R. Poulsen (1846–1896), the founder of the original enterprise, headed the business from 1906 and two years later took over premises in Nyhavn, Copenhagen. The turning point in the then wholesale business occurred in 1911 when Sophus Kaastrup-Olsen (1884–1938) acquired a 50% stake in Poulsen's electrical division. Olsen was a true believer in electric power, as well as a political radical. In 1917, Louis Poulsen retired and Olsen became the sole proprietor of the company. Almost immediately, he began benefiting from the increase in demand brought about by the end of the First World War and the return of the long overlooked Southern Jutland region to Denmark. By 1918, Louis Poulsen had a considerable turnover of 5 million krona, of which 600,000 krona was clear profit. Although the 1920s were a financially turbulent period for the company, it gained a valuable market share after Olsen came into contact with the lighting designer **Poul Hen-** **ningsen,** who once claimed that Olsen "was just as mad as I was". From 1924, Henningsen produced lighting designs for the company that attempted to soften the dazzling effect of electric carbon arc lighting by means of multi-shade configurations. As he noted: "The fact is that electric light is defective and ought not to be condoned in a room where people gather. Its defects are also so profound that electric light, despite its ease of use, low price and abundance, is still unpopular and considered a necessary evil by civilized people." To solve the inherent problems associated with electric lighting, Henningsen's revolutionary light fixtures reflected light in such a way that the glare was effectively defused. These remarkably modern designs, which were both beautiful and functional, won a gold medal at the 1925 Paris "Exposition Internationale des Arts Décoratifs et Industriels Modernes". A year later, Henningsen designed the famous *PH* series of lamps, which remain in production today. The *PH* lamps were startlingly modern for their time and appealed especially to architects and interior designers – **Alvar Aalto**, for example, incorporated them in his design for the auditorium at Turku

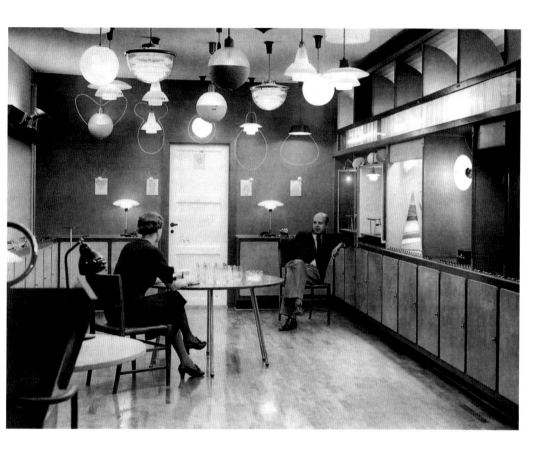

△ Poul Henningsen in the "demonstration room" he designed for Louis Poulsen in Nyhavn in 1939

in Finland. These "shadow-free" lamps with their three highly effective light-diffusing shades were also used in large public buildings, such as the Cologne Railway Station in 1929, as well as in smaller domestic and commercial premises. By 1931, 30,000 *PH* lamps had been sold around the world. Louis Poulsen managed to survive the Second World War, and during the post-war years continued to expand by establishing international subsidiaries and commissioning other well-known designers, such as **Arne Jacobsen**, King & Miranda and Alfred Homann, to design domestic and contract lighting products for the company. By 1997, Louis Poulsen had a workforce of 1,090 and wholly-owned subsidiaries in Germany, Sweden, Norway, Finland, Britain, Holland, France, Switzerland, Australia, Japan and the United States of America. Today, the company continues to produce Poul Henningsen's once-revolutionary designs, alongside classic designs by Arne Jacobsen and **Verner Panton**, as well as some of the most innovative architectural and street lighting currently available.

▽ Poul Henningsen, design for the *Type II A PH* hanging lamp for Louis Poulsen, 1924

▷ German catalogue page showing *PH* lamps by Poul Henningsen for Louis Poulsen, 1930s

▽▽ Plan of the Louis Poulsen stand for the 1929 "Exposición Internacional de Barcelona" – showing the full *PH* lighting range designed by Poul Henningsen for Louis Poulsen

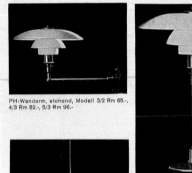

PH-Wandarm, stehend, Modell 3/2 Rm 65.-, 4/3 Rm 82.-, 5/3 Rm 96.-

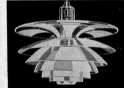

PH-Tischleuchte, Modell $3^1/_2$ / $2^1/_2$ Rm 56.-, 4/3 Rm 70.-, 5/3 Rm 83.-

PH-Hängeleuchte, niedrig hängend, Modell 4/3 Rm 38.-, 5/3 Rm 47.-, 6/3 Rm 99.-

PH-Siebenschirm-Leuchte Rm 190.-

typo canis

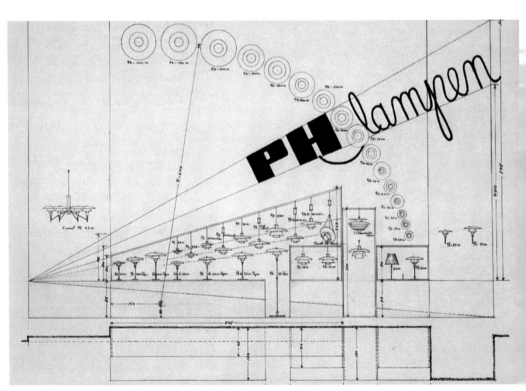

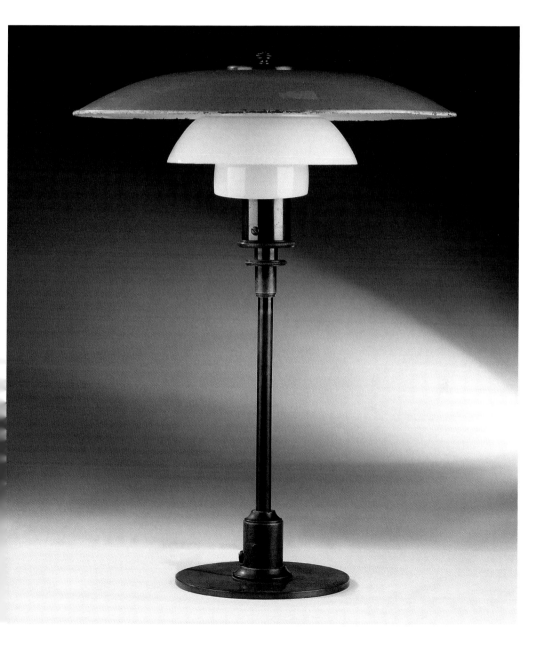

▷ Poul Henningsen, *PH Louvre* lamp for Louis Poulsen, 1957

▽ ◁ Cover of Louis Poulsen catalogue showing large *PH Spiral* lamps by Poul Henningsen, 1968

▽▷ Poul Henningsen, *PH Artichoke* lamp for Louis Poulsen, 1957

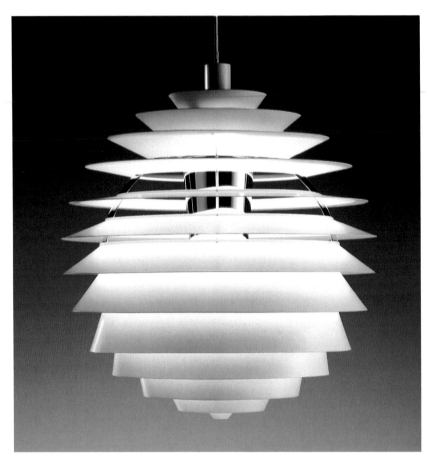

LOUIS POULSEN & CO A/S

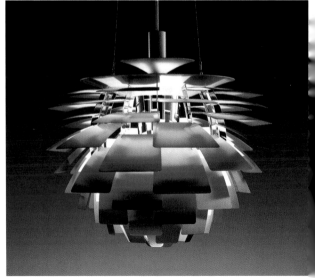

▽ Louis Poulsen advertisement
showing *PH* lamps and the
company's headquarters on
the Nyhavn canal in Copen-
hagen, 1960s

OVERLEAF
◁ Vilhelm Wohlert, *Satellite
Pendant* lamp for Louis
Poulsen, 1959

▷ Louis Poulsen, *Enamel
Pendant* lamp for Louis
Poulsen, 1930

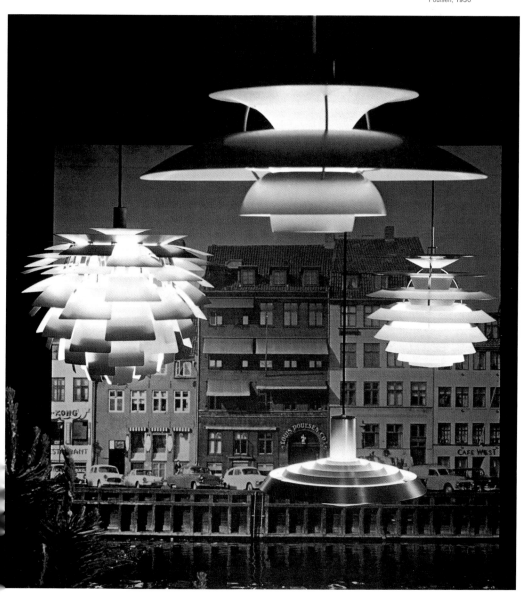

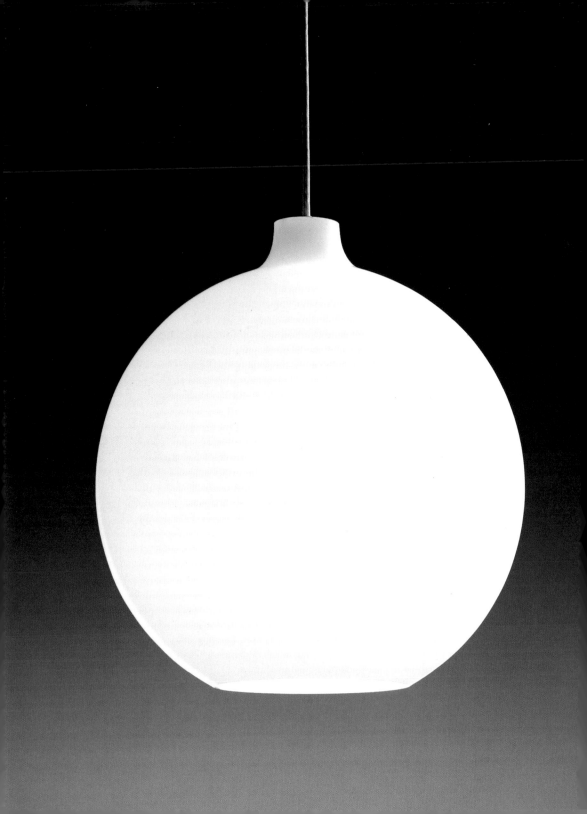

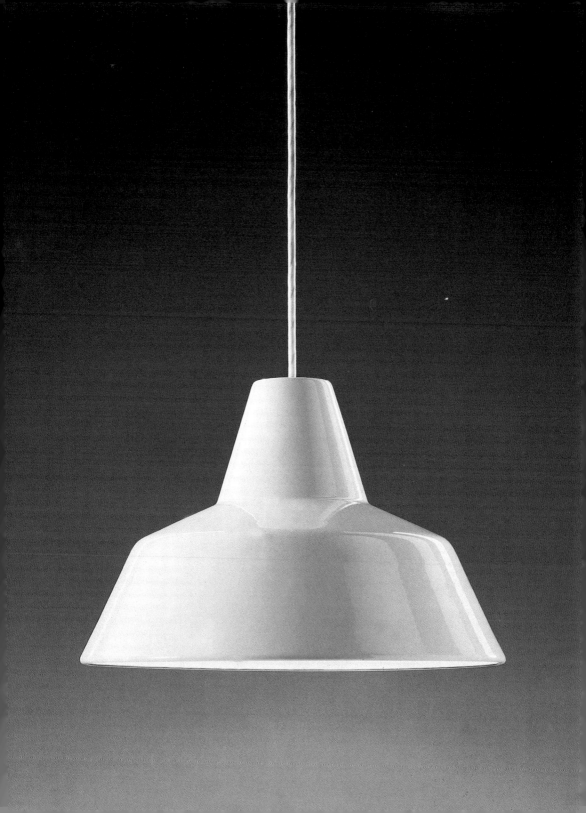

▷ Gunnar Magnússon, *Inka*
(Inca) chair for Nyvirki Ltd.,
1963

▷▷ Gunnar Magnússon,
*Apollo* chair for Kristján
Siggeirsson, 1967

# gunnar magnússon (b. 1933 Ólafsfjördur, Iceland)

One of the leading Icelandic furniture designers, Gunnar Magnússon studied carpentry at the Reykjavik Polytechnic, graduating in 1955. He worked as a carpenter in Reykjavik and Copenhagen until 1959, when he began studying furniture and interior design at the Skolen for Brugskunst (School of Applied Arts), Copenhagen. After graduating in 1963, Magnússon began designing furniture for a number of Danish manufacturers and architects in Copenhagen. The same year he also designed the upholstered pine *Inka* (Inca) chair, which with its exposed construction and squared form projected both directness and purposefulness – common characteristics of Icelandic design. With its use of uncompromising geometric shapes, this design predicted the trend towards more rational forms that took place in Scandinavia during the1970s. In the early 1960s, Magnússon received a number of awards for beds and tables (1962) that he had designed while still a student, and was also awarded fourth prize in the *Daily Mirror's* first "International Furniture Design Competition" for a suite of bedroom furniture that was notable for its strong geometric forms. In 1964 Magnússon returned to Reykjavik and established his own office special-

izing in the design of furniture and interiors for offices, banks and homes, as well as for ships and airplanes. In 1967, he designed his moulded plywood *Apollo* chair, which was inspired by the staging sections of NASA's *Saturn V* moon rocket used for the Apollo space missions, and was based on the constructional concept of "a central point and two types of curve". As the leading Icelandic designer during the 1970s, Magnússon was commissioned to design the chess table used for the famous 1974 World Chess Championship match between Bobby Fischer and Boris Spasski held in Reykjavik. Magnússon's furniture designs reflected the Icelandic penchant for elemental constructions and functional directness and were included in a number of design shows both at home and abroad, most notably the prestigious Copenhagen Cabinetmakers' Guild Exhibitions.

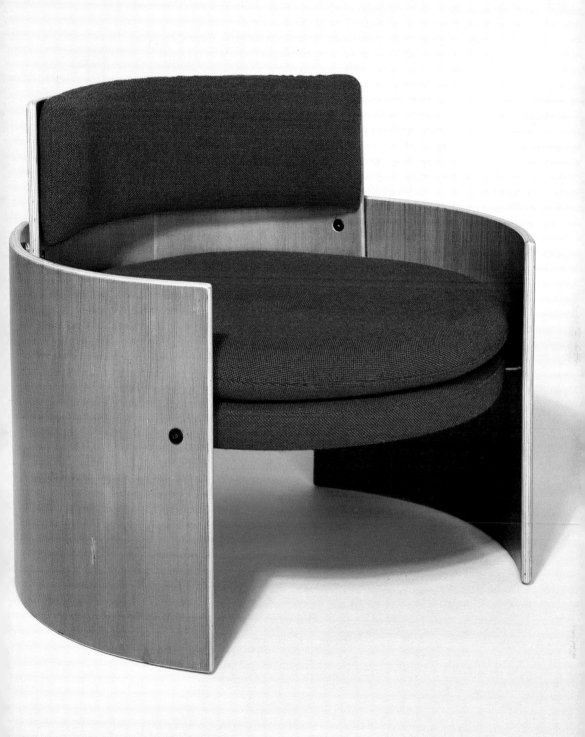

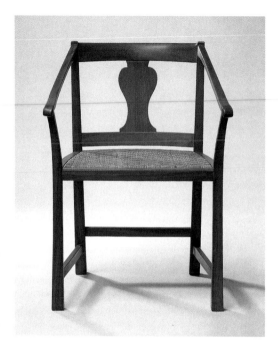

▷ Carl Malmsten, walnut
armchair made in Carl Malm-
sten's workshop in Stockholm,
1915 – With the design for
this chair, Malmsten won a
competition for the interior
design of Stockholm City Hall
thus establishing himself as
a major force in Swedish
furniture design

▷▷ Carl Malmsten, design for
chairs and desk, c. 1912

# carl malmsten *(b. 1888 Stockholm, Sweden – d. 1972)*

One of the leading Swedish furniture designers of the 20th century, Carl Malmsten trained at the Påhlmanns Handelsinstitut and the Stockholms Högskolan (University of Stockholm) in Stockholm until 1908. He also briefly studied economics in Lund in 1910. Between 1910 and 1912, Malmsten served an apprenticeship with the cabinetmaker Per Jönsson and from 1912 to 1915 he studied architecture and handicrafts with the architect Carl Bergsten. In 1916, Malmsten established his own studio in Stockholm and began working as a free-lance furniture and interior designer. The same year, he won first and second prize in a competition for the design of furniture for the Stockholm City Hall. The following year his furniture designs were displayed at the Blanchs Konstsalon exhib-ition in Stockholm. During the late 1910s and 1920s, Malmsten was one of the leading avant-garde designers in Sweden. His work, which mainly comprised modern reworkings of Gustavian forms, was distinguished by functional simplicity and for-mal clarity. Although he was convinced of the need for a modern approach to design, he also believed that it was important to remain true to the cultural roots of Swedish peasant art, which he saw as

a means of providing his product solutions with warmth and character. While the austerity of his furniture anticipated the Modern Movement, Malm-sten rejected the stark and alienating Modernism of the buildings and interiors at the 1930 Stock-holm Exhibition, declaring "Moderation lasts. Extremism palls … and in any event there is always a place for some of both, and every conceivable degree of variation between the two." The same year as this landmark exhibition, he founded the Carl Malmstens Verkstadsskola (Handicraft School) in Stockholm, presumably in opposition to the pure functionalism being championed by designers such as **Erik Gunnar Asplund**. Apart from his design and teaching work, he also headed his own com-panies, Firma Carl Malmsten (from 1933) and Carl Malmsten AB (from 1944). Throughout his career Malmsten promoted a humano-centric approach to design – near the end of his life, in the late 1960s and early 1970s, he co-designed with his son Vidar a range of furniture suited to the needs of geriatric users, which included chairs with raised seat heights, straight backs and upward curving armrests to facilitate sitting, resting and rising. By synthesizing traditional European styles with

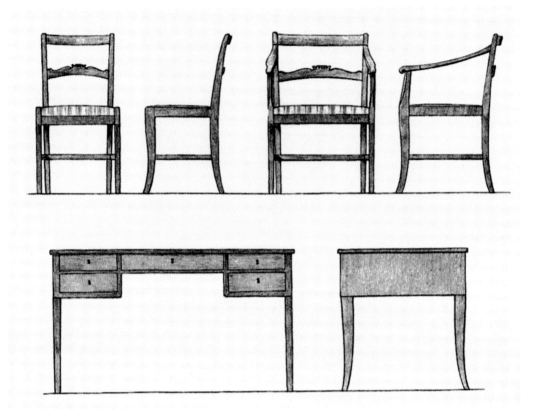

Swedish vernacularism and simplified, functionalist
forms, while stressing the importance of production
quality, elegant proportions and practical utility,
Malmsten developed a hybrid idiom from which
modern Swedish design would evolve. The influ-
ence of his work on later Swedish designers, such
as **Bruno Mathsson**, cannot be overstated.

▷ Marimekko store at
Kalevankatu 4, Helsinki,
early 1960s

# marimekko *(founded 1951 Helsinki, Finland)*

The origins of the internationally celebrated Finnish textile company Marimekko can be traced to a textile printing company known as Printex, which had been established by Viljo Ratia (b. 1911) in 1949 in response to the dire shortage of clothing in Finland during the immediate post-war years. His wife, Armi (1912–1979), who had trained at the Ateneum School of Art, decided that it was important to manufacture textiles that were different from what was already on the market, which for women at the time mainly comprised rather drab printed florals. Armi subsequently designed a couple of patterns that sold relatively well, but she was not particularly keen on becoming a designer and so began looking for someone else to fill this role. To this end she approached her old friend, the rector of the Ateneum School of Art, Arttu Brummer (1891–1951), who suggested that the company hire **Maija Isola**. Having been duly appointed the principal designer at Printex, Isola devised a number of bold non-figurative silk-screen printed patterns using inexpensive cotton sheeting. In May of 1951, Armi and Viljo Ratia founded a new company, Marimekko – which means "Mari's dress" or, in other words, "a simple everyday dress

without frills" – with the aim of promoting Printex textiles through it for use in interiors and clothing, because although people liked the company's textiles "they did not know how or exactly where to use them." In the Official Register of Trading Associations it was noted that, "The purpose of the (new) company is the production of all kinds of clothes and clothing accessories, including made-to-order, as well as their wholesale and retail, import and export." Marimekko's first collection, which was exceptionally bright and colourful for its time, was launched in the spring of 1951. Although the fashion show was a critical success, it was not a financial one. Worse was to follow over the next few years when the parent company Printex went into bankruptcy. Marimekko struggled to keep afloat, despite receiving huge press interest in its products. In 1953, **Vuokko Eskolin-Nurmesniemi** joined the design team at Marimekko and subsequently devised the company's "anti-fashion" design policy. Setting rather than following trends, Nurmesniemi's landmark clothing designs were born out of her belief in the primacy of form and its relationship to material. The outlines of her clothes were as bold and elemental as the fabrics she

◁ Maija Isola, *Melooni* (Melon) textile for Marimekko, 1963

▽ Various dress designs created for Marimekko by Annika Rimala – clockwise from top left: *Chickweed* (using *Buckwheat* textile – co-designed with Oiva Toikka), 1961; *Plinth* (using *Hatch* textile), 1963; *Circus* (using *Petrooli* textile), 1963; *Glitter* (using *Packet* textile), 1965; *Outfitter* (using *Big Square* textile), 1965; *Line Sign* (using *Gallery* textile designed by Vuokko Eskolin-Nurmesniemi in 1954), 1965; *Balcony* (using *Garden* textile), 1963; *Lupin* (using *Garden* textile), 1963; *Seaweed* (using *Oasis* textile), 1966

▽▽ Fujiwo Ishimoto, *Korsi* textile, 1989 – inspired by Annika Rimala's boldly striped *Tasaraita* textile that had become synonimous with the Marimekko name during the late 1960s and early 1970s

N:o 20
17. 5.
1966

1 :—
(sis. lvv)

△ Magazine cover showing
Marimekko dress designed
by Annika Rimala, 1966

designed for them. Marimekko's projection of its brand image was similarly progressive – the models used in its promotional photography had a very natural look, while the clothes "appeared to take a back seat". It was not until 1955, however, that the company was able to purchase its own sewing machines, which eventually allowed it to turn the financial corner. In 1958, the international reputation of Marimekko was established when the company exhibited at the World's Fair in Brussels. This exhibition led to a number of export contacts including Benjamin Thompson who began importing Marimekko clothes into the United States in 1959. A year later Jacqueline Kennedy during her husband's presidential campaign bought seven of the company's dresses at Thompson's Design Research Store in Cape Cod, which helped Marimekko gain considerable publicity. As Viljo Ratia remembered, "Jacqueline was criticized for her expensive Paris fashions. So it was a choice morsel for the Kennedy press (team) when they could tell their readers that Mrs Kennedy had just bought some inexpensive Finnish cottons." Certainly Marimekko bucked the trend by insisting on the use of 100% cotton rather than on the new wonder material – nylon. In 1959, Armi Ratia met the designer Annika Rimala (b. 1936), who the following year took over from Vuokko Eskolin-Nurmesniemi – who left Marimekko to start her own company, Vuokko Oy – as artistic director of Marimekko. Rimala's early textile designs, such as *Hilla* (Cloudberry), were rather subdued, but these were soon followed by bolder and more brightly coloured textiles that had an attention-grabbing, youthful appeal. The simple, chic yet casual clothes pioneered at Marimekko by Rimala, including the rather curious *Ryppypeppu* dungarees (1965) with their ruched behind, were similarly unconventional. Appealing in particular to professional creatives, Marimekko clothing was described by the influential American *Women's Wear Daily* as virtually a "uniform for intellectuals". Just as the swinging Sixties were drawing to a close and about to be overtaken by the more thoughtful and conformist 1970s, Rimala introduced her versatile *Tasaraita* collection in 1969. Made from her trademark even-striped tricots, this landmark range of clothing (comprising T-shirts, nightgowns, underwear and shirts) was intended to complement the growing fashion for blue jeans. Easy-to-wear and casual,

△ ◁ Annika Rimala, *Petrooli* textile for Marimekko, 1965

△ Marimekko dress and hat featured on the cover of *Mobilia*, January 1964

the *Tasaraita* collection was an instant success with its basic blue-and-white and red-and-white stripes, and in some ways mirrored the colourful yet no-nonsense simplicity of the emerging High-Tech style that was being pioneered in Scandinavia by among others **Johan Huldt** and **Jan Dranger**. From the mid-1960s to the present, Marimekko has also produced innovative textiles and clothing by other designers, including Liisa Suvanto (1910–1983), Fujiwo Ishimoto (b. 1941), Katsuji Waki-saka (b. 1944), Pentti Rinta (b. 1946), Marja Suna (b. 1934), Ristomatti Ratia (b. 1941), Albert Turick (b. 1953) and most recently Antti Eklund (b. 1960). Although Marimekko was sold after Armi Ratia's death in 1979, the company enshrined her core belief that "You have to be different" – a principle that has stood the company in good stead for over fifty years. Through its pioneering textiles and clothes Marimekko not only brought Finnish design to a wider international audience, but also played an instrumental role in defining some of its key attributes – bold outlines, bright colours and innovative forms.

▷ Sven Markelius, textile for
Nordiska Kompaniet, 1958

# sven markelius

*(b. 1889 Stockholm – d. 1972 Stockholm, Sweden)*

The Swedish architect and designer Sven Marke-
lius studied at the Kungliga Tekniska Högskolan
(Royal Institute of Technology), Stockholm, from
1909 to 1913 and later trained at the Kungliga
Akademien för de fria Konstrena (Royal Academy
of Fine Arts) from 1913 to 1915. He then served
an apprenticeship in the architecture practice
of Ragnar Östberg (1866–1945), where he
assisted in the design of the façade of Stock-
holm's City Hall. Markelius's language of design
was initially inspired by Romanticism and then
later by Neo-Classicism. After becoming aware of
Le Corbusier's (1887–1965) architecture and the
ideas emanating from the Bauhaus, he began to
embrace Modernism. For the 1930 Stockholm
Exhibition, he designed exhibition buildings as well
as an interior that included an innovative orange-
lacquered beech and linoleum writing desk (1930),
which was manufactured by Nordiska Kompaniet.
He also exhibited a lounger at the Stockholm Fair
that was remarkable for its pioneering undulating
organic form. In 1932, he designed the concert
hall in Helsingborg, which included site-specific
functionalist stacking chairs. He also designed
the Swedish pavilion for the 1939 New York
World's Fair, which brought him widespread
international recognition. From 1938 to 1944 he
was a member of the Building Administration in
Stockholm, and after the Second World War was
elected to the United Nations Planning Board
and was a member of the UNESCO Arts and
Building Committees. From 1944 to 1954, Marke-
lius headed the Stockholm Planning Office and
devised a scheme for expanding the city, which
included suburban communities known as "town
sections". During his career, he designed numerous
buildings in Sweden, including the Building Union's
headquarters and the People's House in Stock-
holm, and also assisted in the design and planning
of the United Nations building in New York. During
the 1950s, Markelius also designed a range of
printed textiles with **Astrid Sampe** for Nordiska
Kompaniet, which were marketed by Knoll Textiles.
His *Pythagoras* textile (1952) reflected his continu-
ing interest in strong geometric forms. As one of
the most important pioneers of modern design
in Sweden, Markelius' work exemplified the less
dogmatic Scandinavian approach to Modernism –
his wooden furniture, for example, while plain
and undecorated, rejected the functionalist

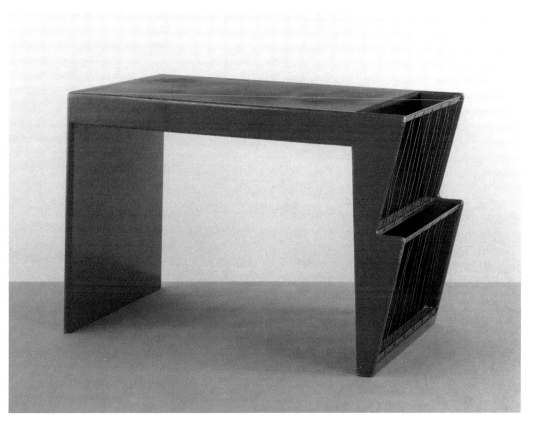

machine aesthetic of the Bauhaus in favour
of a more humanistic language of design.

△ Sven Markelius, writing desk
for Nordiska Kompaniet, 1930

▽ Sven Markelius, sitting room
installation for Nordiska Kom-
paniet that was exhibited at
the 1930 Stockholm Exhibition
– This landmark exhibition
established him as one of
the foremost exponents of
Swedish Functionalism or
"Funkis" during the 1930s

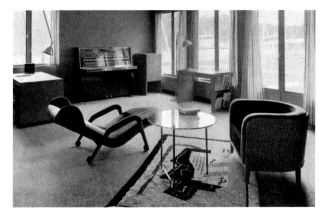

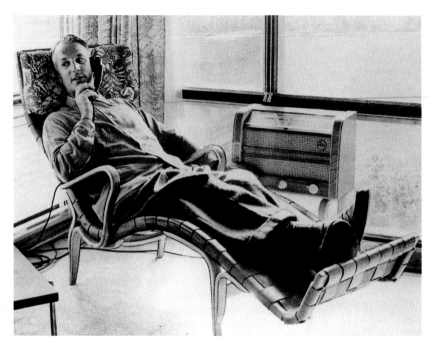

▷ Bruno Mathsson in his
glasshouse in Värnamo,
1950

▷▷ Bruno Mathsson, *Eva* chair
for Karl Mathsson, 1933–1936
– originally known as the
*Arbetsstol* (Working Chair)

# bruno mathsson

*(b. 1907 Värnamo – d. 1988 Värnamo, Sweden)*

Alongside **Carl Malmsten** and **Erik Gunnar Asplund**, Bruno Mathsson is recognized as one of the great pioneers of modern Swedish furniture design. He trained as a cabinetmaker with his father Karl Mathsson, and from 1933 designed furniture mainly for his family's business Firma Karl Mathsson in Värnamo. During the early 1930s the "Funkis" movement dominated Swedish design practice with designers such as **Axel Larsson** and **Sven Markelius,** producing functionalist furniture designs in wood with strong geometric forms. In contrast, Mathsson promoted a new approach to the design of seat furniture that involved the use of soft undulating organic forms, which were better suited to the shape of the user. Believing that furniture should be designed for how people sit naturally, Mathsson designed his seating from an ergonomic perspective with its contours closely echoing the form of the human body. For added flexibility and comfort he also made great use of breathable jute or hemp webbing, which did away with the need for bulky upholstery. The first chair Mathsson designed using these principles was his *Arbetsstol* (Working Chair). Developed between 1933 and 1936,

the *Arbetsstol* not only afforded the sitter greater comfort but both aesthetically and philosophically it represented an important generational shift in Swedish design, from geometric Functionalism to organic Modernism. Mathsson's furniture signalled a new sculptural confidence in Scandinavian product design, though this became a defining feature more strongly associated with Danish and Finnish design than Swedish design during the postwar years. It is often overlooked that Mathsson's highly organic *Arbetsstol* and *Pernilla* chaise longue (c. 1934), both with bent laminated wood frames, woven hemp webbing and solid beech seat frames, predate **Alvar Aalto**'s similarly constructed *Model no. 43* chaise longue (1936) and *Model no. 406* chair (1936–1939). Although Mathsson's designs were less utilitarian than Aalto's, they were more ergonomically resolved and were somewhat more forward-looking. In 1936, Mathsson was given a one-man show at the Röhss Museum for Design and Applied Art, Gothenburg, and a year later he participated in the 1937 Paris "Exposition Internationale des Arts et Techniques dans la Vie Moderne". Between 1945 and 1957 he mainly concentrated on architecture,

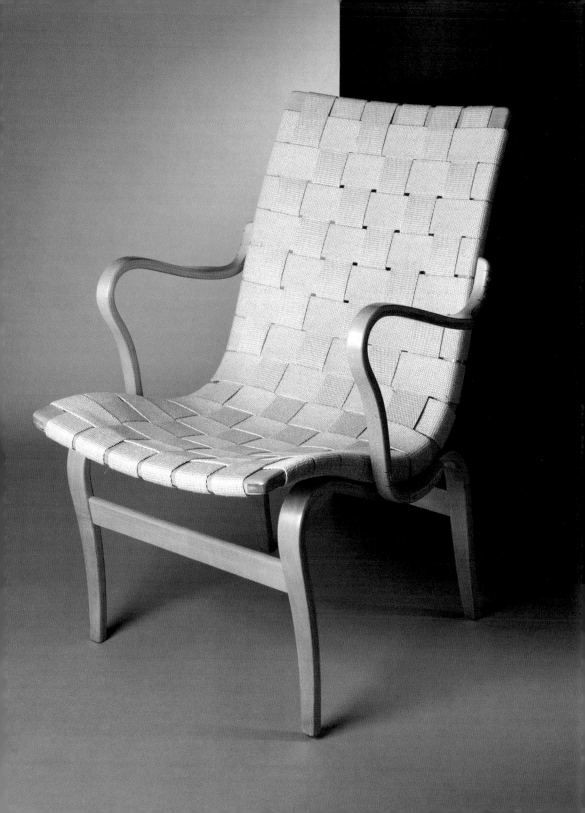

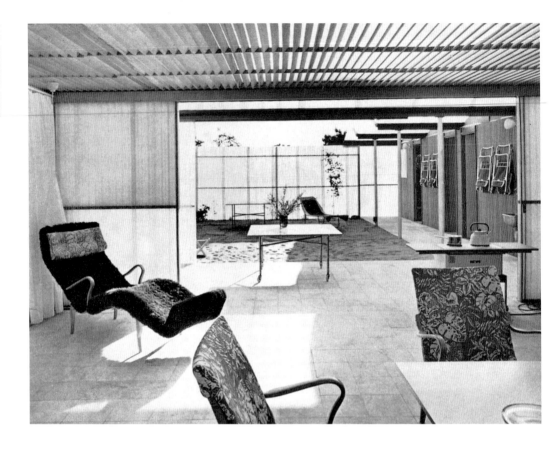

△ Living area in Bruno Maths-
son's own summerhouse in
Frösakull, 1961

▷▷ Bruno Mathsson, *Pernilla*
lounge chair for Karl Mathsson,
c. 1934

designing several simple structures in glass, wood
and concrete for use as summerhouses and
schoolrooms. He took over the management of
the Firma Karl Mathsson in 1957 and from 1958
began developing furniture in collaboration with
the mathematician and designer **Piet Hein**, which
included the famous *Superellipse* table (1964)
that was later manufactured by **Fritz Hansen**.
Mathsson also designed furniture for DUX Indus-
trier in Trelleborg, including most notably the *Karin*
chair (1968) – a proto-High-Tech design with a
tubular metal frame and hemp canvas seat/back
sling with upholstered cushions. As one of Swe-
den's leading mid-century designers, Mathsson
was awarded the Gregor Paulsson Trophy in
1955 and his furniture was exhibited in numerous
one-man shows and a number of hugely influential
group exhibitions, including the 1939 New York
World's Fair, the 1946 Copenhagen "Svenska
Form" (Swedish Form), the 1955 Helsingborg
"H55", the 1957 Berlin "Interbau" and the Paris
1958 "Formes Scandinaves". Throughout his
career, Mathsson devoted himself to the continual
refinement of ideal types based on structural puri-
ty and humano-centric logic. The fact that his

chairs remain in production today must be seen
as a vindication of his guiding belief in the suc-
cess and abiding appeal of these values. When in
1978 DUX Industrier took over Firma Karl Maths-
son and the production of Mathsson's furniture, it
changed the name of the *Working Chair* to *Eva*.

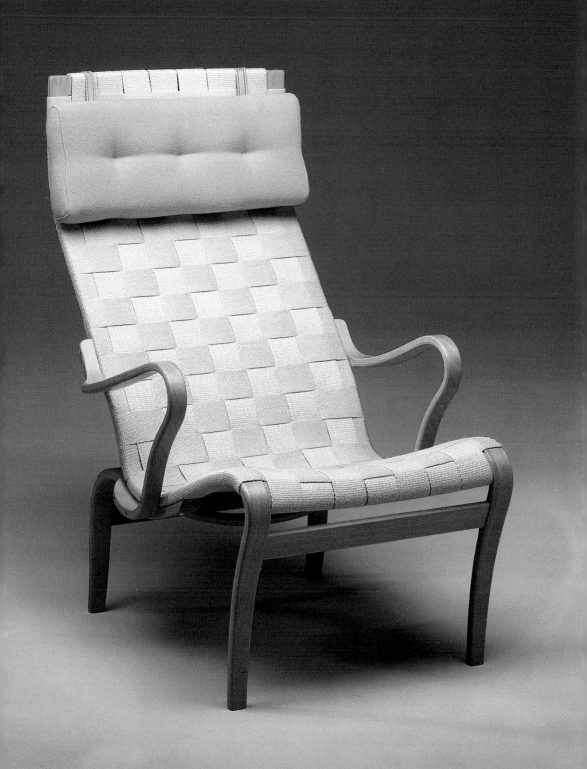

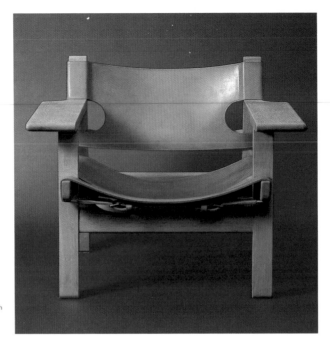

▷ Børge Mogensen, *Model no. 2226 Spanish* chair for Fredericia Furniture, 1959 – Based on a vernacular Spanish chair, this design delights in the natural and humanizing qualities of its materials

# børge mogensen
*(b. 1914 Aalborg – d. 1972 Copenhagen, Denmark)*

The well-known Danish furniture designer Børge Mogensen studied at the Kunsthåndværkerskolan (School of Arts & Crafts), Copenhagen, from 1936 to 1938. He later trained under **Kaare Klint** at the furniture school of the Kongelige Danske Kunstakademi (Royal Danish Academy of Fine Arts), Copenhagen, from 1938 to 1941. Under Klint's guidance, Mogensen studied the proportions of a number of "ideal types", such as the traditional English *Windsor* chair, and was encouraged to update forms such as these within a modern idiom. Klint's pioneering studies into anthropometrics – the systematic collection and correlation of measurements of the human body – also had a significant formative influence on Mogensen's work. In 1940, he began designing furniture specifically for young people – a completely novel endeavour at the time – under the "Hansen's Attic" and later "Peter's Bedroom" labels. Between 1942 and 1950, Mogensen headed the furniture design section of the Association of Danish Cooperative Wholesale Societies and designed simple utilitarian pieces. In 1944, he designed an armchair closely based on a traditional English *Windsor* chair and the simple yet refined beech and paper-

cord *J-39 Shaker* chair, which was strongly influenced by the purity and integrity of American Shaker furniture. Importantly, this latter design incorporated standardized components and was one of the first Danish furniture designs to speculate on industrial mass-production. A year later, Mogensen designed his well known *Model no. 1789* sofa that was similarly inspired by earlier precedents. Between 1945 and 1947, he also worked as an assistant to Klint at the Kongelige Danske Kunstakademi. In 1950, he established his own studio and subsequently designed furniture for Søborg Møbelfabrik, Fredericia Furniture and Karl Andersson & Söner. Mogensen also undertook ergonomic research, which resulted in the *Öresund* (1957) and *Boligens Byggeskabe* (1956) cabinet-storage systems designed in collaboration with Grethe Meyer. Like his mentor, Kaare Klint, Mogensen's approach to furniture design involved the reworking of traditional types, as his *Spanish* chair (1959) and *Asserbo* chair (1964) most notably demonstrate. His furniture was distinguished by the frequent use of attractive blond beech wood, masculine proportions and superlative craftsmanship, which reflected the skill of the

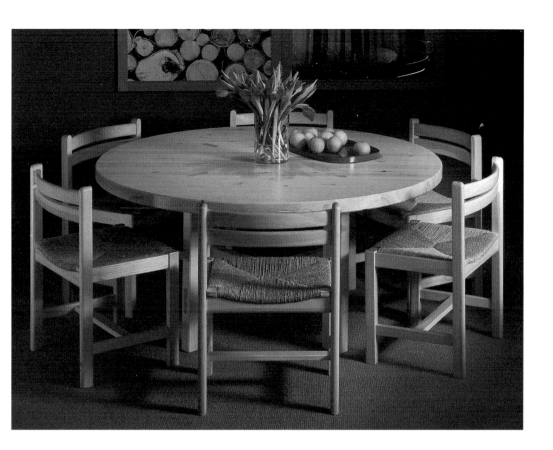

Danish cabinetmakers he worked with, most notably Erhard Rasmussen. From 1953, he also co-designed with **Lis Ahlmann** several furnishing textiles for C. Olesen. Above all else, Mogensen's well-designed and well-executed furniture epitomizes Danish design – the use of natural materials, simplicity, high-quality construction and the re-interpretation of historically successful forms.

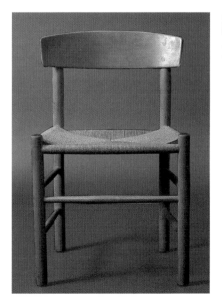

△ Børge Mogensen, *Asserbo* chairs for Karl Andersson & Söner, 1964

◁ Børge Mogensen, *Shaker J-39* chair for FDB, 1944

▷ Børge Mogensen, room
with teak furniture designed
1947 – The sofas were uphol-
stered with a textile that was
designed by Lis Ahlmann

▽▷ Børge Mogensen, teak
chair executed by Erhard
Rasmussen, 1949 – A contem-
porary commentator noted of
this design, "Børge Mogensen
has created a product which
will serve as a model for future
chairs."

▽◁ Børge Mogensen, drawing
for *Model no. 1789* sofa, 1945

▽▽ Børge Mogensen, design
for teak chair, 1949

▷▷ Børge Mogensen, *Model
no. 1789 Spindle Back* sofa
for Fritz Hansen, 1945 – Like
many of Mogensen's designs
this sofa was a modern reinter-
pretation of a traditional
seating type

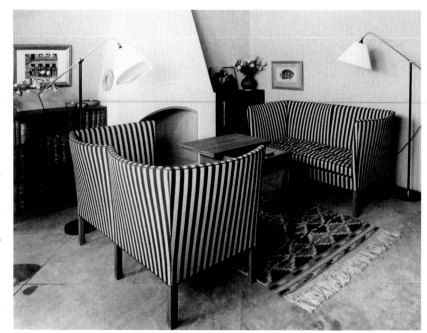

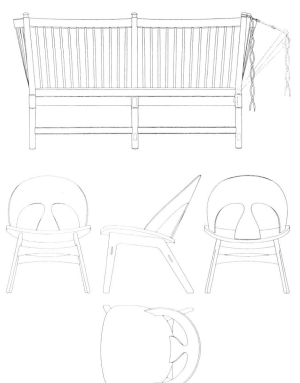

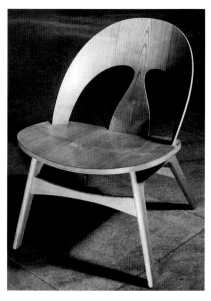

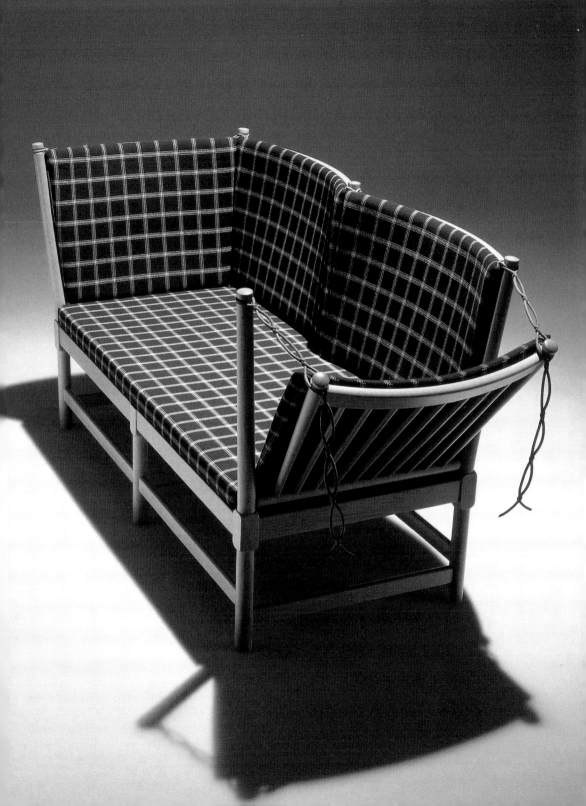

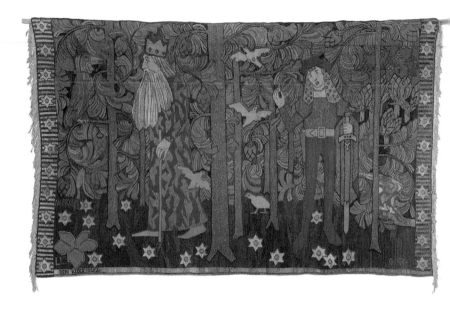

▷ Gerhard Munthe, *Den Klogefugl* tapestry,1903

# gerhard munthe *(Norwegian 1849–1929)*

Gerhard Munthe studied painting under J. F. Eckersberg (1822–1870), Knud Bergslien (1827–1908) and Julius Middlethun in Oslo. He also trained in Düsseldorf in 1874 and from 1877 to 1882 lived and worked in Munich. In 1886, Munthe with fellow artists Christian Skredsvig (1854–1924), Harriet Backer (1845–1932), Kitty Kielland (1843–1914), Eilif Petersen (1852–1928) and Erik Werenskiold (1955–1938) established an artists' collective at the Fleskum farm in Dælivannet, some fifteen kilometres west of Oslo (then known as Christiania). During what has become known as the "Fleskum Summer", the collective pioneered a Neo-Romantic style that reflected Norway's desire to assert its own cultural identity. The group was also inspired by Japanese art thanks to the recent publication of Karl Madsen's *Japansk Malerkunst* (1885), which was the first Scandinavian book to explore Japanese painting. During the late 1880s and early 1890s, Munthe's textiles and wallpaper designs (many now in the collection of the Oslo Museum of Applied Art) and under-glaze ceramics – such as his *Blue Anemone* service produced by the Porsgrund porcelain factory (1892) – were strongly influenced by the art of Japan, with some

incorporating *Mon* style motifs while others were inhabited by swirling koi carp and stylized cranes. Inspired on the one hand by Japanese art and on the other by the cultural strength of the artistic community in Denmark, in the winter of 1890–1891 Munthe developed the idea of revitalizing the decorative arts of his own country by pioneering a distinct Norwegian aesthetic. He subsequently drew inspiration from ancient Norwegian legends as well as his country's indigenous flora and fauna. In his designs he also incorporated motifs found in medieval "dragon-style" woodcarvings and folk art tapestries. His bold Neo-Viking narrative tapestries were exhibited at the 1900 Paris "Exposition Universelle et Internationale" and – alongside work by other Scandinavian designers – led a commentator in the *Studio* magazine (1901) to note that, "In these remote countries a powerful art movement is forcing its way into the general art development of Europe." Munthe believed that tradition was not "ancient romance or history" but a crucial element in "the developing power of the nation itself". He attempted to bring about a dynamic synthesis of the past and the present so as to realize objects that were infused with a vital national spirit. As the

◁ Gerhard Munthe, chair from the *Fairy Tale Room* at Holmenkollen Tourist Hotel, 1896

▽ Gerhard Munthe, *Fairy Tale Room* at Holmenkollen Tourist Hotel, 1896

▽▽ Gerhard Munthe, *Blue Anemone* service for Porsgrund, 1892

greatest proponent of the Viking Revival, Munthe's work was imbued with a strong symbolism that reflected the Norwegians' overwhelming desire for cultural, social and political autonomy. His decoration of the medieval Håkon Hall in Bergen was generally acknowledged as the culmination of the National Romantic movement in Norway – sadly, however, it was destroyed during the Second World War.

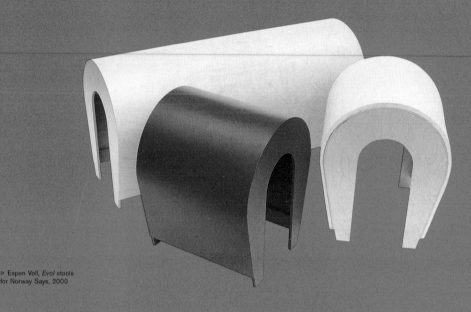

▷ Espen Voll, *Evol* stools
for Norway Says, 2000

# norway says *(founded 1999 Oslo, Norway)*

While Scandinavian design is renowned the world over, the term is usually associated with products from Denmark, Finland and Sweden rather than Norway, which is better known for its folk art than for designed products. One of the reasons why modern design has not flourished in Norway to the same extent that it has in these other Nordic countries is that since the 1970s, Norway has enjoyed unprecedented prosperity through oil revenues, which in turn has meant that the economic importance of design has been overlooked. In an attempt to readdress this situation, especially now that Norway's oil reserves are predicted to become seriously depleted within the next twenty years, the Norwegian government has at long last begun actively promoting Norwegian design abroad. Against this background of state support, the design group Norway Says was founded in 1999 by five young furniture designers who were studying at, or had recently graduated from either the Statens Håndverks- og Kunstindustriskole (National College of Art and Design), Oslo, or the National College of Art and Design, Bergen. Its five members, Torbjørn Anderssen (b. 1976), Tore Borgersen (b. 1966), Andreas Engesvik (b. 1970), Frode

Myhr (b. 1974), and Espen Voll (b. 1965), initially formed the group with a view to collectively showing their work at the Salon Satellite at the Milan Furniture Fair in 2000. Sponsored by among others the Norwegian Ministry of Foreign Affairs, the group was eventually "able to put their own prototypes in a van and drive the 2,500 kilometers down to Milan." This first group exhibition included a number of innovative and elegant designs, such as the *Dock* chair (2000) designed by Espen Voll and Tore Borgersen, the *Comfort Living* multi-functional chaise longue (1998) by Andreas Engesvik, the *24 Meccano* modular storage system (2000) by Torbjørn Anderssen, and the *Kazu* ceiling lamp (2000) by Frode Myhr. This work consciously rejected "the over-representation of cabin-looking furniture all made of pine" and was born out of the belief that "design is an essential tool in manufacturing good everyday products." Later in 2000, the Norway Says group participated in the London "Designers Block" exhibition. Efforts such as these to promote Norwegian design both at home and abroad may well enable the "little brother" of Scandinavia to finally assert its own distinctive cultural identity within the international design community.

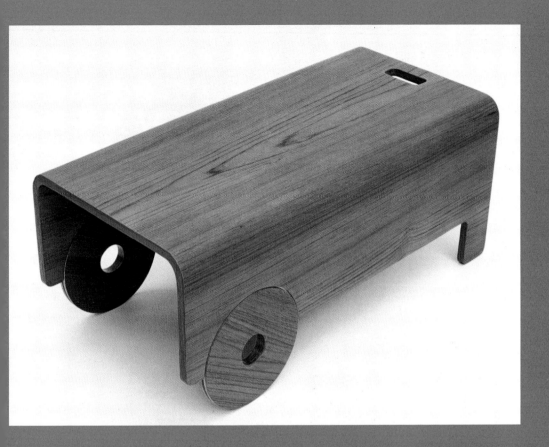

Torbjørn Anderssen has summed up the goals of the group: "I want to make everyday objects for everyday people. Needs and demands are important. Personal expression is not a goal, but a way of getting there" – sentiments that are in complete accord with the philosophical precepts of Scandinavian design.

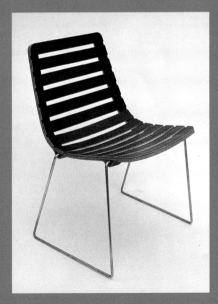

△ Espen Voll, *Hole* table for Norway Says, 2000

◁ Tore Borgersen & Espen Voll, *Dock* chair for Norway Says, 2000

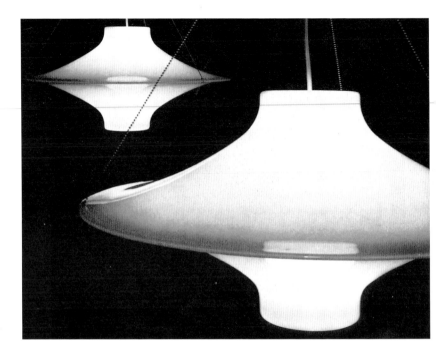

▷ Yki Nummi, white opaline glass pendant lamps for Stockmann-Orno, c. 1963

▷▷ Yki Nummi, *Modern Art* acrylic table lamp for Stockmann-Orno, 1955

# yki nummi *(Finnish b. 1925 China – d. 1984)*

Born in China, Yki Nummi was one of the leading Scandinavian lighting designers of the mid-20th century. During the immediate postwar years he studied mathematics and physics in Helsinki and Turku (1945–1947) and also trained as a "decorative" painter at the Taideteollinen Korkeakoulu (University of Art and Design) in Helsinki (1946–1950). From 1950 to 1975, Nummi designed numerous lamps and light fittings for Stockmann in Helsinki – the largest department store in Scandinavia. Many of his lighting designs produced by Stockmann-Orno were remarkable for their use of new materials – acrylic resins, opaline glass, and aluminium – such as his best-known design the *Modern Art* table lamp (1955), which incorporated a section of clear acrylic tubing that functioned as a "transparent" support for the translucent shade. His designs were also often distinguished by their use of innovative forms, as demonstrated by his space-age white opaline glass pendant lights from around 1963. Nummi was also highly regarded as a colour specialist, and from 1958 he headed the colour section of the paint manufacturing company Schildt & Hallberg. He was responsible for the colour schemes of the cathedral in Helsinki and the new garden city of Western Tapiola, and collaborated with fellow lighting designer **Lisa Johansson-Pape** on colour selections for Stockmann-Orno in Kerava. His innovative designs won gold medals at the 1954 (X) and 1957 (XI) Milan Triennale, and his work was included in numerous international design shows, including the influential "Design in Scandinavia" exhibition that toured Canada and the USA 1954–1957, and the landmark 1955 Helsingborg "H55" exhibition. As an extremely versatile designer and gifted draftsman Nummi designed a wide range of products, from silverware and floor-coverings to radio cabinets and furniture. He also wrote several articles on lighting design, colour theory, and the philosophical principles governing design practice. Through their innovative use of new materials and production techniques and adoption of unusually forward-looking forms, Nummi's lighting designs exemplified the alternative and rather elitist approach to Modernism that was common in Finland in the 1950s and early 1960s.

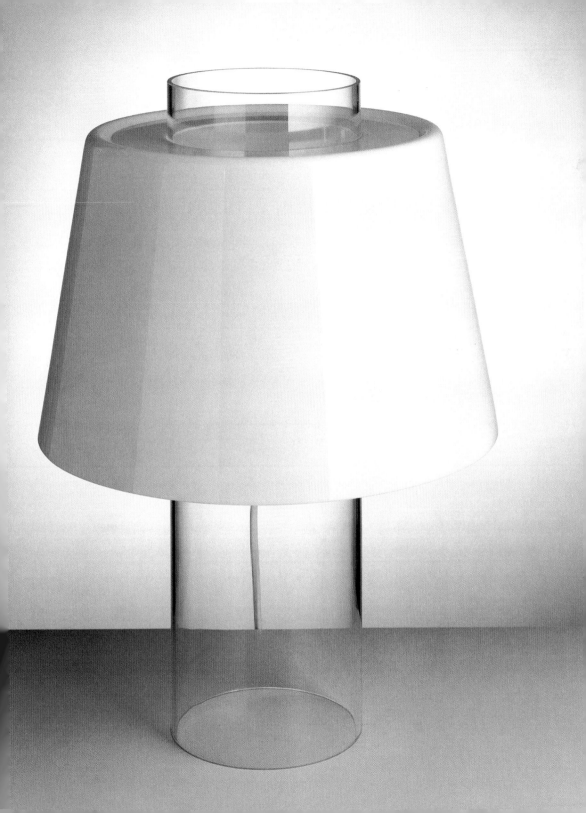

> Antti Nurmesniemi, *Sauna* stools for G. Söderström, 1952 – This horseshoe-shaped birch and teak stool was designed site-specifically for the Palace Hotel, Helsinki

>> Antti Nurmesniemi, enamelled steel coffee pot for Wärtsilä, 1957

# antti nurmesniemi

## (b. 1927 Hämeenlinna, Finland)

The well-known Finnish designer Antti Aarre Nurmesniemi designed and constructed model airplanes as a child and later undertook a training course in gliding at the Jämijärvi school of aviation. During the Second World War, he worked in a metal workshop and an aircraft factory repairing planes for the war-effort. This early hands-on work experience at the Kuorivesi plane factory gave Nurmesniemi a crucial understanding of the inherent properties of wood and metal that would later inform his work as a designer. After the cessation of hostilities, **Alvar Aalto** brought the New York Museum of Modern Art's "America Builds" exhibition from Stockholm to Helsinki. According to Kaj Kalin, this landmark show gave Nurmesniemi "a new, modern view of the world". In fact, he was so inspired by what he saw that he enrolled at the Taideteollinen Korkeakoulu (University of Art and Design), Helsinki, in 1947. Significantly for Nurmesniemi's development as a designer, the school had adopted the "Nordic Line" approach to design, which concentrated on both social and technical issues. Between 1949 and 1950, he worked at the Taideteollinen Korkeakoulu (University of Art and Design) in Helsinki and also in the Stockmann

department store's design office, which was then headed by Werner West. To celebrate his graduation in 1950, Nurmesniemi took his first trip abroad to Stockholm and Copenhagen, where he was inspired by the exquisite craftsmanship and organic forms of Danish design. On his return he worked from 1951 to 1956 in the architecture practice of Viljo Revell (1910–1964) and Keijö Petäjä (1919–1988) in Helsinki, which was pioneering a new rationalist approach to architecture in Finland that reflected the continuing influence of the Modern Movement. Nurmesniemi designed various interiors and furniture for the firm, including his well-known horseshoe-shaped *Sauna* stool, which was designed site-specific for the Palace Hotel (1951–1952). In 1953, he married the well-known textile designer **Vuokko Eskolin-Nurmesniemi** and later worked for six months in Giovanni Romano's design practice in Milan, where he was inspired by functional yet stylish products designed by, among others, Marco Zanuso (1916–2001) and Roberto Sambonet (1924–1996). In 1956, he established his own Helsinki-based design practice and a year later, designed his well-known enamelled coffee pots for Wärtsilä – the colours of which (red, yellow

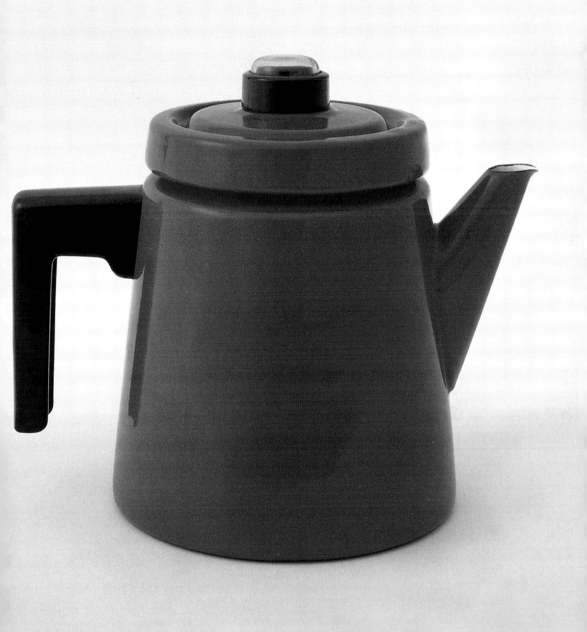

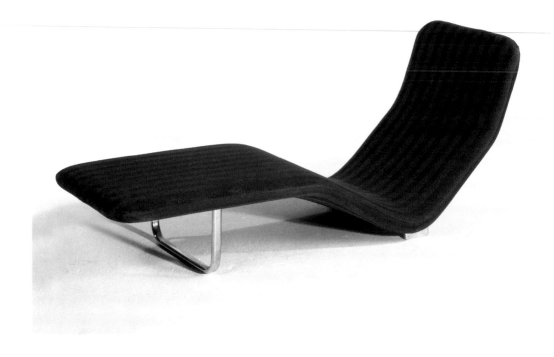

△ Antti Nurmesniemi, *Model no. 001* chaise longue for Vuokko, 1968 – upholstered in a textile designed by Vuokko Eskolin-Nurmesniemi

▷ Antti Nurmesniemi, *Triennale* chair for J. Merivaara, 1960 – This elegant design won a gold medal at the 1960 (XII) Milan Triennale – reissued by Arvo Piiroiinen

and light blue) were chosen by his wife. The design has since become an acknowledged "icon" of Finnish Modernism because it rejected the Baroque-style rounded forms of traditional coffee pots in favour of a more up-to-date industrial aesthetic that also predicted the colourful nature of Scandinavian design in 1960s. Intended for every-day use, Nurmesniemi described his coffee pot as one of only a "few household objects of its day (that) communicated the growing gulf between town and countryside." Later, he designed furniture for **Artek**, Tecta and Cassina, kitchenware for Arabia and Kymi, and trains for the Helsinki metro and Valmet. Among his most successful and characteristic designs were the *Antti* and *Yleispuhelin* telephones (both 1984) for Fujitsu, which reflected his belief that, "An object should not be designed simply to fulfil a purpose (not to mention manufacturing), but for the user. … A simply designed object is wrong, if its use is complicated. … A designed object does not need to reflect the times. It is much better if it offers a hint of the future." Nurmesniemi was awarded a Lunning Prize in 1959 for his refined designs, the distinctive formal vocabulary of which was derived from his synthe-

sization of modern European forms with Scandinavian craftsmanship. Like his compatriot Alvar Aalto, Nurmesniemi was guided by the concept of shared responsibility – both social and environmental – and promoted a humanistic approach to Modernism, which revealed itself in the practical beauty and utility of his products.

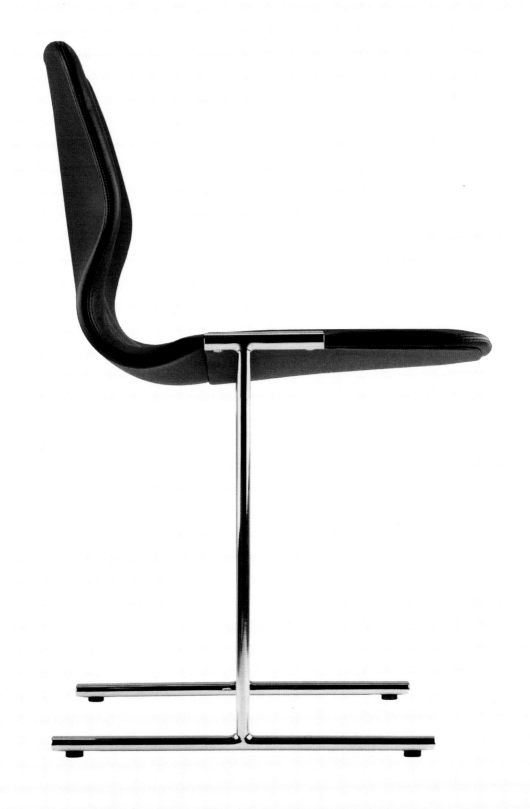

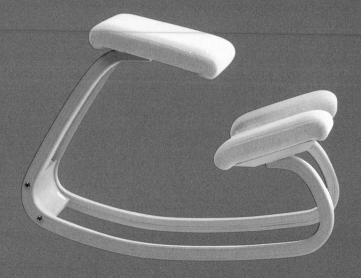

▷ Peter Opsvik, *Balans Variable* sitting tool for Stokke, 1979

# peter opsvik *(b. 1939 Stranda, Norway)*

The leading Norwegian furniture designer Peter Opsvik studied at Bergen College of Applied Art from 1959 to 1963 and the State College of Applied Art in Oslo from 1963 to 1964, prior to working as an industrial designer for the Tandberg Radio Factory in Oslo from 1965 to 1970. In 1967, Opsvik won a design scholarship from the Norwegian Credit Bank and two years later was awarded another scholarship from the Norwegian Design Centre. He began working as a freelance furniture designer in 1970 and designed the innovative *Mini Max* desk and chair, which could be height adjusted to meet the needs of both adults and children and was manufactured by **Stokke**. Using the same revolutionary concept of *Generationenstuhl* (a chair that grows with the child), Opsvik later designed the best-selling *Tripp Trapp* high-chair/chair in 1972. This remarkable design not only elevated the child to a normal table height, but with its foot-rest also ensured that the necessary support was provided so as to allow enough freedom of movement "to explore the world in comfort and safety". In 1974 Opsvik designed his *Model no. 2010* office chair for Håg and five years later, having collaborated with Hans Christian

Mengshoel (b. 1946) on the development of better performing ergonomic seating solutions, introduced the revolutionary *Balans Variable* sitting tool. With its balanced rocking base and provision of an ergonomically beneficial kneeling position, the *Balans Variable* afforded the user a good upright posture while working at a desk or table. During the 1980s, Opsvik continued to produce ergonomic seating designs for both Stokke and Håg, including his two Post-Modern products – the *Balans Supporter* (1983), which provided support for a semi-seated position, and the *Garden Seating Sculpture* (1984), which was more of an aesthetic exercise than a particularly functional solution. Since the mid-1980s, Opsvik has produced both conventional style ergonomic seating, such as the *Sitti* child's chair of 1993 and the *Actulum* rocking chair of 1995, as well as more experimental and expressive furniture designs, such as those shown at the "Dimension in Wood – Sculpture or Furniture?" exhibition held at the Applied Art Museum in Oslo in 1986. Some of this latter type of furniture, which is distinguished by quirky forms and ambiguous function, has been put into limited production by Cylindra. Although the majority of

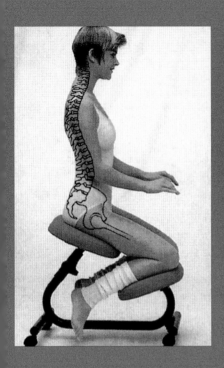

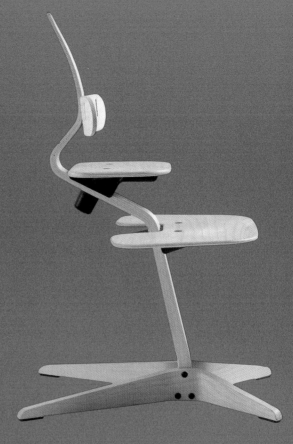

Opsvik's furniture designs exemplify the Scandinavian concern for social inclusiveness (children's furniture) and healthful living (ergonomic products), there is another side to his work that is more concerned with expressive form, which is perhaps a reflection of the Norwegian penchant for quirkiness within the visual arts.

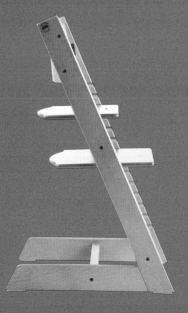

△ ◁ Photograph showing the correct ergonomic position afforded by the *Balans Variable* sitting tool, 1979 – This innovative design was developed with the assistance of Hans Christian Mengshoel and formed the blueprint for later ergonomic designs by Peter Opsvik

△ Peter Opsvik, *Sitti* adjustable child's chair for Stokke, 1993

◁ Peter Opsvik, *Tripp Trapp* adjustable high-chair for Stokke, 1972

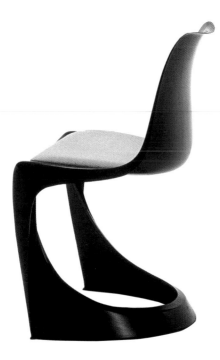

▷ Steen Østergaard, *Cado 290* stacking chair for Poul Cadovius (Cado), 1968

# steen østergaard *(Danish b. 1935)*

Steen Østergaard trained as a journeyman joiner, receiving a Silver Medal in 1957 and graduating from the Kunsthåndværkerskolen (School of Arts & Crafts), Copenhagen, in 1960. The same year, he was awarded first prize at the Saddlemakers' and Upholsterers' Guild anniversary competition. Between 1962 and 1965, he worked in the design office of **Finn Juhl**, where he assisted in the development of several chairs with exceptionally high-quality solid wood frames. In 1965, Østergaard established his own design practice and later designed his first plastic product – the *Cado 290* chair (1968), which was manufactured from around 1970 by Poul Cadovius. Importantly, this design was one of the first single-material, single-form plastic chairs to be injection-moulded in polyamide (nylon). The elegant cantilevered form of this chair was obviously inspired by **Verner Panton**'s earlier *Panton* stacking chair (1959–1960), which had originally been manufactured in injection-moulded Baydur (a polyurethane hard foam) in 1968 and then from 1970 onwards in injection-moulded Luran-S (a polystyrene thermoplastic). Unlike Panton's design, however, the *Cado 290* was available with optional seat cushions, which were

screwed directly onto the chair's frame. Østergaard's chair could also be linked to form rows and twenty-five units could be stacked onto a specially designed trolley. There were also armchair and high-backed variations of the design. In some ways the *Cado 290* chair was a more economic design than Panton's chair, for its scooped out lower section ensured that less material was used. The thickness of its wall construction was also thinner, which minimized the chair's overall weight. Østergaard has since designed a number of other chairs, but none have matched the *Cado 290* – a functionally and aesthetically exciting process-driven design that fully exploited newly developed high-tech plastics technology.

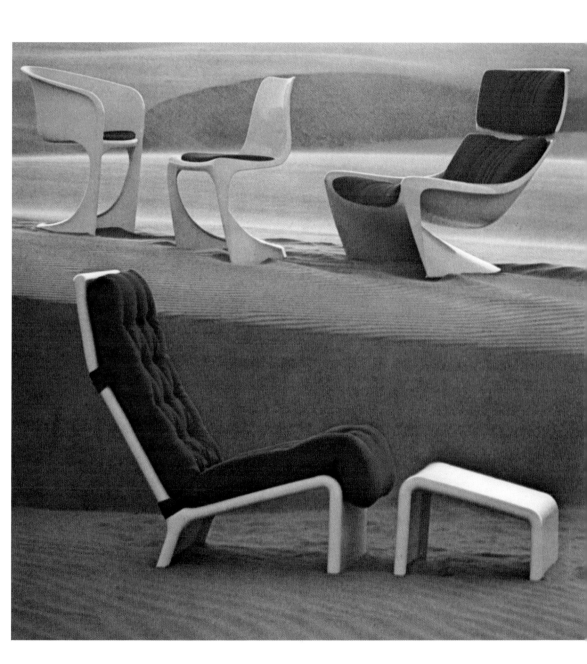

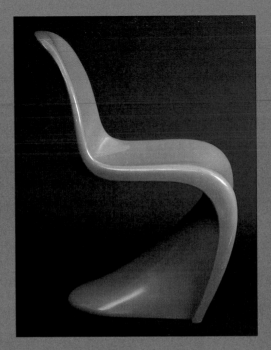

▷ Verner Panton, *Panton* chair, 1959–1960, manufactured by Vitra.

▷▷ Marianne Panton seated on a *Panton* chair with matching table, c. 1970

# verner panton

(b. 1926 Gamtofte – d. 1998 Copenhagen, Denmark)

With a rainbow of saturated colours and space-age sculptural forms, Verner Panton playfully yet radically transformed design not just in Scandinavia but throughout most of the Western world. The son of an innkeeper, he spent his childhood on the Danish island of Funen before training at the Odense Tekniske Skole (Polytechnic). He later studied architecture at the Kongelige Danske Kunstakademie (Royal Danish Academy of Fine Arts) in Copenhagen, graduating in 1951. Between 1950 and 1952, he worked in the drawing-office of the celebrated Danish architect and designer **Arne Jacobsen**. During this period he assisted Jacobsen with a number of experimental furniture designs, including the well-known *Ant* chair (1951–1952). After leaving Jacobsen's studio, Panton began making furniture models, designing auto equipment, and arranging exhibitions. In 1955, he established his own design practice and became well known for his innovative architectural proposals, including a collapsible house (1955), the *Cardboard House* (1957), and the *Plastic House* (1960). For Panton, the mid- to late 1950s was a period of imaginative exploration and playful experimentation. Around this time he began to receive

increasing critical acclaim for his numerous designs for seating, lighting, textiles, carpets and exhibition installations. In 1958, he received his first major architecture/interior design commission from Baron Berner Schilden Holsten. The brief was to rebuild and expand the Baron's Komigen Kro (Come Again Inn) sited in the small town Langesø on Funen. For this project Panton broke with all conventions and designed an all-red interior that included his famous *Cone* chair (1958) – a design that had an eye-catching ice-cream cornet form. This unusual seating solution brought Panton yet more international attention – when it was exhibited in the window of a corner-sited shop in New York it distracted drivers so much that the traffic police had to ban its exhibition in that particular location for fear of any more car accidents. The *Cone* chair and the slightly later *Heart* chair (1959) – a "cornet with angel wings" – were eventually put into production by Percy von Halling-Koch's newly established firm Plus-Linje. In 1959, Panton continued to confound the press and the public alike when he designed an exhibition at the Købestævnet trade fair, which literally turned the world upside down – the ceiling was carpeted and all

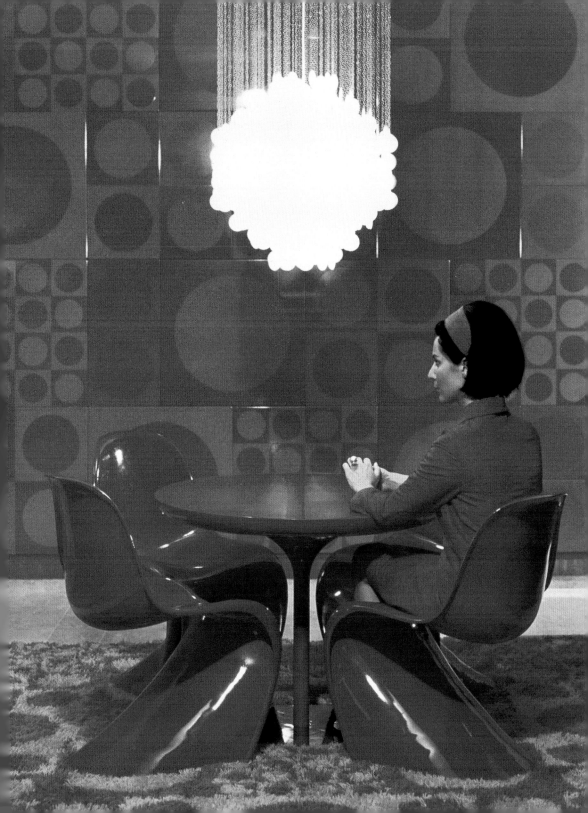

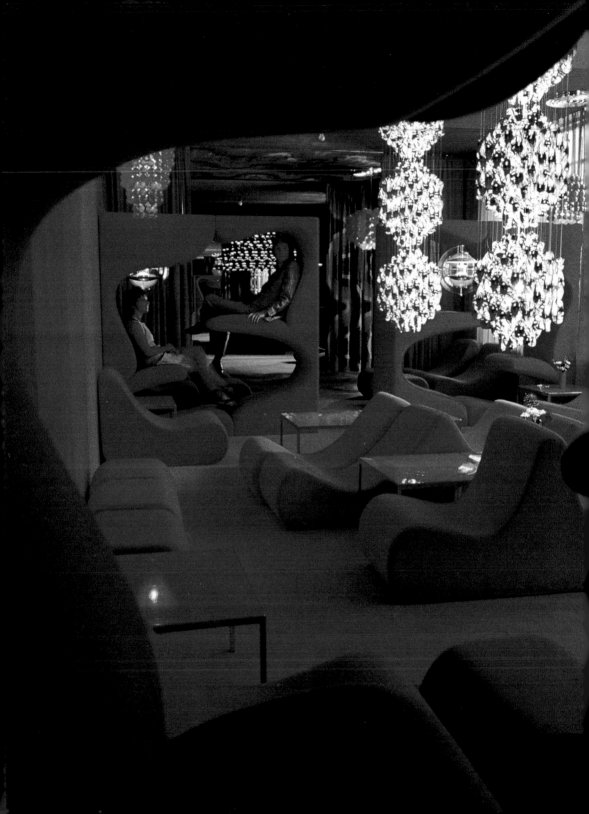

◁ Verner Panton, lobby of
the Varna Restaurant, Århus,
1971

▽ Verner and Marianne
Panton's home in Basel-
Binningen, 1973 – showing
*Ring Lights* designed for
Louis Poulsen in 1969

▽ Verner Panton, *Modular* chair for Plus-Linje, late 1950s – produced from 1960

▽▽ Verner Panton, *Cone K1* chair for Plus-Linje, 1958

▽▷ Verner Panton, *Series 100 Pantonova* chair *(model no. 125T)* & ottoman *(model no. 126S)* for Fritz Hansen, 1971

▽▽▷ Verner Panton, *Wire Cone K2* chair for Plus-Linje, 1960

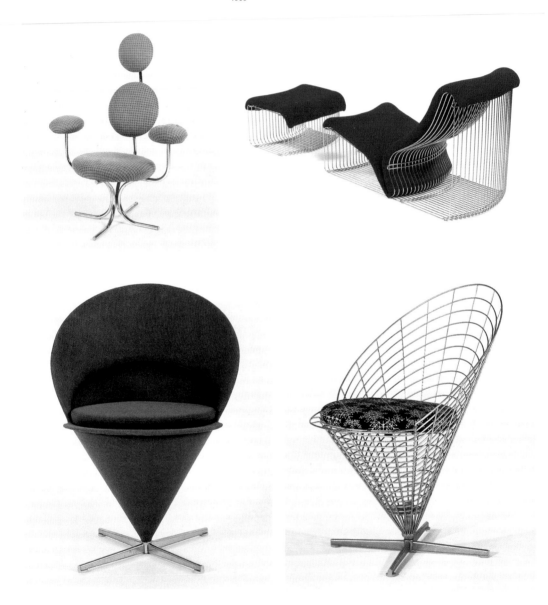

◁ Verner Panton, *System 1-2-3* lounge chair for Fritz Hansen, 1973 – rare lounge model with swivelling wood base

▽ Verner Panton, *Peacock T5* chair for Plus-Linje, 1960

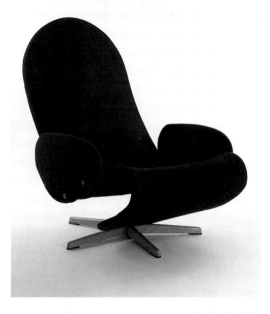

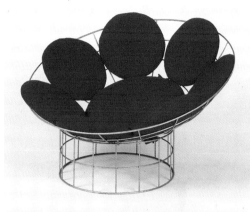

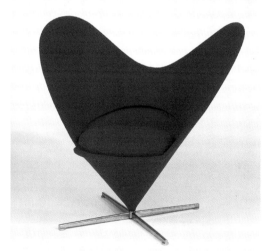

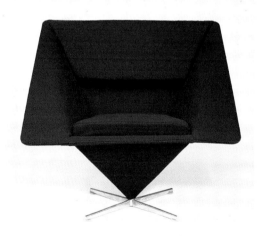

△◁ Verner Panton, *Heart Cone K3* chair for Plus-Linje, 1959

△ Verner Panton, *Pyramid K4* chair for Plus-Linje, 1960

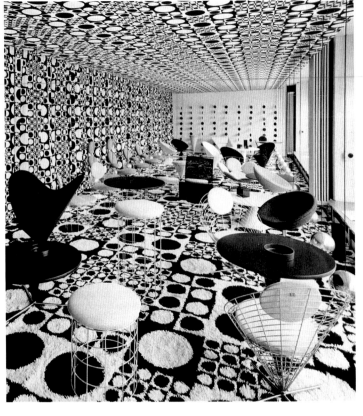

△ Verner Panton, *Geometri 1* carpet for Innovation Randers, 1960 – designed specifically for the Hotel-Restaurant Astoria

△▷ Plus-Linje Collection, sales exhibition held at the Pfister furnishing company, Zürich, 1960

the furniture and lighting was inverted and attached to it. The reasoning behind this extraordinary scheme was that the fair was normally so crowded that people could often only see the back of the person in front of them, whereas if the furniture and lighting were above them everyone could see them more easily. In 1960, Panton produced a similarly unconventional installation at the Cologne Furniture Fair with the ceiling covered in silver foil. During the same year, he was commissioned to redesign the Astoria Restaurant in Trondheim. The resulting interior was shocking not only because of the unusual forms adopted, but also because of the brightness of the colours used. **Poul Henningsen** remarked of the project, "Verner Panton's Astoria restaurant is a square peg in a round hole. It is something different, because it combines a tenacity in sticking to an idea with due regard for the comfort of the guests. … I feel that this is the first solution to the big question that has been tormenting us ever since functionalism got its big breakthrough: How do we make a restaurant a nice place for guests?" Certainly, the interiors transported the restaurant's diners into a fantasy space-age world with their Op Art inspired wall-

coverings and globe-like lamps. Apart from creating groundbreaking interior schemes, Panton also explored designs for the first-ever single-form chair in plastic. He had previously designed the single-form cantilevered plywood *S-chair*, which was developed in conjunction with Thonet GmbH in 1955–1956. For a number of years afterwards, he attempted to translate this design into plastic. From 1957 to 1960, he refined his ideas, sketches and models in order to achieve this goal and by 1962 his concept for the revolutionary *Panton* chair was fully formed. The same year, Panton left Denmark and stayed briefly in Paris before establishing a design office in Cannes. During this period he tried unsuccessfully to find a manufacturer for his landmark design, until he came into contact with Willy Fehlbaum, a Basel-based furniture manufacturer who was producing Herman Miller products under license. Although George Nelson, the design director of Herman Miller, was not convinced of the viability of the design, Fehlbaum decided that his own firm, Vitra, would risk developing the chair. Eventually, Panton moved to Basel to assist Willy Fehlbaum with the five-year-long production development of the *Panton* chair. In 1967 a small

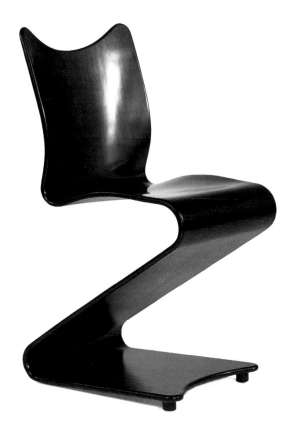

△ ◁ Verner Panton, *S-Chair Model 275* for Thonet, 1955–1956 – produced from 1965

△ Verner Panton, *Big Flowerpot* pendant lamp for Louis Poulsen, c. 1971 – showing the strong influence of Op Art on Panton's work

number of chairs (100 to 150 units) were produced from cold-pressed fibreglass re-enforced polyester (FRP) and the following year the design was launched to international acclaim at the Cologne Furniture Fair. That same year a new plastic known as Baydur (a polyurethane hardfoam) was used and as a result the *Panton* chair became the first single-material, single-form chair to be injection-moulded. Although this material allowed the chair to be produced in greater numbers, it still required a significant amount of finishing (including painting). In 1971, a new plastic known as Luran-S (a polystyrene thermoplastic) was used instead, but despite its gleaming surface finish the plastic did not have sufficient strength and eventually the production of the chair was discontinued in 1979 (only to be later revived by Vitra in 1990 using polypropylene and also polyurethane hard-foam). Having established a design office in Basel, Panton decided to remain there and set about cultivating a wide-ranging clientele, including, among others A. Sommer, Kaufeld, Haiges, Schöner Wohnen, Nordlys, Kill, Wega Radio, Thonet, Knoll International, Lüber and Bayer. Panton also designed psychedelic *Phantasy Land-*

*scapes* for Bayer at the 1968 "Visiona 0" and 1970 "Visiona II" exhibitions in Cologne, which combined fantastic sculptural shapes with pure saturated colour. Each room for the "Visiona 0" installation contained different furniture and "sitting sculptures" – one room had large orange Dralon-covered foam balls, while another had "three-dimensional" carpets on the ceiling. As one commentator noted, "Every room had its own sounds and odours, so that the sensations from nearly all the human senses added spice to the unique perception of space. … You went through the exhibition and forgot time and place." The installations designed for "Visiona II", however, were even more other-worldly, with walls, ceiling and furniture melting together to form space-age grottoes. These imaginative and sensuously disorientating rooms epitomized the experimental character of the psychedelic era with their kaleidoscope vistas of shape, colour and texture. From 1969 to 1985, Panton produced geometrically patterned textiles for Mira-X, which also used his characteristically bright rainbow palette. During the late 1960s and early 1970s, he designed a range of seating for **Fritz Hansen**, and a system of storage units

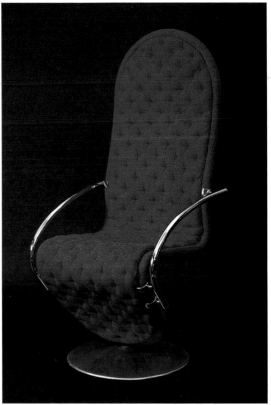

△ Verner Panton, *Onion* cotton velour textile from *Collection Décor (I)* for Mira-X, 1976

△▷ Verner Panton, *System 1·2·3* chair for Fritz Hansen, 1973

▷▷ Verner Panton, *VP-Globe* lamp for Louis Poulsen, 1969

as well as floor and desk lamps with chromed wire constructions for Lüber. These designs were inspired by Op Art and were developed from his earlier wire seat furniture of 1959–1960. In 1973, he designed the comprehensive *1-2-3* seating system for **Fritz Hansen**, which comprised twenty different models with four different seating heights for resting, dining and working. His interest in systems solutions was also explored in the colourful block-like *Pantonaef* toy (1975) for Naef, Switzerland. During the 1970s, Panton designed several lights for **Louis Poulsen**, including the spherical *VP-Globe* and *Panto* lamps (1975). During the 1980s, he designed his *Art Chairs-Chair Art* series (1981), which was made up of sixteen plywood single-form chairs with unusual amorphous cut-out shapes. He also experimented in 1985 with pure geometric forms – cubes, spheres, and cones – for a proposed seating range. Unlike many other Danish designers, Panton took a revolutionary rather than evolutionary approach to design. Throughout his career, he produced highly innovative and bold designs that often utilized state-of-the-art technology and reflected both his optimistic belief in the future as well as his playful

imagination. With his uniquely colourful and synthetic vision of the future, Panton rejected the Danish tradition of refining existing furniture types and using natural materials, but at the same time held onto the Scandinavian belief that design should first and foremost be about durability, unity and integrity.

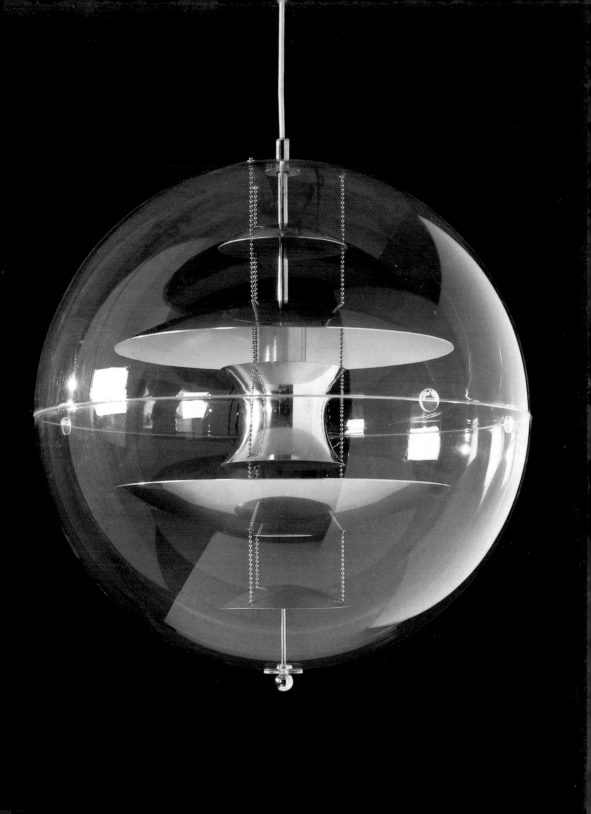

▷ Verner Panton, *Living Tower* for Herman Miller/Vitra, 1968–1969 – reissued by Vitra

▽ *Living Tower* in Panton's house, c. 1970

▽▽ Verner Panton, *System 1-2-3* partitions for Fritz Hansen, 1973

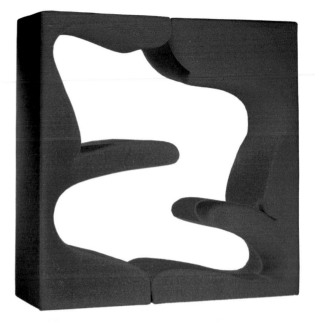

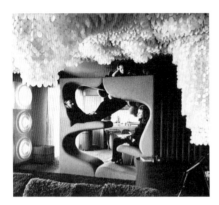

▽ Verner Panton, *Phantasy Landscape*, Visiona II exhibition by Bayer AG at the Cologne Furniture Fair, 1970 – The housing shortage during the 1960s prompted designers and radical design groups (from Joe Colombo to Archizoom Associati) to explore the idea of space-age micro-environments. Panton's remarkable out-of-this-world installations exhibited at the Visiona II epitomized this fascination with alternative living spaces and futuristic forms. Not only did Panton playfully experiment with form, function, colour and space but also blurred the long-held distinctions between furniture design and architecture, with his sculptural 3-D carpets and cave-like passageway of melting seating forms.

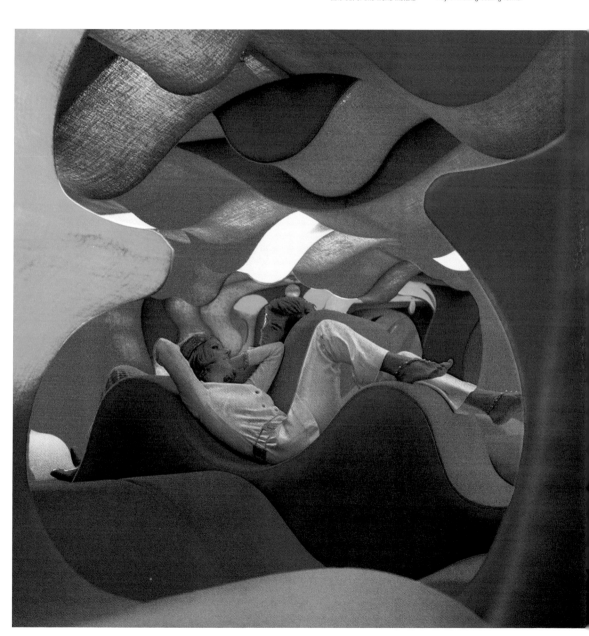

◁ Verner Panton, *Curve* cotton velour textile from the *Collection Décor (I)* for Mira-X, 1969

▽ Verner Panton, *Square* cotton velour textile from the *Collection Décor (I)* for Mira-X, 1969

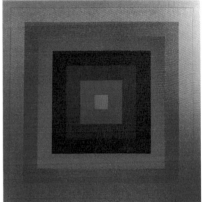

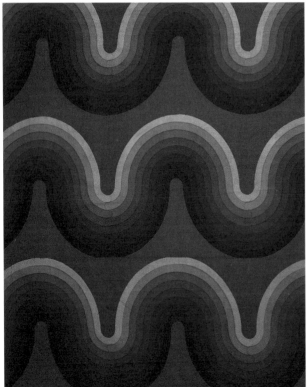

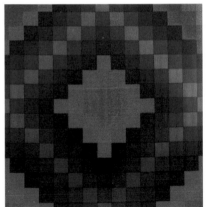

◁ Verner Panton, *Curve* cotton velour textile from the *Collection Décor (I)* for Mira-X, 1969

△ Verner Panton, *Chequers* cotton velour textile from the *Collection Décor (I)* for Mira-X, 1969

▷ Verner Panton, *Kugel-Lampen TYP F* (Ball lamp) hanging lamp for J. Lüber, 1969 – produced from 1970

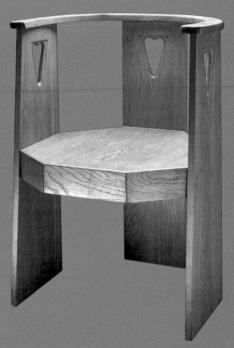

▷ Eliel Saarinen, wooden chair with heart motifs, 1909 – This design shows the strong influence of the British Arts & Crafts movement, especially the work of Charles Rennie Mackintosh and Charles Voysey

# eliel saarinen

*(b. 1873 Rantasalmi, Finland – d. 1950 Bloomfield Hills, Michigan, USA)*

One of the great figures of Finnish design, Gottlieb Eliel Saarinen studied fine art at the University of Helsinki and later architecture at the Helsinki Polytechnic, alongside Herman Gesellius (1874–1916) and Armas Lindgren (1874–1929). After graduating in 1898, the three young architects formed a partnership and were subsequently commissioned to design the Finnish Pavilion for the 1900 Paris "Exposition Universelle et Internationale". With its Karelian-style roof-line and ceiling painted by Akseli Gallén-Kallela (1865–1931), the resulting building exemplified the emerging National Romantic Movement. In reaction to the political suppression of Finland by Russia and the intensifying programme of "Russification" of Finnish culture, Saarinen and other protagonists of National Romanticism sought to define and promote an autonomous national character within all the arts. Looking to ancient Karelian culture for an untainted Finnish identity, they embellished and romanticized historical fact in order to create the mythology of "Karelianism", which was a projection of their own nationalistic aspirations. Gesellius, Lindgren and Saarinen were also strongly influenced by the Glasgow School and the Wiener Sezession, as the bold

massing of elements in their buildings demonstrates, for example the Finnish National Museum (1902–1912) and the Helsinki railway station (1904–1919), the latter of which Saarinen alone designed. By the turn of the century, the practice was inundated with architectural commissions and the three architects decided to flee Helsinki for a rural retreat. Their destination was a sixteen-acre site on a forested ridge above the shores of Lake Hvitträsk, where they each built a house around a central grassed courtyard and a large communal studio that connected the Saarinen and Lindgren houses. Each house was an intensely personal *Gesamtkunstwerk* – the interiors of the Saarinen House included furniture, lighting, textiles, wall paintings and carpets, all designed site-specifically by Eliel Saarinen. In 1905 Saarinen subsequently purchased Lindgren's share of the estate, and later in 1916 he acquired Gesellius'. During this period, Saarinen continued to promote the National Romantic Movement, and in 1912 he joined the Deutscher Werkbund. In 1922, he won second prize in the Chicago Tribune Tower competition and a year later, the Saarinen family emigrated to the United States (although they return-

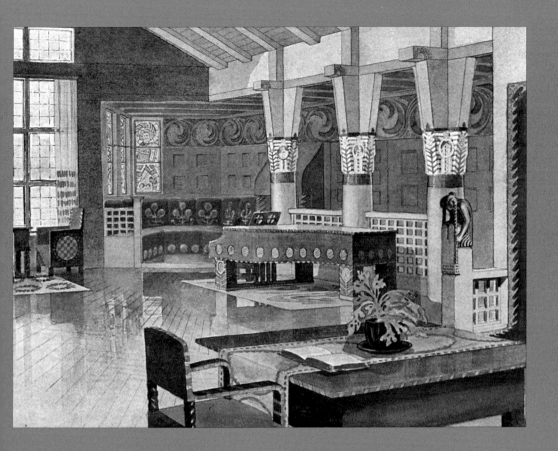

△ Eliel Saarinen, watercolour
interior design for a country
house in Kirkkonummi, 1902

ed almost every summer to Hvitträsk until 1949).
Initially, they resided in Evanston, Illinois, while
Saarinen worked on the development of the Chicago
lake front. The family later settled in Ann Arbor,
where Eliel Saarinen was appointed a visiting pro-
fessor of architecture at the University of Michigan.
In 1923, he met the wealthy newspaper baron and
philanthropist George C. Booth, who asked him
to draw up plans for the development of the Cran-
brook Educational Community. In 1925, Saarinen
moved to Bloomfield Hills and in 1932, the Cran-
brook Academy of Art was officially founded with
Saarinen as its first president. Under his director-
ship the Academy became the premiere design
institution in America and produced many of
the country's most talented designers, including
Charles and Ray Eames. As director of the Cran-
brook Academy, Saarinen promoted the humanist
ethos of Scandinavian design and had an enor-
mous impact on the evolution of modern design
in the United States. Saarinen's only son, Eero,
became an architect and was one of the greatest
pioneers of American post-war design.

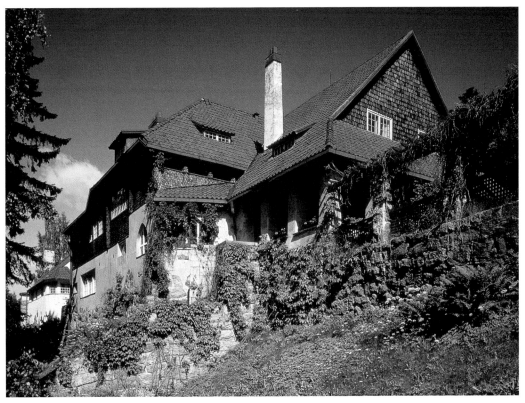

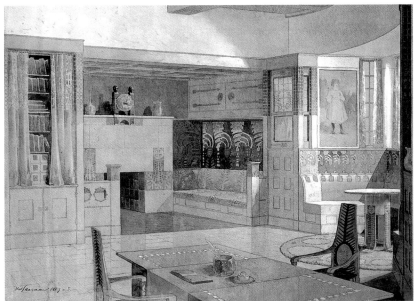

◁◁ Eliel Saarinen, design for *Ruusu* (Rose) ryjiy rug, 1904

△ South wing (Saarinen House) of Hvitträsk buildings viewed from the west (lakeside), 1906–1907

◁ Eliel Saarinen, watercolour interior design of library at Suur-Merijoki, 1903

▷ The studio at Hvitträsk –
Eliel Saarinen believed that
"Work is the key to creative
growth of the mind."

▽ Living room in the Saarinen
House at Hvitträsk

▷▷ Eliel Saarinen, chair from
the *Koti* (Home) collection,
1903 – This unusual design
alludes to Karelian artistic
tradition and as such can be
seen as an expression of
Finnish patriotism

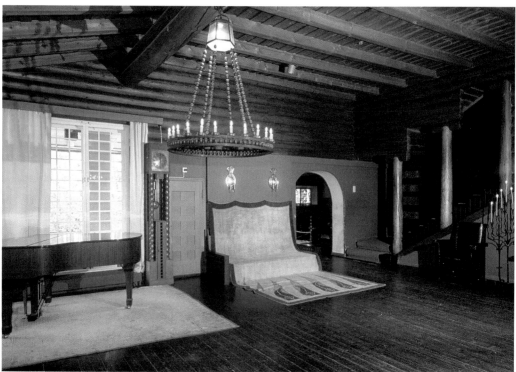

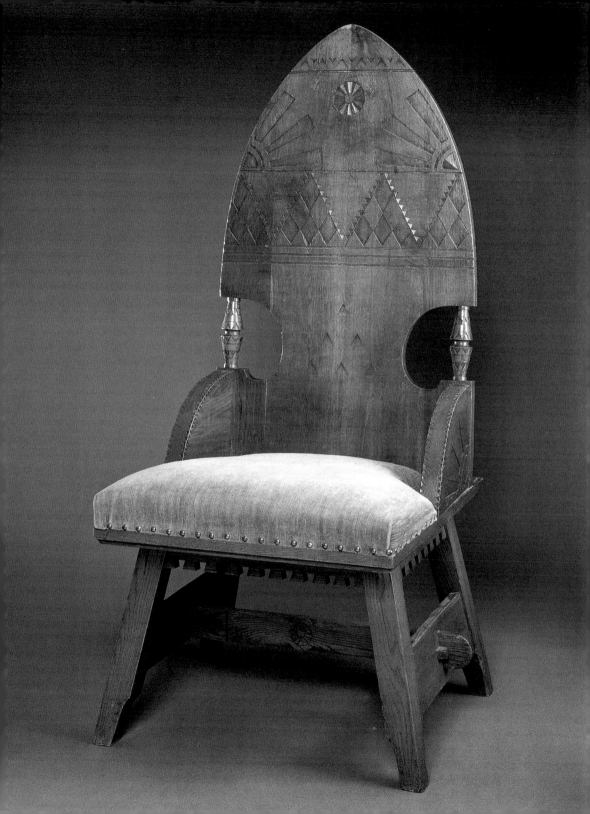

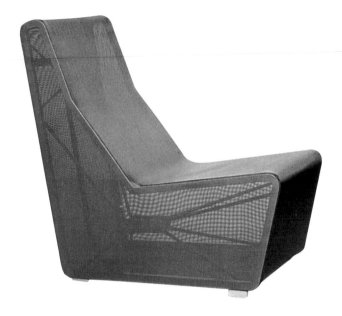

▷ Timo Salli, *Tramp* chair
(prototype) for Cappellini,
1996

# timo salli *(b. 1963 Helsinki, Finland)*

Well-known among the international design community for his innovative and thought-provoking design work, the Finnish designer Timo Salli began his working career as a welder. He later studied furniture design at the Lahti Design Institute, graduating in 1992, and then studied craft and design at the Taideteollinen Korkeakoulu (University of Art and Design) in Helsinki, graduating in 1996. While still at college, he worked in the design office of Stefan Lindfors before establishing his own practice in 1993. Three years later, he designed the *Tramp* chair for Cappellini, which was constructed from a two-piece steel frame covered with a transparent nylon net bag. Although large in scale, this design "gives a light and immaterial illusion". In 1997 he designed the quirky *Jack-in-the-Box* television that can be closed away into its box when not in use, so as to produce "space for human action without TV's dominating, catching eye". The same year he also designed the collapsible and semi-transparent *Zik Zak* chair as a one-off for the **Snowcrash** exhibition in Milan. Following this, in 1998 he collaborated with **Ilkka Suppanen** on the design of the Nomadhouse exhibition. Salli's work, which playfully contests the conventions of

daily living, continues to exemplify the cutting edge of contemporary Scandinavian design. Describing his work as "low-tech choices for a digital era", Salli seeks to make more direct and meaningful connections between objects and users, particularly within domestic realms, where according to him our homes have become "so full of things we no longer even see". His designs are intended to challenge our perceptions of everyday "relics", with many being multi-functional, such as the *Lamp-Lamp* (2000) – a mirror that also functions as a light. Like other contemporary Scandinavian designers, Salli is very aware of changes in living patterns, especially within the home environment, and so he also promotes his designs as "basic living equipment for the urban nomad". As one of the designers associated with Snowcrash, Timo Salli demonstrates through his idiosyncratic designs an originality and inventiveness that verge on the poetic.

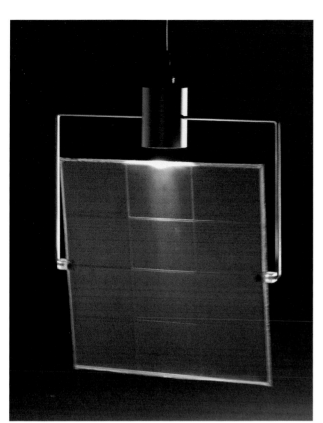

◁ Timo Salli, *ScreenLamp* light (prototype), 1998

▽ Timo Salli, *Jack-in-the-Box* television (self-production), 1997

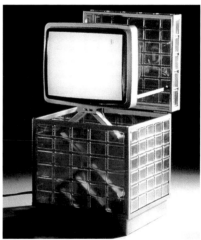

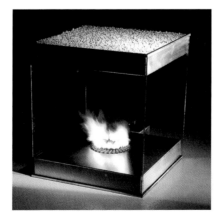

◁ Timo Salli, *Firecase* fireplace (prototype), 2000

▷ Astrid Sampe, detail of *Jobs Blommor* (Jobs' Flowers) textile – blue version, c. 1950

▷▷ Astrid Sampe, *Versailles* polyester and viscose textile for Almedahls, 1972

# astrid sampe *(Swedish 1909–2002)*

The Swedish textile designer Astrid Sampe trained at the Konstfackskolan (University College of Arts, Crafts and Design) in Stockholm and later at the Royal College of Art in London. In 1937 she began working as a designer for Nordiska Kompaniet and exhibited at the "Exposition Internationale des Arts et Techniques dans la Vie Moderne". A year later, she became head of Nordiska's newly-founded textile design department, where she produced a number of influential designs that testified to her skill as both a colourist and a pattern maker. She later worked with the architect **Sven Markelius** (who had also produced designs for Nordiska) on the design of the Swedish Pavilion for the 1939 New York World's Fair. Like other designers working in the 1940s and 1950s, Sampe revitalized the long Scandinavian tradition of woven "art" textiles with her vigorous abstract patterns designed within a modern idiom. Sampe is also credited with being the first textile designer to introduce glass cloth to Sweden (1946), and was particularly influential in the development of textiles designed specifically for architectural settings. She was awarded a Grand Prix at the 1954 (X) Milan Triennale and two years later was the recipient of the

Gregor Paulsson trophy. In 1948 she co-wrote with Vera Diurson the book *Textiles Illustrated,* and the following year was elected an honorary member of the Royal Designers for Industry in London. She also designed textiles for Knoll International in New York and Donald Brothers in Dundee, as well as for companies in Sweden. During the 1950s, Sampe executed striking patterns for the Wohlbeck and Kasthall carpet factories, which were instrumental in revitalizing the industrial production of woven rugs. In 1955, she produced several designs for domestic linens that employed repeating geometric patterns and folk-inspired motifs that could be used in an interchangeable manner. In 1972, Sampe left Nordiska Kompaniet and established her own studio in Stockholm so as to concentrate on the design of textiles and interiors. Alongside a number of other prominent Scandinavian designers, Sampe adapted the craft ideals of the past for the industrial reality of the present and in so doing preserved and extended the traditions of Nordic textile design.

FRAMHLID.

▷ Gudjón Samúelsson, archi-
tectural design for Yfirbygd
Sundlang in Reykjavik, 1925

▷▷ Gudjón Samúelsson, white
painted chair, 1926–1930

ÞVERSKURÐUR.

# gudjón samúelsson *(Icelandic 1887–1950)*

The greatest protagonist of Modernism in Iceland, Gudjón Samúelsson studied architecture at the Kongelige Danske Kunstakademi (Royal Danish Academy of Fine Arts) in Copenhagen under Martin Nyrop (1849–1921), the leading figure behind the National Romantic movement in Denmark. In 1919, Samúelsson was appointed the first National Architect of Iceland and subsequently designed a number of important public buildings. These were chiefly built using reinforced concrete – a material that had been imported into Iceland from the 1900s due to the lack of local construction materials. Samúelsson's buildings were constructed in a modern style that in Iceland became known as *Steinsteypuklassík* (concrete classicism). For his building projects, which included the Landsbankinn (National Bank, 1922–1924) and the Lansspítalinn (National Hospital, 1925–1930), Samúelsson designed site-specific furniture, such as his white painted chair (1930) made from imported pine. This design epitomized his curious synthesizing of Neo-Classical forms with Modern Movement functionalism. In the mid-1930s, Samúelsson also designed furniture for the Icelandic Parliament Building, including chairs whose rather austere

forms were enlivened by subtle vernacular detailing that made reference to traditional Icelandic woodworking. Samúelsson's furniture was manufactured locally and because of the lack of available materials, was somewhat stylistically constrained. Based on rationalist principles, his buildings and furniture must be seen as distinctive national interpretations of Modern Movement precepts. Inspired by the functionalist approach to design, Samúelsson pioneered, along with others, such as the architect Sigurdur Gudmundsson (1885–1958), a new modern identity for Icelandic design that subtly embraced rather than rejected both national vernacularism and Scandinavian Classicism.

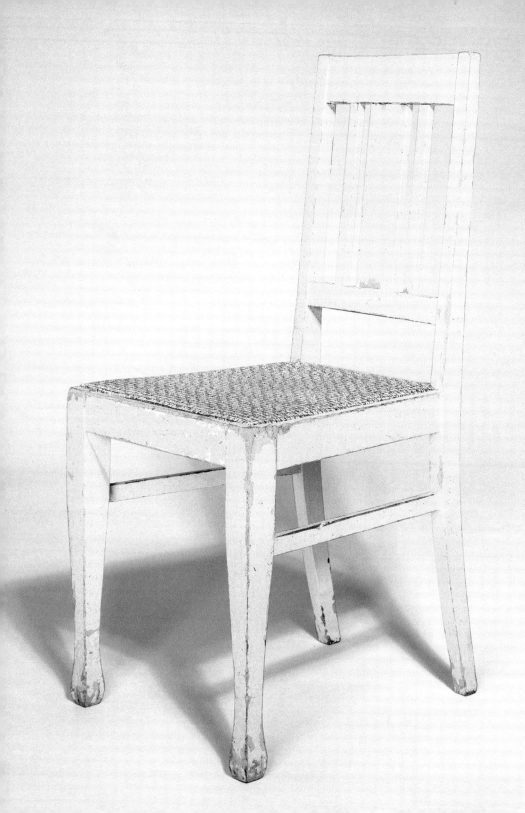

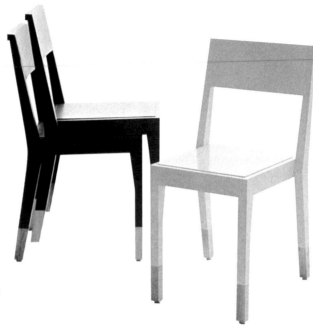

▷ Thomas Sandell, *T.S.* chairs
for Asplund, 1994

# thomas sandell *(b. 1959 Jakobstad, Finland)*

Thomas Sandell was born in Finland but his family moved to Sweden the same year. Between 1981 and 1985, he studied architecture at the Royal Institute of Technology in Stockholm and then worked in the architecture practice of Professor Jan Henriksson. In 1986 he executed illustrations for the *Metallarbetaren* magazine and worked on a number of saloon car projects for Volvo. The following year he headed a consulting group for the rebuilding of the Royal Library in Stockholm, and a year later collaborated with fellow Swedish designer **Jonas Bohlin** on the design of a Shaker-style interior for the Rolfs Kök restaurant. Having founded his own architecture and design practice in 1990, Sandell has since worked on numerous building and interior design projects, notably the Villa Börjesson in Aspö (1990), the café for the National Museum of Cultural History in Stockholm (1993), and interiors for the Modern Museum (1995) and the Architecture Museum (1996) in Stockholm. Apart from his architecture and interior design work, Sandell has also designed furniture for a number of leading manufacturers, including **Artek**, Asplund, B&B Italia, Gärsnäs and **Källemo**. Since the early 1990s Sandell has also

designed furniture and various domestic products for Cappellini, including his wall-mounted *Key Cupboard* (1992), which takes the form of an out-sized escutcheon, and his well-known polished aluminium *9235* candleholders (1995). In 1995, he was one of several designers who contributed to the popular *PS* series of furniture for **IKEA** – his *PS Armoire* and *PS Bureau* with their cut-out drawer/door pulls and wheels for easy transportability epitomize the strong functional and aesthetic clarity not only of his own work but that of contemporary Swedish design in general. Also in 1995 he co-founded with Ulf Sandberg the SandellSandberg partnership – a concept company with a broad approach to communication that unites advertising, branding, architecture, design and the Internet. More recently, Sandell has designed the London headquarters of Ericsson (1997), the "Insideout-house" for *Wallpaper\** magazine (1998), and interiors for the Swedish Parliament building in Stockholm (2000). He has received a total of five Excellent Swedish Design Awards and has acted as chairman of SAR (National Association of Swedish Architects) since 1999. Along with Thomas Eriksson and Jonas Bohlin's work,

◁ Thomas Sandell, *Snow* cabinet storage system for Asplund, 1993 – co-designed by Jonas Bohlin

▽ Thomas Sandell, *Wedding* stools for Asplund, 1992

▽▽ Thomas Sandell, *Air* carpet for Asplund, 2001

Sandell's simple, practical yet stylish designs have greatly influenced the new-found confidence and vitality of contemporary Swedish design.

▷ Teppo Asikainen & Ilkka
Terho, *Netsurfer* computer
work station for Snowcrash,
1995

# snowcrash *(founded 1998 Helsinki, Finland)*

SNOWCRASH

The Stockholm-based Snowcrash design company is renowned for its innovative and experimental products, which are born out of an approach that aims to go "beyond the obvious to explore contemporary needs and equip contemporary lifestyles". The business evolved from an earlier design group known as Valvomo (Crisis), which was founded in 1993 by a collective of young Finnish designers and architects who had known each other since their student days. The original members included Teppo Asikainen (b. 1968), Vesa Hinkola (b. 1970), Markus Nevalainen (b. 1970), Kari Sivonen (b. 1969), Ilkka Terho (b. 1968), Jan Tromp (b. 1969), Rane Vaskivuori (b. 1967), and Timo Vierros (b. 1967). In 1997 the group exhibited their work together with designs by **Ilkka Suppanen** and **Timo Salli** at the Milan Furniture Fair under the name of Snowcrash – reflecting not only their Nordic origins but also their desire to overthrow the "bent plywood" heritage of Scandinavian design in favour of "visionary things for a network age". The following year Snowcrash was officially founded in Helsinki as a design-led organization that would oversee the development of furniture and lighting by both

in-house and independent designers. Since then Snowcrash has launched a number of radical products, including the *Netsurfer* computer work station (1995) by Teppo Asikainen and Ilkka Terho (a tongue-in-cheek attempt at reconciling computer technology and furniture within the domestic environment); the *Globlow* lamp (1996) by Vesa Hinkola, Markus Nevalainen and Rane Vaskivuori (a "living light" that inflates when switched on and deflates when switched off); the *Airbag* chair (1997) by Ilkka Suppanen (an inflatable chair/mattress for indoor/outdoor use); and the *Soundwave* panel system (1999) by Teppo Asikainen (a system of sculptural wall panels designed to enhance the acoustic properties of interior spaces). The Snowcrash brand was purchased by Proventus AB in 1998 and its operations were subsequently moved from Helsinki to Stockholm in 2000. The same year Snowcrash became part of Proventus' Art & Technology group (which also owns **Artek** and Kinnasand), and since then has built up an international network of collaborating designers, including the Paris-based Israeli designer Arik Levy (b. 1963) and the Swedish designer, Monica Föster (b. 1966). Apart from considering practical

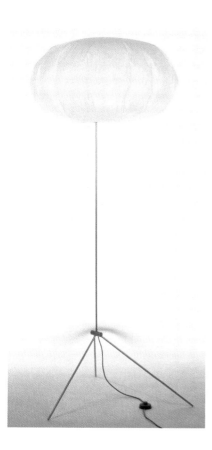

◁ Vesa Hinkola, Markus
Nevalainen & Rane Vaskivuori,
*Globlow* floor lamp for Snow-
crash, 1996

▽▽ Teppo Asikainen, *Chip*
lounger for Snowcrash, 1996

▽ Ilkka Suppanen, *Airbag* chair
for Snowcrash, 1997 – co-
designed with Pasi Kolhonen

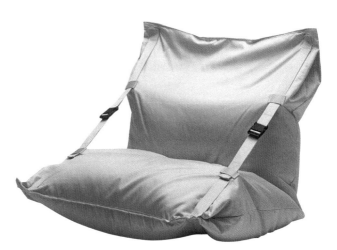

needs, Snowcrash "aims to address values such
as well-being, creativity and even playfulness",
which its members consider to be equally import-
ant for a humane workspace.

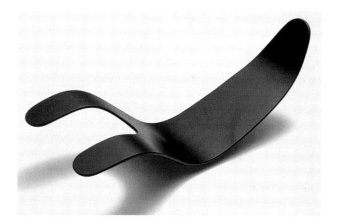

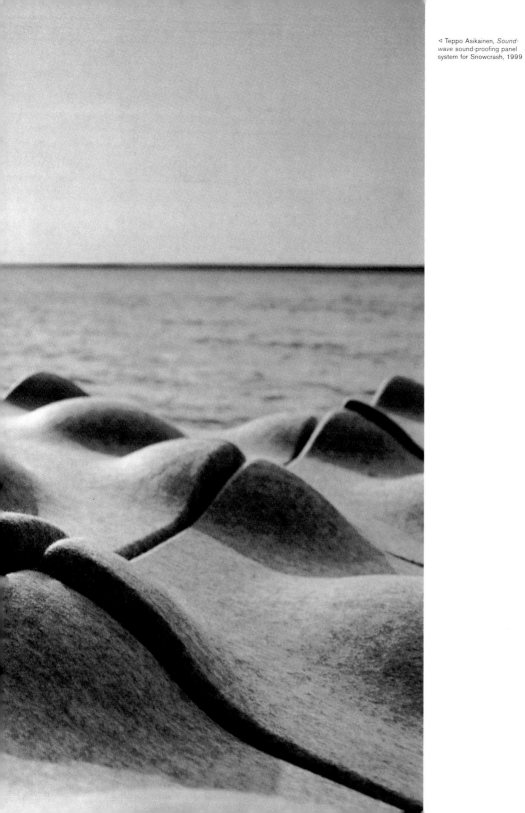

◁ Teppo Asikainen, *Sound-wave* sound-proofing panel system for Snowcrash, 1999

▷ Magnus Stephensen,
armchair for Fritz Hansen,
1932

# magnus stephensen

*(b. 1903 in Frederiksberg – d. 1984 in Helsingør, Denmark)*

Magnus Stephensen studied at the Teknisk Skole (Polytechnic), Copenhagen, until 1924 and later trained as an architect at the Kongelige Danske Kunstakademi (Royal Danish Academy of Fine Arts), Copenhagen, graduating in 1931. He also briefly studied architecture at the French School in Athens. Following his training he designed a number of buildings, but mainly concentrated on domestic architecture, which revealed his preference for precise and uncluttered lines. Between 1938 and 1952 he designed tableware, including several flatware patterns and a teapot, for Kay Bojesen's workshop, that was remarkable for its stylish sophistication yet "serviceable utility". He also began designing metalware for Georg Jensen in 1950, which led to his *Tanaquil* and *Frigate* cutlery patterns. In 1954, he designed his exquisite sterling silver saucepan, the handles of which were particularly notable for the way they made carrying easier. The same year he also designed a stainless steel coffee set as well as a range of high-quality stainless steel casseroles and saucepans for Georg Jensen. These beautifully crafted objects were made by drawing the steel plate over rotating steel cores and then hand

polishing the forms so as to produce the highest quality finish. Because the steel plate used was of a sufficiently thick gauge, the rims of the pieces did not require additional reinforcing and so were left straight-edged. Later, Stephensen designed the *Patella* range of oven-to-table ware (1957) for Royal Copenhagen, which featured a speckled brown glaze inspired by the colour of a withered oak leaf. The glaze also had the added benefit of effectively covering any iron spots in the earthenware, thereby reducing the number of rejected "seconds" in manufacture. Similar to his stainless steel hollowware for Georg Jensen, this product range was distinguished by soft yet rational forms. The *Patella* range also heralded the trend towards more informal mix-and-match multi-functional tableware. Like many other Danish designers at the time, Stephensen was strongly influenced by Japanese art (to such as extent that he even wrote a book on the subject), and because of this many of his products possessed a quiet and understated beauty. His domestic ware also exemplified the Danish traditions of high quality craftsmanship, precision engineering and practical utility. Over the course of his long career Stephensen won numer-

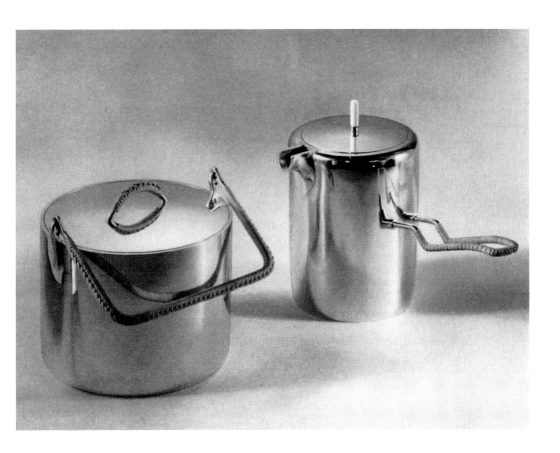

ous awards for his excellent product designs,
including three gold medals and two Grand Prizes
at the 1954 (X) and 1957 (XI) Milan Triennale.

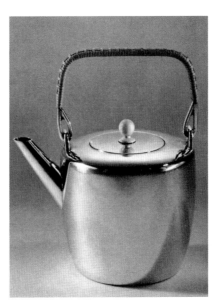

△ Magnus Stephensen, silver
entrée dish and coffee pot
with plaited wicker handles for
Kay Bojesen's workshop, 1938

◁ Magnus Stephensen, silver
tea-pot with wickerwork handle
for Kay Bojesen's workshop,
1938.

▷ Peter Opsvik, *Balans Duo*
chair for Stokke, 1984

# stokke *(founded 1932 Skodje, Norway)*

Stokke, the largest and most prestigious furniture company of Norway, evolved from a small business that was founded in 1932 by Georg Stokke and Bjarne Møller. Its "humble production" of chairs and sofas was significantly upgraded in 1936 when a new factory was established that enabled much higher rates of production. In 1955, Georg Stokke acquired sole ownership of the company and it subsequently became known as Stokke Fabrikker AS. A sister company, Westnofa, was founded in Åndalsnes in 1968 to specifically cater to the domestic seating market, while Stokke concentrated on the development of other types of furniture. In 1972, Stokke launched the *Tripp Trapp* high-chair/chair designed by **Peter Opsvik**, which could be height-adjusted so as to in effect "grow with the child" from the age of six months to eight years old. Since its introduction, over three million of these revolutionary chairs have been sold worldwide. Later, Opsvik began research with Hans Christian Mengshoel (b. 1946) into dynamic seating solutions based on ergonomic principles, which resulted in the introduction of the remarkable *Balans Variable* sitting tool in 1979. Based on the company's philosophy of "movement and

variation", this innovative rocking seat evolved from the concept that furniture should stimulate a good sitting position and freedom of movement, while providing enough flexibility for a variety of body sizes. The *Balans Variable* and other seating designs from the *Balans* range are renowned for promoting excellent posture, and as such are particularly recommended for backache sufferers. During the 1980s, Stokke produced Opsvik's unusual *Garden Seat* and the playful *Ekstrem* chair designed by Terje Ekstrøm (b. 1944), which function as much as interactive sitting sculptures as ergonomic seating products. In 1999, Stokke launched a new children's furniture concept designed by Grønlund & Knudsen known as *Sleepi*, which transmutes from a crib to a bed to a sofa or two chairs. Like the hugely successful *Tripp Trapp* chair, this innovative design can be adapted to the children's needs as they grow and underscores the Stokke Group's belief that "good design is good business". Stokke's specialization in ergonomic seating and innovative children's furniture typifies the Scandinavian attitude towards not only health issues, but also children's development. It is interesting to note that as early as 1901 the progres-

◁ Per Øie, *Move* stool for
Stokke, 1984 – allows full
freedom of movement through
360 degrees.

▽ Terje Ekstrøm, *Ekstrem* chair
for Stokke, 1984 – designed
so that the sitter can adopt
a number of sitting positions
while still maintaining full back
support – first launched in
1987

sive Swedish social reformer Ellen Key (1849–
1926) was predicting *Barnets århundrade* (The
Century of the Child), and that in Norway today
there is a government ombudsman specifically con-
cerned with the rights and interests of children.

▽ Peter Opsvik, *Multi Balans*
folding sitting tool for Stokke,
1982

▷ Ilkka Suppanen, *Nomad* chair (limited edition/self-production), 1994

# ilkka suppanen *(b. 1968 Kotka, Finland)*

One of the leading avant-garde Scandinavian designers of his generation, Ilkka Suppanen studied architecture and design at the Polytechnic and the Taideteollinen Korkeakoulu (University of Art and Design) in Helsinki, graduating in 1989. He later completed his design studies at the Rietveld Academy, Amsterdam, in 1992 and the same year exhibited at the Fifth International Exhibition of Architecture at the Venice Biennale. In 1995 he began teaching at the Faculty of Design in Helsinki, and the following year designed the innovative *Airbag* chair for Valvomo, an inflatable chair/mattress for indoor/outdoor use that can be folded away or hung up when not in use. He also became a founding member of the Scandinavian design co-operative **Snowcrash** in 1996 and devised the group's trademark. He later teamed up with **Timo Salli** in 1998 on the design of the *Nomad*-house, which included the *Nomad* chair (1994) with an undulating felt sling seat. The Nomad project focused on how "people are driven by two conflicting impulses: the desire to move and the desire to stay. ... Nomadic designs are made from as few materials as possible. They disassemble easily and are readily transported. They must be

extremely functional." The same year he designed a sofa version of the *Nomad* chair for Cappellini known as the *Flying Carpet* – so called because of the way the seat section appears to hover in the air. Suppanen also received considerable recognition when he presented his work with Snowcrash at the 1998 International Furniture Fair in Milan. Utilizing materials that "demand and create new forms", such as synthetic fibres and copper cloth, Suppanen designs highly innovative product solutions that are practical yet possess a strong aesthetic identity. As an independent designer, he has worked for, among others, Cappellini, Proventus, Nokia and Saab, and was nominated by Ettore Sottsass for the Dedalus prize for young European Designer as one of the four most important young designers under forty. Believing that "design is like poetry: absolute and precise, with the minimal use of means employed to achieve the maximal result", Suppanen's nomadic and frequently multi-functional designs are primarily concerned with exploring the relationship "between the transitory and the timeless". In 2000 he became the creative director of Snowcrash while continuing to operate his own design practice in Helsinki.

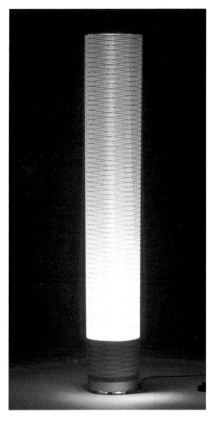

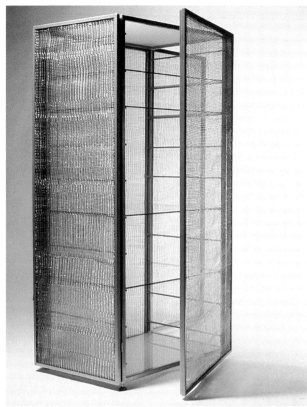

His work has also been selected for the permanent collections of numerous institutions, including the Stedelijk Museum in Amsterdam and the Museum für Angewandte Kunst in Cologne.

△ ◁ Ilkka Suppanen, *Roll-light* floor lamp for Snowcrash, 1997

△ Ilkka Suppanen, *AV Rack* cabinet (self-production), 1998

▽ Ilkka Suppanen, *Game-shelf* table for Snowcrash, 1999

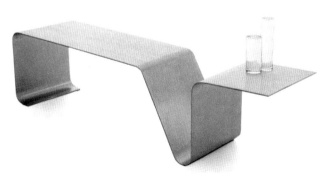

▷ Ilmari Tapiovaara demon-
strating his *Wihelmiina* stack-
ing chair for Wilhelm Schau-
man, c. 1959

▷▷ Ilmari Tapiovaara,
*Wilhelmiina* stacking chair for
Wilhelm Schauman, 1959

# ilmari tapiovaara *(Finnish 1914–1999)*

Throughout his career, Ilmari Tapiovaara dedicated himself to the design and development of the "ideal" multipurpose chair. From 1935 to 1936 he worked in the London office of **Artek**, a design-led company founded by **Alvar** and **Aino Aalto**. He later studied industrial and interior design at the Taideteollisuuskeskuskoulu (Central School of Industrial Design) in Helsinki, graduating in 1937. Following this, he served an apprenticeship in the Paris office of Le Corbusier (1887–1965) before working as the art director of Asko (a furniture manufacturer based in Lahti) from 1937 to 1940. In 1946, he designed his well-known solid birch and moulded plywood *Domus* chair (1946) site-specific for the Domus Academica student hostel in Helsinki. This pioneering knock-down design was manufactured by Keravan Puuteollisuus, a furniture company established and directed by Tapiovaara. Around 1950, he co-founded with his architect wife Annikki Tapiovaara (b. 1910) a design office in Helsinki, and subsequently worked as a freelance designer developing various "universal" seating solutions. As a functionalist and one of the most important pioneers of knock-down furniture, Tapiovaara believed particularly strongly in the

principle of revealed construction. With an eye on the ever-increasing furniture export market, he concentrated in the late 1940s and early 1950s on developing low-cost, efficiently constructed chairs that could be easily dismantled and packed for overseas shipment – an example of which he submitted to the 1948 "International Competition for Low-Cost Furniture Design" at the Museum of Modern Art, New York. His later tubular metal and plywood stacking *Lukki I* chair (1952) for Lukkisep-po, which was first used in the Olivetti Showroom in Helsinki, featured a plastic cord wound around its arms that not only afforded the user much comfort, but also functioned as a protective device when the chairs were stacked. His elegant *Wilhelmiina* chair (1959) for Wilhelm Schauman, with its moulded plywood seat and back elements, was similarly inventive in the way it could be stacked. He was awarded six gold medals in total for his chairs at the 1951 (IX), 1954 (X), 1957 (XI) and 1960 (XII) Milan Triennale and received a Good Design Award in Chicago in 1950. Apart from designing highly rational furniture, which also included pieces for Knoll International, Thonet, and Asko, Tapiovaara worked extensively as an interior

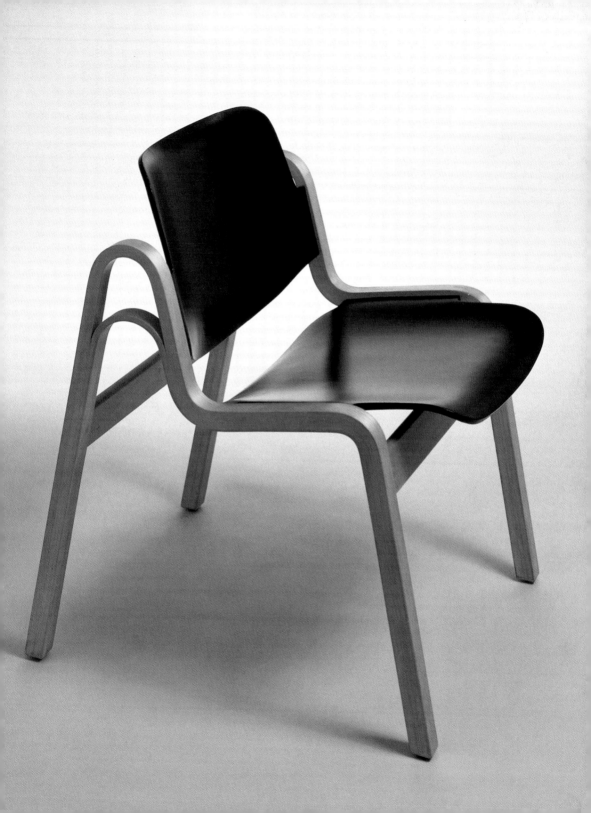

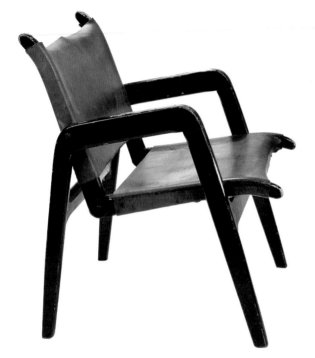

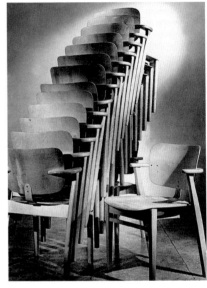

△ Ilmari Tapiovaara, ebonized wood and leather armchair, c. 1947 – This chair was designed for the Museum of Modern Art's "International Competition for Low-Cost Furniture Design" (1948) and was later distributed by Thonet

△▷ Ilmari Tapiovaara, *Domus* stacking chair for Keravan Puuteollisuus, 1946 – Later produced by Wilhelm Schauman, this chair was retailed under the names *Stax* and *Finnchair* in Britain and America respectively

▷▷ Ilmari Tapiovaara, *Domus* stacking chair for Keravan Puuteollisuus, 1946

designer and extended his skills into other product disciplines, including lighting, glassware, stainless steel flatware (Hackman), stereo equipment, carpets, textiles, wallpaper and toys. Between 1950 and 1952, he headed a department at the Taideteollinen Korkeakoulu (University of Art and Design) in Helsinki and from 1952 to 1953 was a visiting professor at the Institute of Design, Illinois Institute of Technology in Chicago. During this American sabbatical, he also worked in the Chicago design practice of Ludwig Mies van der Rohe (1886–1969). In 1971 he received the Finnish State Design Award, and later a prize from the Finnish Culture Foundation in 1986. Tapiovaara was one of the first Finnish designers to work extensively abroad and once noted, "Being a designer is rather like being a doctor: once you have the professional skill, you can practice wherever you like. If what you do is good, it's good everywhere." Having been directly inspired by some of the greatest names of the Modern Movement, Tapiovaara evolved a distinct language of design, which, while rooted in functionalism, imparted a sense of timelessness and character to his work.

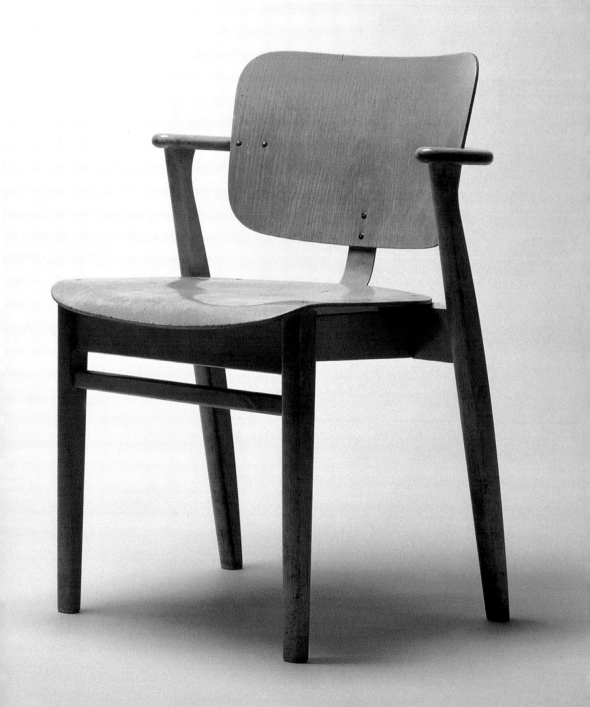

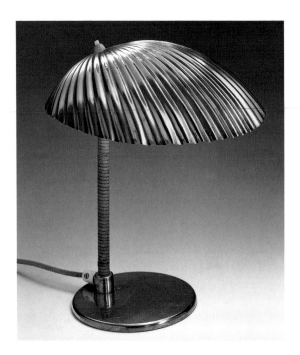

▷ Paavo Tynell, brass and leather table lamp for Taito, 1941

▷▷ Paavo Tynell, brass chandelier for Taito, 1948

# paavo tynell *(b. 1890 Helsinki – d. 1973 Tuusula, Finland)*

Paavo Tynell studied metalworking at the Taideteollinen Korkeakoulu (University of Art and Design, Helsinki) in Helsinki and then taught there from 1917 to 1923, instructing plate iron, tin and copper-smiths and playing an important role in disseminating handcraft skills. In 1918 he founded his own manufacturing company, Taito Oy, and subsequently produced a wide range of metal objects, including the enormous bronze doors of the Finnish Parliament building in Helsinki. Under Tynell's directorship during the 1920s and 1930s the firm employed a number of young designers such as **Alvar Aalto**, Gunnel Nyman and Kaj Franck, who went on to become key exponents of Finnish design. By the 1940s, Taito Oy was producing innovative light fittings designed by Tynell, including a brass and leather table lamp (1941) with a scallop-shaped shade and an extraordinary chandelier (1948) with a cascade of brass snowflake-like elements suspended from delicate wire arcs. Inspired by antique crystal chandeliers and traditional Finnish Yuletide *himmeli* mobiles made of straw, Tynell's highly decorative chandelier was intended to cast interesting shadows and produce a shimmering light effect reminiscent of candle or gas-light. In 1948, Taito Oy began exporting light fittings to the United States, which were retailed by the Finnish company Finland House in New York. Through economic necessity Taito Oy was merged with Idman Osakeyhtiö in 1950, which resulted in Tynell's designs becoming less fanciful and more suited to industrial production. During this period he designed a number of lamps that were manufactured under the Taito label, many with perforated shades and sweeping sculptural forms. While Tynell's lighting products were notable for their structural simplicity, their constructions often featured unusual combinations of brass and glass, which gave them an opulent yet elegant appearance. In many cases his lights were hand-made, and so production was frequently limited to only a few examples of each design. Tynell received numerous awards for his work, including the Ornamo golden badge of honour in 1961.

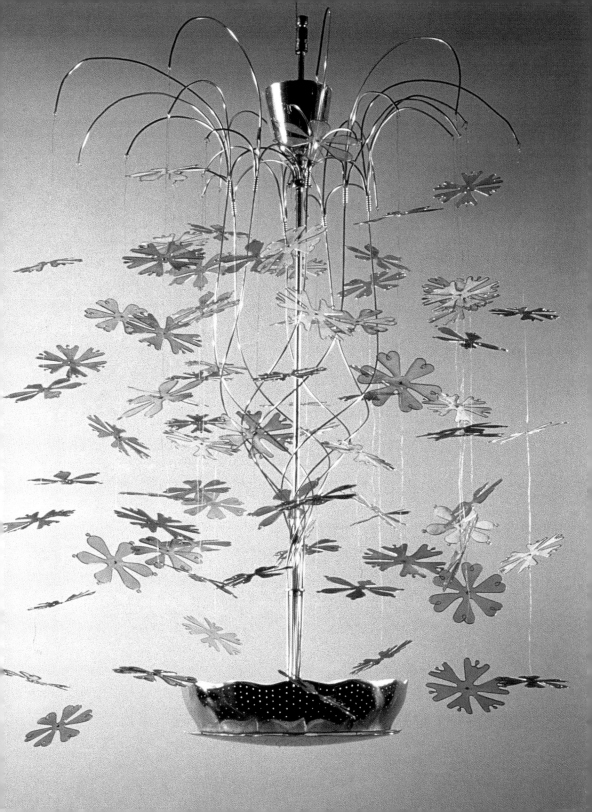

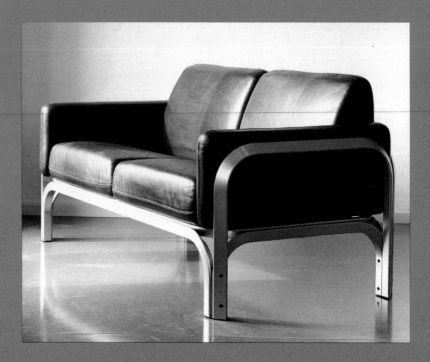

▷ Jørn Utzon, *Floating Dock* sofa for Fritz Hansen, 1968

# jørn utzon *(b. 1918, Copenhagen, Denmark)*

The Danish architect and industrial designer Jørn Utzon is best known for his dynamic, highly innovative, but problematical design for the Sydney Opera House (1957–1973) – one of the most famous buildings in the world. He studied under Kay Fisker and Steen Eiler Rasmussen (1898–1990) at the Kongelige Danske Kunstakademi (Royal Danish Academy of Fine Arts) from 1937 to 1942, and following this worked for three years in the design practice of the great Swedish functionalist **Erik Gunnar Asplund**. It was, however, the unified architectural schemes of **Alvar Aalto** and Frank Lloyd Wright (1867–1959) – the two great patriarchs of Organic Modernism – that had the biggest influence on his work. Having established his own design practice in Zurich and Ålsgarde in 1947, Utzon went on to win a number of building competitions, most notably first prize for the design of the Sydney Opera House and Concert Hall in 1956. The resulting building with its magnificent sail-like vaults brought him much international fame, but from the start the project was dogged by controversy. Construction of the prefabricated concrete roof shells, which were inspired by the cellular structures of nature that

Utzon described as "additive architecture", posed a variety of problems. He eventually worked out a solution for their construction with an ingenious piece of spherical geometry, but was nevertheless forced to resign from the project in 1966 (the building and interiors were completed by an Australian firm of architects). In addition to buildings, during the 1960s and 1970s Utzon also designed lamps (for Nordisk Solar), glassware, and furniture. His *Floating Dock* furniture collection (1967) for the Danish furniture manufacturer **Fritz Hansen** was also born of his concept of additive architecture. Comprising a number of differently sized tables and chairs (including a curious sofa-bed style chair), the construction of the *Floating Dock* range was based on an innovative system of arc-like components of anodized triangular-section extruded aluminium that locked together at a forty-five degree angle. His undulating, expressionistic *8101* chair (1969), which could be linked with additional pieces to create a wider seating unit or a sofa, was similarly inspired by his architectural concepts, and reflected his fascination with inventive construction operating "at the edge of the possible". Beyond his love of nature, Utzon also

▽ Jørn Utzon, *Floating Dock* modular seating with matching table for Fritz Hansen, 1968

▽▽ Jørn Utzon, lounge chair and ottoman for Fritz Hansen, 1968

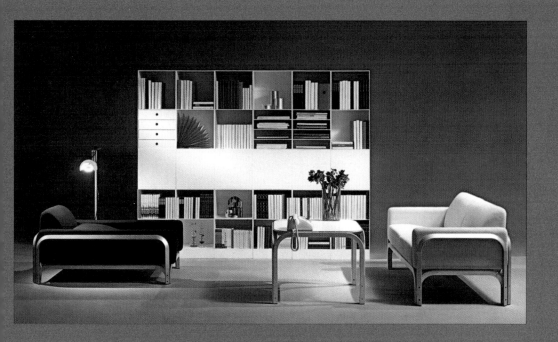

found much inspiration in the buildings of other ages and cultures, such as Chinese, Islamic and Mayan. Throughout his career he received numerous awards, including the Eckersberg Medal (1957), the German Institute of Architects Medal (1965), the Danish Furniture Prize (1970), and a gold medal from the Royal Institute of British Architects (1978).

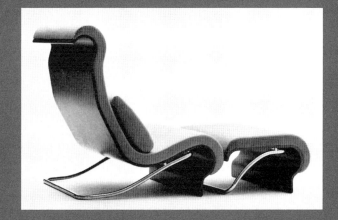

▷ Kristian Vedel, adjustable
child's chair for Torben Ørskov
& Co., 1957

# kristian vedel *(Danish b. 1923)*

The Danish furniture designer Kristian Vedel
served an apprenticeship as a cabinet-maker and
became a journeyman joiner in 1942. He trained
under **Kaare Klint** in the furniture department
of the Kongelige Danske Kunstakademi (Royal
Danish Academy of Fine Arts) from 1944 to 1945,
and graduated from the Kunsthåndværkerskolen
(School of Arts & Crafts) in 1946. Following this,
he was employed as an assistant between 1946
and 1949 by the architecture and furniture de-
sign husband-and-wife team Tove and Edvard
Kindt-Larsen (1906–1994 & 1901–1982). He
later worked for Palle Suenson (1904–1987) from
1949 to 1955, and was a teacher at the Kunst-
håndværkerskolen in Copenhagen from 1953
to 1956. Strongly influenced by Klint's standards
of economy, simplicity and function, during this
period Vedel designed an innovative child's chair,
which was formed as a curved plywood shell and
fitted with slots at various heights for seat adjust-
ment. Two of these chairs could also be joined
together to make up an integrated chair-cum-feed-
ing table. This highly practical design, which was
manufactured by Torben Ørskov & Co., was based
on Vedel's belief that, "The starting point for an

industrial artist's work must always be that he,
from his own point of view, and as objectively as
possible, takes a position with regard to what he
feels society and his fellow men need; he must
personally take a stand on the existing possibili-
ties and responsibilities." In 1955 he established
his own design practice and the following year
produced a range of multi-functional melamine
kitchenware – storage jars, bowls, beakers, salad
servers and an egg-cup – that was remarkable
for its sculptural simplicity. Five years later he de-
signed his well-known *Modus* furniture system
with its low and high-backed lounge chairs, arm-
less dining chairs and matching glass-topped
tables. Manufactured by Søren Willadsen from
1963 onwards, the *Modus* range was notable for
its use of padded leather slings that formed the
arm and back sections when fitted onto the sup-
porting rosewood frame. In 1962, Vedel was
awarded the Lunning Prize for his utilitarian con-
sumer products in plastic that "demonstrated his
acceptance of materials beyond those traditional
to the furniture craftsman". Between 1966 and
1968 he was chairman of the IDD (Industrial
Designers of Denmark), and from 1969 to 1972

▽ Kristian Vedel, *Modus* dining table and chairs for Søren Willadsen, 1963

▽▽ Kristian Vedel, children's furniture executed by I. Christiansen, 1949 – This furniture was designed to grow with the child

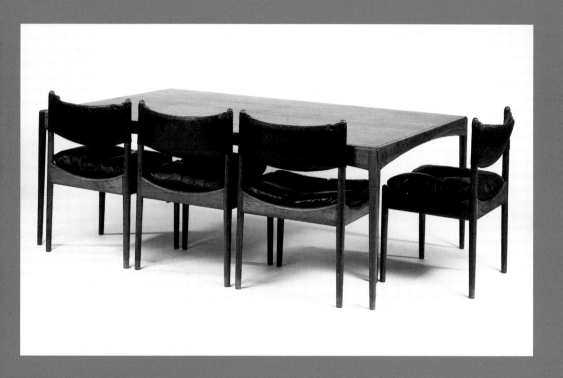

organized and led the department of industrial design at the University of Nairobi in Kenya with the aim of meeting "the needs of the population as a whole". On his return to Denmark in 1972, Vedel and his wife, Ane, established a design studio in Thyholm and began exploring different uses for wool. As one of the leading Danish furniture designers in the late 1950s and 1960s, Vedel received numerous accolades including silver and gold medals at the 1957 (XI) and 1960 (XII) Milan Triennale.

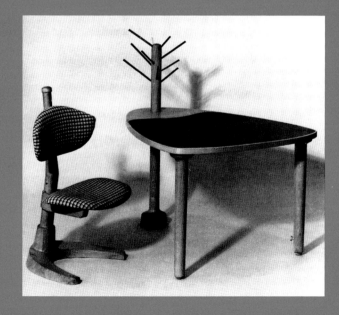

▷ Poul Volther, teak dining chair for FDB, 1951

▷▷ Poul Volther, *Model no. EJ 605 Corona* chair for Erik Jørgensen, 1961

# poul volther *(Danish 1923–2001)*

The Danish architect and furniture designer Poul Volther worked as a journeyman joiner before studying at the Kunsthåndværkerskolen (School of Arts & Crafts) in Copenhagen. Upon graduating in 1949 he established his own architecture and design practice, which he operated until 1985. Over his career Volther designed numerous pieces of furniture, including an elegant teak dining chair (1951) for FDB (Association of Danish co-operative stores), which can be seen as a radical re-working of the traditional ladder-back chair. A decade later he used similar floating elements for his well-known *Corona* chair (1961) which were reminiscent of time-lapse photographs of solar eclipses. Constructed of moulded plywood upholstered with cold-cured polyurethane foam, these elliptical seat pads could also be used as armrests. The frame of the chair to which they were attached was first produced in solid oak, but in 1962 this was changed to chromed spring steel. Similar to the upholstered furniture designed by **Arne Jacobsen** and **Verner Panton**, the *Corona* chair, which was and still is manufactured by Erik Jørgensen, exemplified the trend among the Danish avant-garde away from the re-working of existing furniture types

towards a more sculptural and "synthetic" language of design. But while forward-looking designs such as these embodied the optimistic spirit of the period, they did not embrace the Pop culture ethos of ephemerality and disposability – they were high-quality products intended to stand the test of time. Beyond his architecture and design work, Volther also taught at the Kunsthåndværkerskolen (until 1953) and later at the School of Furnishing and the Polytechnic in Copenhagen between 1955 and 1980. As a leading Danish architect, he was also a member of the Academic Architects' Society from 1955. In keeping with other Scandinavian designers at the time, Volther combined traditional craftsmanship with modern technology so as to produce furniture that was not only durable and comfortable, but also visually exciting.

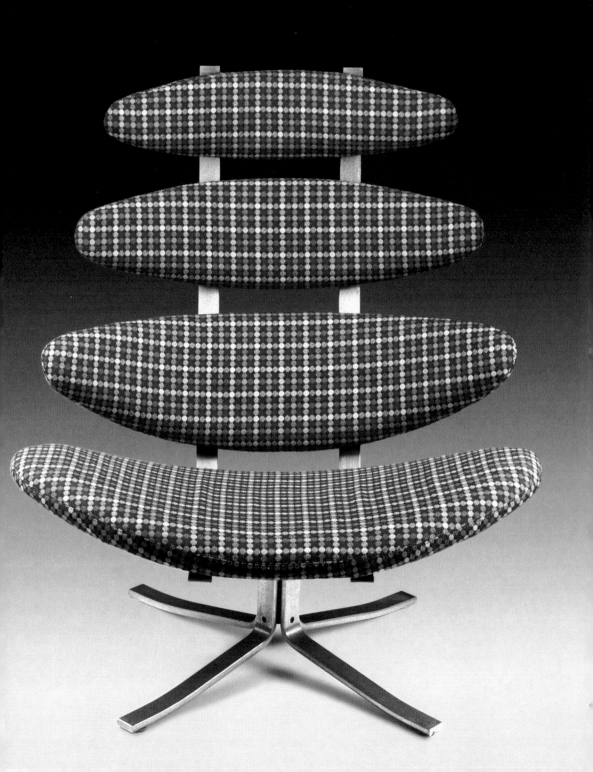

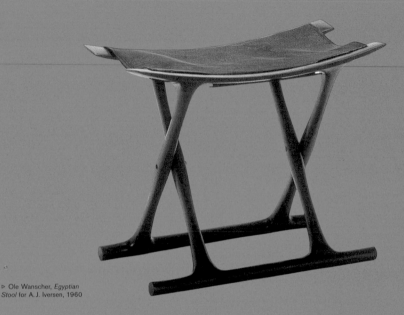

▷ Ole Wanscher, *Egyptian Stool* for A.J. Iversen, 1960

# ole wanscher *(Danish 1903–1985)*

The Danish furniture designer and historian Ole Wanscher studied under **Kaare Klint** at the Kongelige Danske Kunstakademi (Royal Danish Academy of Fine Arts). His father was an art historian who influenced Wanscher's life-long interest in furniture design history. He made several trips to Europe and Egypt to study vernacular and historical furniture types, which provided the background research material for his many books, including *Furniture Types* (1932), *Outline History of Furniture* (1941), *English Furniture c. 1680–1800* (1944) and *History of the Art of Furniture* (1946–1956). Wanscher was one of the founders of the influential annual exhibitions arranged by the Cabinetmakers' Guild in Copenhagen and designed elegant, classical furniture for numerous manufacturers, including P. Jeppesen, Rud. Rasmussen, France & Son and A.J. Iversen. Like his mentor Kaare Klint, Wanscher firmly believed that designers should study historical furniture types that had been functionally and formally honed over time. His own work was especially influenced by 18th century English furniture and Chinese, Egyptian and Greek antecedents – the folding form of his mahogany and leather *Egyptian Stool* (1960), for example,

was based on an ancient exemplar in the collection of the Staatliche Museen zu Berlin. Wanscher's furniture was also notable for its high quality construction and finish, and as such, it exemplified the sheer breathtaking virtuosity of Danish craftsmanship. In 1955, he succeeded Klint as professor of furniture design at the Kongelige Danske Kunstakademi (1955–1973), where he continued to promote the study of period furniture. In 1960 he was awarded a gold medal at the Milan Triennale and the Copenhagen Cabinetmakers' Annual Prize. He also participated in numerous exhibitions, including "Design in Scandinavia" (USA 1954–1957) and "Neue Form aus Dänemark" (Germany 1956–1959). Although Wanscher's furniture was exquisitely crafted and used luxury materials such as rosewood and leather, not all of it was intended solely for the exclusive end of the market. In actual fact, he was one of the first Danish designers to develop furniture for serial mass production. The exquisite detailing of his designs underlined his masterful understanding of furniture-making techniques, while their elegant, timeless forms reflected his scholarly interest in the analysis of period types.

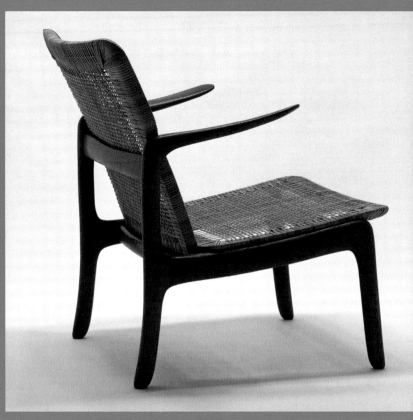

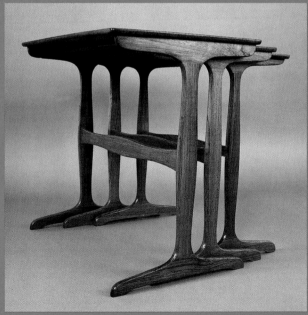

◁ Ole Wanscher, oak and cane chair for Rud. Rasmussen, 1951

▽ Ole Wanscher, rosewood nest of tables for A. J. Iversen, 1953

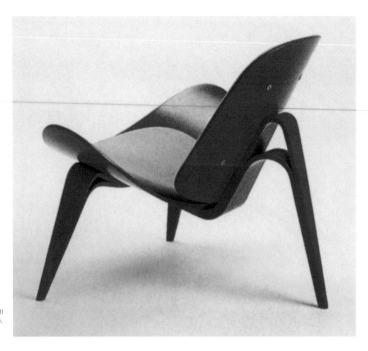

▷ Hans Wegner, *3-benet skalstol* (Three-Legged Shell Chair) for Johannes Hansen, 1963

# hans wegner *(b. 1914 Tønder, South Jutland, Denmark)*

One of the greatest Danish designers of all time, Hans Wegner was the son of a master cobbler who grew up with a deep appreciation of hand-craftsmanship and the inherent qualities of materials. At an early age he developed a real love and understanding of wood, which led him to undertake an apprenticeship in H. F. Stahlberg's carpentry workshop. After becoming a qualified cabinet-maker, Wegner remained at the workshop for three years until he began his military conscription. He later studied joinery at the Polytechnic in Copenhagen, where some of his lessons involved measuring period furniture displayed at the Copenhagen Museum of Decorative Arts. This experience, as well as the annual furniture exhibitions held by the Copenhagen Cabinetmakers' Guild, so influenced the young carpenter that he eventually decided to become a designer. With this intent, he began his training under the furniture designer **Orla Mølgaard-Nielsen** at the Kunsthåndværkerskolen (School of Arts & Crafts) in 1936. Two years later, Wegner worked in the design practice of Erik Møller and Flemming Lassen in Århus, and in 1940 began working in the office established by Møller and **Arne Jacobsen** for

the design of Århus Town Hall. For this project, Wegner designed simple yet well-crafted furniture that epitomized his approach to design at this point in his career, which he described as "stripping the old chairs of their outer style and letting them appear in their pure construction". From 1943 to 1946, Wegner ran his own Århus-based design studio and with **Børge Mogensen** designed a range of good quality yet inexpensive furniture (1945–1946) for the director of the Danish Cooperative Union, Frederik Nielsen, which was intended for small post-war apartments. Following this, Wegner worked in partnership with the architect Palle Suenson (1904–1987) in Copenhagen from 1946 to 1948, prior to establishing his own independent design practice in Copenhagen. From 1940 he also worked with the furniture-maker and chairman of the Cabinetmakers' Guild, Johannes Hansen, and designed numerous chairs for his manufacturing company, including the famous *Round* chair (1949), which became known as *The Chair* or the *Classic Chair*. By the 1950s, Wegner had become one of the leading Scandinavian designers and was internationally celebrated for his exquisitely balanced and beautifully crafted

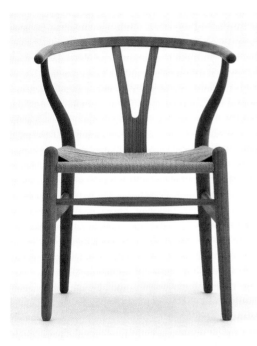

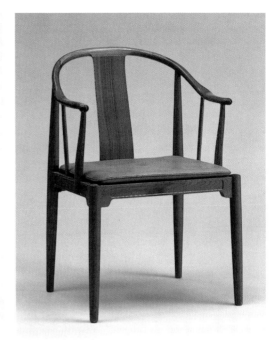

△ ◁ Hans Wegner, *Model no.
CH24 Y-Stolen* (Wishbone
Chair) for Carl Hansen & Søn,
1950

△ Hans Wegner, *Chinese*
chair for Fritz Hansen, 1943

furniture that for the most part was constructed
of solid wood. Manufactured by Johannes Hansen,
**Fritz Hansen**, Andreas Tuck, Getama, A.P. Stolen,
Carl Hansen & Søn and PP Møbler, Wegner's
furniture was intended, as he explained, to be "as
simple and genuine as possible, to show what we
could create with our hands, to try to make wood
come alive, to give it spirit and vitality, and to get
things to be so natural that they could only have
been made by us". His characteristically Scandi-
navian organic approach to design, as exemplified
by his *Chinese* chair (1943), *Peacock* chair
(1947), *Y-chair* (1950) and *Valet* chair (1953),
focused on the importance of the physical, psycho-
logical and emotional connections between users
and their tools for living. By simplifying and purify-
ing form and construction, Wegner created time-
less, supremely beautiful modern re-workings of
traditional furniture types that expressed both a
material and structural honesty. Over his long
career he won numerous awards, including the
Lunning Prize in 1951 – the first year it was estab-
lished. A gifted designer and master craftsman,
Wegner made Danish design world famous.

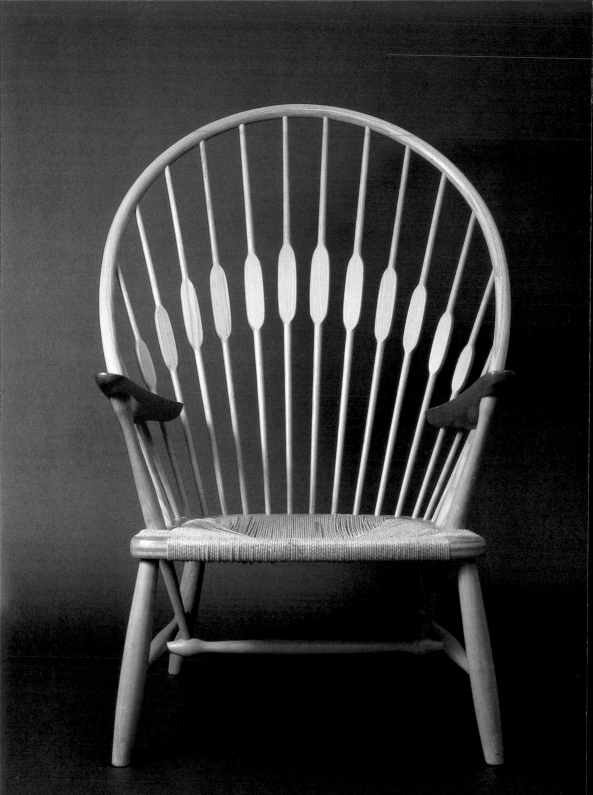

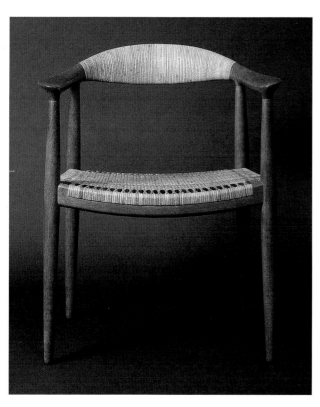

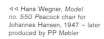

◁◁ Hans Wegner, *Model no. 550 Peacock* chair for Johannes Hansen, 1947 – later produced by PP Møbler

◁ Hans Wegner, *Model no. 501 Round* chair for Johannes Hansen, 1949 – later produced by PP Møbler

▽ ◁ Hans Wegner, Design for the *Round* chair, 1949

▽ CBS television station purchased twelve *Round* chairs for the famous television presidential candidate debate between John F. Kennedy and Richard Nixon in 1960

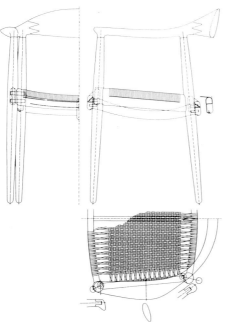

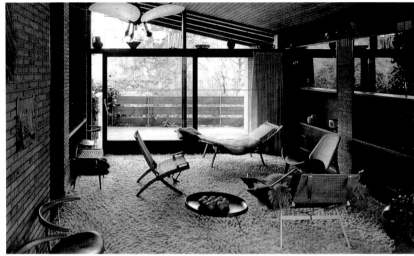

▽▷ Interior of Hans Wegner's house, Tinglevvej – The house was designed in 1962

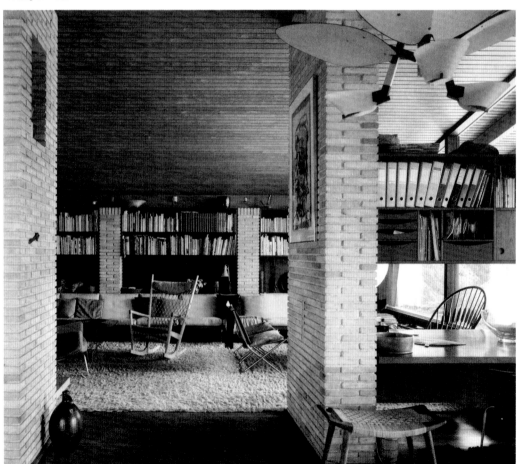

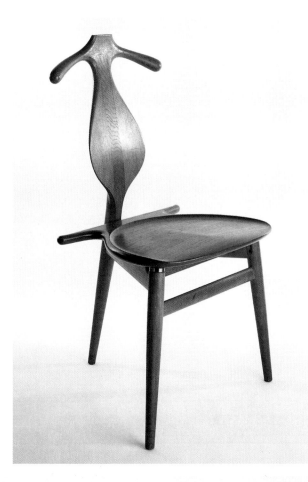

◁ Hans Wegner, *Model no. PP250 Valet* chair for PP Møbler, 1953

▽ Hans Wegner, *Model no. PP512* folding chair for PP Møbler, 1949

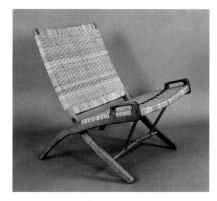

◁ Hans Wegner, *Model no. 27* easy chairs for Carl Hansen & Søn, 1949

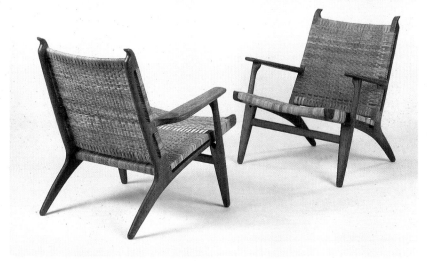

▽ Hans Wegner, working
drawing for the *Kontordrejestol*
(Office Swivel Chair), c. 1955

▷ Hans Wegner, *Kontor-
drejestol* (Office Swivel Chair)
for PP Møbler, 1955

▽▽ Hans Wegner, *Model no.
GE225 Flaglinestolen* (Flag
Halyard Chair) for Getama,
1950

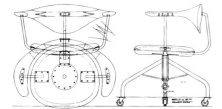

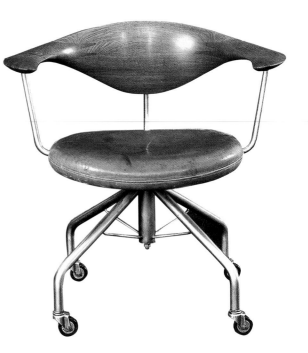

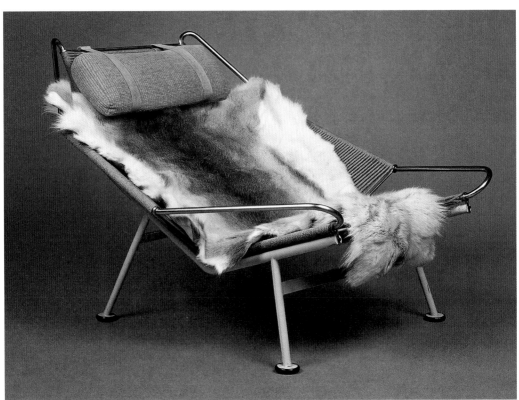

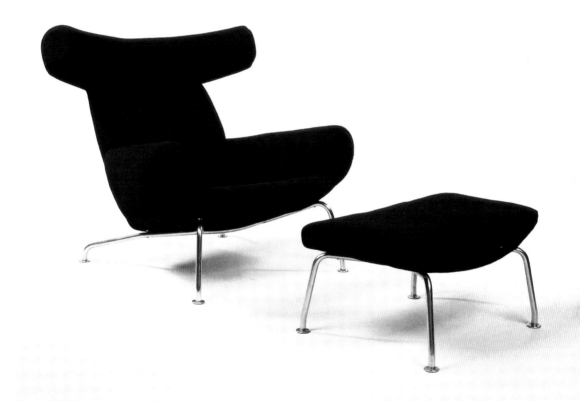

▷ Tapio Wirkkala, laminated
birch platter executed by Martti
Lindqvist, 1951

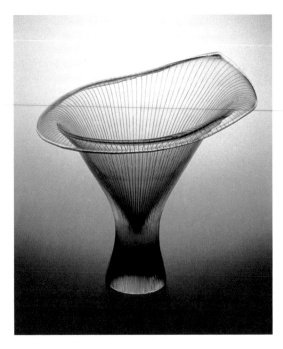

▷ Tapio Wirkkala, *Kantarelli*
(Chanterelle) vase for littala,
1947 – Originally designed for
a competition organized by the
littala glassworks, this vase
was later exhibited at the 1951
(IX) Milan Triennale

# tapio wirkkala

*(b. 1915 Hanko – d. 1985 Esbo, Finland)*

Tapio Veli Ilmaari Wirkkala was one of the great figures of Finnish design, whose work evoked a strong sense of national identity by embracing the traditional materials and processes of Finnish hand-craft and the emotionally seductive forms found in nature. He was a designer of remarkable versatility, who worked in a diverse range of disciplines, in-cluding glass, ceramic, metalware, furniture, light-ing, jewellery, exhibition, graphics, packaging and industrial design. His output ranged from the every-day to the highly exclusive and often blurred the boundaries between art, craft and design. A bushy-bearded pipe-smoker, Wirkkala took a workman-like approach to design and acknowledged the need to "get away from the drawing board, to see just how a product is made and get to know the people who will help make it … [in order to] get a real contact with the job". Beyond his technical virtuosity, Wirkkala also possessed a remarkable empathy for the materials he used. As he noted, "All materials have their own unwritten laws. This is forgotten far too often. You should never be vi-olent with the material you're working on, and the designer should aim at being in harmony with his material." By sensitively exploring the formal poten-

tial of different mediums such as metal, wood, glass, ceramics and plastics, Wirkkala produced innovative and poetic designs that elegantly expressed the materials' intrinsic qualities. Through his extensive body of work he pioneered an expres-sive language of organic form that was astonish-ingly modern, yet also projected a sense of time-less beauty. This aspect of his work resulted from the way in which he tirelessly honed his designs, often drawing a hundred sketches just to perfect one model. Deeply inspired by and spiritually con-nected to the natural environment that surround-ed him, Wirkkala used forms that captured the abstract essence of the natural world – from birds and leaves to the frosted patterns made by ice. He was also interested in the Lapp (Sami) culture and drew much inspiration from it: he employed the age-old form of a traditional Lapp kurska (a wooden drinking vessel), for example, as the start-ing point for a number of his ceramic cup designs. Guided by a dialogue between "eye, hand and thought", Wirkkala produced objects that can be seen as a unity of opposites – traditional and innovative, rational and romantic, organic and geo-metric, artistic and functional, visual and tactile,

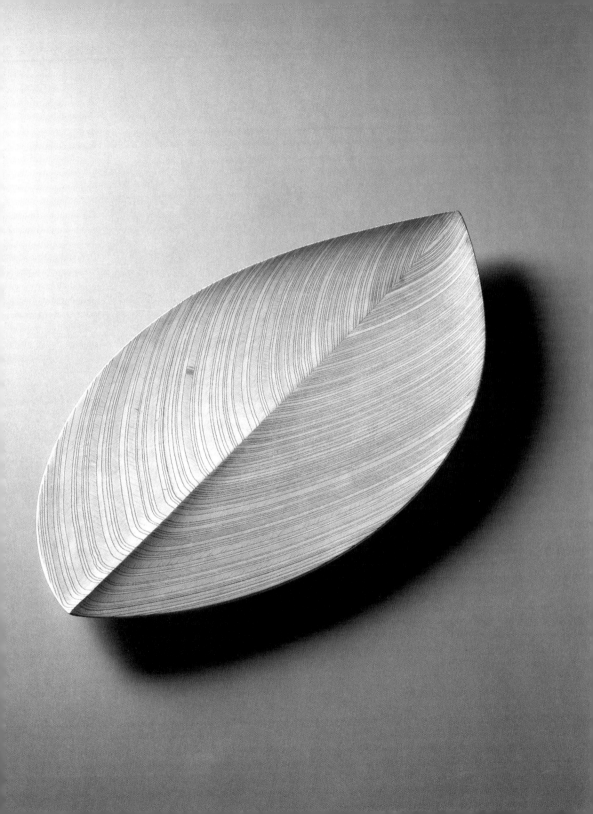

▷ Tapio Wirkkala, *Century* tea service for Rosenthal, 1979

▽ Tapio Wirkkala, *Model no. 3851 Paperbag* vase for Rosenthal, 1977

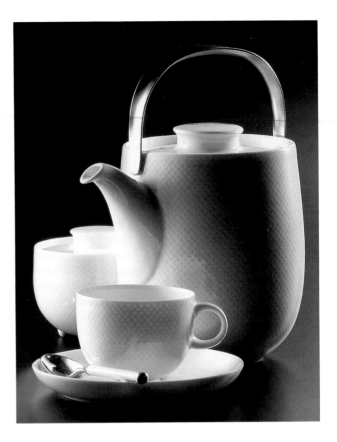

national and international. Frequently he brought ancient craft sensibilities to the design of modern objects for mass production, whether it was for a range of inexpensive pressed glassware or a plastic-handled hunting knife. Having studied sculpture at the Taideteollinen Korkeakoulu (University of Art and Design), Helsinki, from 1933 to 1936, he later worked as a sculptor and graphic designer. In 1947, he shared first prize with Kaj Franck in a glassware competition organized by Iittala and subsequently produced designs for the glassworks on a freelance basis until his death in 1985. His blown-glass *Kantarelli* vases, the forms of which were inspired by chanterelle mushrooms, captured the fluid organic abstraction that came to exemplify post-war Scandinavian design. This series of vases was produced from 1947 to 1960 and helped establish his reputation internationally. Wirkkala was also widely celebrated for his laminated wood leaf-shaped bowls and furniture, which although made from an essentially man-made material, possessed an extraordinary natural beauty. The multi-coloured wood laminates were laid up by him and then cut and scooped to reveal a remarkable striped effect. Using this

technique, he also produced a series of outstanding plywood sculptures and sculptural reliefs that demonstrated his complete mastery of expressive abstracted form. His designs were shown at the 1951 (IX) and 1954 (X) Milan Triennale where they were awarded six Grand Prix. Over his career he won many other awards, including the Lunning Prize in 1951, the Golden Obelisk, Domus Italia in 1963 and the Prince Eugen Medal in 1980. From 1951 to 1954 Wirkkala was the artistic director of the Taideteollinen Korkeakoulu, Helsinki, and later, between 1955 and 1956, worked briefly in the New York office of Raymond Loewy (1893–1986). While Wirkkala worked extensively for the Iittala glassworks, producing a plethora of memorable and highly influential designs – such as his *Ultima Thule* range (1968), which spawned the widespread fashion for frosted glassware in the 1970s – he also designed colourful glassware for Venini, ceramics for Rosenthal, knives for Hackman, furniture for Asko and lighting for Airam. More than any other designer, Wirkkala's extensive body of work powerfully embodied the underlying humanist ethos that has shaped and continues to define Scandinavian design.

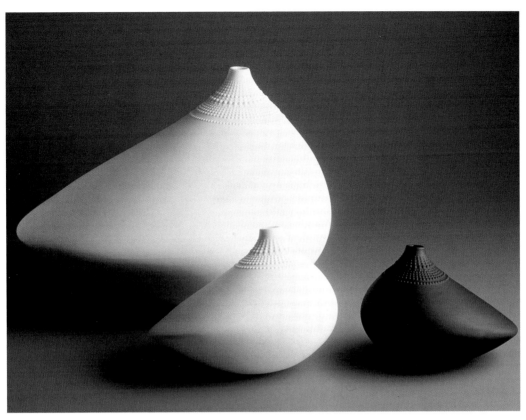

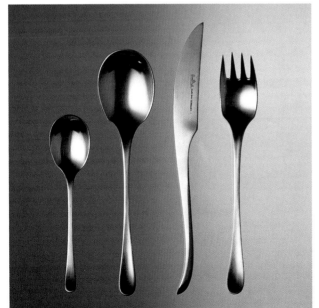

◁ Tapio Wirkkala, *Kurve* flat-
ware for Rosenthal, 1968

△ Tapio Wirkkala, *Pollo* vases
for Rosenthal, 1970

▽ Tapio Wirkkala, *Tapio* silver
flatware for Kultakeskus,
1955–1957

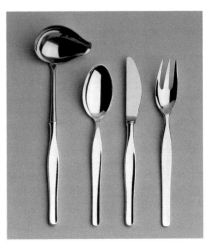

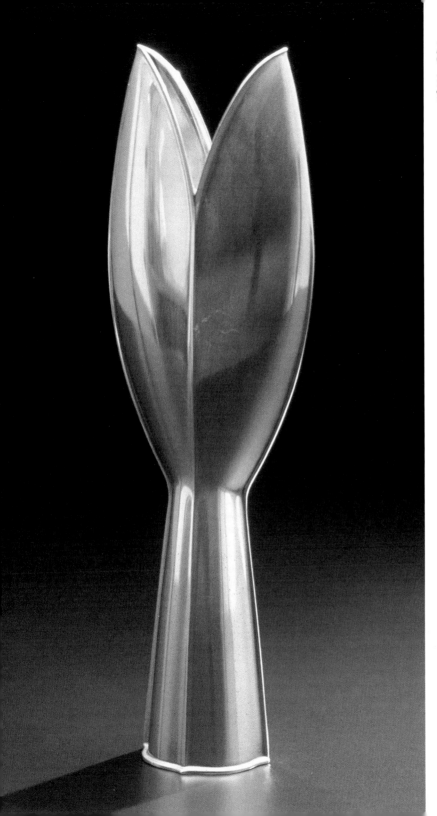

◁◁ Tapio Wirkkala, *Model no. TW412* silver candelabrum (hand-made to order), 1969

◁ Tapio Wirkkala, *Model no. TW2* silver-plated alpaca vase executed by Nils Westerback, 1954

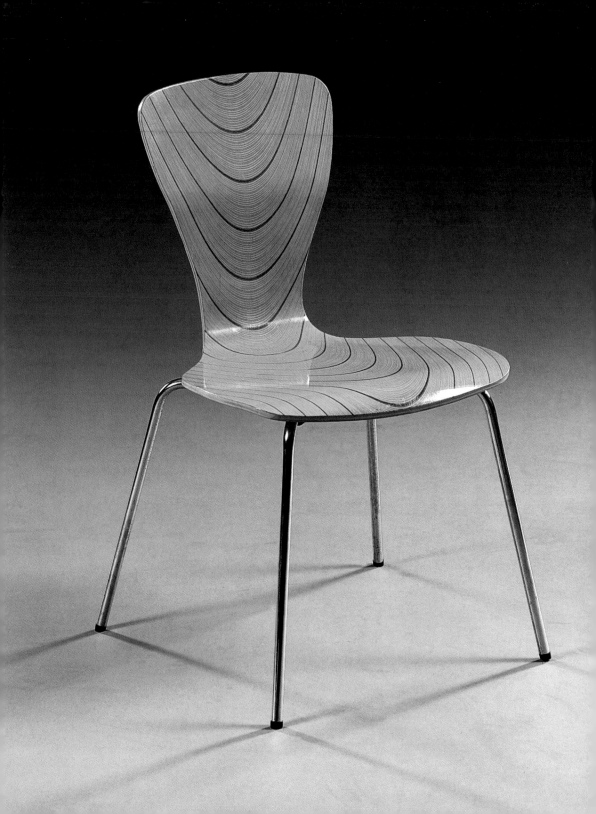

◁ Tapio Wirkkala, *Nikke 9019* laminated plywood chair for Asko, 1958

▽ Tapio Wirkkala, *Model no. 9016* table (laminated padouk, maple and hazel) for Asko, 1958

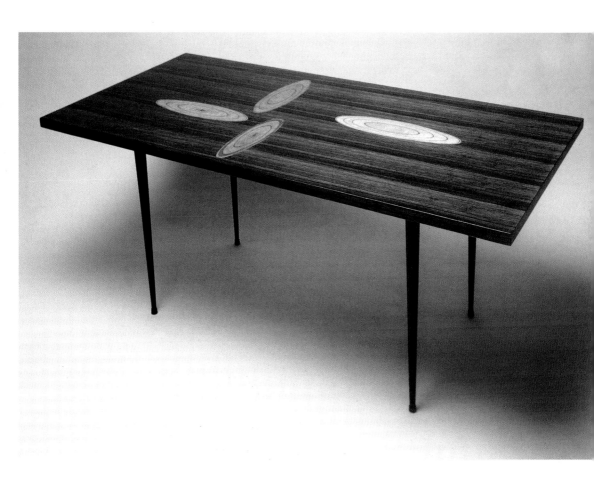

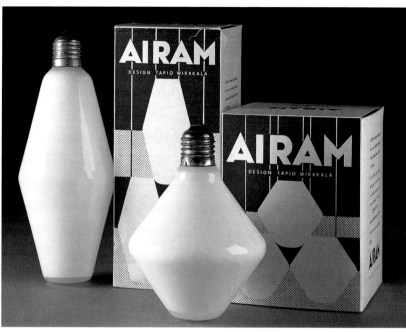

◁◁ Tapio Wirkkala, *Model no. 66-057* hanging lamp produced by Iittala for Stockmann, 1961

◁ Tapio Wirkkala, opalescent glass light bulbs and packaging for Airam, 1959

▽◁ Tapio Wirkkala, hanging lamp from the *K2* series produced by Iittala & Idman, 1960

▽▷ Tapio Wirkkala, hanging lamp from the *K2* series produced by Idman, 1960

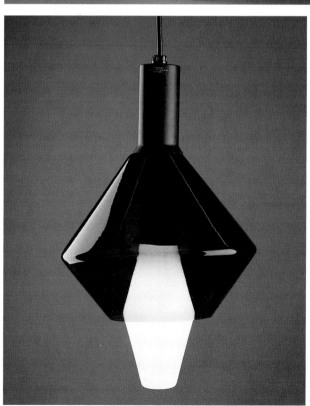

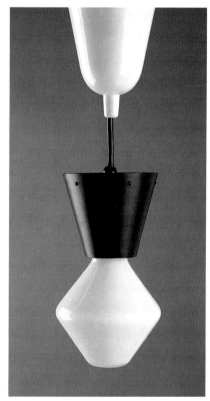

FISKARS

| | |
|---|---|
| BEFORE **1800** | |

1649 Fiskars ironworks founded in Fiskars, Finland

1689 Husqvarna founded as arms factory in Husqvarna, Sweden

1742 Kosta glassworks founded in Kosta, Sweden

1754 Royal Danish Academy of Fine Arts established in Copenhagen

1762 Hadeland glassworks founded in Jevnaker, Norway

1775 Royal Copenhagen porcelain factory founded in Copenhagen, Denmark

1790 Hackman founded in Vipuri, Finland

1793 Notsjö glassworks founded in Urjala (later Nuutajärvi), Finland

**1800**

1809 Sweden cedes Finland to Russia in the Fredrikshamn Peace Treaty; Finland becomes a Grand Duchy under the Russian Tsar

1812 Finnish capital moves from Turku to Helsinki

1814 Denmark cedes Norway to Sweden in the Treaty of Kiel

**1820**

1825 Gustavsberg ceramics factory founded in Gustavsberg, Sweden
Holmegaard glassworks founded in Holmegaard, Denmark

1835 Elias Lönnrot publishes first version of Finnish national epic *Kalevala*; final version 1849
Danish author Hans Christian Andersen publishes his first booklet of four *Eventyr og Historier* (Fairy Tales and Stories); a further 152 tales follow until 1873

1836 Swedish-American John Ericsson patents the screw propeller

**1840**

1843 Tivoli Gardens opens in Copenhagen, Denmark
The Althing, the world's first democratic parliament, founded 930, re-established in Reykjavik, Iceland

1845 Svenska Slöjdföreningen founded – the world's first association to promote applied arts

1849 Royal autocracy in Denmark abolished; the country becomes a constitutional monarchy

1853 Bing & Grøndahl porcelain factory founded in Copenhagen, Denmark

**1860**

1865 Nokia pulp mill established on the Emäkoski River, Finland

1866 Swedish chemist Alfred Nobel invents dynamite

1871 British Arts and Crafts figurehead William Morris visits Iceland for the first time

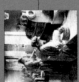
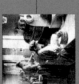

| Year | Event |
|---|---|
| 1872 | Fritz Hansen founded in Copenhagen, Denmark |
| 1873 | Arabia ceramics factory established in Helsinki, Finland, by Swedish parent company Rörstrand |
| | William Morris returns to Iceland for a second visit, calls it his "Holy Land" |
| 1874 | Louis Poulsen & Co founded in Copenhagen, Denmark |
| | Edvard Grieg composes his *Peer Gynt* suite, finished and performed 1875 |
| 1876 | David-Andersen goldsmithy established in Christiania (later Oslo) |
| | L. M. Ericsson founded in Stockholm, Sweden |
| 1879 | Norwegian author Henrik Ibsen writes his controversial play *A Doll's House* |
| 1881 | Iittala glassworks founded in Iittala, Finland |
| 1886 | Porsgrund ceramics factory founded in Porsgrunn, Norway |
| 1888 | Swedish author August Strindberg writes his scandalous play *Miss Julie* |
| 1892 | Gerhard Munthe designs *Blue Anemone* service for Porsgrund |
| 1893 | Norwegian artist Edvard Munch paints *The Cry* |
| 1896 | Gerhard Munthe designs his *Eventyrværelset* (Fairy Tale Room), including original chair, for Holmenkollen Tourist Hotel |
| 1897 | Iris Workshops established in Porvoo, Finland |
| 1898 | Inventor Valdemar Poulsen patents magnetic sound recorder |
| | Orrefors glassworks founded in Småland, Sweden |
| 1899 | Finnish composer Jean Sibelius composes his *Finlandia* symphony, but is forced to publish it as *Opus 26, no 7* |
| | Carl Larsson publishes *Ett Hem* (Our Home) to "reform taste and family life" |
| | Ellen Key publishes her booklet *Skönhet åt alla* (Beauty for All) to reform Swedish design |
| 1900 | Frida Hansen's textiles awarded a gold medal at the "Exposition Universelle et Internationale" in Paris |
| | The Karelian-style Finnish Pavilion by Saarinen, Gesellius & Lindgren exhibited at the "Exposition Universelle et Internationale" in Paris |
| | Ellen Key publishes her influential *Barnets århundrade* (The Century of the Child) |
| 1901 | First Nobel Prizes awarded to "those who during the preceding year shall have conferred the greatest benefit on mankind" |
| 1902 | Saarinen, Gesellius & Lindgren design the Finnish National Museum in Helsinki |
| 1904 | Georg Jensen founds his silversmithy in Copenhagen, Denmark |

1880

1900

Denmark grants Iceland partial home rule; full independence under Danish King granted in 1918

Eliel Saarinen designs the Helsinki Railway Station, finally finished in 1919

**1905** Treaty of Karlstad dissolves Swedish-Norwegan union; Norway gains independence and re-establishes its monarchy

**1906** Finnish women are the first in Europe to gain the right to vote; women received the right to vote in Norway 1913, in Denmark and Iceland 1915, in Sweden 1921

**1909** Gustav Gaudernack designs *Dragonfly Bowl* for David-Andersen

**1910** Rihimäki glassworks founded in Rihimäki, Finland

**1912** Stockholm (Sweden) hosts the Summer Olympic Games

**1914** First Husqvarna motorbike launched

Denmark, Iceland, Norway and Sweden remain neutral in World War I; Finland is formally allied with Russia but takes no part in the fighting

**1915** Large parts of Reykjavik's old wooden buildings devastated by fire

Svenska Slöjdföreningen establishes agency to promote collaboration between artists and industry

**1916** Simon Gate develops his *Graal* technique at Orrefors

**1917** After the Russian revolution, Finland declares its autonomy in all areas except foreign policy and defence

Wilhelm Käge designs his *Liljeblå* service for Gustavsberg

The first "Hemutställing" (Exhibition of the Home) is held at Lijevalchs Art Gallery in Stockholm

**1918** Finland given independence by Russian Bolshevik government; civil war rages between Finnish "Red" and "White" Guards; the Whites are victorious

Iceland is given independence within retained Crown Union with Denmark

**1919** Gudjón Samuelsson appointed first National Architect of Iceland; retains position until 1950

Electrolux founded in Stockholm, Sweden

Gregor Paulsson's influential *Vackrare Vardagsvara* (More beautiful Things for Everyday Use) is published

**1920** Hjalmar Branting forms Sweden's first Social Democratic government, lasting from March 10 to October 27

Denmark, Norway and Sweden are among the founder-members when the League of Nations is launched in January; Finland joins later in the year

**1922** Gustaf Dalen designs the first Aga cooker, still in production since 1929

**1925** Simon Gate designs the *Parispokalen* for Orrefors, specifically for the Swedish Pavilion at the "Exposition Internationale des Arts Décoratifs et Industriels Modernes" in Paris

Thor Bjørklund designs the Spar cheese slicer for Thor Bjørklund & Sønner

Bang & Olufsen founded at Quistrup, near Struer, Denmark

British critic Morton Shand coins the term "Swedish Grace"

1910

1920

**1927** Volvo founded in Gothenburg, Sweden

**1930** Søren Hansen designs the *DAN* chair for Fritz Hansen

Svenska Slöjdföreningen arranges the "Stockholmsutställningen" (Stockholm Exhibition), heralding the emergence of Scandinavian Modernism

Jean Heiberg designs the *DHB 1001* telephone for a joint venture between Norsk Elektrisk Bureau and L. M. Ericsson

**1932** Swedish industrialist Ivar Kreuger dies; the collapse of his financial empire causes a deep economic depression; the Social Democrats win the forced election and remain in power until 1976

First LEGO workshop founded in Billund, Denmark

Steen Eiler Rasmussen publishes *British Brugskunst* (British applied art) and arranges an exhibition of the same name at the Museum of Industrial Art in Copenhagen; the impact on Danish design is immense

Aino Aalto wins second prize in the Karhula-Iittala competition for her pressed *Bölgeblick* glassware range (produced from 1934)

**1933** Wilhelm Kåge designs *Praktika* tableware for Gustavsberg

Kaare Klint designs *Safari* and *Deck* chairs for Rud. Rasmussen

**1934** Thorbjørn Lie-Jørgensen designs silver and ebony jug for David-Andersen

Alva & Gunnar Myrdal publish their book *Kris i befolkningsfrågan* (The Population Issue Crisis), which leads directly to the Social Democrats adopting wide-ranging "social engineering" policies that will affect Swedish society throughout the 20th century

**1935** Artek Oy founded in Helsinki to manufacture and retail furniture designed by Aino and Alvar Aalto

**1936** Bruno Mathsson designs the chair later known as *Eva* for Karl Mathsson

Alvar Aalto designs his *Savoy* vase for Karhula

**1937** Edvin Öhrström develops the *Ariel* technique at Orrefors

Guðjón Samúelsson is given the assignment to design the Hallgrímskirkja (church) in Reykjavik; building is finally finished in 1986

SAAB is founded in Linköping, Sweden

Jacob Jacobsen designs *L-1* lamp for Luxo

**1939** Finland is attacked by the Soviet Union; on the Continent, World War II begins

Wilhelm Kåge designs his *Grå ränder* service for Gustavsberg

Alvar Aalto designs the Finnish Pavilion for the New York World's Fair

Still officially subject to German-occupied Denmark, Iceland is occupied by British and American forces throughout the war, 1939–1945

**1940** German forces invade and occupy Denmark and Norway; the Norwegian King escapes to England, the Danish king remains in Copenhagen

Armistice in Soviet–Finnish war; Finland grants territory to the Soviet Union

Sweden maintains neutrality throughout the war, but makes concessions to German interests

**1941** After the German, Italian and Rumanian declarations of war against the Soviet Union, Finland too declares war

**1943**  Le Klint is founded in Odense, Denmark

Sixten Sason designs the *Model 248* vacuum cleaner for Electrolux

IKEA is founded in Älmhult, Sweden

Icelandic author Halldór Laxness publishes the first volume of his historical trilogy *Íslandsklukkan* (The Bell of Iceland), completed 1946

**1944**  The Soviet Union attacks Finland; after three months, an armistice is reached between Finland and the allies

Iceland proclaims itself an autonomous Republic; after the German occupation ceases in 1945, Denmark recognises Icelandic autonomy

Hans Wegner designs his *Chinese chair* for Fritz Hansen

Finn Juhl designs his *Model no. NV-44* armchair for Niels Vodder

**1945**  German occupation of Denmark and Norway ceases at the end of the war in May

Swedish author Astrid Lindgren publishes *Pippi Långstrump* (Pippi Longstocking), the most widely-read Swedish book of the century

**1946**  Norway is the 12th, Denmark the 15th state to ratify the United Nations charta in 1946; Iceland and Sweden join later that same year

Ilmari Tapiovaara designs *Domus* chair for Keravan Puuteollisuus/Wilhelm Schauman

Henning Koppel designs biomorphic 89 jewellery for Georg Jensen

**1947**  The first Swedish small car, Sixten Sason's streamlined *Saab 92*, is introduced

Tapio Wirkkala designs the *Kantarelli* vases for Iittala

Peter Hvidt and Orla Mølgaard-Nielsen design *AX chair* for Fritz Hansen

**1948**  Hasselblad launches its *1600F camera*, designed by Sixten Sason, in New York

**1949**  NATO formed to defend Europe against the Soviet threat; Denmark, Iceland and Norway are among the 12 founder-member nations

Arne Korsmo designs *Korsmo silverware*, produced by Jacob Tostrup from 1953

Hans Wegner designs his *Round chair* (later *The Chair* or *The Classic Chair*) for Johannes Hansen

**1950**  First Danish industrial design consultancy, Sigvard Bernadotte & Acton Bjørn Industridesign, Merkantil Grafik founded in Copenhagen; designs melamine bowl *Margrethe* for Rosti

**1951**  Marimekko founded in Helsinki, Finland

Tetra Pak founded in Lund, Sweden

**1952**  Oslo (Norway) hosts the Winter Olympic Games

Helsinki (Finland) hosts the Summer Olympic Games

Lunningpriset, a travel stipend in honour of Frank Lunning, owner of Georg Jensen Inc. in New York, is awarded for the first time; for 20 years it is given annually to at least two outstanding Scandinavian designers (in all, 13 Danes, 10 Finns, 7 Norwegians and 14 Swedes received it)

Kaj Franck designs *Kilta* tableware for Arabia (picture showing *Teema* tableware range, 1977–1980, based on the *Kilta* design)

Denmark, Iceland, Norway and Sweden form the Nordiska rådet (Nordic Council) to promote cooperation between the Nordic states; Finland joins in 1955

1945

1950

1953 Konrad Galaaen designs *Spire* tableware range for Porsgrund

1955 Finland joins the United Nations
Helsingborg hosts the influential "H55" architecture and interior design fair
Ingeborg Lundin designs *Äpple* (Apple) vase for Orrefors
Arne Jacobsen designs *3107 Series 7* chair for Fritz Hansen

1956 L. M. Ericsson launches its *Ericofon*, designed by Hugo Blomberg, Ralph Lysell & Gösta Thames in 1954
Volvo launches its classic *Volvo P120*, known as the *Amazon*

1957 Arne Jacobsen designs the *Ægget* and *Svanen* chairs as part of his SAS Air Terminal and Royal Hotel in Copenhagen
Vuokko Eskolin-Nurmesniemi designs the *Jokapoika* shirt for Marimekko
Antti Nurmesniemi designs enamel coffee pot for Wärtsilä
Ulla Procopé designs her *Liekki* (Flame) cooking and serving range for Arabia
Nils Landberg designs his *Tulpan* (Tulip) glass for Orrefors
Poul Henningsen designs his *PH Artichoke* hanging lamp for Louis Poulsen

1958 Verner Panton designs his *Cone* chair for Plus-Linje
LEGO patents and introduces its "stud-and-tube" brick coupling system

1959 Nils Bohlin invents the three-point seat-belt for Volvo

1960 Lapponia Jewelry founded in Helsinki, Finland
Jens Quistgaard designs teak ice bucket for Dansk International Designs
Stelton founded in Hellerup, Denmark

1961 Tias Eckhoff designs *Maya* cutlery for Norsk Stålpress
Poul Volther designs *Corona* chair for Erik Jørgensen
Tapio Wirkkala designs *Puukko* knife for Hackman

1962 Verner Panton finally completes his *Panton* chair, sketched since 1957; produced by Vitra in 1967
Eero Aarnio designs his *Globe* chair for Asko

1963 Volvo is the first car manufacturer to offer safety belts as standard fittings in all models

1964 Timo Sarpaneva designs "frosted" *Finlandia* vases for Iittala
Maija Isola designs *Kaivo* textile for Marimekko

1965 Poul Kjærholm designs *Hammock PK24* chaise for E. Kold Christensen
Yrjö Kukkapuro designs *Karuselli* (Carousel) chair for Haimi

1967 Stelton launches Arne Jacobsen's *Cylinda Line* hollowware range
Olof Bäckström's *O-Series* scissors launched by Fiskars
Gunnar Magnusson designs *Apollo* chair for Kristján Siggeirsson

1955          1960          1965

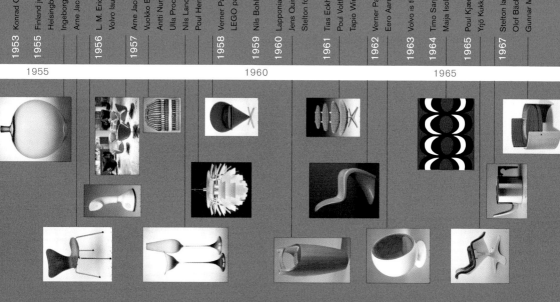

**1968** 1968 is "the year of revolt", as student protests and anarchist movements in the US and on the continent reach the North; in all countries, student protesters clash with police and young people are gripped by anti-establishment sentiments

Tapio Wirkkala designs the *Ultima Thule* glassware range for Iittala

A&E Design industrial design consultancy is founded in Stockholm, Sweden

Johan Huldt & Jan Dranger found Innovator Design in Stockholm, Sweden

**1969** Birger Kaipiainen designs *Paratiisi* (Paradise) tableware for Arabia

**1970** Verner Panton designs *Phantasy Landscape* installation for Visiona II in Cologne

Kompan launches *M100/Classic* rocking playground toy

**1971** 10-Gruppen launches its first textile collection in Paris

The Free State of Christiania is declared in Copenhagen and still exists today

**1972** Knud Holscher designs his *d-line* range of door furniture

The Helsinki Accords are signed as part of the Conference on Security and Cooperation in Europe

Peter Opsvik designs the *Tripp Trapp* high chair for Stokke

Jakob Jensen designs *Beogram 4000* record player for Bang & Olufsen

**1973** Denmark joins the European Union (then the European Economic Community)

Norway signs free-trade agreement with the European Union

**1975** Norway becomes a significant exporter of oil extracted from the North Sea

**1976** First entirely non-socialist Swedish government in 44 years elected

Erik Magnussen designs *Thermal Carafe* for Stelton

Svenska Slöjdföreningen, founded 1845, changes its name to Svensk Form; in 1983, it inaugurates its annual award "Utmärkt Svensk Form" (Excellent Swedish Form)

Grethe Meyer designs oven-proof *Firepot* range for Royal Copenhagen

**1978** Sigurd Persson designs stainless steel saucepan range for Kooperativa Förbundet

Yrjö Kukkapuro's *Fysio* office seating introduced by Avarte

**1979** Stokke launches Peter Opsvik's *Balans Variable* seat

Ergonomi Design Gruppen founded in Stockholm, Sweden

**1980** Ergonomi Design Gruppen designs *Eat/Drink* cutlery for RFSU Rehab

**1981** Jonas Bohlin designs *Concrete* chair, re-issued by Källemo

**1982** Nokia launches first-ever transportable phone, the *Mobira Senator Talkman* car phone

In Sweden, after six years, the Social Democrats regain power, retaining it (apart from 1989–1992) since then

**1984** Timo Sarpaneva designs *Claritas* vases for Iittala

1970

1980

Ulf Hanses designs *Streamliner* toy car for Playsam

**1985** Ole Palsby designs *Classical* thermal jug for Alfi

**1986** Prime Minister Olof Palme is assassinated in Stockholm

**1988** Stefan Lindfors designs *Scaragoo* table lamp, later produced by Ingo Maurer

**1990** Asplund gallery founded in Stockholm, Sweden
NordForm90, exhibiting architecture, industrial design and crafts from all five Nordic countries, is held in Malmö
Mats Theselius designs *National Geographic Magazine* bookcase for Källemo

**1992** InterDesign designs award-winning returnable milk bottle for Arla
Pia Wallén designs felt slippers for Cappellini/Asplund

**1994** Ilkka Suppanen designs *Nomad* chair
Lillehammer (Norway) hosts the Winter Olympic Games
In a referendum vote, Norwegians reject membership of the European Union

**1995** Sweden and Finland join the European Union

**1996** Timo Salli designs *Tramp* chair for Cappellini
Copenhagen (Denmark) is designated the European Cultural Capital of the year

**1997** Harri Koskinen designs *Block Lamp*, later produced by Design House
Hrafnkell Birgisson designs the *Sleep & Go* hotel pod

**1998** Björn Dahlström designs *Tools* cookware range for Hackman
Stockholm (Sweden) is designated the European Cultural Capital of the year

**1999** Norway Says design group founded in Oslo
Harri Koskinen designs *Relations* storm candleholder for Iittala

**2000** Helsinki (Finland), Reykjavik (Iceland) and Bergen (Norway) are designated three of the nine European Cultural Capitals of the year
"Design in Iceland" exhibition held at the Reykjavik Art Museum
Norway Says design group exhibits at the Milan Furniture Fair and at Designers Block in London

**1990**

**2000**

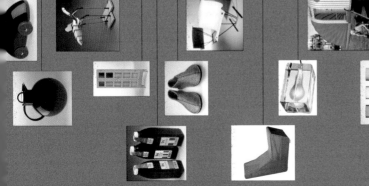

# picture credits

10-Gruppen: 77 (tl), 77 (t) ▷ Adelta Oy: 89 ▷ Artek: 79 (l), 96, 98, 99 ▷ Arvo Piiroiinen Oy: 261 ▷ Asko Oy Archives: 89 (middle), 89 (b) ▷ Asplund: 100 (tr), 292, 293 ▷ Avarte Oy: 204, 205, 206, 207 ▷ Barry Friedman Gallery: 80 ▷ Bonhams: 89 (t), 271 (br) ▷ Archiv Torsten Bröhan: 22, 134 ▷ Butterfields: 315 ▷ Carl Hansen & Søn: 319 (l) ▷ Carl Larsson-gården, Sundborn: 212, 213 (t) ▷ Christie's Images: 30 (l), 58, 91 (t), 109 (tl), 161 (bl), 166, 168, 182 (b), 183 (b), 190, 195 (t), 197, 223, 226, 229, 242, 260, 270 (tl), 270 (tr), 271 (bl), 271 (tr), 272 (l), 273 (l), 273 (r), 274 (l), 275, 278, 279, 312, 313 (t), 318, 323 (b), 330, 327 ▷ Danish Design Center: 322 (t), 322 (b) ▷ Danish Tourist Board: 21 (photo: Jørgen Schytte) ▷ Dansk Møbelkunst: 120, 136 (t), 161 (t), 194, 196, 248, 249 (b), 266, 270 (bl), 274 (r), 317 (b), 320, 321 (tl), 323 (middle r), 324 (tr) ▷ Det Danske Kunstindustrimuseum, Copenhagen: 94, 95, 102, 103, 130, 135 (photo: Ole Woldbye), 145 (photo: Ole Woldbye), 198, 199, 220, 221 ▷ Nanna Ditzel: 109 (tr), 109 (b), 111, 113 (t) ▷ Fiell International Limited: photo: Paul Chave: 8, 9, 11, 14, 19, 20 (Collection of Sacha Davison), 23, 24, 25, 27, 29, 32, 36, 39, 40, 41, 42, 48, 49, 51, 52, 56, 59, 62, 63, 68, 70, 71, 72, 73, 77 (b), 78, 83 (bl; Fischer Fine Art), 90, 141 (l), 157 (Collection of Sacha Davison), 165 (Collection of Ross & Miska Lovegrove), 167, 171, 193, 271 (tl), 323 (tl; Collection of Ross & Miska Lovegrove) ▷ photo: Fridrik Orn Hjaltested Photography: 44, 47, 50, 235, 291 ▷ photo: Jerry Sarapochiello: 334 (Collection of Sam Kaufman), 335 (t; Collection of Sam Kaufman), 335 (bl; Collection of Sam Kaufman), 335 (br; Collection of Daniel Ostroff) ▷ photo: Nicholas Toyne: 142 ▷ Finlans Arkiekturmuseum: 283 (t), 283 (b), 284 (t), 284 (b) ▷ Finnish Tourist Board – UK Office: 35 ▷ Fischer Fine Art: 97 (t), 243 (t) ▷ Fiskars: 38 ▷ Fredericia Furniture A/S: 33, 112, 113 (b) ▷ Fritz Hansen: 121 (l), 121 (r), 122 (t), 122 (b), 123, 131, 144 (l), 144 (r), 191, 192 (t), 192 (b), 251, 298, 310, 311 (t), 311 (b), 319 (r) ▷ Galerie THE-LOSCHs, Bonn: 16 ▷ Galerie Thomas Berg: 137 ▷ Georg Jensen Museum: 28, 108, 132, 163 ▷ Haslam & Whiteway: 83 (t) ▷ Herman Miller: 30 (r) ▷ Iceland Tourist Board: 45 ▷ Iittala Museum: 79 (tr), 79 (br), 202, 203 (t), 203 (b) ▷ IKEA of Sweden: 124, 125, 146, 147, 148, 149, 150 (l), 151 ▷ John Jesse Decorative Arts: 17 ▷ Jonas Bohlin Design: 104, 106/107 ▷ Källemo: 18, 93 (tl), 100, 186, 187, 188 (t), 188 (b), 189 ▷ Karl Andersson & Söner: 249 (t) ▷ Kim Ahm Photography: 158/159, 160 ▷ Kunstindustrimuseet, Oslo: 54, 55, 128, 129, 252, 253 (tl), 253 (b) ▷ Lammhults: 208, 209 ▷ Le Klint: 218, 219 (t), 219 (b) ▷ Louis Poulsen: 26, 138, 139, 164, 227, 228, 230, 231, 232, 233 ▷ Gunnar Magnússon: 46, 234 (photo: Vigfus Birgisson) ▷ Marimekko: 114, 152, 153 (t), 153 (b), 154/155, 238, 239, 240, 241 (l), 241 (r) ▷ The Montreal Museum of Fine Arts: 57 (Liliane & David M. Stewart Collection, photo: Giles Rivest, Montreal), 65 (Liliane & David M. Stewart Collection, photo: Richard P. Goodbody, New York), 87 (Liliane & David M. Stewart Collection, photo: Schecter Lee), 97 (Liliane & David M. Stewart Collection, photo: Richard P. Goodbody, New York), 222 (Anonymous gift, photo: Giles Rivest, Montreal), 224 (b; Liliane & David M. Stewart Collection, gift of Geoffrey N. Bradfield, photo: Richard P. Goodbody, New York), 288 (Liliane & David M. Stewart Collection, gift of Astrid Sampe & Almedahls AB, photo: Giles Rivest, Montreal), 309 (Liliane & David M. Stewart Collection, photo: Richard P. Goodbody, New York), 331 (Liliane & David M. Stewart Collection, photo: Richard P. Goodbody, New York) ▷ Muotoilutoimisto Salli Ltd.: 286 (photo: Ulla Hassinen), 287 (photo: Ulla Hassinen) ▷ Museum of Art & Design, Helsinki: 34 (photo: Rauno Träskelin), 81 (b; photo: MuseoKuva – courtesy of The Bard Graduate Center for Studies in the Decorative Arts, New York), 174 (photo: Rauno Träskelin), 175 (photo: MuseoKuva – courtesy of The Bard Graduate Center for Studies in the Decorative Arts, New York), 185 (photo: MuseoKuva – courtesy of The Bard Graduate Center for Studies in the Decorative Arts, New York), 257 (photo: MuseoKuva – courtesy of The Bard Graduate Center for Studies in the Decorative Arts, New York), 259 (photo: MuseoKuva – courtesy of The Bard Graduate Center for Studies in the Decorative Arts, New York), 280 (photo: Jean Barbier), 282 (photo: Rauno Träskelin), 285 (photo: Niclas Warius), 305 (photo: MuseoKuva – courtesy of The Bard Graduate Center for Studies in the Decorative Arts, New York), 307 (photo: Jean Barbier), 308 (photo: MuseoKuva – courtesy of The Bard Graduate Center for

Studies in the Decorative Arts, New York), 326, 327 (photo: Bruce White – courtesy of The Bard Graduate Center for Studies in the Decorative Arts, New York), 329 (br; photo: Bruce White – courtesy of The Bard Graduate Center for Studies in the Decorative Arts, New York), 330 (photo: Ulla Paakkunainen) ▷ **Nationalmuseum,** Stockholm: 66, 76, 92, 101, 105, 117 (b), 127, 140 (photo: Hans Thorwid), 172, 173, 211, 214 (t), 214 (b), 215 (t), 215 (b), 224 (t), 225, 236 (photo: Hans Thorwid), 288 ▷ **Norway Says:** 254, 255 (t), 255 (b) ▷ **Norwegian Tourist Board:** 53 ▷ **Antti Nurmesniemi Archive:** 43 ▷ **Collection of Noritsuga Oda:** 10 (photo: Yoshio Hayashi), 110 (photo: Yoshio Hayashi), 133 (photo: Yoshio Hayashi), 143 (photo: Yoshio Hayashi), 169 (t), 176, 177 (t), 178, 179, 180 (t), 181 (b), 182 (tl), 183 (t), 264, 314, 316, 317 (t) ▷ **Orrefors:** 12 ▷ **Panton Archiv,** Basel: 31, 267, 268, 269, 272 (r), 276 (tl), 277 ▷ **Philadelphia Museum of Art:** 84 ▷ **Phillips, de Pury & Luxembourg:** 15, 306 (l) ▷ **Simo Rista:** 85, 86 ▷ **Rosenthal AG:** 328 (l), 328 (r), 329 (t), 329 (bl) ▷ **Rud. Rasmussen:** 200 ▷ **Snowcrash:** 294, 295, 296/297 ▷ **Stelton:** 162 ▷ **Stendig Archive:** 91 (bl) ▷ **Stokke:** 262, 263, 300, 301 ▷ **Ilkka Suppanen:** 302, 303 ▷ **Svenskt Tenn:** 69, 116, 117 (t), 118, 119 (l), 119 (r) ▷ **Swedish Travel and Tourism Council:** 61 ▷ **Taschen Archiv:** 216, 217 (photos: Barbara & René Stoeltie) ▷ **Vin-Mag Archive:** 150 (r) ▷ **Vitra:** 276 (tr) ▷ **Volvo:** 60 ▷ **Vuokko:** 115 (l), 115 (r) ▷ **Wright:** 13, 37, 91 (br), 156, 181, 270 (tr), 276 (b), 324 (b), 325

r = right; l = left; t = top; tl = top left; tr = top right; b = bottom; bl = bottom left; br = bottom right

# index

# acknowledgements

We would like to express our immense gratitude to all those who have helped us with the successful realisation of this project, especially Sacha Davison for her excellent graphic design and extraordinary patience, Thomas Berg for his enthusiasm and practical editorial advice, our research assistant Eszter Karpati for her unwavering dedication to the cause, Paul Chave for his beautiful new photography, Jane Hastrup, responsible for the Danish translation, and John-Henri Holmberg, responsible for the Swedish translation, and, of course, Susanne Husemann, Kathrin Murr, Sonja Altmeppen and Ute Wachendorf as well as other members of "Team TASCHEN". We would also like to offer special thanks to the numerous institutions, companies and individuals who assisted us with images and information including:

Alvar Aalto Foundation – Marjaana Launonen ▷ Alvar Aalto Museo – Katariina Pakoma ▷ Kim Ahm (photographer) ▷ Artek – Tytti Forsgård ▷ Avarte Oy – Marita Almiala ▷ Torsten Bröhan ▷ Bruno Mathsson International – Mr Thelander ▷ Carl Hansen & Søn – Jørgen Gerner Hansen ▷ Carl Larsson-gården – Marianne Nilsson ▷ Christie's Images – Charlotte Grant ▷ Danish Design Center – Jette Knudsen ▷ Danish Tourist Board ▷ Dansk Møbelkunst – Ole Hoestbo ▷ Det Danske Kunstindustrimuseet – Aase Sylow ▷ Tor Alex Erichsen ▷ Erik Jørgensen – Kirsten Lørup ▷ Eva Denmark A/S – Jacob Mohr Hansen ▷ Finlands Arkitekturmuseum – Timo Keinänen ▷ Figgjo ▷ Fredericia – Mette Lund ▷ Fritz Hansen – Maianne Gulløv ▷ Georg Jensen Museum – Michael von Essen ▷ IKEA of Sweden AB – Linda Wikstrom & Eivor Paulsson ▷ Iittala Glass Museum – Tiina Tervaniemi ▷ Källemo – Ago Kubar & Karin Lundh ▷ Kinnasand – Kerstin Jeanson ▷ Knud Holscher Industriel Design AS ▷ Kunstindustrimuseet, Oslo – Wenche Thiis-Evensen ▷ Lammhults – Ulrika Ståhl ▷ Le Klint – Kim Jensen ▷ Ursula & Rainer Losch ▷ Louis Poulsen – Vibeke Munk Jensen ▷ Søren Matz ▷ Musée des Beaux-Arts de Montreal – Linda-Anne D'Anjou ▷ Museum of Finnish Architecture ▷ Nationalmuseum Stockholm – Elisabeth Hoier ▷ Norwegian Tourist Board – Lene Trondsen ▷ Noritsuga Oda ▷ Daniel Ostroff ▷ Fridrick Orn (photographer) ▷ Marianne Panton ▷ Phillips, de Pury & Luxembourg – Alexander Payne ▷ Marimekko – Riika Finni ▷ Pelikan Design – Niels Gammelgaard ▷ Reykjavik Art Museum – Pétur Ármannsson ▷ Simo Rista (photographer) ▷ Rud. Rasmussens Snedkerier ▷ Skandium – Chrystina Schmidt & Magnus Englund ▷ Søbogaard ▷ Stokke – Lars Olausen ▷ Snowcrash – Jane Withers & Catherine von Hauswolff ▷ Svenskt Tenn – Annika Hauaf ▷ Taideteollisuusmuseo, Helsinki – Merja Vilhunen ▷ Victoria & Albert Museum – Nick Wise ▷ Vuokko Oy – Vuokko Eskolin-Nurmesniemi ▷ Wright Auctions – Richard Wright ▷ Michael Young & Katrin Petursdottir